Graphic Culture

D0160997

Graphic Culture

Illustration

and

Artistic Enterprise

in Paris,

1830–1848

Jillian Lerner

McGill-Queen's University Press

Montreal & Kingston · London · Chicago

© McGill-Queen's University Press 2018

ISBN 978-0-7735-5455-9 (paper)
ISBN 978-0-7735-5514-3 (ePDF)
ISBN 978-0-7735-5515-0 (ePUB)

Legal deposit third quarter 2018
Bibliothèque nationale du Québec

Printed in Canada on acid-free paper

MM

Publication of this book has been aided by a grant from the Millard Meiss
Publication Fund of the College Art Association.

This book has been published with the help of a grant from the Canadian
Federation for the Humanities and Social Sciences, through the Awards
to Scholarly Publications Program, using funds provided by the Social
Sciences and Humanities Research Council of Canada.

We acknowledge the support of the Canada Council for the Arts, which
last year invested $153 million to bring the arts to Canadians throughout
the country.

Nous remercions le Conseil des arts du Canada de son soutien. L'an
dernier, le Conseil a investi 153 millions de dollars pour mettre de l'art
dans la vie des Canadiennes et des Canadiens de tout le pays.

Library and Archives Canada Cataloguing in Publication

Lerner, Jillian, 1974–, author
Graphic culture : illustration and artistic enterprise in Paris, 1830–1848
/ Jillian Lerner.

Includes bibliographical references and index.
Issued in print and electronic formats.
ISBN 978-0-7735-5455-9 (paper).–ISBN 978-0-7735-5514-3 (ePDF).
ISBN 978-0-7735-5515-0 (ePUB)

1. Prints, French – France – Paris – 19th century. 2. Art and society – France
– Paris – History – 19th century. 3. Visual communication – France –
Paris – History – 19th century. 4. Communication and culture – France –
Paris – History – 19th century. I. Title.

NE485.L47 2018 769.944'36109034 C2018-901464-4
 C2018-901465-2

Contents

Acknowledgments

I have many generous people and institutions to thank for their support of this project. I am grateful for an invaluable postdoctoral fellowship from the Social Sciences and Humanities Research Council of Canada, and for doctoral funding from the Graduate School of Arts and Sciences and the Department of Art History and Archaeology at Columbia University. For their expert assistance and kind provision of resources, I thank the staffs of the Bibliothèque nationale de France, the Museé de la Publicité within Les Arts Décoratifs, Paris, the Musée Carnavalet, the British Museum, the British Library, Brown University Library, Yale University Art Gallery, the University of Exeter Library, the New York Public Library, Art Resource, New York, the University of Michigan Museum of Art, and the Harry Ransom Center at the University of Texas at Austin. This book has been published with the help of a grant from the Federation for the Humanities and Social Sciences, through the Awards to Scholarly Publications Program, using funds provided by the Social Sciences and Humanities Research Council of Canada.

I am deeply indebted to my two graduate mentors, Jonathan Crary and Anne Higonnet, for their ongoing support and the inimitable example of their scholarship. While these thinkers are known to the world for their visionary reframing of nineteenth-century visual culture, their less visible work as awe-inspiring teachers also deserves enormous tribute. The opportunity to serve as teaching assistant to both of these tremendous lecturers was the bedrock and the highlight of my doctoral degree. For their sage advice, criticisms, and encouragement, I also thank my other dissertation readers: Barry Bergdoll, Sharon Marcus, and Alistair

Acknowledgments

Wright. Among the other exceptional teachers at Columbia University, I am obliged to David Rosand, Christina Kiaer, Benjamin Buchloh, Keith Moxey, and Andreas Huyssen. Anne Higonnet deserves one extra round of gratitude for her unstinting warmth, her fierce example of feminist scholarship, and for introducing me to her bright, open-handed friends Sharon Marcus, Vanessa Schwartz, and Margaret Cohen.

For enriching my research through conferences, invited talks, peer review, and conversations, my thanks to Hazel Hahn, Mary Hunter, Richard Taws, Louisa Iarocci, John Potvin, Martha Ward, Caroline Arscott, Karen Beckman, Patricia Mainardi, Matthew Biro, and Luke Gartlan. I thank the editors and reviewers at *Grey Room* and *Oxford Art Journal* for their help in refining my articles, and permitting me to incorporate revised versions of those essays here. Colleagues at the University of British Columbia who have helped this project along the way include Maureen Ryan, John O'Brian, Scott Watson, T'ai Smith, Ivana Vranic, Sarika Bose, and especially Deana Holmes. I am grateful for the energy and intelligence of the students I have had the pleasure to teach and learn from over the past decade.

For his interest in and stewardship of this project, I thank Jonathan Crago of McGill-Queen's University Press. My thanks also to the anonymous manuscript reviewers and to the editorial team at MQUP for their excellent and most welcome contributions to the improvement and production of this book.

For their friendship, solidarity, and carousing, I thank graduate-school comrades Ethan Blankenship, Andrew Manson, John Harwood, Andreas Broegger, Abigail Susik, and the late Caleb Smith, whose memory lives on in our hearts and in the mixed tapes he made us. Adam Lerner, Neel Scott, Mario Lopez-Cordero, Robert Franek, Lauren Larocca, Emily Manson, and Jessica Green made New York City a home as well as a source of adventure. For extending that home in London, Paris, Mainz, Austin, Memphis, and Vancouver, I am beholden to Sophie Howarth, Schorsch Berg, Leo and Bini Acerenza, Maryvonne Kreim, Jenn and Paul Kramer, Syd and Lauren Lerner, Dory Lerner and Sabrina Adams, Danielle Wilmore and Wade Papin, Jo and Stuart Rolland, Maggie and Noah Russell, and my sister, Lydia Taylor, who is a force of nature I am grateful to have on my side.

I owe the greatest debt to my family, the unflappable provider of sustenance, affection, humour, and fanfare for all occasions. I have abiding gratitude for my mum, who folded her own dreams into mine and taught me to always have a pencil handy to underline the important bits. For my dad, who cheers me onward, in life as in naval battles: never mind the manoeuvres, just go straight at 'em. For Adam's steadfast companionship, delight in the absurd, and studied disregard for the usual

measurable outcomes. Finally, for Sophie and Ian, who have grown from cherubs, to gremlins, to wonderful human beings in the time it took to write this book. Before I could complete it, we lost our two beloved grandmothers, Jane Franklin Manshreck and Betty Wolf Loeb. It is to these marvellous women of heart and steel that I dedicate this work.

Graphic Culture

Introduction

Caricature and fashion illustration were central elements in the charged visual culture of July Monarchy Paris (1830–48). City streets and middle-class homes were gradually infiltrated with images and print publications of various kinds, many of them depicting the manners and attitudes that characterized the present moment. The graphic artists who portrayed these urban mores and current ideas became the seminal painters of modern life. They were pioneers of new media, cultivators of broad audiences, and influential interpreters of social experience.

During the 1830s and 1840s, prints became a prominent form of instruction and entertainment: at once novel consumer products circulating within the urban environment, and artistic forms that offered critical commentary on that environment. A generation of untried editors and visual artists adapted their expertise accordingly. Some became penetrating observers of the rapidly changing society around them, taking up the new techniques of lithography and wood engraving to disseminate sketches of manners in myriad forms, from single-sheet prints to albums, books, and newly launched periodicals. As they chronicled the significant constituents of city life, these artists strove to make volatile social differences and cultural nuances perceptible. They actively shaped the manner in which Parisian modernity was understood.

Examined here are a selection of caricatures, fashion plates, celebrity portraits, advertising posters, costume designs, and illustrated city guides that promised to depict every facet of modern Paris and Parisians. The range of case studies should reveal the professional versatility of nineteenth-century illustrators and indicate their mobile position within a nascent market for contemporary art and ideas. It

should restore to view the breadth of graphic specialities practised by familiar artists like Gavarni (Guillaume Sulpice Chevalier, 1804–1866), Honoré Daumier (1808–1879), and Achille Devéria (1800–1857), alongside lesser-known colleagues like Bertall (Charles Albert d'Arnoux, 1820–1882). Although all of the profiled illustrators are men, each chapter highlights the importance of female collaborators and viewers. The changing horizons of nineteenth-century women – among them journalists, dancers, brazen actresses, respectable wives, dressmakers, amateur artists, and discerning readers – are central to this investigation.

Through a series of close readings, this study demonstrates that popular prints and ephemeral sketches are worthy of sustained formal and critical analysis. It is meant to be exploratory and reappraising rather than encyclopedic or definitive. Selected for discussion are graphic images distinguished by their visual sophistication and their reflexive potential to illuminate the horizons of nineteenth-century visual culture. The goal is to understand how sketches of fashions and manners were consciously positioned within old and new systems of visual representation and actively embedded in social and economic history.

These protean sketches defy scholarly balkanization and require an interdisciplinary approach. The development of graphic art in the early nineteenth century is inescapably intertwined with the histories of literature, journalism, publishing, fashion, theatre, consumption, and urbanism. However, this complexity does not diminish its relevance to the history of art. The position of everyday print images at the edges of other pictorial and literary genres – and somewhere between art and commerce – is precisely what makes them revealing objects of art-historical and historical inquiry. Exploration of these edges reveals fertile connections between different media, spaces of representation, and modes of experience.

There were myriad forms of illustrated print culture circulating in early-nineteenth-century France, many of which are beyond the focus of this book. I leave to other scholars the study of political caricature, literary and historical vignettes, pedagogical and event-driven illustrations for the periodical press, popular woodcuts, reproductive engravings, and fine-art prints,[1] although I do attend to the points where these forms intersect with the careers and markets researched here. The historical and geographic focus is July Monarchy Paris, a limited terrain but nonetheless crucial to the development of modern European visual culture, and a formative period for the expansion of media, publicity, and commercial diversification in both the art world and sites of urban leisure. Currents in this microcosm intermingled with flows in the provinces and neighbouring countries (especially Britain and the German states) and had significant effects in the later nineteenth century. Admittedly, I share an obsession with my objects of study: the exploration

of early-nineteenth-century Paris as a microcosm in which some of the roots and diagnostic signs of modernity (perceptual, economic, and social) can be found. But this is not just another book about Paris as the capital of modernity. It is a book about the first cultural producers who actively marketed their ability to summarize and decipher Parisian modernity.

A cascade of revolutionary events and social upheavals in early-nineteenth-century France made the need for new forms of representation and decipherment a matter of urgency. After "three glorious days" of popular insurrection in July 1830, the ultra-conservative reign of Charles X (the last Bourbon monarch) was ended. Freedom of the press was one of the firebrand drivers of this July Revolution and one of the key rights enshrined in the resulting Charter of 1830.[2] The Parisian press helped propagate the revolutionary fervour and its workers were leading constituents of the strikes and actions in the streets.[3] Diverse citizens fought together on the barricades erected in Paris, but the coalition between labourers and middle-class combatants soon broke down. For the next eighteen years, France would be governed by a constitutional monarchy that embraced the policies of the *juste milieu*: a middle way between further revolution and return to the hereditary privileges of the old regime. It was an uneasy compromise that disappointed both republicans and legitimists and failed to bring greater prosperity to French workers and the poor. The regime of "citizen-king" Louis-Philippe encouraged the growth of manufacturing, trade, commercial, and financial sectors and guaranteed the continued dominance of a landowning elite that combined old nobility and ascendant middle classes.[4]

Caricaturists and illustrators were among the incisive observers who attempted to identify the significant constituents of this emerging society. They would take stock of the local gains and losses, promises and betrayals, as well as the great privations and divisions that characterized the times. Some forms of graphic art were pointedly political and incendiary. However, many artists addressed the same issues via the more subdued, sustainable path of the representation of manners. Here graphic artists joined a host of essayists, playwrights, novelists, and journalists in chronicling the changing social situation. Social sketches by Gavarni and Daumier were seen as a significant visual counterpart to the vast human comedy penned by Honoré de Balzac.[5] These observers of everyday life aspired to a panoramic representation of the nineteenth century that would be sweeping in scope but thick with vital details and, more importantly, meted out in tantalizing fragments that could be digested at regular intervals: in instalments, suites, serials, and open-ended compilations. As Martina Lauster demonstrates, the sketch became a pivotal form throughout Europe in the 1830s and 1840s: it was the hallmark of a metropolitan

intellectual culture driven by publishing, feuilleton journalism, and new graphic media. Verbal and visual sketches worked well together; their flexible, open-ended forms encouraged collective works, omnibus publications, and dynamic exchanges across genres and national boundaries.[6]

The overlaps between social caricature, the realist novel, and other sketches of contemporary life were thematic, methodological, physical, and commercial. Often these pictorial and literary forms appeared side by side in the same periodicals, anthologies, or urban spaces and they aimed at the same broad anonymous audiences. Because sketches of manners were episodic and recombinable, they could be nimbly responsive to transitory themes and market opportunities. Parisian sketches of the 1830s and 1840s tended to be light-hearted, mixing insight, counsel, and entertainment; they were widely circulated and eagerly consumed. Some thinkers rightly critiqued these new genres as mercenary or affirmative of bourgeois ideology.[7] These everyday images were not radical, but they could still draw attention to the era's crucial political compromises, economic schemes, and social aspirations.

One of the guiding methodological assumptions of this book is that these quotidian artifacts of capitalist image-culture carry critical information – in both their form and content – about some of the key perceptual, cultural, and institutional transformations of the early nineteenth century. The printed images analyzed here are significant objects of study because they were at once pioneering *products* circulating within an emerging capitalist market for culture and discursive *producers* of commonly held social values and modes of experience.

By way of introduction to the themes and methods of this study, I offer an initial visual example (Fig. 0.1): a lithographic caricature by Gavarni that comments upon the fundamentally altered relationship between artist and patron, circa 1838. Gavarni dramatizes an encounter between a flamboyantly dressed artist and an uptight sitter who has come to the studio to have his portrait painted. The caption – "Let's see! Do I look good like this?" – suggests the sitter's nervousness about being scrutinized, first by the painter who has the temporary power to flatter or diminish him, and subsequently by the peers and descendants who he hopes will view the final product. He sits expectantly on the edge of his chair, neatly dressed in a starched collar and form-fitting suit. Middle-class aspirations are visible in his tidy attire and the fact that he hopes to display his wealth and status by commissioning a large painted portrait. The parvenu elite (perhaps a banker, lawyer, or business owner) could thus participate in a traditional model of patronage and luxury consumption associated with the old aristocracy.

The sitter's self-consciousness also draws our attention to the overly self-conscious pose of the artist, who has clearly exceeded the bounds of nonchalance

in his intentional dishevelment. The painter's face is shrouded by a wild thicket of hair. He wears indoor leisure clothes, including a soft cap and a smoking jacket of patterned velvet. He leans back in a casual contrapposto, hands stuffed in his pockets; instead of brushes and palette, his only accessory is a cigar flicked carelessly to the floor. He could be sizing up the sitter, but it seems more likely he is striking a pose himself. We realize the caption could just as easily report the artist's speech: "Let's see! Do I look good like this?" Of course, we now notice, it is the artist's profile that is at the forefront of the scene and perfectly framed by the blank canvas on the easel. Gavarni indicates that the bohemian's own appearance and identity are among his most important creative products: he produces himself as a work of art.

Where the bourgeois is stiff and square (seemingly one with the immobile rectilinear structure of the chair), the bohemian is loose, rumpled, and dynamic. One conforms to accepted conventions of bourgeois self-presentation in dress and painted portraiture, and the other conforms to a model of rebellious nonconformity in his appearance and choice of creative profession. These characters are equal sufferers of cultural pretensions and they share a desire for social distinction that is expressed in two different but equally standardized varieties of conspicuous consumption. Both are posers who wear the uniform of their type.

Although the bohemian and the bourgeois appear to be binary categories, Gavarni indicates all the important ways in which they are the same. Likely these men have the same backgrounds, upbringing, and education. A generation ago their relatives were craftsmen, clerks, provincials, shopkeepers, farmers, and day labourers. They are among the rising classes who benefited from the eclipse of feudal society. Both are self-made men who distance themselves from their humble origins and put on airs; they both need that blank canvas. Their identities are provisional and mutable, made up of elements given and contested, studied and invented, performed and exaggerated. They have become caricatures of themselves.

Gavarni's sketch reminds us that the bohemian and bourgeois are social peers and economic partners. The area where these characters are most uneven is in the commercial transactions of the studio. The modern artist must make his living by pandering to the interests of a bourgeois clientele, whether he persists with painting or embraces the growing possibilities of print (as Gavarni has done in producing this lithograph to be circulated in the satirical press) or later, perhaps, photography. Because the artist is dependent on the bourgeois purse, he finds other (cultural) grounds to feel superior: in this scenario he clearly has the advantage of style, as well as the power of representation. Sustained by romantic ideals, the bohemian of the 1830s imagines himself an intellectual outsider, not spiritually at home in an increasingly commercial age, nor subject to its stifling conventions and practicalities.

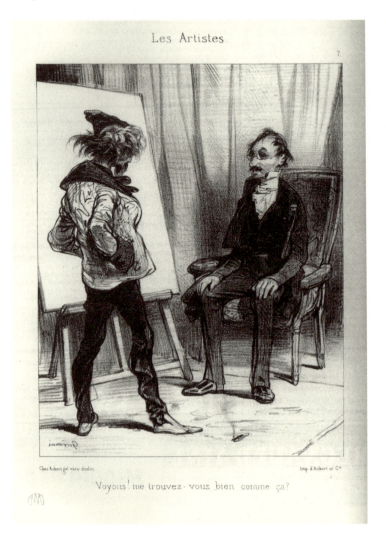

Figure 0.1. Gavarni, *Let's see! Do I look good like this?* 1838.

But Gavarni shatters the artist's pretense to transcend the economic circumstances of modernity. He reveals that the desired outside is nothing more than a pose, an act of stylistic deviance. Bohemia was not a given ethnic identity or class position but a lifestyle adopted in order to renounce certain social givens. Unlike the gypsies and street entertainers with whom they wished to be identified, bohemian artists intentionally chose to inhabit (or simply feign identification with) the margins of bourgeois society. And as cultural producers their rebellious stance was actively

taken up *within* the capitalist marketplace rather than somewhere outside of it. This "metaphysics of the provocateur," as Walter Benjamin would describe it, was the essence of bohemia: an artistic rebellion fought for its own sake and armed with a highly attuned sense of marketable innovation.[8]

These are all things that viewers can see – can learn to read – in Gavarni's sketch. The illustrator shows us how to gauge each significant social nuance: with his clever composition and multivalent caption, his charged delineation of clothing and bodily comportment, the way he pairs the characters and modulates the line to give each social type its own frequency. His design steers viewers to perceive the subtle differences between the bohemian and bourgeois, and then to appreciate their sameness and to reflect upon the larger historical context that shapes these values. The sketch demonstrates a range of *visible criteria*, guidelines for assessing the potential meanings conveyed in gestures, fashions, habits, social performances, and idiomatic speech, the micro-distinctions crystallized in bodies, things, pictures, and other less obvious semiotic surfaces. I borrow the term "visible criteria" from Jean Baudrillard in order to highlight how social meanings and particular ways of seeing were *graphically articulated* by the illustrators of modern manners. Studying the development of consumer societies in post-revolutionary Europe, Baudrillard observed that the ostensible achievements of modernity – the mythic qualities of equality and happiness – began to be attested and measured optically in new flows of visible objects, commodities, and signs.[9] The chapters to follow explore this notion of optical assessment and new semiotic economies, investigating the places where graphic currencies were improvised and propagated in the quotidian print culture of July Monarchy Paris.

For a variety of practical and methodological reasons, art historians have not yet thoroughly explored the forms of illustration researched here. The logistical challenges are substantial. Owing to the sheer volume and dispersal of nineteenth-century illustrations, it is difficult to track down and evaluate a sufficient archival sample, an even greater challenge to obtain an overview, understand representative patterns in both breadth and depth, and select exemplary objects.[10] However, other impediments are created by value judgments and lingering disciplinary prejudices in art history. The tendency of both formalists and social historians of nineteenth-century art has been to place the highest value on "autonomous" pictorial works, fine art made primarily for public exhibition rather than for sale and often purporting to transcend the market that determines other products and labours. This

has led not only to the privileging of high art over mass culture but to the valorization of radical artists who strive to resist the dominance of the middle class or subvert the capitalist conditions of culture.[11]

According to these criteria, one particular area of nineteenth-century print culture has been more studied than the rest: namely, the most biting forms of political caricature pursued in the 1830s by Honoré Daumier, Charles Philipon (1800–1862), and their talented collaborators at the pioneering satirical newspapers *La Caricature* (1830–43) and *Le Charivari* (1832–1937). The fact that these artists waged a searing campaign against the government of Louis-Philippe, censorship, and the reign of bourgeois liberalism has received a great deal of consideration.[12] Daumier continues to be heralded as an avant-garde artist *avant-la-lettre*: a heroic anti-phantasmagoric flâneur who penetrated the fetish character of modernity.[13]

July Monarchy political caricature is indeed highly significant and worthy of scholarly attention. But it should not be falsely isolated from the surrounding context of genres, careers, businesses, and audiences. Our view should include the diversified practice of the artists involved as well as the systemic structure of the cultural field they navigated and shaped. Daumier and Philipon made some of the most brilliant political satire aimed at the king, the *juste milieu*, and the middle class, but they also produced a wide spectrum of other, seemingly incompatible things: graphic advertisements, self-promoting *réclame*, lucrative and formulaic *physiologies* of Parisian types, erotic images, harmless sketches of manners, and compilations that were expediently assembled by recycling artworks made for other purposes. We cannot fully understand any of these forms without studying the complex relations between them and tracing the significant overlaps in the contexts of production and reception. To a great extent these seemingly disparate forms issued from the same networks of cultural producers; they circulated in the same social spaces and commercial markets for current art and ideas; and they were consumed by the same broad audiences as well.

Substantial efforts to deepen our understanding of these interrelated images and contexts are already underway, but there are still many topics and interdisciplinary connections to be explored. Much important groundwork has been contributed by historians of the press and literature, along with scholarship in the growing meta-fields of visual and cultural studies.[14] Historians Hazel Hahn and Jennifer Terni have pursued excellent interdisciplinary research on the cross-platform nexus of art, publishing, publicity, consumption, and urban spectacle in July Monarchy Paris.[15] Ségolène LeMen, Michel Melot, Beatrice Farwell, Annemarie Kleinert, Nancy Olson, Judith Wechsler, Gabriel Weisberg, Petra Ten-Doesschate Chu, and Ruth Iskin are among those who forged the seminal art-historical studies and exhibitions of

French lithographic caricatures, book illustrations, and posters.[16] Most recently, Patricia Mainardi has produced a rich survey of illustrated periodicals, books, comic art, and popular prints in nineteenth-century France and Britain. Building "a bridge between traditional art history and the new areas of visual studies," her book provides a much-needed map of illustrated print in this era and indicates numerous paths in need of further research.[17]

Graphic Culture aims to build upon and complement this foundation. It follows the careers of graphic artists who are overdue for further study, chiefly Gavarni and Devéria, while highlighting the importance of their collaborations and professional networks. It takes a closer look at several graphic genres – sketches of manners and Parisian types, book posters, fashion plates, and costume designs – while remaining attentive to the porosity between different image types and artistic careers. Moreover, one of the more pointed shifts of emphasis is that this study concentrates on the importance of commercial developments rather than political exigencies or technical innovations in publishing; it explores how July Monarchy artists and editors were not simply avoiding censorship or pursuing new visual strategies in newly available graphic media, but also endeavoring to form new markets, business practices, and audiences. As Brian Maidment has ably shown in relation to the English print context, the novel genres of this era were often created by reworking existing themes and image types to form new commercial propositions.[18]

Paradoxically, it is the very issue of cultural prominence and commercial success that has made the suddenly fashionable and widely known visual materials examined here unattractive for many critics. The grounds for objection were colourfully articulated by the first historians of nineteenth-century caricature in slightly retrospective essays written in the 1850s and 1860s. Charles Baudelaire ranked Gavarni among the foremost chroniclers of modern life, but he also suspected that Gavarni was "slightly tainted with corruption." "Often he flatters instead of biting … [his work] caresses the dogmas of fashion"; as a result, Gavarni's sketches of Parisian manners were "popular" and had "a considerable effect upon manners."[19]

Jules Champfleury was likewise wary and polarizing. He praised Daumier as a robust artist, a virile and brutal critic of the bourgeoisie, but he found Gavarni's caricatures too much like fashion illustrations: feminine, chic, and amusing. Champfleury accused Gavarni of creating "the very ideal of the bourgeois of his time, getting down on his knees before a sack of money."[20] Notice how gender, class, and markets are conflated in a tidy mythical opposition between an authentic, masculine, republican art of the people and a feminized, faddish, and prostituted commercial product for the bourgeoisie. Gavarni was set up as a straw man – an effigy of bourgeois self-interest, ephemeral pleasure, and historical amnesia, rather than

a maker of such effigies – to be skewered by critics bristling against the reactionary climate of the Second Empire.

Despite their misgivings, both Baudelaire and Champfleury were struck by how influential Gavarni's sketches were. Baudelaire remarked that young people – specifically students, humble working-class *grisettes*, and the promiscuous, opportunistic *lorettes*[21] –were actually imitating manners and idiomatic expressions delineated by Gavarni. Indeed, he credits Gavarni for inventing the very category of the *lorette*: visually defining the appearance and habits, as well as the particular dialect and affections, that made up this important (mercenary and fashionable) female type and shaped its social expressions among the populace.[22] When Champfleury echoed Baudelaire's observation, he elevated the class profile a few notches: "Worldly women and dandies imitate the poses of Gavarni's heros."[23] Both critics recognized the enormous discursive power and cultural significance of fashion illustration and topical social caricature, and the rich semiotic nuances these graphic genres could convey. They acknowledge the central role played by Gavarni and other illustrators in shaping contemporary values, identities, attitudes, rituals, and social interactions. The visual distinctions conveyed in these sketches clearly became part of the *habitus* of Parisians, to borrow the concept of Pierre Bourdieu. In other words, they were incorporated as "embodied history, internalized as second nature," becoming part of the durable dispositions and systems of definition through which everyday social experience is structured.[24]

It is worth examining several key terms that are deeply consequential for commentators yet nowhere clearly defined: bourgeois, popular, and commercial. When nineteenth-century critics disparaged the philistine tastes of the bourgeoisie, they were in fact bemoaning social and infrastructural changes that, among other things, drastically affected how modern artists and thinkers made a living. As Christopher Prendergast has shown, the "detested 'bourgeois' public" is in fact a mythic image of the public onto which nineteenth-century authors projected their frustrations with the pressures of the market.[25] Much of the time rhetorical invective against middle-class audiences and commercial art is accompanied by sociological vagueness and wishful cultural differentiation on the part of the commentator. Sarah Maza argues that *bourgeois* was rarely deployed as a term of self-identification in France; rather, it was almost always a way to describe someone else, an "imaginary other against whom the nation's values and destiny were forged."[26] Instead, positive articulations of social, cultural, and political ideals in nineteenth-century France tended to favour either the distinctive qualities associated with nobility or the presumed authenticity of working people.

The issue of the popular is equally slippery and contentious. If popular means "of the people," should it then denote peasants, commoners, labourers, everyone outside the nobility, or the entire population? Alternatively, if popular means "widely adopted and approved of by ordinary people," then again we come up against problems of inclusion and taste, authenticity and domination, re-education and resistance. (How widely adopted? Whose approval? How ordinary? Are popular forms only "authentic" traditional folkways or also elements that are adaptive, commercial, or imposed?)[27] Moreover, the term popular must be nuanced to account for ongoing historical transformations, for neither the social relations nor the relevant cultural forms have fixed values. Even the most obvious, seemingly undebatable distinctions run the risk of over-simplification and mystification. We may agree, for example, that formations of popular culture in the early nineteenth century were different from folk traditions and participatory entertainments of the eighteenth century, as well as from the twentieth century's well-developed culture industries in radio, print publishing, cinema, music, and television. But the finer distinctions and cross-currents, along with the dynamism of cultural forms and social forces, make efforts to define or periodize any of these configurations of "popular culture" extremely difficult.

If there is a popular print culture in the July Monarchy it must refer to a cluster of productive forces that are neither predominantly artisanal nor completely industrial, aimed at audiences that are neither peasant, proletarian, nor aristocratic but somewhere in between. The tricky task at hand is to understand how this middle thing emerges in the early nineteenth century: a nascent artistic and commercial print culture that aims to serve a broad, mixed, middle-tier public.

We cannot say that the work of Gavarni, Daumier, and their colleagues is popular in the sense of belonging to the majority of the population. In the 1830s and 1840s, well over half of the French citizenry would still be excluded from metropolitan print culture for reasons of both illiteracy and poverty.[28] However, as Gabriel Weisberg and Petra Chu have shown, there was an unprecedented "popularization of images" in this period that brought with it "a growing sameness in taste and consumption patterns." They argue that the expansion of literacy and print capitalism "eliminated the dividing line between high and folk culture, creating instead a popular culture that encompassed a social continuum ranging from the privileged class of landlords and urban capitalists to the petty bourgeoisie and upper crust of the laboring class (artisans, prosperous farmers, etc.)."[29] July Monarchy print culture was shared by a diverse group of viewers: predominantly Parisian and middle class, mixed with a few aristocrats and workers, as well as a growing contingent of provincials and foreigners

eager to participate in the culture of the French capital. This world of print was accessible enough that, for the first time, ordinary Parisians could expect to encounter a variety of pictures in their neighbours' homes[30] and in the public spaces of boulevards, cafés, and shopping arcades. Seamstresses, bankers, porters, gutter snipes, tradesmen, tax collectors, and salon hostesses might enjoy some of the same quotidian images and publications; moreover, they were each likely to find themselves (or at least their peers, neighbours, and other familiar constituents) represented in these everyday images. This meant that there was a broadening franchise of citizens who could participate in a common metropolitan culture, and with it, an imagined community of Parisian modernity.[31]

We can assume that the paying public for most of the illustrated publications covered in this study was relatively small, somewhere between two to six thousand for periodicals and serial instalments of books, and the same or less for lithographic albums, single-sheet prints, and bound volumes. There were 2,600 subscribers to *La Mode* in 1830; the other leading fashion periodicals (*Journal des dames et des modes, Petit courrier des dames, Le Follet*) each claimed between one and two thousand subscribers, up to half of them provincial.[32] The most successful satirical paper, *Le Charivari*, delivered a new lithograph every day to around 3,000 subscribers in the years between 1832 and 1846.[33] The Maison Aubert's popular *physiologies* (cheap pamphlets illustrated with wood-engraved vignettes that proliferated from 1840 to 1842) were printed in runs of 3,000, 4,000, or 6,000, with second editions for the best-selling social types, such as *Physiology of the National Guardsman* (9,000 copies) and *Physiology of the Flâneur*, which attracted an exceptional 13,000 buyers.[34] A similar range could be expected for the premium illustrated anthologies and sketch collections. *Les Français peints par eux-mêmes* (1839–42) was considered a great success, with an average of 6,000 copies per instalment.[35] Pierre-Jules Hetzel managed to sell a staggering 14,000 copies of *Scènes de la vie privée et publique des animaux* (1842).[36] All of these publications were appropriately priced to be affordable to middle-class buyers and prosperous craftsmen.[37] This clientele constituted a new public for printed imagery in the July Monarchy, larger than (though in some cases involving or extending) the cohort of wealthy amateurs who represented an established market for fine-art engravings, eighteenth-century genre prints, and images of antiquarian interest sold by picture dealers, *bouquinistes*, and the open-air stalls of *étalagistes* along the Seine.[38]

Of course, sketch publications and journals devoted to caricature or fashion were only one aspect of an expanding market for illustrated periodicals and newspapers in the July Monarchy. Edouard Charton's *Le Magasin pittoresque* (1833–1938) – an illustrated penny magazine aimed directly at the working classes and intent

on advancing a Saint-Simonian agenda of emancipation through universal education – achieved a circulation of 50,000, while the illustrated weekly news digest that was its up-market sibling, *L'Illustration, Journal universel* (1843–1944), printed 12,000 to 20,000 copies per issue.[39] The largest-circulation daily newspapers of the era, *La Presse* and *Le Siècle*, increased their readerships from 73,000 in 1836 to 148,000 by 1845. Both of these newspapers were unillustrated; their unprecedented commercial success has been attributed to reliance on advertising revenue, low subscription prices, the advent of "colourless" non-political news, and the prominent feature of serial novels.[40]

It is unlikely that July Monarchy workers would purchase more than the occasional print, instalment of an illustrated novel, or satirical journal. But it was not necessary to own publications in order to consume them. Anyone could read the papers for free in many Parisian cafés with the purchase of a five-centime *eau de vie*; or for ten centimes one could secure a six-hour session in a reading room, where a vast number of books and current journals were available.[41] Furthermore, caricatures and prints were displayed for the benefit of non-paying passersby through the mechanism of publishers' shop windows (as discussed in chapter 3). This meant that beyond active purchasers there was a wide range of readers and viewers who gained access to (and familiarity with) prints and publications in the streets and public establishments of the capital.

Almost as obscure as the issue of bourgeois or popular audiences are the commercial parameters of this print culture. There was certainly a new degree of entrepreneurship and speculation in print during the July Monarchy. Publishers were among the first French manufacturers to reorganize finance capital, labour, and workplaces to accommodate mechanized manufacturing technologies.[42] This increased production capacity, lowered costs, and made it possible to prepare ready-made consumer products for sale in a retail environment. Correspondingly, by the 1830s, we see a significant shift from specialized publications and deluxe-bound books, available by prior commission or subscription models, to inexpensive formats, serials, instalment models, and periodicals funded by advertising revenue.

This is a publishing world on its way to industrializing but not yet industrial: the technologies of production, methods of content development, and distribution were still in an emergent state. The story of July Monarchy publishing is one of continual crisis and innovation, characterized by recurring bankruptcies, reshuffled capital partnerships, and appeals to government for financial subsidies, judicial protection, and reform of the credit system.[43] The business of publishing was unpredictable, with few obvious examples of commercial success, little knowledge about target audiences, and only the faintest outlines of disciplinary expertise in

marketing, publicity, or retailing. Worlds away from a commercial mass culture that is strategic, administered, or formulaic, July Monarchy print culture was highly experimental in both its business models and artistic forms.

Commercial immaturity and improvisation are evident in many of the case studies to follow. Take, for instance, fashion illustration in the 1830s, as explored in chapter 4. It is clear that many of the fashion plates from this era showcased the ideas of the graphic artists who produced them, rather than toilettes provided by manufacturers and retailers of clothing. If these fashion illustrations encouraged the clothing trade, they did so only indirectly; their central mandate was to promote the products of the publisher and the graphic artist: his sketches, costume ideas, and ability to distill the essence of current fashions. A similar combination of experimental art and immature commerce is evident in the case of publishers' posters in the 1830s and 1840s, as discussed in chapter 3. Publishers' posters were one of the first pictorial forms of advertisement to be displayed in Parisian streets. I show that they were pictorial inventions first, and advertisements only by subsequent feats of bricolage, transference, and repurposing. In most cases these images were not designed as posters but adapted for that purpose by superimposing practical information (such as prices, contributors' names, and subscription information) onto illustrations poached from the artistic content of the books being sold. As a result, we find that many early-nineteenth-century forms of fashion illustration and advertising imagery were still rooted in realms of graphic imagination and artistic research. Having no specialized professional expertise in publicity or consumer marketing to draw upon, artists and publishers would pioneer this terrain by extrapolation, appropriation, and improvisation.

If we study nineteenth-century print culture closely, we can learn something about visual representation, economic conditions, and the changing texture of everyday life. My method for unravelling these phenomena involves researching both historical factors and representations of those historical factors. Although this approach may seem oddly circular, it suits the historically active images and discourses we are tracing. For the goal is to understand both objective conditions and ways of making meaning, and to grasp the constitutive circuitry between them. How did prints contribute to the economic and social life of the capital? How did they inform and constitute new publics? How did the prolific web of topical, quotidian representations alter the social landscape it purported to describe?

As Anne Higonnet and Margaret Cohen have argued, one of the most effective ways to trace the complex patterns of nineteenth-century visual culture is to look for uniquely self-reflexive images: "Some objects make their external edges and positioning within a field the subject matter of their representations, as they stage

within themselves the conditions of their position (or what phenomenology might call their horizon of possibility). Objects that thus carry within themselves the signs of their situation might be thought of as kinds of critical *mises en abyme*. They are objects that act as microcosms, designating the critical structures of visual culture."[44] Many of the images chosen for close examination in the chapters to follow provide this type of critical *mise en abyme*. These charged graphic images are at once exemplary objects situated in pivotal zones of the cultural field and rich pictorial statements that endeavour to bring their own situation to light.

The first chapter explores how the illustrator of modern life emerged in the early nineteenth century as both a concept and a historical profession. Several representations of this artistic type are analyzed, in order to grasp how the sketchers of manners were seen by contemporaries such as Benjamin Roubaud, Bertall, Nadar, Gavarni, Hippolyte Pauquet, and Jules Janin. Subsequently, the careers of several graphic artists are surveyed, with an eye to understanding their social origins, professional options, and the range of spaces in which their work appeared. To conclude I consider the development of the painter of modern life, as it morphed from a cluster of historical practices into a broader theory of experience and representation adapted by thinkers such as Charles Baudelaire and Walter Benjamin.

Chapter 2 considers the emergence of expert guides to Paris, in the form of both initiated human observers and the vast array of books and images that commodify their expertise. How did these artists and writers propose to make the modern capital legible, and just as significantly, how did they market their ability to do so? I analyze several descriptions of Parisian observers that convey the most valued modes of urban vision and social knowledge. I also explore how publishing editors devised new catch-all albums, sketch collections, and city guides in order to attract the widest range of celebrity contributors and local readers. The central examples are drawn from *Le Diable à Paris* (*The Devil in Paris*, 1844–46), a collectively authored compilation that promised a "complete picture" of private and public life in Paris. Several illustrations by Gavarni and Bertall portray the book's editor, Pierre-Jules Hetzel, as a devil who commissions work from local artists in order to gain an overview of the pleasures and miseries that define the city of Paris. I explore why these compositions present the book's editor as a devil, a dandy, a flâneur, a ragpicker, and a magic-lantern projectionist. This composite portrait of editorial and artistic expertise summarizes the value proposition of the book; suggests the relative merits of particular optical and literary devices; and points to institutional shifts that require cultural producers to develop new kinds of social discernment and curatorial power.

Advertising posters, window displays, and the marketing strategies of Parisian publishers are the subject of chapter 3. I explore how a variety of new pictorial

advertisements asserted themselves and trawled for a public, researching book posters by Gavarni and Grandville and the businesses of publishing editors Charles Philipon and Léon Curmer. The emergence of the poster form is discussed in relation to the history of billposting, ambulant advertising (as practised by traditional street hawkers), and retail and promotional techniques in France. Furthermore, I examine the appeal of illustrated typologies of Parisian characters, such as the street criers and *petit métiers*, the *physiologies* of Parisian types, and *Les Français peints par eux-mêmes* (*The French Painted by Themselves*, 1839–42) with its grand ambitions to provide "a moral encyclopedia of the nineteenth century" through a portrait gallery of social types. Throughout I explore the overlaps – thematic, professional, urban, commercial – between the new graphic publicity techniques and the new graphic products. The argument hinges on the proposition that typical social portraits were useful to both cultural marketers and social aspirants learning to navigate the nascent consumer culture of the July Monarchy.

Chapter 4 examines fashion illustration, bourgeois domesticity, and the lives of artists and well-to-do women through the lens of Achille Devéria's *Les Heures du Jour* (*The Hours of the Day*, 1829). This album of fashion plates depicts a series of acculturating rituals that a young lady cycles through in the hourly intervals of an ideal day. It also portrays the artist's friends and relations, the female members of the rarified social circle anchored by Victor Hugo and the Devéria brothers in the late Restoration. I consider the complex position of the artist's sister, Laure Devéria, as both a model for her brothers and an artist in her own right. The careers of the three Devéria siblings (Achille, Laure, and Eugène) reveal interesting contact zones between commercial, amateur, and academic art in the early nineteenth century. Among other things, this chapter considers how commercial fashion publications began to colonize the pictorial forms and social contexts of women's amateur art. It also illuminates a cluster of gender norms and ideals of private life at a significant point in their transformation. Special attention is paid to the domestic contexts of romanticism and the feminization of consumer behaviours and "accomplishments" in music, drawing, and watercolour painting. The relationship between fashion plates, genre scenes, celebrity portraiture, and typical images is explored.

Chapter 5 surveys Gavarni's work as a fashion illustrator and designer of costumes for theatre productions and masked balls. We learn how Gavarni helped to renovate masked balls and the art of masquerade in the 1830s and 1840s. His role in the invention of the *débardeur* costume and the planning of carnival parties is examined in depth, as is his collaboration with the famous stage actress Virginie Déjazet, who specialized in transgressive performances and cross-dressing roles.

This chapter explores the role of artistic celebrities as fashion innovators, taste professionals, and promoters of various products and entertainments. The deviance, everyday performativity, and self-publicizing strategies of several individuals and types are analyzed, with an emphasis on female performers, bohemians, dandies, *rats* (opera dancers), and *lorettes*. It considers how transgressive styles and performative inversions of class and gender were central not only to the theatre and carnival but also to aspects of daily life in the modernizing city. The porosity between print, stage, and street is explored, as is the extent to which popular amusements were transformed and commercialized in the July Monarchy.

My hope is that these individual case studies will contribute to an enriched picture of nineteenth-century print and visual culture. One of the leitmotifs that emerges in bringing them together here is that of new kinds of artistic expertise and optical connoisseurship generated by graphic artists through a combination of pictorial and commercial experimentation. The techniques of visual and social discernment that viewers encountered in the sketches of Gavarni, Devéria, and their colleagues were transferable from image to image and from images to the products, spaces, and inhabitants of the world at large. In the chapters that follow we can see how these artists propagated a new range of attitudes, commodities, and advertisements and added a significant graphic dimension to the perception of modernity.

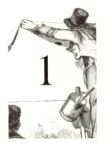

The Illustrator of Modern Life

What did it mean to be an illustrator or caricaturist in mid-nineteenth century Paris: an artist who made sketches of modern life for a range of print genres, periodicals, and books with topical themes? If this description seems unwieldy it is because this type of artist remains ill-defined just as his protean output confounds the familiar categories of artwork and authorship. Despite this irritating misfit, even because of it, the illustration of manners was a crucial term in nineteenth-century visual culture. It had tremendous significance both in its own time and in its impact on subsequent theories of modernity and "the painting of modern life."

This chapter aims to clarify the role of the illustrator of modern life circa 1840, charting his professional status, aesthetic strategies, and efforts to position his products – both rhetorically and economically – within an emerging Parisian market for art, news, and ideas. Although I regret the exclusive use of the masculine pronoun, it fits the artists examined here: Gavarni, Achille Devéria, Honoré Daumier, Grandville (Jean Ignace Isidore Gérard, 1803–1847), Nicholas-Toussaint Charlet (1792–1845), Henry Monnier (1799–1877), Charles-Joseph Traviès (1804–1859), Denis Auguste Raffet (1804–1860), and Bertall.

The analysis to follow considers both concrete historical conditions and partisan descriptions of this illusive artistic type. The first section examines how the illustrator was represented by his colleagues and contemporaries; the second charts the biographical and sociological particulars of graphic artists working in early-nineteenth-century Paris. I look for common patterns in their social origins and professional training, and survey the astounding range of genres, publications, and venues in which their work appeared. I also discuss the shifting landscape of institutional constraints and new opportunities that made up the contemporary

art world, with special attention to emerging contact zones where versatile cultural producers worked to invent new roles and specializations. To conclude, the third section of the chapter discusses the historiographical development of the painter of modern life as it morphed from a profession pursued by historical individuals (writers, illustrators, then painters) to a broader theory of experience and representation. It evaluates the importance of early-nineteenth-century sketches of Parisian manners in shaping the canonical work of later thinkers such as Charles Baudelaire and Walter Benjamin.

Portraits and Manifestos:
The Graphic Artist Painted by Himself

Let us begin by looking for contemporary descriptions of the illustrator of modern life. Although this artistic type made his living by cataloguing all of the important characters that made up Parisian society, the illustrator himself was rarely featured in the most popular social taxonomies of the 1830s and 1840s, such as the ephemeral *physiologies* published by the Maison Aubert and the monumental collaboration of *Les Français peints par eux-mêmes* (*The French Painted by Themselves*, 8 volumes, 1839–42). Whether by his own choice or the directives of his editors, the illustrator did not become a familiar Parisian type in the way of the grocer, the ragpicker, and the *lorette*. Nor was the successful academic painter represented in the well-known catalogues of Parisian types. Tellingly, the most conspicuous visual artist in these surveys of modern life was the *rapin*, a lowly apprentice painter: hungry, disgruntled, stubbornly pursuing an over-subscribed and outmoded path without much chance of material success or institutional support.[1] The *rapin*'s inability to thrive or adapt to changing conditions drew attention to tectonic shifts underway in the contemporary art world.

Yet, although the illustrator was not one of the more visible Parisian types in the July Monarchy, he was becoming a celebrity. The names of individual illustrators were highlighted on title pages and posters, and their faces featured among the famous personages of the day. Graphic artists benefited from the new prominence accorded to contemporary artists and intellectuals in the many illustrated biographies and portrait galleries published in the 1830s and 1840s. Benjamin Roubaud (1811–1847) included caricatured portraits of Charles Philipon, Daumier, Grandville, Gavarni, and Traviès among "all the artistic and literary notabilities of Paris" in his *Panthéon charivarique* (1838–42).[2] Roubaud also included a self-portrait in this series (Fig. 1.1), which celebrates the power of the caricaturist to summon an eager urban

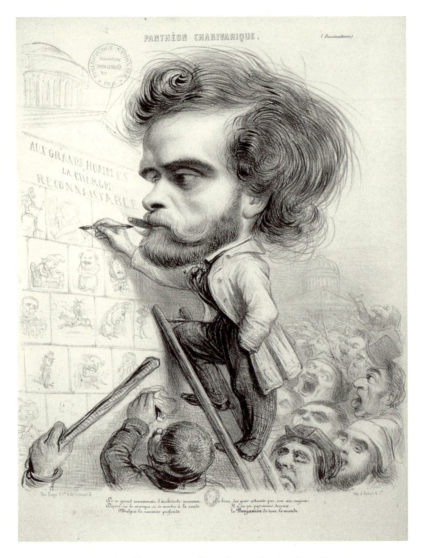

Figure 1.1 Roubaud, self-portrait in "Panthéon charivarique," 1842.

crowd and to immortalize his peers. Likewise, many of the illustrators who con-
tributed to *Les Français* are featured in large vignettes on the tables of contents.[3]

Bertall glorified a host of graphic artists in the beaux-arts panel (Fig. 1.2) of his
four-part "Panthéon du *Diable à Paris*" (1845–46). In this cheeky manifesto, Bertall
has made the illustrators more prominent and numerous than the illustrious
painters, sculptors, and musicians in the scene. While a handful of academic painters

La Musique, la Peinture, la Sculpture

Par BERTALL Gravé par ROUGET

Figure 1.2 Bertall, *Music, Painting, Sculpture* in "Panthéon du *Diable
à Paris*," 1844.

occupy the middle ground – Horace Vernet working on a massive military mural,
Jean-Auguste-Dominique Ingres and Eugène Delacroix locked in a stale duel be-
tween line and colour – they are eclipsed by Louis Daguerre, who captures the sun
above them, and upstaged by a crew of graphic artists in the foreground, including
Gavarni, Tony Johannot (1803–1852), Ernest Meissonier, Monnier, Grandville,
Charlet, Daumier, Cham (Amédée de Noé, 1818–1879), and Bertall himself.[4] In all
of these portrait galleries the illustrator is suddenly raised up by proximity to other
esteemed cultural producers and, more importantly, by the power and bias of his

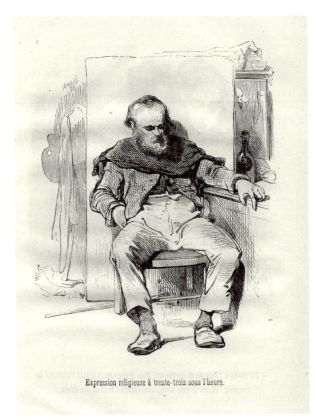

Expression religieuse à trente-trois sous l'heure.

Figure 1.3
Gavarni, *Religious expression for thirty-three cents an hour*, 1844.

own act of representation. The *Panthéon Nadar* (1854) continues this tradition of wishful self-commemoration into the second half of the century and affirms the apotheosis of the illustrator within it.[5]

Print capitalism would provide both the vehicle and the justification for the illustrator's self-promotion as a central protagonist of Parisian modernity. Involvement with the press – with its increasingly sophisticated means of mechanical reproduction and commercial distribution – gave these men enormous potential for image propagation, idea propagation, and fame. The illustrators' names and graphic styles, even their opinions and affiliations, were well known to a broad cross-section of the metropolitan public. Their sketches of manners were widely disseminated and discussed, and thus had the potential to shape how the public evaluated the prominent individuals and topics of the day.

To enhance our picture of the illustrator's expertise – his purview, working methods, and the advantages of his profession (first as seen through the bias of his own interests) – we can compare the charged depictions of two different work en-

vironments: the studio and the street. First, consider how Gavarni depicts the "Mœurs d'ateliers" (Mores of the Studios) (Fig. 1.3) in a caricature that takes aim at the practice of a history painter. The central figure is an old man with unkempt whiskers, ratty clothes, crude wooden clogs, and a wine bottle near at hand. He snoozes, slumped in a chair, surrounded by the paraphernalia of a painter: palette, smock, framed painting, blank canvas. Below him is a caption: "religious expression for thirty-three cents an hour." Apparently, this old fellow is being paid to pose in a painter's studio for 1.65 francs an hour, plus a quiet spot to nod off.

Gavarni mocks the painter who would model "religious expression" on this man's inebriation. How perverse to have a bum pose as a saint, to work up from such a grisly model to a beatific scene from holy scripture. Would the study of this head be sutured to a more exemplary body, clothed according to a study of anatomy and classical drapery, and then inserted into a dramatic composition? How strange to construct noble exempla and formal harmonies out of such incongruous parts, including studies of live models, flayed figures, and plaster casts. Gavarni points out the absurdity of the academic history painter's methods, as well as the obvious gap between means and ends, between the vulgar reality of the studio and the supposedly elevated ideals attached to the final product. Furthermore, he suggests that the history painter's subjects are formulaic, superficial, and terribly out of touch. How was a painter of vagrant apostles to understand the texture of life in the present or engage the interests of contemporary viewers?

By contrast, Gavarni and other illustrators of modern life could embrace subjects like these, they could forge an aesthetic that includes the lowly, banal, absurd, unsightly, or abject. Contemporary individuals from indigent to elite could be drawn directly from life. They need not be trussed up with historical costumes or religious expressions to enter the space of representation. All the inhabitants, scenes, and ignoble realities of the modern city belonged in the frame of caricature and sketches of manners. And that meant that a broad range of contemporary issues could be tackled as well. Here Gavarni takes the measure of studio methods, academic criteria, and class relations in a tone that is simultaneously comic and critical. In the process he showcases the dynamic, responsive, and self-reflexive potential of his graphic means, especially the capacity to engage the changing realities of modern life and to promptly disseminate his critical impressions to the public.

Hippolyte Pauquet (1797–1871) one of Gavarni's collaborators on *Les Français*, drew a more definitive portrait of this painter's opposite: the illustrator of modern life primed for action in the world outside the studio (Fig. 1.4). He is armed with a pencil and drawing board, maintains an athletic stance, and displays keen attention to the characters around him. Beside him are two other observers who attempt to

Figure 1.4
Pauquet, frontispiece in
*Les Français peints par
eux-mêmes*, vol. 3, c. 1840.

portray the scene; one is an older man – trim, bespectacled, seated with a notebook in his lap – who watches our protagonist rather politely from the margins. The contrast makes our central illustrator appear more heroic, active, and of his time. The illustrator's style of dress is modern, with calculated departures from bourgeois fashion and formality: Van Dyke beard, long hair, loose cravat. He wears no hat and has cast his jacket aside. His manner combines the elegant superiority of the man of the world and the gruff solidity of the indomitable man of the people. His work is both intellectual and physical, artistic and commercial; he is an aristocrat in spirit and a worker by trade.

The dynamism of the sketch is paramount here, both as theme and formal practice. We sense that the illustrator's method of inscription is rapid and vigorous, calibrated to register the flow of life around him. The contours appear to take shape impetuously, unevenly (here dark and reinforced, there faint and fugitive), and can be left open-ended. Pauquet is confident in the self-sufficiency of the sketch: not a

preliminary outline requiring later refinement but a finished product with its own aesthetic and informational value. Evidently, it is also the signature of an expert interpreter whose insightful readings of modernity are inscribed upon the social body. In this sense, the sketch must double as a faithful transcription of the empirical environment and a subjective vision of its underlying structure.

This coupling of the documentary and the interpretive would help graphic artists legitimize their art, particularly with respect to an academic hierarchy in which both contemporary subject matter and print media were declassed. As depicters of everyday life, illustrators had to defend themselves against charges of the vulgar and mimetic, while as printmakers they struggled against the spectres of the mechanical, the reproductive, and the commercial. These were long shadows cast by academic paradigms that privilege the ennobling and idealizing potential of monumental history painting. As a counterpoint, we see illustrators insisting on a balance between recording and imagination, as, for example, in the etymology of caricature as an interpretive "charge" that both exaggerates and reveals the truth of character, or in the rhetorical positioning of sketches of manners as both immediately excerpted from the flux of experience and mediated by a penetrating artistic vision. We can see this same balance of objective and subjective mobilized in defence of other low-ranking or aspiring genres such as landscape painting, photography, and other suspect forms of naturalism.[6]

Note that Pauquet does not indicate an urban scene or even a spatial construct. He depicts a world comprised solely of figures, books, drawing surfaces, and his own linear matrix. He signals that the illustrator of modern life is chiefly concerned with the social landscape and the experiential possibilities of the sketch and the print. It is his job to describe the characters he encounters, to distinguish their defining features, manners, fashions, attitudes, and habitats. He represents and catalogues the constituents of the Parisian crowd, in sketches designed to be multiplied and distributed back to the Parisian crowd. As a result, the space of representation and the space of everyday life begin to inform and produce each other in a circular manner.[7] Illustrations of modern life were among a host of diverse forms and sites in nineteenth-century Paris that produced such "spectacular realities" and "reality effects."[8]

The feedback loop between his art and everyday life gave the illustrator enormous discursive power; he could determine how modernity was experienced and read, how its fleeting effects were made visible in the features of typical Parisians. To a certain extent, this created an imbalance between the artist and the crowd that he explores, which is the same crowd he intends to inform, amuse, and serve. He is in a position to flatter or mock, to fabricate or reshape, to appraise, re-educate,

F. D.

Sire,

Nous avions tort de faire fi des hommes! ces pygmées sont des géants, et, à côté de leurs femmes, ces géants eux-mêmes ne sont que des pygmées.

Sire, Paris est le plus beau fleuron de votre couronne, et je serai bientôt en mesure d'envoyer successivement à Votre Majesté un compte rendu fidèle de ces mille choses gaies et de ces mille choses tristes dont se compose l'univers parisien, — toutes choses contre lesquelles votre ennui ne saurait tenir, — sans oublier ce que vous aimez tant, — des images à toutes les pages!

Notre œuvre, du reste, est pour faire du bruit dans le monde entier, et je puis promettre à Votre Majesté que dans peu elle sera satisfaite.

FLAMMÈCHE.

Figure 1.5 Bertall, "Prologue" illustration in *Le Diable à Paris*, 1844.

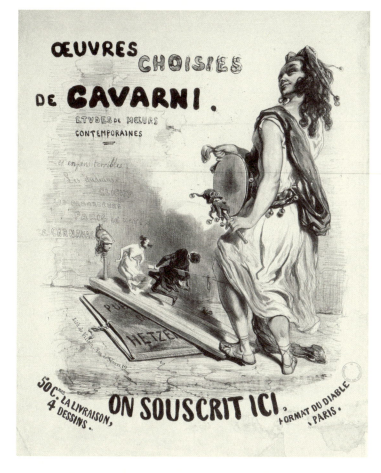

Figure 1.6 Gavarni, poster for *Oeuvres choisies de Gavarni*, 1845.

manipulate, influence, exploit. For his part, Pauquet hints at this peculiar power dynamic by creating disproportion between the monumental illustrator and the crowd of tiny Parisian characters who gather at his feet. These wee figures indicate at once the microscopically scrutinized objects of his study, the miniaturized products of his art, and the subordinate status of his pliant audience.

This uneven dynamic is a recurring motif in many of the manifesto-like images that adorn the frontispieces, introductory essays, and posters for the graphic publications on modern Paris. One finds other portraits of overgrown illustrators and writers interacting with little doll-like Parisian types. For example, in Bertall's prologue images for *Le Diable à Paris, Paris et les Parisiens* (*The Devil in Paris, Paris and the Parisians*) (Fig. 1.5), we see demonic authors torturing ordinary Parisians, here roasting them on a spit, there stringing along helpless marionettes. The same puppet-show contraption is featured in the frontispiece for *Selected Works by Gavarni* (Fig. 1.6).

The marionette theme draws attention to the artist's special authority to animate Parisian characters and make them perform his narrative of modern life. Furthermore, Gavarni's portrayal of this puppet master as a gypsy also suggests an unusual social position: that of a nomadic popular street entertainer who works outside established cultural institutions (and sometimes outside the law), earning a living through the custom of an anonymous pedestrian public. The gypsy demonstrated the positive potential of estrangement from bourgeois institutions; he had a potent mixture of marginality and freedom that illustrators and other "bohemians" readily identified with. They too could forge an alternate path, making do with little private property, cultural capital, social prestige, or official recognition by the academic establishment. They would still need the middle class as customers, as enablers and marks, but they did not have to be constrained by official values or middle-class conventions. The gypsy/illustrator could take pleasure in escaping those constraints and use them as raw material to be converted into art.

At least that's how the world may have looked from the illustrator's perspective, as manifest in numerous programmatic statements, self-portraits, and caricatures of his rivals. Now we turn to a different kind of evidence, in search of more concrete historical information about the biographical and sociological contexts in which those self-images were forged.

Careers, Specialties, Competing Spaces of Representation

Typically, the illustrators of modern life were newcomers who had to work their way over and up to gain ground in Parisian society. With few exceptions they came from working-class and petit-bourgeois families, and often from the provinces or neighbouring countries.[9] Daumier was born in Marseilles, the son of a glazier who aspired to be a poet; when his family moved to Paris in 1815, "their poverty caused them to lead an unsettled existence."[10] Philipon came from Lyon, where his father worked as a hatter and maker of wallpaper.[11] Charlet was Parisian; his father had been a soldier of the republic.[12] Gavarni was also born in Paris; one of his uncles was a successful actor but their Burgundian relatives made wine barrels.[13] Pauquet's father was an engraver.[14] The Devérias were once well-to-do, but Achille struggled to support his mother and siblings after his father's death in 1828.[15] Tony and Alfred Johannot were born in Germany to a family recently ruined and declassed; they came to Paris as teenagers hungry for work.[16] Other immigrants to Paris include Traviès, who was born in Switzerland to English parents,[17] Grandville (from Nancy), and Gustave Doré (1832–1883, from Strasbourg). In general, these artists were among

the new men in Paris, migrants and strivers from the lower end of the social scale. Very few had the advantages of inheritance, investment income, family connections, or introductions to Parisian society.

Many graphic artists were trained as painters, pupils in the most distinguished studios of the day. Célestin Nanteuil (1813–1873) studied with Ingres. Eugène Lami (1800–1890) was taught by Horace Vernet and Antoine-Jean Gros. Baron Gros also taught Charlet, Raffet, Philipon, and Henry Monnier (who also studied with Anne-Louis Girodet).[18] Achille Devéria studied with Louis Lafitte and with Girodet at the École des Beaux-Arts.[19] Traviès was a pupil of François Joseph Heim. Daumier studied with painter Alexandre Lenoir, before his apprenticeship to lithographer Zepherin Belliard.[20] Gavarni was one of the few illustrators who had no beaux-arts training. He studied mechanical drawing at the Conservatoire des Arts et Métiers and worked as an industrial draftsman for an architect and then a maker of precision instruments.[21] Aside from Gavarni, most of the illustrators of modern life were *rapins* at some point in their careers.

So why not remain painters? It would be difficult for these upstart men to pursue painting exclusively. A painter would need to support himself for an indefinite period – paying upfront for a studio, materials, and models, working for months or years on a single canvas – in hopes of a purchase or reward at some distant future date.[22] This was not a practical route for individuals without family resources to sustain them. Artists who needed dependable near-term income could look to the publishing sector and tap a steady stream of commissions from the likes of Charles Philipon, Emile de Girardin, Edouard Charton, Achille Ricourt, Alexandre Paulin, Jacques-Julien Dubochet, Charles Furne, Charles Gosselin, Léon Curmer, and Pierre-Jules Hetzel.[23] These Parisian publishers were prolific acquirers of graphic art, and they all understood illustration to be a central feature and a major selling point of the diverse prints, periodicals, and books they produced.

Still, it is crucial to emphasize that illustration was not just a practical choice for penniless artists or failed painters. Caricature and illustration offered significant opportunities for technical and formal experimentation; for exploration of modern life as subject matter and terrain of experience; for collaboration with other artists, writers, and publishers; and for circulating one's work to a wider audience using the newest and most efficient media available. Lithography and wood-end engraving were the cutting-edge techniques: rapid, inexpensive, repeatable in larger quantities than previous print forms, and full of new pictorial potential. Both were recent inventions that engendered new visual strategies and artistic specializations as well as vigorous commercial experimentation. However, it is important to stress that this new field was characterized by endurance and adaptation

alongside innovation. Brian Maidment's research on British print culture has been most attentive to these continuities. He indicates that the great vitality and diversity of graphic genres in the 1830s and 1840s was in large part due to the investment of new entrepreneurial energy in existing graphic traditions, especially those of the 1790s and 1820s. New commercial propositions were wrought by formal and generic experimentation, which included devising new packages for older material (re-editions, serials, collected works, and anthologies), new combinations of images or images with texts, and the reworking of familiar graphic themes, motifs, and vocabularies of social analysis.[24]

Lithography was the quickest and most direct printmaking technique: the artist could sketch with a grease crayon directly on the stone, which could then be inked and run through a press without any further mediation (such as the repeated acid baths and stopping-out of etching or the painstaking incisions of engraving). Invented in 1796 by Bavarian Alöys Senefelder, lithography was taken up by French painters around 1816. At first these early adopters made their own publishing opportunities: hiring printers to issue single lithographs or sets of their prints in portfolios or albums of varied subjects, typically costumes, landscapes, city views, genre subjects, and scenes drawn from life.[25] Most of these pioneering forms were stand-alone prints or image collections without accompanying texts. By 1830, these artists could contribute lithographic sketches to a number of new journals, beginning with Charles Philipon's *La Silhouette* (1829–31) and *La Caricature* (1830–35), as well as *La Mode* (1829–54) and *L'Artiste* (1831–1904).

Wood-end engraving was a little more expensive and labour-intensive to produce than lithography because the artist's drawing would have to be transferred to a block and incised by a skilled engraver; nevertheless, it was a technique that brought new possibilities for illustration, graphic design, and interactions with literary or journalistic texts. These plates were compatible with mechanized letterpress printing, so that pictorial and textual elements could be composed and printed together in a single page layout. Hence wood engraving became the technique of choice for publishers of illustrated books, periodicals, and newspapers.

The contemporary reader can glimpse this climate of experimentation and open-endedness by perusing the diversity of image types produced by July Monarchy illustrators. Take, for example, the range of lithographic pictures, "innumerable as grains of sand," made by Achille Devéria. The provisional list assembled by print connoisseur Henri Béraldi proceeds as follows: historical subjects, famous lovers, national types, religious subjects, sentimental subjects, lithographic albums, erotic pictures, diverse works published in *La Caricature* and *L'Artiste*, the cover and poster

for Delacroix's *Faust*, costume suites, and contemporary portraits "of the first order."[26] This is a dizzying array, and yet it focuses mostly on lithographs that were approached as stand-alone works which Devéria issued in the form of single-sheet prints, suites, or albums, though some were published in journals and books.

The complexity increases with an artist like Gavarni, whose designs appeared in an even greater range of physical formats and contexts of display. Gavarni's chief specialties included fashion illustration, costume designs, and social caricatures of typical Parisians, with an emphasis on the mores of women, students, artists, and carnival revellers. He also made portraits, genre subjects, *fantasies, diableries, abécédaires*, illustrative vignettes for novels and collectively authored works, and advertising posters.[27] Béraldi estimated that Gavarni's print œuvre comprises around 3,000 lithographs from his own hand, plus 2,000 prints (on stone, wood, or steel) made from his drawings by other printmakers, as well as 3,000 assorted drawings and watercolours.[28] One finds these works scattered in newspapers, women's magazines, satirical journals, comic albums, pamphlets, and multi-volume books. Gavarni's fashion sketches were published in *Journal des dames et des modes, L'Artiste, Journal des femmes, La Psyche*, and *La Mode* (where he was the principal illustrator from 1830 to 1833). He contributed nearly a thousand lithographs to Philipon's satirical daily *Le Charivari* from 1837 to 1848. His sketches of Parisian types appeared in both cheap *physiologies* and lavish anthologies like *Les Français* and *Le Diable à Paris*. One also encountered Gavarni's vignettes in novels – notably the *Oeuvres de Balzac* (1842) and Eugène Sue's *Le Juif errant* (1845) – and periodicals like the *Magasin pittoresque* and *L'Illustration*.

Alongside this astounding diversity of graphic subjects, genres, and formats, we should note that many early-nineteenth-century artists combined work in illustration or caricature with painting, sculpture, photography, journalism, or other pursuits.[29] Devéria and Charlet continued to work as painters, taking on pupils and exhibiting at the Salon (the official annual showcase of the Académie des Beaux-Arts). Daumier was an accomplished sculptor and painter whose work was also shown at the Salon.[30] Doré painted and sculpted.[31] Monnier was an actor, playwright, and critic.[32] Gavarni was a writer of newspaper articles, short stories, and novels; he also worked in watercolour, painted fans, designed textiles, and painted at least one shop sign in oil.[33] These men were ambidextrous to say the least.

Given this heterogeneity, it is incredibly difficult to scan, catalogue, and assess the work of these artists, or to grasp it with art-historical terms of oeuvre or signature style. It is equally difficult to come up with professional nomenclature that is appropriate and descriptive. The available terms tend to denote specific image types

(caricaturist, fashion illustrator) or techniques (lithographer, engraver) and belie the fluidity and migration between them, obscuring the complex patterns and over-laps in contexts of production and reception.

The term caricaturist was employed in the two most important early histories of this material: Charles Baudelaire's "Some French Caricaturists" (1857) and Jules Champfleury's *Histoire de la caricature moderne* (1865).[34] However, I find the term caricature too narrowly aligned with specific modes of satire and political critique; the category tends to exclude or diminish modes of illustration that are not comic, grotesque, or incendiary. Likewise, the term illustrator – an English word adopted by the French in the 1820s[35] – can be problematic. It suggests an auxiliary mode of drawing, supportive and secondary to a text it might accompany, which is distant from the perceptual, contemporary, and self-sufficient model of picture making pi-oneered by the illustrators of modern life.[36] Moreover, as Philippe Kaenel notes, the rubric of illustrator is too elastic: it could include everyone – if it expanded to every member of the artistic community who made vignettes for publication at one time or another – or no one, if it shrunk to those who practised illustration to the exclu-sion of any other pursuits.[37]

Kaenel also observes that most of the artists concerned avoided the label of il-lustrator, for a variety of reasons. Alongside its meagre status within the artistic field, illustration lacked definition as an identifiable métier. It was a field without specific training, without governing bodies or professional associations, and without a corresponding designation in commercial directories and dictionaries of the era.[38]

Dessinateur is much better as a catch-all category, for it can encompass a variety of practices, including drawing, painting, printmaking, fashion design, theatrical art direction, and the applied arts. Unfortunately, there are no perfect English equiv-alents for *dessinateur*, a person who draws; the closest options are *designer* and *draftsman*, both more limited terms that suggest a misleading split between indus-trial and artistic drawing.

Dessinateur was one of the professional terms embraced by our polymathic nineteenth-century illustrators. Gavarni, Monnier, Daumier, Grandville, and other artists who contributed to *Les Français* are acknowledged there as *dessinateurs*. They are also recognized as "painters of manners" in Jules Janin's introduction to the book. Janin argues that all of the contributing writers and *dessinateurs* share a common vocation as moralists, observers, and painters of contemporary manners.[39] In effect, Janin articulates a new kind of interdisciplinary expertise, a cross-platform painting of modern manners (belonging equally to graphic sketch and prose essay) that draws upon a range of pictorial, theatrical, and literary traditions. The advertising prospec-

tuses for both *Les Français* and *Le Diable à Paris* echo this expanded concept of painting by describing each of these illustrated books as an all-encompassing *tableau* of modern Paris.[40]

Interestingly, we can also see the generalizable term of artist taking shape around this time, both as a broader professional category linking different types of practitioners and as a mode of experience or way of being in the world, a special aptitude for perceiving, imagining, discerning, commentating, and creating, regardless of medium. Among other places, the category is given new form and public platform in the illustrated weekly journal *L'Artiste*, founded in 1831.[41] This leading review of contemporary art promoted the "fraternity of arts" (painting, sculpture, poetry, theatre, music, architecture, and decorative arts), priding itself on including a diversity of aesthetic positions and a generous display of lithographic images. *L'Artiste* was yet another site where the work of Janin, Balzac, Théophile Gautier, Eugène Sue, Gavarni, Johannot, Déveria, Charlet, et al. was gathered together, and where their diverse sketches of modern Paris were at home. In fact, we should add the study of modern Paris as yet another generalizable cross-platform category. As Théophile Gautier remarked in his introduction to *Paris et les Parisiens au XIXe siècle* (1856): "With this magic title of Paris, a play or review or book is always assured of success."[42] Modern Paris itself was a catch-all term, a common denominator, an object of interdisciplinary expertise, and a magnet of interest for the local reading public (as discussed further in chapter 2).

Given the hybrid and mutable nature of their specialties, the illustrators of modern life were keen to search for better professional descriptors and less ghettoizing terms. Tony Johannot described himself as a "peintre d'histoire" and Charlet preferred to be known as an "artiste-peintre."[43] Béraldi categorized Devéria as a "peintre, dessinateur" in an essay that describes only his lithographic output.[44] Grandville sought to be recognized as an "artiste-créateur."[45] He is celebrated as the romantic book illustrator par excellence, and yet he fought vehemently and creatively against the perception of his art as illustrative or in any way subordinate to text. Gavarni was one of the few artists who embraced the titles of illustrator and caricaturist. Perhaps because he was not trained as a painter, he was less concerned with opinions rooted in the studios and the Salon. Still, the Goncourt brothers declared the term caricature inadequate to Gavarni's magisterial "comedie de mœurs au crayon."[46] Béraldi was likewise expansive, calling Gavarni "*le* peintre de mœurs du XIXe siècle" (*the* painter of manners of the nineteenth century).[47] Even Baudelaire praised Gavarni and Daumier as the most significant chroniclers of the age, judging the incisiveness and immensity of their representations of modern manners on par with

Balzac's *Human Comedy*.[48] As important pioneers of the topical sketch, the comedy of manners, the *tableau de Paris*, and the painting of modern life, these illustrators were later ranked among the greatest authors and artists of the century.

What should we make of the fact that Philippe Kaenel, author of the best scholarly monograph on the métier of the illustrator in nineteenth-century France, describes the position of illustrators as dominated and declassed, workers who toiled in the "banlieue" – the impoverished outskirts – of the artistic field?[49] To understand the distinctions one must first grasp the hierarchies of genres and techniques defined by the French Academy of Fine Arts. Printmakers had a humble but legitimized position within the categories practised and exhibited at the Academy in the early nineteenth century, and there was considerable common ground in training and networks as well as strategic professional exchanges between painters and printmakers. Stephen Bann recounts that early-nineteenth-century painters considered their works in light of their possible reproduction in print and the associated practical arrangements of marketing to an audience beyond the Salon.[50] Similarly, Tom Gretton shows that, for most of the nineteenth century, illustrators and printmakers shared a cultural field with Salon painters, since they were all makers of handmade images with similar education and convergent skills who catered to the same demands; this homology of ambition was destabilized in the 1870s and 1880s with the introduction of photomechanical processes for image reproduction in illustrated periodicals.[51] Of the forty coveted chairs given to lifetime members of the Academy, fourteen were reserved for painters and four were occupied by engravers; lithographers were not considered.[52]

Until the 1860s, traditional burin engraving held its position as the most prestigious and professionalized form of printmaking: it was a pedigreed craft that took years to master and a distinguished image type in which an incredible amount of skilled artistic labour was invested. Burin engravers might work on original designs or make extremely fine reproductions of esteemed artworks (from the past or present) that would increase the fame and accessibility of the originals. It took Bervic six years to complete the magisterial *Laocoon* (an 1809 engraving after a drawing of a classical sculpture) and Paul Mercuri invested twenty-two years in the celebrated engraving of Paul Delaroche's *The Execution of Lady Jane Grey* (Salon of 1834).[53] Stephen Bann demonstrates that Delaroche was especially quick to grasp the advantages of reproductive engraving, from the outset designing his paintings with an eye to their distribution and popularization through print.[54]

Some of the Academy's painter-members experimented with the new art of lithography, among them Carle and Horace Vernet, Pierre-Narcisse Guérin, Antoine-

Jean Gros, Anne-Louis Girodet, and Eugène Delacroix.[55] In 1817 lithography joined engraving and etching as one of the art forms showcased at the Salon, albeit among the lesser genres.[56] This was a surprisingly rapid adoption, if one contrasts the frosty reception of photography at the Salon, after a delay of almost twenty years from the medium's invention. From the fine-art perspective, lithography had the advantages of responsiveness, a great tonal range, and the indexical trace of the artist's hand; it was embraced as an autograph technique nearly identical to drawing, easy to reproduce in large quantities without image degradation and without recourse to the intermediary translation of an engraver.

The fact that the printed pictures under consideration here were devalued within the beaux-arts scene had less to do with medium, skill, or formal quality than with genre. Sketches of modern life and genre scenes ranked low according to long-established academic criteria pegged to history painting above all else, so that the ideal was valued above the real, historical and literary subjects took priority over the modern and everyday, and monumental, public formats took precedence over small images designed for private or momentary consumption. Yet significant changes were afoot. Contemporary sketches were not well suited to the massive, cluttered space of academic exhibition where five-metre-wide paintings dominated, but they were optimized for print publication and thus for other spaces of domestic and urban display that would proliferate in the 1820s, 1830s, and 1840s.

It would be a mistake to think of illustrators and printmakers as outcasts scraping out an existence in denuded borderlands shadowed by a central academic citadel. For artists of the July Monarchy there was no such fixity of coordinates and no failure to thrive at the frontiers. A variety of forces and economic circuits had destabilized the formerly centripetal field to the extent that all practising artists would be affected. The citadel was in need of repair, and new productive centres would compete to take its place.

By the 1840s, there were many indicators that the existing beaux-arts infrastructure was no longer sufficient to accommodate the growing population of working artists. Only a tiny minority could count on the available streams of training, exhibition, and patronage provided by the Academy. Scholars Harrison and Cynthia White have marshalled the relevant statistics: only 1 per cent of serious painters could expect to get elected to the Academy in their lifetime; less than a quarter received medals at the Salon; less than a fifth received the Legion of Honour.[57] The Academy still offered the ultimate art education for aspiring painters, but its system of competitions, prizes, and stipends was insufficient to support the growing number of students. Likewise, the annual Salon exhibitions – still the best forum to gain

the attention of juries, patrons, critics, and the general public – were insufficiently accessible to the majority of professional painters. The number of paintings submitted increased roughly tenfold from 1800 to 1850, so that by the 1840s Salon juries were rejecting thousands of works each year.[58]

As a result, many visual artists were forced to look elsewhere and the Academy of Fine Arts would be steadily "displaced from an active role in the organisation of productive forces," as Adrian Rifkin has argued. Although it would retain its social prestige, control of art education and the Salon, the Academy would have less effective power with respect to the production and distribution of visual art.[59] More and more these activities took place within a protean commercial market. However, a robust system of private dealers, commercial galleries, group shows, middle-class collectors, art criticism, and the accompanying art-historical apparatus would not be in place until the 1870s.[60] This is a crucial point, for it meant many decades of uncertainty and transition for early- and mid-nineteenth-century artists, who could no longer rely on old regime patronage and corporatist institutions but were not yet reliably served by the modern dealer-critic system. Betwixt the two formations, French artists faced "an uneasy mixture of unstable state patronage and unstable private markets."[61]

The July Monarchy is a fascinating period partly because we can see the gradual and uncertain development of new markets for art, a proliferation of new media and image types, and a great expansion and diversification of audiences, all of which would bring the interests and purchasing power of the middle classes to new prominence. Visual artists developed a range of innovative strategies and specialties in an effort to thrive in these evolving conditions.

One important sector of the emergent market for art and ideas was developed by the publishers of books, prints, albums, and illustrated periodicals. In fact, the cluster of productive forces gathered around July Monarchy print publishing should be recognized as a significant early stage of the modern dealer-critic system, for we find there not only complex financial arrangements, methods of mass production, and circuits of commercial distribution – including new retail strategies and advertising campaigns – but also crucial collaborations between speculators and investors, commissioning editors, authors, illustrators, and critics. In other words, there were symbiotic alliances between cultural producers and the various dealers, commentators, and arbiters who determined the market value of their products.

Another sector of the nascent market for contemporary art was developed by Parisian picture dealers and boutiques. Nicholas Green demonstrates how art dealing in July Monarchy Paris grew apace with luxury consumption and a self-conscious metropolitan culture of visual pleasure and display. In this context,

certain genres of contemporary art were highly marketable to a middle-class clientele who valued them "less as art than as luxury commodities."[62]Among these picturesque commodities were small consumable paintings, drawings, sculptures, and fine-art prints, especially landscape and genre pictures. An up-market clientele might also collect rare books, art reproductions, and older engravings and etchings, including eighteenth-century costume, fashion, and genre prints. An exemplary enterprise was the shop of Susse established in the 1820s in the Passage des panoramas. Initially an upscale art dealer, Susse transformed his gallery and its shop windows into a popular urban attraction, selling a variety of inexpensive machine-made sculptures, statuettes, small furniture, and decorative objects, along with modest paintings and drawings for sale or rent. A savvy advertiser, Susse produced catalogues and lithographic albums featuring particular artists he represented, paid for extensive editorial advertising in the columns of fashion journals, and placed weekly ads in *Le Charivari*.[63]

Visual art was no longer a rarified item that an ordinary Parisian would see only infrequently in specialized settings, such as the annual Salon, or the decorative schemes of theatres and public buildings. There were now many more images and objects visible in the spaces of everyday life: in shops and window displays, in the streets, cafés, and arcades, and in frames, folios, and publications displayed in ordinary homes. As Jonathan Crary has insisted, this meant that artworks could not be conceived or consumed in isolation from other types of merchandise and visual experience. "The observer of paintings in the nineteenth century was always also an observer who simultaneously consumed a proliferating range of optical and sensory experiences. In other words, paintings were produced and assumed meaning not in some impossible kind of aesthetic isolation, or in a continuous tradition of painterly codes, but as one of many consumable and fleeting elements within an expanding chaos of images, commodities, and stimulation."[64] This "overloaded and plural sensory environment"[65] would have profound effects on the formation of audiences, consumers, citizens, and historically constituted observers. And it would have far-reaching consequences for the producers of images.

How did artists navigate this chaos of competing products, attractions, and vectors of visual stimulation? We can detect a wide spectrum of strategies on the part of early-nineteenth-century painters who endeavored either to stave off or to embrace these new plural conditions of visuality. Even those artists most wed to academic values and traditional kinds of painting adapted their approaches to nascent market conditions and the tastes of bourgeois audiences. Some of the major indicators here are a shift to smaller pictures suited to private consumption and domestic decor, including increased production in the lesser genres (landscapes, genre,

portraits), increased distribution of artwork through reproductive engravings, and a turn to more intimate and domesticated forms of history painting, such as troubadour pictures and historical-genre scenes.[66]

Many of these strategies of painterly compromise (however resented and repressed) can be seen in the career of Jean-Auguste-Dominique Ingres (1780–1867). Despite the fact that he was deeply conservative and painfully eager to defend the timeless values of academic classicism against the rising tide of industry and modernity, the logic of the market and bourgeois taste still pervaded Ingres's work. Scholars note that Ingres's oeuvre is full of incompatible styles, random painterly signs, and repetitions that make sense only as symptoms and effects of the marketplace he was intent on disavowing. Albert Boime contends that Ingres's "inconsistency" reflects "his attempt to satisfy a diverse clientele ... Ingres seemed to have owned something like a carpet or wallpaper patternbook with 'deluxe,' 'quality,' and 'standard' samples to show his prospective aristocratic and middle-class buyers."[67] Similarly, Adrian Rifkin recognizes "something of the shop window" in Ingres's oeuvre: an erratic array consistent with the merchandise-like quality of art and the urban environment of consumer choice and distraction.[68]

Ingres was an extreme case: a painter who repudiated the new conditions of visual pluralism and commercial competition yet adapted to them nonetheless. Of course, there were many more adventurous early-nineteenth-century painters who were keen to venture beyond traditional frameworks of painting and to make the painter's vocation more adequate to the expanded visual field. Take just two incomparable, epoch-making examples: Théodore Géricault (1791–1824) and Louis-Jacques-Mandé Daguerre (1787–1851). Géricault profoundly expanded the language and spaces of history painting through exploratory dialogue with "other" discourses and modes of visuality. He painted battle portraits that were more like blown-up prints, unfinished sketches, or fragments of paintings. With *Raft of the Medusa* he monumentalized a scandalous current event; collapsed the academic *grande machine* with the news item and journalistic sensation; incorporated elements of medical discourse, travel literature, and eyewitness testimony; and later exhibited the work in a space of popular attraction, demonstrating its affinities with adjacent ethnographic curiosities, human anomalies, and other "reality effects."[69] Géricault was also an early investigator of lithography who made an exceptional album of prints featuring gritty scenes of destitution, industrial labour, and contemporary London street life (Fig. 1.7).[70] He was a painter of modern life decades before this was a term applied to painters.

Louis Daguerre's experimentation with diverse formats and optical effects was similarly explosive and visionary. He carved out a specialty in painterly illusion that

Figure 1.7 Théodore Géricault, *Pity the sorrows of a poor old Man!* 1821.

could migrate across an astounding range of media from theatrical sets to panoramas, Salon paintings, watercolours and pastels, smoke drawings, paintings on glass, a diorama theatre of his own invention, and the daguerreotype. He sought recognition from the Academy of Fine Arts but also from sources as diverse as the royal family, the popular press, and a mixed urban public of attraction seekers.[71] Daguerre also made early forays in lithography, exhibiting prints at the Salon in 1819 and 1822 and contributing ten plates to *Picturesque and Romantic Voyages in Ancient France,* "the greatest compilation of lithographic imagery of the century."[72] Both Géricault and Daguerre pushed the formal, conceptual, generic, physical, and social limits of painting; they make insular definitions and defences of the medium seem ludicrous. These two expansive painterly careers demonstrate the complex interconnections between seemingly incommensurate modes of representation, spaces of display, audiences, and systems of value attribution.

This particular moment of visual culture demanded a painter who could work in the interstitial zones of the complex field, an acute observer who could cross spaces without missing a beat, whose techniques were protean and exploratory and well calibrated to compete in an expanded, plural sensory environment. This is a

climate that would favour the illustrators of modern life as well. Not only were their means responsive and expeditious, but their output was mobile and repeatable so it could be many places at once. The illustrators of modern life were among the open-minded artistic shifters who worked in emergent media and in the contact zones between different image types and modes of visuality. They carved out a new type of expertise aligned with new technologies (lithography, wood engraving), new audiences (a broad and diverse urban public), and new or remade genres (journalistic, popular, commercial, topical) that aimed to describe the social and sensory experience of modernity.

Afterlives: Historiography of the Illustrators and Painters of Modern Life

The impact of these cheap topical pictures was profound. No doubt they shaped the views and expectations of ordinary Parisians in the 1830s and 1840s. And they remained a crucial touchstone for later generations of viewers, critics, and cultural producers. The quotidian prints considered here provided essential visual and conceptual foundations for later theories of modern experience and the painting of modern life. They should be central to any account of how the discourses of modernity and the modern artist developed in nineteenth-century France. And yet this has not always been business as usual for art history.

Although the discipline has changed enormously in the past few decades, one still encounters stories of modern art that begin with Charles Baudelaire's essay "The Painter of Modern Life" (1863) only to trace how his ideas are made manifest in modernist painting after 1860. Some narrators jump directly from a literary portrait of the modern artist (framed by a single canonical writer) to a hermetically sealed lineage of "advanced" art pursued exclusively by modernist painters. This framework not only neglects heaps of significant visual precedents without which these modernist practices would be unthinkable. It also sidesteps Baudelaire's most crucial insights about visual culture, chiefly, his recognition that by mid-century there were already significant transformations underway in both modes of perception and modes of image production, including forces that would undermine the centrality and autonomy of painting as a medium adequate to the age.

In fact, Baudelaire put print culture at the heart of modern aesthetics. It is the graphic artist who is the quintessential "observer, philosopher, flâneur – call him what you will; but whatever words you use in trying to define this kind of artist, you will certainly be led to bestow upon him some adjective which you could not

apply to the painter of eternal, or at least more lasting things, of heroic or religious subjects." It is not the history painter but the illustrator of fashions and manners who is best equipped to articulate the particular character and beauty of modernity, who is most attuned to the fugitive qualities of the present. And this maker of ephemeral sketches and prints also possesses "the technical means that is the most expeditious and least costly." Thus, Baudelaire concluded that the leaves of the "vast dictionary of modern life" would not be found in academic paintings and museum collections but in "the libraries, the portfolios of collectors and in the windows of the meanest of print shops."[73]

Some artists working after mid-century sought to resuscitate their insular high-art practices by learning from the sophisticated precedents they found in the work of Gavarni, Daumier, and the illustrated literature of modern Paris. Looking back from the 1860s, Baudelaire, Edouard Manet, and Edgar Degas conscientiously studied, collected, and built their work upon this vast archive of July Monarchy texts and images already well known to both the common reader and the artistic community.[74] They found in it not only a fecund source of themes but sophisticated visual precedents, valuable models of representation, and acute diagnoses about historical conditions of visuality.

Baudelaire's own aesthetics of modernity – developed simultaneously in his art-critical essays and the lyric poems of *Les Fleurs du mal* (1857) – was built upon this archive. As Karlheinz Stierle has shown, he continued a tradition that began with Louis Sebastian Mercier's *Tableau de Paris* (1782) and branched into the diverse surveys of nineteenth-century Paris, from city guides and essay collections to treatises, novels, albums, encyclopedias, and galleries of portraits and types.[75] While many of the early *tableaux de Paris* were in written form, in the 1830s and 1840s they were increasingly loaded with illustrations, vignettes, portraits, caricatures, and sketches of manners by Gavarni, Daumier, Grandville, Alfred and Tony Johannot, Monnier, and their colleagues. Enterprising editors, along with chagrined authors like Balzac, noted that it was the printed images that guaranteed the sale and popularity of these works.[76]

The *tableau de Paris* is another unwieldy category, containing predominantly lowly forms, mongrel mixtures of styles and voices, names known and unknown. Nonetheless, we can discern some threads of commonality in the goals, objects, and methods of representation. What these diverse works have in common is the aim to create a portrait of Paris that would also be a portrait of the century, a revealing overview of the present historical moment. And, crucially, the authors would trace the great social and historical transformations of the era in the medium of everyday experience.[77] This meant forgoing an abstract or omniscient vantage (rational,

systematic, disembodied, as in the encyclopedist's tree of knowledge) and adopting instead the perceptual and aesthetic device of a first-hand observer (embodied, mobile, subjective). These Parisian chroniclers would present the raw sensual particulars of lived experience in a way that might provide glimpses into the nature of the whole; they would relay significant facets of modernity without imposing a false totality or fixity upon it.

What this looked like in practice was extremely variable, yet these pioneering *tableaux* would typically embrace the sketch and the fragment. Mercier found useful coordinates in the eighteenth-century theatre and Salon – in the pregnant moment of Denis Diderot's bourgeois *drame* and the moral painter's *tableau* – yet his journalistic *Tableau de Paris* would abandon dramatic unity in favor of "contrasts" and "fugitive nuances." Mercier's compilation was made up of short informal prose descriptions, fragmentary urban scenes jotted down by a mobile observer. His peripatetic cumulative prose style was emulated by a succession of Parisian hermits, *rodeurs*, and flâneurs who churned out *tableaux de Paris* through the Empire and Restoration.

Continuers of this tradition after 1830 tended to publish more enterprising, heterogeneous, and visually oriented works. Aesthetic and commercial ambitions expanded apace and in many cases outgrew the capacity of a single author. One of the landmark forms of the 1840s was the multi-volume anthology (*Les Français, Scènes de la vie privée, Le Diable a Paris*), featuring short essays and wood-engraved illustrations by celebrated writers and illustrators. These undertakings required large production teams, capital investment, and editorial oversight. The multiplication of creators and modes of description greatly intensified the formal logic of contrasts and accumulated fragments. It also pushed graphic art and modes of visual attention to the forefront as one of the selling points and familiarizing elements in the otherwise chaotic assortment of voices and genres.

Attempts to describe the new type of representation manifest in these portraits of modern Paris often favour visual media as reference or metaphor. Terminology associated with the *tableau* is still present in the 1840s, alongside the more animate and discontinuous implications of a moving *tableau* or optical *review*: a sequence of vivid scenes that succeed one another as they would in the gaze of a pedestrian or a spectator watching a moving scene or picture. Several July Monarchy publications promise to "pass in review modern Paris." The illustrated periodical or book is imagined as a kinetic viewing device akin to a parade or procession, a kaleidoscope, a magic lantern show, a phantasmagoria, or moving panorama. It is a miniature pageant set in motion by the meanderings of a network of observant sketch artists and their armchair-bound virtual travel partners (more on which in chapter 2).

The power and utility of this language is the way it suggests animation, transience, and spectacle. It is significant that the passing scenes are both reality-based and illusory: cleverly observed and artfully rendered, meaningful by virtue of their relationship to everyday life and yet marvellously unreal. Furthermore, the scenes flash up or pass by but are never fully present. These fragments cannot be grasped as a totality but are among a host of possible vectors temporarily available to a distracted viewer.

Certainly, the surge of *tableaux de Paris* in the July Monarchy is evidence of a commercial opportunity recognized by producers and marketers of prints and books, if not also a perceptible category demanded by consumers. Baudelaire counted on his audience's familiarity with this valuable "subliterary" tradition and its related graphic imagery when he pursued its poetic sublimation in the "Tableaux Parisiens" (one of six sections in *Les Fleurs du mal*) and gathered up its central themes in "The Painter of Modern Life." Baudelaire's critical activity helped to make this thriving but dispersed assortment into a more legible category of representation and a legitimate vocation for artists, particularly those with grander aspirations and allegiances to consecrated genres of literature and art. Nevertheless, it is worth emphasizing that he found this vocation by studying the early-nineteenth-century illustrators of modern life. He also admitted that the vocation was incredibly difficult to define and name; regarding this painter of the passing moment, he advised, you may "call him what you will," as long as you admit he cannot be found in the studio or in the Salon.

The great twentieth-century philologist and cultural theorist Walter Benjamin was also fascinated with this material. He spent years combing the archive of early-nineteenth-century print culture as part of his research on Baudelaire, Paris, and capitalist modernity. In the *tableaux de Paris* and illustrations of modern life, Benjamin found not only rich descriptions and themes but also methods of representation that would guide his work as a cultural critic and philosopher of history. Quotations from these sources form the central armature of his *Passagen-Werk* (*The Arcades Project*), "a gigantic unfinished archive of nascent modernity figured as the cultural history of Paris,"[78] which he worked on from the early 1920s until his death in 1940.

As Irving Wolfarth notes, "the 'author' of the *Passagen-Werk* is – as befits – deeply implicated in his own bibliography." The *Arcades Project* was "an attempt to realize the dream of a certain romantic tradition of literature and historiography, and to implement decisive elements of that dream for the purpose of 'awakening from the nineteenth century.'"[79] Benjamin continued the literary and graphic tradition we have been tracing, mining key aspects of its content, form, and theoretical apparatus

and reconfiguring these historical components to release new possibilities for critical thought and political action in his own time.

The *tableaux*, *physiologies*, and illustrated guides to Paris were key sources for Benjamin. It is through the eyes of nineteenth-century observers like Balzac, Gavarni, and Grandville that Benjamin explores the spaces, products, and social relations of nineteenth-century Paris. Moreover, these works prefigured aspects of Benjamin's unorthodox methodology, demonstrating a model of history that is micrological, polyvocal, and imagistic. Benjamin was intrigued by the way the authors of the *tableaux* approached nineteenth-century Paris as a microcosm and imagined themselves as flâneurs, ragpickers, and physiognomists who could categorize any stranger and reveal the secret language of things. They too hoped that the big picture – an understanding of nascent capitalist modernity – would emerge from the trivial details and from the raw data of their own sensory and social experience. They also embraced a formal logic of contrasts and fragments, offering up a revealing but unresolved assortment of voices and styles, images and texts, to present a non-linear review of the era.

Benjamin's *Arcades Project* is clearly heir to this tradition: "Method of this project: literary montage. I needn't say anything. Merely show. I shall purloin no valuables, appropriate no ingenious formulations. But the rags, the refuse – these I will not inventory but allow, in the only way possible, to come into their own: by making use of them."[80] Embracing the vantage of the peripatetic street philosopher, he attempts to "assemble large-scale constructions out of the smallest and most precisely cut components. Indeed, to discover in the analysis of the small individual moment the crystal of the total event."[81] Instead of a linear argument or theoretical exposition, Benjamin produces an archive of quotations, notes, aphorisms, and descriptions of illustrations, an open-ended network of themes and categories with vital passages between them. He maps the terrain through montage, through strategic acts of extraction, triage, transition, and juxtaposition. By reconfiguring these details, he endeavoured to reactivate the ruins of modernity and illuminate the as-yet-unfulfilled hopes condensed in them.

Ironically, the nineteenth-century images discussed here are a casualty of Benjamin's method. For, although graphic illustrations and prints were central objects of study for Benjamin – among his key sources and case studies, the important emblems of and interpretive keys to the modernity he seeks – they are absent from the archive of textual fragments that he assembled. Unfortunately, he did not have the technical means to reproduce images in his note-files the way a present-day researcher armed with camera, copier, and scanner could. This means that the illustrations of modern life are not physically present in the handwritten form of

the *Arcades Project* we have inherited; to a certain extent, they have been lost in translation. But anyone who knows to look for them will find them throughout as part of the bedrock substrate, as enchanted objects of ekphrastic description and fecund sources of thematic inspiration and critical rumination.

Surely July Monarchy graphic culture also informs his visual approach to neo-Marxist analysis and his development of an imagistic theory of knowledge. Benjamin aimed to demonstrate how the capitalist economy is *expressed* in the products of mass culture, made manifest in visual representations and modalities of visual experience.[82] He sought to make history itself more perceptible, recognizable, and visible, to give critical theory a heightened graphicness, which he termed *Anschaulichkeit*. Montage was one of his central tactics for achieving this visibility. He would mobilize striking arrangements of quotes and thought-fragments (deployed spatially, like images) without recourse to the dulling mediation of discursive propositions or rational theories.[83] Another visual tactic is his use of the dialectical image: a collision of old and new, of dormant collective energies and moments of revolutionary awakening spurred by juxtapositions, chance encounters, and shocks of historical recognition. Looking to contemporary cinematic and literary techniques of surrealism and the Russian avant-garde, Benjamin's method was decisively shaped by the artistic and technological imagination of his day. In this, too, he followed the nineteenth-century illustrators of Parisian life who imagined they would make modernity legible by leveraging the enchantment and revelatory power of the latest visual techniques of their own era (also cinematic and literary): magic lanterns, panoramas, lithographic sketches, and urban flâneurie.

Perhaps more than any other factor in the present, it is the scholarly fascination with Benjamin's work that has created a new "now of recognizability" for nineteenth-century illustration, making it possible to perceive and evaluate the importance of those first graphic historians and theorists of Parisian modernity. This was his pedagogic goal for the *Arcades Project*, expressed in words directly scavenged from another author: "to educate the image-making medium within us, raising it to a stereoscopic and dimensional seeing into the depths of historical shadows."[84] We, too, can see in different dimensions, experience other kinds of illusions and realities, access many historical layers when we employ multiple borrowed lenses simultaneously. Benjamin's work informs the visible criteria that we bring to bear on the early nineteenth century today, and, at the very least, it helps us to see the significant work of perceptual re-education attempted by his Parisian predecessors.

The Editor as Ragpicker
City Guides and Urban Connoisseurship

When it came to selling prints and books in the nineteenth century, Paris was a winning subject. It was sure to gather the interest of assorted locals, tourists, and readers abroad, all eager for knowledge about current developments and social mores in the growing French metropolis. The subject was also favoured by editors keen to design publications that would be artistic, popular, and practical to produce. Among the key features of the sought-after books on Paris were topical themes, rich illustrations, inexpensive serial instalments, and an enticing list of celebrity contributors. Publisher Pierre-Jules Hetzel discovered that it was easier to secure contributions from famous writers and artists when there were few stipulations as to the topic, style, or even originality of the submissions.[1] In a letter of solicitation to Alfred de Musset regarding *Scènes de la vie privée et publique des animaux* (*Scenes of the Private and Public Life of Animals*), Hetzel showed he was eager to have just about anything from this esteemed author: "dramas, comedies, novels, discourses, essays, meditations, considerations, confessions, voyages, lamentations, reviews, real or fantastic stories, memoires, confidences, etc. etc. whatever you might make, sir, I would be extremely happy if you would make something."[2] To be included in Hetzel's compilation a work needed only lightly touch upon the broad theme of animals or of Paris. A new range of modular anthologies and albums was born: expediently assembled, formally diverse, yet held together by the open-ended framework of contemporary sketches (literary, graphic, journalistic, or satirical). The best of these collections were also held together by editorial talent and oversight.

This chapter explores Parisian city guides, the anthology form, and the editor's role through the study of one of Hetzel's crowning achievements, *Le Diable à Paris.*

Paris et les Parisiens (*The Devil in Paris. Paris and the Parisians*). Following the re-sounding success of *Scènes de la vie privée et publique des animaux* (1842),[3] Hetzel published *Le Diable à Paris* in serial instalments beginning in April 1844, and the project grew into a two-volume anthology completed in 1846.[4] While Grandville's illustrations were the main draw of *Scènes de la vie*, drawings by Gavarni and Bertall would take centre stage in *Le Diable à Paris*, alongside texts by Balzac, George Sand, Léon Gozlan, Frédéric Soulié, Charles Nodier, Gérard de Nerval, Arsène Houssaye, Théophile Gautier, Alfred de Musset, and others.[5] The first instalment or chapter of *Le Diable à Paris* is an introduction written by Hetzel (under the pen name P.J. Stahl) and featuring fantastic illustrations by Bertall. In this comic prologue, which doubled as an advertising prospectus for the project, Hetzel narrated a fictional genesis for the book.

This most comprehensive study of Parisian manners, he explains, was conceived in the throne room of Hell (Fig. 2.1). It seems Satan had instigated a reconnaissance mission to Paris, a relatively obscure and suitably vice-ridden region of his vast empire. Far too busy to travel in person, the diabolic emperor decreed that a juicily detailed field report should provide enough novelty and vicarious adventure to ward off the eternal boredom that plagues him. Satan instructed an attendant demon named Flammèche to act as his "correspondent and … ambassador," to infiltrate the French capital and record "everything that is, diabolically speaking, possible to know about it."[6] This Flammèche has devilish assets to employ in car-rying out his descriptive mission, yet he enhances these with local human expertise that is crucial to the success of the project. Being rather lazy, Flammèche decides to outsource the work to the most celebrated Parisian writers and graphic artists. So it came about that beguiling essays and caricatures from the likes of Balzac and Sand, Gavarni and Bertall, were brought together in the kaleidoscopic picture of Paris that Flammèche assembled for his master and, of course, Hetzel assembled for his customers.

In his role as cultural scout, commissioning editor, and expeditious distributor, Flammèche shows himself as Hetzel's fictional alter ego. Flammèche's commitment to Satan doubles as a promise from the editor to his public: to deliver in weekly instalments "a complete and faithful account of … the Parisian universe … without forgetting what you love the most – images on every page!"[7] If Flammèche stands in for the editor, it follows that Satan is a satirical proxy for the reading public: a bored tyrant with an insatiable appetite for informing amusements, especially in the ever-current forms of caricatures and inexpensive serials.

Gavarni's design for the frontispiece of *Le Diable à Paris* (Fig. 2.2) confirms the overlap of these two editorial figures, and it illustrates the kind of artistic and social

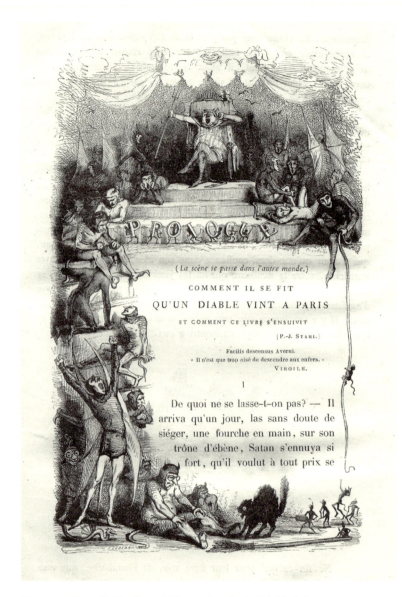

Figure 2.1 Bertall, "Prologue" illustration in *Le Diable à Paris*, 1844.

discernment that experts required as producers of the city guides and "panoramic literature" in vogue in the 1840s.[8] In essence this title motif – which also appeared on book covers and advertising posters[9] – is a portrait of Flammèche, the eponymous devil in Paris, in which Hetzel's sharp facial features and moustaches are recognizable. Close inspection of this lanky fellow's gear reveals an assortment of visual and literary devices, among them a map, a monocle, a magic lantern, and a basket overflowing with manuscripts. These objects in turn suggest the presence of certain character types – including the dandy, itinerant magic-lantern showman, and rag-

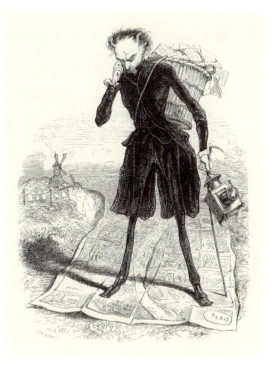

Figure 2.2
Gavarni, frontispiece in *Le Diable
à Paris*, 1844.

picker – whose attributes augment those of the devil and editor. As we shall see, these exemplary media and personae signal the diabolical editor's ability to decipher and represent the modern capital and they indicate the modes of vision and knowledge appropriate to the undertaking. By superimposing these attributes in a depiction of Hetzel as Flammèche, Gavarni creates a composite portrait of authorial expertise that proclaims the editor to be the ultimate artistic guide to the city. Through a close analysis of Gavarni's design, this chapter explores how the self-proclaimed guides to Paris purport to make the capital legible and how they convert that legibility into social, professional, and commercial capital.

Seeing Tools: The Map and the Monocle

Aside from the slight hint of demonic horns, Gavarni signals Flammèche's otherworldliness by the fact that the Paris unfurled before him is a map rather than a physical setting. The devil's exteriority to the plan of Paris emphasizes his status as a cosmic tourist with a foreign perspective on the city. But it also suggests his ability to grasp the city in its entirety, as a surveyable object of knowledge and representation.

Graphic Culture

Walter Benjamin and Pierre Bourdieu would later investigate the diagrammatic power of the Parisian plan in the work of Balzac and Gustave Flaubert, as both the physical stage and semantic field upon which these nineteenth-century authors inscribe social relations.[10] Perhaps instead the first readers of *Le Diable à Paris* would have enjoyed the resonance of Gavarni's devil's-eye view of Paris with the "bird's-eye view of Paris" provided by Victor Hugo in *Notre Dame de Paris* (1831). Hugo's disembodied narrator had described the holistic contours of the capital as they appeared from the cathedral's rooftop prospect, alternately as a panoramic "picture that on every side at once unfolded before the eye"; as an organic "single body" with a circulatory web of "arteries"; and as a map or legible "ground plan."[11] By replacing Notre Dame's towers with Flammèche's spindly frame, Gavarni would claim the totalizing orientation of this urban vantage for the *Diable à Paris* and its authors.

Nevertheless, the panoramic survey has certain shortcomings that Flammèche endeavours to overcome. Taking in the relative positions and bristling architectural features of the city's bridges, streets, and monuments, this topographic vision might be perfectly suited to Hugo's historical and conservationist interests.[12] But the distance and abstraction that allow an overall ground plan to be perceived eliminate the social particulars that were most intriguing to the authors and readers of studies of modern manners. In Hetzel's estimation, a shift in focus from the city's static body to its animate life made the *Diable à Paris* superior to its predecessors and competitors: "Until now we've been able to elucidate the number of Parisians, undertake statistical research … [draw up] plans and topographies … monuments … What's missing, is a work that reproduces in the finest detail the living and contemporary physiognomy of Paris … a work that is a faithful and animated mirror of Parisian life … Until now we've described the anatomy of Paris, today the task is to render its physiology."[13] The book's full title heralds this more dynamic societal concentration: *The Devil in Paris. Paris and the Parisians. Manners and Customs, Characters and Portraits of the Inhabitants of Paris, Complete Picture of Their Life: Private, Political, Artistic, Literary, Industrial, etc. etc.*[14]

Subsequent city guides would follow Hetzel's lead. Edmond Texier's *Tableau de Paris* (1852–53) would pronounce the transcendent perspective inadequate for the description of urban life: "Do you want to see this proud city, in all its grandeur, stretched out at your feet and unfurling its vast panorama before your gaze? Climb the rue des Martyrs, the levels of the Panthéon, the paths of Père Lachaise … From a bird's-eye view, one could say that the edifices touch each other … But leave the landscape brush there … What remains for us to describe is the soul of this great body … the Paris of flesh and bone, the Paris of men after the Paris of stone. Enter

into the big city: here is the crowd … that immense and populous bazaar, that universal meeting point of the species that Buffon ranked between the monkey and God."[15] Notice the representational techniques that Texier couples with topographic and social objects of study: the moving panorama, the bird's-eye view, and the landscape sketch are to be abandoned in favour of embedded street-level observation, human interaction, and taxonomic social discernment.

Flammèche aimed to reconcile these contrasting strategies: to maintain a commanding purview of the city while also exploring the Parisian scene from within, to build a complete picture out of the most intimate and varied parts. In this feat he was preceded by another literary devil named Asmodeus, the protagonist of Alain René Le Sage's *Le Diable boîteux* (*The Lame Devil*, 1707).[16] Asmodeus was a "tutelary demon" who showed his audience everything there is to know (again, diabolically speaking) about eighteenth-century Madrid. Le Sage had Asmodeus perch atop a church tower to describe the city from above. But he also empowered Asmodeus to peel back the rooftops and delve into the hidden human dramas unfolding behind the public façades of each household. This devil's transgressive vision proved irresistible to the authors who later promised all-encompassing surveys of nineteenth-century Paris. In his introductory article to *Paris, ou le Livre des cent-et-un* (*Paris, or the Book of a Hundred and One*, 1831–34), Jules Janin describes Asmodeus as an irreverent spirit who has guided the great literature of manners throughout the ages and into the present.[17] Similarly, Hetzel connected Asmodeus and Flammèche in one of his prospectus drafts for *Le Diable à Paris*: "[He] will guide you into the salons and into the garrets, into the political assemblies and into the street, and like his elder brother le diable boîteux he will lift … the roofs off the houses in order to initiate you in the most hidden, most intimate [and] mysterious secrets of this strange and exceptional life."[18]

Asmodeus does not have to enter the city in order to know what transpires there. This scandalously omniscient devil peers into houses and minds purely for rhetorical effect and voyeuristic pleasure. With Flammèche, however, the case is different. Paris is illegible even to the all-powerful and lazy Satan, who hence dispatches Flammèche to discover at first-hand the hidden logic of modern metropolitan life. To the synoptic overview Flammèche must add micrological insight, and whereas the former is signalled by the map in Gavarni's sketch, the latter is invoked in the monocle. This visual device summarizes Flammèche's two-pronged strategy for appropriating the modes of urban vision and knowledge possessed by local initiates. On the one hand, he will enter the city vicariously, like his readers, by looking through the expert lenses of the Parisian authors who supply the numerous texts and some

one thousand images that make up *Le Diable à Paris*. And, while this editorial strategy helps him to accumulate the views of cultural insiders, Flammèche also endeavours to *emulate* these privileged observers as he prepares for his own physical entry into the city.

Hetzel's prologue tells us that Flammèche, being a devil after all, could choose any form he liked in which to arrive on the Parisian scene. Ultimately, he equipped himself as a dandy, a character whose combination of social privilege, discerning observation, and leisure make him the perfect avatar for a devil who is both on a reconnaissance mission and on holiday. Aside from Gavarni's rendering of the superb outfit with its form-fitted tailoring, elegant cuffs, and square-toed boots, the monocle is perhaps the frontispiece's best pictorial clue to this chosen disguise. Rosalind Williams has aptly described dandyism as a historically specific mode of conspicuous consumption taken up in post-revolutionary times by the proponents of a "purely social type of authority enjoyed by trendsetters, obtainable simply through conviction of one's own superiority in taste rather than being dependent upon title, land, or office."[19] Crucially, the dandy expresses his superior taste both in the judicious display of an original personal style and in the critical adjudication of his contemporaries' success in the same arena. The monocle is a fitting accessory to both these kinds of judgment: an ornament of meticulous self-fashioning as well as an instrument of incisive social appraisal. In Balzac's *Illusions Perdues* (*Lost Illusions*, 1837–43), for example, the monocle is the main signature prop of the dandy de Marsay, whose impeccable style and cutting assessment make him the most intimidating and enviable "lion of Paris."[20]

Within the pages of *Le Diable à Paris*, the image that most obviously depicts the monocle as a marker of dandyism underscores how difficult it is to imitate this social type. In a full-page caricature within the anthology's subseries "Parisiens de Paris" (Fig. 2.3), Gavarni mockingly depicts two social strivers who fumble clumsily with eyeglasses in order to pose as dandies. These buffoons are doubly posers, for they ape rather than initiate a fashionable attitude, and they fail to realize how readily their effortful imposture can be seen by others. It follows that their monocles are also doubly useless, neither inspiring the rigorous production and analysis of their own look, nor facilitating a view of the world beyond their own noses and awkward squints.

In contrast to these pretenders, Flammèche's use of the monocle appears rather convincing. Sketches by both Gavarni and Bertall indicate Flammèche's confidence in bringing the amplified discernment of the monocle to bear upon representations of the city as well as directly upon its inhabitants. While the frontispiece shows a bespectacled Flammèche scrutinizing the map of Paris, a prologue vignette by

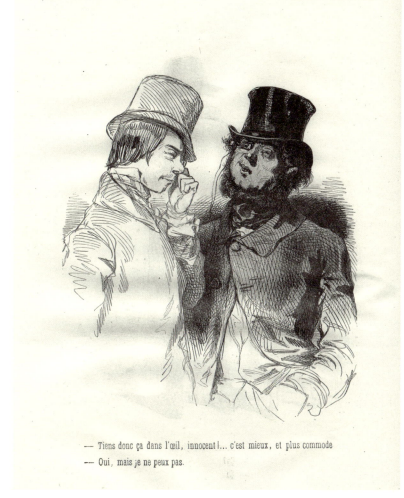

— Tiens donc ça dans l'œil, innocent!... c'est mieux, et plus commode
— Oui, mais je ne peux pas.

Figure 2.3 Gavarni, *Put that in your eye, innocent! It's better, and more useful*, 1844.

Bertall shows Flammèche in the same pose directing his magnified gaze toward a heap of manuscripts and images that genuflecting Parisian authors have piled at his feet (Fig. 2.4). To achieve his scheme Flammèche must be a knowing arbiter of images and texts as much as of manners and fashions; in this sense, the monocle is a key link between the sort of social discernment he aspires to as an embedded observer of metropolitan culture and the kind of aesthetic connoisseurship he needs as an editor of Parisian representations. We will return to Flammèche's editorial traffic in urban sketches shortly. But let us first reflect upon the curious authorial position staked out by his use of the map and the monocle in tandem.

The New View from Notre Dame

Both of these visual tools are essential to Flammèche's posing as an expert guide to Paris: the map declares the comprehensive scope of his urban survey and the monocle announces his possession of an initiated subjective vision. Their combination suggests that the capital can be made legible only by an author who reconciles panoramic overview and penetrating local insight. This dialectical perspective is given exemplary visual form in an 1853 photograph by Charles Nègre (Fig. 2.5). We return to the view of Paris from Notre Dame, although, rather than sweeping across the city to the horizon, our gaze is brought up short on two viewers in the foreground. Paris is still an object of vision but only obliquely; the urban vantage we seek is transferred to the bodies of these observers and available only through the mediation of their parallel perspectives.

The gargoyle at left is a permanent fixture of this Gothic threshold. Rooted to a sovereign yet lonely vantage, he seems resigned to what looks like world weariness, if not depression. Perhaps he is tired of the view, or rather envious of his temporary human companion who has ascended by choice and can return to the city at will. Unlike the diabolic emperor Hetzel's prologue portrays, this stony demon cannot cure his boredom with reports from the city below. He is more like a petrified relative of Hugo's narrator, brought down from his magical position outside the

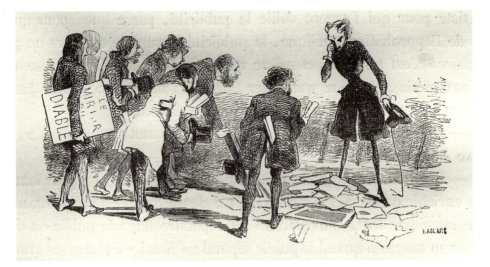

Figure 2.4 *Above* Bertall, "Prologue" illustration in *Le Diable à Paris*, 1844.

Figure 2.5 *Opposite* Charles Nègre, *The Vampire*, 1853.

confines of space and time to find himself imprisoned within a concrete body and representational frame. This disenchanting trajectory resonates with an epistemological shift described by Michel Foucault, whereby the transcendent subject of classical knowledge is eclipsed by a precariously situated modern subject: "a strange *empirico-transcendental doublet*" that is at once an agent and an increasingly circumscribed object of research and representation.[21] Considering more specifically visual terrain, Jonathan Crary traces a corresponding shift from a disembodied sovereign vision, based on the classical model of the camera obscura, to a synthetic vision located within the productive yet manipulable physiology of the modern observer.[22] According to this logic, we could interpret Nègre's two observers as parallel demonstrations of the compromises inherent in the new view from Notre Dame: with the gargoyle's material imprisonment emphasizing the limitations of his companion's subjective vision. Or alternatively, we could interpret them as a comparative illustration of two models of vision and knowledge side by side: the medieval fossil's panoramic remove offsets the modern observer's dynamic social perspective.

Nègre's composition seems to favour the latter interpretation. Both the gargoyle's melancholy and the perspective of the image point to the potent centrality of the top-hatted observer. The artist's notations reveal that the man portrayed is the photographer Henri le Secq. Hence the depicted photographer at the centre of the frame is the immanent counterpart of the invisible photographer who grounds this particular representation of Paris from outside its frame; Nègre and le Secq are as two halves of an "empirico-transcendental doublet." Moreover, this professional association suggests that the top-hatted observer is not only a constituent but also an influential producer of contemporary Parisian culture. He has climbed the cathedral's tower seeking some distance from the crowd and the fabric of the city, thus temporarily sharing or appropriating the commanding vantage of the demonic observer beside him; yet he brings with him a measure of subjective experience and social influence that could be accumulated and exercised only in the labyrinth below. Reconciling initiated proximity and exegetical distance, he stakes out an authorial position that James Clifford has shown to be central to ethnographic authority, namely, that of a "participant-observer" both inside and outside the cultural totality he represents.[23]

In 1853 Nègre placed a photographer at this productive centre both in and above the legible capital. In 1863 Baudelaire would assign a similar dialectical position to his "painter of modern life," a graphic artist whom he characterized as both a man of the crowd dissolving into a reservoir of social electricity and a sovereign prince enjoying his incognito.[24] Still others would equate this balance of immanent and

transcendent perspectives with the flâneur, whether as a privileged social type, an authorial figure, or, in the words of Vanessa Schwartz, a more open "positionality of power … through which the spectator assumes the position of being able to be part of the spectacle and yet command it at the same time."[25]

In contrast to subsequent emphases, however, neither the flâneur nor the dialectical position he is later associated with were particularly prominent authorial tropes within the introductory manifestos of the July Monarchy Parisian anthologies. In *Paris, ou le Livre des cent-et-un* and *Les Français peints par eux-mêmes*, the flâneur is an important modern type endowed with considerable philosophical, literary, and physiognomic power. Yet, however much the authors may have praised the flâneur in constituent articles, he does not appear as an emblem of authorship in the prospectuses, introductions, and frontispieces in which the authors define their expertise and summarize the aesthetic experience that their city guides provide.[26] Not until Texier's *Tableau de Paris* would the flâneur figure centrally in the introductory essay and be linked to the power of the author and the book to provide a virtual tour of the capital. Moreover, although these accounts locate the flâneur at the centre of the Parisian crowd, they show that he is embedded in it rather than being both in and above it.[27]

The *Diable à Paris* frontispiece is the first of these sources to give visual form to the precarious yet desirable balance between transcendent and immanent perspectives on the Parisian scene. And it is the first of these artistic city guides expressly to ascribe this hybrid position to its authors, its editor, and to the urban experience offered up by the anthology form. In Gavarni's sketch it is Flammèche who takes up the liminal position later enjoyed by Nègre's two observers, although here the dandy and the devil are collapsed into a single figure. Flammèche assumes a position of physical and metaphorical domination over the ground plan of Paris and at the same time displays the monocle as evidence that he possesses the empirical vision and interpretive acumen of an embedded initiate. Substituting his own body for the architectural platform of the church, this expert replaces and indeed *becomes* the view from Notre Dame, his towering frame rising over the city as the central landmark of its sacred geography and productive centre of its symbolic panorama. In a convoluted echo of Hugo's prophesy that print capitalism would eclipse the *Gesamtkunstwerk* of medieval architecture, Gavarni's diabolic editor usurps the cathedral's place as the *axis mundi* of the Parisian microcosm and world view. Hugo had envisioned the unfinished edifice of a second tower of Babel displacing the cathedral: a beehive of all human discursive activity piling out of a spewing printing press. In Gavarni's vision, Notre Dame is replaced not by a heteroglossic archive

but by a new kind of authorial authority: an editor who culls and subdues the end-lessness of the Parisian archive. Remarkably, this figure's remaining accessories show that it is as a *chiffonnier*, a ragpicker, that the editor is able to achieve this monu-mental task.

The Editorial Chiffonnier

The chiffonnier is the most visible social type in Gavarni's composite portrait of the editor, clearly identifiable by the occupational equipment of basket, hook, and lantern. Rather than the eclectic stuff one might customarily find among this noc-turnal scavenger's booty – including spent clothes, scraps of metal, and animal car-casses – the basket carried by Gavarni's ragpicker appears to contain an assortment of manuscripts. Significant framing vignettes by Bertall round out the frontispiece's suggestion that Flammèche is an editorial ragpicker who sorts through the prolific output of Parisian writers and illustrators. Whereas a prologue sketch shows Flam-mèche deploying the monocle to examine and select authorial submissions (Fig. 2.4), the first volume's closing image demonstrates how Flammèche uses the chif-fonnier's tools in a later stage of the editorial process (Fig. 2.6). Here Flammèche and a helper demon have gathered their final selections into two baskets labelled with roman numerals corresponding to the two volumes of *Le Diable à Paris*. And, as befits the sketch's functional placement, Flammèche is dumping out the basket containing the first volume's contents, offering a well-placed preview of artistic con-tributions that readers will find within the book and listed directly below in the table of contents.

Although the ragpicker was a decidedly lowly member of the city's indigent un-derclass, he had often been included alongside the urban tradesmen depicted in traditional social typologies like the *cris de Paris* and *petits métiers*.[28] The chiffon-nier's status as an important constituent of modern Paris and its new metropolitan typologies was solidified in the 1840s by Léon Curmer, who devoted to the character one of the 422 chapters of his monumental anthology *Les Français peints par eux-mêmes* (Fig. 2.7). Nevertheless, that written profile emphasizes the chiffonnier's oth-erness: his exclusion from the norms, communities, and modes of urban experience that define metropolitan modernity across the other portraits in *Les Français*. Al-most a perfect foil to de Lacroix's description of the flâneur as a quintessentially national character fluent in the changing semiotics of modern manners,[29] Berthaud depicts the chiffonnier as a foreigner: a fascinating specimen of an ailing race with its own peculiar habitats, languages, hierarchies, and diseases.[30] Moreover, the ac-

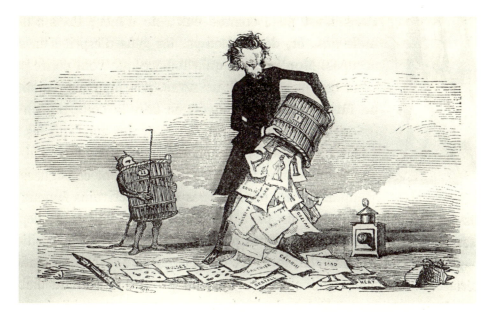

Figure 2.6 Bertall, "Table of Contents" in *Le Diable à Paris*, 1844.

companying wood-engraved portrait by Traviès conceals the face of this humbly bowed character, a compositional anomaly within the book's relatively formulaic gallery of national types.[31]

The chiffonnier did have a supporting role to play in the burgeoning print culture of the early nineteenth century, for his collection of rags was a necessary step in the manufacture of paper. This is the only bookish aspect of the chiffonnier's activity mentioned in Louis Sebastien Mercier's seminal *Tableau de Paris* (1782)[32] and again by Curmer in an 1839 report on the essential contributors and suppliers of the publishing industry.[33] Beyond such material contributions, the ragpicker began to accrue authorial symbolism in Jules Janin's improvisation on the Asmodeus theme in *Paris, ou le Livre des cent-et-un*. Janin has Asmodeus take the form of a chiffonnier in the revolutionary era as he gets right down into the gutter to portray the everyday life of the people.[34]

The stage was thus set for Hetzel's graphic collaborators to elaborate a literary role for the ragpicker in the thematic illustrations of the *Diable à Paris*. And, although at first it may seem counterintuitive to associate such an abject character with the book's protagonist and editor, there are rather strategic motivations for this coupling. In Gavarni's and Bertall's portraits of Flammèche, the chiffonnier's tools signal the overlapping of authorial and editorial expertise, and, more precisely,

Figure 2.7 Traviès, *The Ragpicker*, in *Les Français peints par eux-mêmes*, 1840.

facilitate the usurping of the former by the latter. For insofar as the map and monocle indicate an ethnographic authority to interpret and represent the *culture* of the capital, they characterize authorial qualities common to all of the anthology's contributors. By contrast, the ragpicker's tools seem to suggest an extra layer of expertise possessed only by the devilish editor, denoting his curatorial authority in relation to the work of his contributors or the *images* and *discourses* of the legible capital.

The ragpicker's hook and basket herald the editor's creative role in producing collectively authored anthologies, which involved overseeing a vast range of processes from conception and recruitment to manufacture, marketing, and distribution. Publishing editors like Hetzel and Curmer might be mere merchants with respect to some types of publication, but the production of illustrated albums and anthologies

required a skilful editorial foreman who could attract local talent; orchestrate a complex division of labour between contributing writers, artists, and engravers; and unite the divergent styles and perspectives of these multiple authors. These aspects of creative oversight demanded by illustrated books were emphasized by Curmer as he wrote one of the first descriptions of the editorial profession in 1839. But the report he crafted was prepared for the jury of an industrial exhibition and therefore concentrated on the profession's contributions to French commerce and industry.[35] The modern *libraire-éditeur* Curmer describes is first and foremost an industrial contractor who patronizes a number of national industries, including the suppliers of paper, ink, and machinery, and the newspaper publishers who profit from his advertising budgets, as well as bookbinders, printers, engravers, and colourists.

For the most part, any such business activity is downplayed in the editorial portrait defined jointly by Hetzel, Gavarni, and Bertall within the fictional parameters of the *Diable à Paris*. Yet their invocation of the ragpicker cannot help but call attention to the editor's commercial role. Like the ragpicker, the publishing editor makes his living by acts of collection, triage, and recontextualization that prepare goods for sale. He is a capitalist who performs a value-added service, converting works of literature and art into exchangeable commodities. What's more, an editor like Hetzel redoubled this economic resemblance to the ragpicker if he created new products out of *recycled* or *repurposed* materials, inventing ways to package articles and images that had been published in other forms. Not surprisingly, the modish illustrated anthologies and albums that proliferated in the July Monarchy were among the successful catch-all formats expressly suited to this kind of lucrative modular recombination. Under Charles Philipon's direction, the Maison Aubert was particularly adept at this strategy: he might publish the same image as an independent print, then again in one of his satirical journals such as *Le Charivari*, or in a *physiologie*, and then again in an album like *Paris comique*.[36]

Hetzel also practised this strategic recycling in the *Diable à Paris*. Hetzel's contract with Balzac for the *Diable à Paris* commissions five new articles but also enshrines the publisher's right to reuse two articles that he had already paid for and published as part of Balzac's collected works in *La Comédie humaine* (1841).[37] The first volume of the *Diable à Paris* also contains a short "Histoire de Paris" by Theodore Lavallée that is spatially, stylistically, and thematically distinct from the rest of the book, containing picturesque views and historical descriptions of ancient Paris; this incongruity is explained by the fact that the article is related to, if not directly excerpted from, *L'Histoire des Français depuis le temps des Gaulois jusqu'en 1830* published by Paulin and Hetzel in 1838.[38] Likewise, the correspondence between Hetzel and Gavarni regarding the *Diable à Paris* testifies that the artist would be

happy to offer his *Gens de Paris* series if Hetzel was willing to accommodate an existing group of caricatures that could only appear "à part en series," as self-sufficient full-page plates.[39] This explains the disparity between the stand-alone format of Gavarni's caricatures, which came to the anthology ready-made, and the more customized and integrated vignettes by Bertall that embellish typeset pages in the prologue and end-matter.

It is also evident that many of Gavarni's *Gens de Paris* caricatures included in Hetzel's anthology were republished by Texier in his *Tableau de Paris*. Significantly, these same two books are among the first Parisian anthologies to include the chiffonnier prominently within their introductory manifestos. Texier's introduction expands upon the notion of an editorial ragpicker given visual form by Gavarni and Bertall in the *Diable à Paris*. Whereas the literary archive that Flammèche presides over seems to consist solely of the manuscripts and images that Parisian authors submit to *Le Diable à Paris*, the archive as Texier understands it is a much larger intertextual field of urban representations from the past and present in every possible genre and tone. Texier acknowledges the relationship between his *Tableau de Paris* and the prolific web of Parisian representations into which his project is self-consciously inserted.[40] Promising novel means of navigating this still mysterious city and its myriad representations, Texier takes his cues from the chiffonnier: "What remains for us to do, we who descend into the arena after one hundred thousand before us and before one hundred thousand to come? Time has freed up the room, and in the meantime we have been able to glean again there where the pitiless reaper has passed by, the great chiffonnier who heaps so many things in his immortal basket ... We have neglected nothing that has been done before us, drawing our information from right and left, and in this already explored domain, we take hold of all the booty, of all the quarry, that our patrimony can accommodate."[41]

As an editorial gleaner picking through an already much-harvested terrain, Texier promises to guide his public through the Parisian archive. This hubristic declaration provides a key to the apparent paradox behind both Hetzel's and Texier's embrace of the basest recycler as an icon of editorial activity, especially when repetition is seemingly antithetical to the authorial role they assert. Association with the ragpicker would communicate these editors' claims to an aesthetically superior role as a curator and critic who creates the legible capital out of a chaotic Babel of competing urban codifications.

Initially, it may be tempting to understand this editorial gleaner, who substitutes curatorial selection for authorial originality, in terms of Michel Foucault's "Fantasia of the Library": as a figure who "erects [his] art within the archive" and whose work can thus "claim originality only with respect to its meticulous organization."[42] But

far from relinquishing the authority of authorship, the portraits of the editorial ragpicker in Hetzel's *Diable à Paris* and Texier's *Tableau de Paris* posit instead a more powerful kind of author. The ability of these editors to manage discursive heterogeneity is central to their claims for social and professional status, and it clearly compensates for their positional insecurity as industrial producers who package up ready-made cultural goods. Moreover, this signature authority would help to distinguish the editors' offerings in a competitive cultural marketplace, positioning their superlatively curated publications as the most discriminating guides to the fashionable culture of the modern capital and to the consummate work of its most celebrated writers and artists.

Illuminate the Lantern

The ragpicker's lantern provides the final key to Gavarni's portrait of the editor as the potent animus of this exceptional compilation. Through the selection and juxtaposition of numerous urban descriptions, Hetzel and Flammèche aim to provide a summative tour of the city's manners, fashions, and arts. They must possess considerable creative powers and sophisticated technical means in order to organize that tour as an exhibition that is more than the sum of its parts. It is for this work of display and animation that the editorial ragpicker's lantern comes into symbolic play. The structure of the particular lantern wielded by Gavarni's devil in Paris is identical to that of a Lapierre magic lantern (Fig. 2.8), an optical apparatus that projects glass slides, causing a succession of luminous images to appear (on a wall, scrim, or other surface) before its audience. Here it is the editorial device through which Flammèche and Hetzel breathe life into the images and texts they have collected, effecting a series of transitions to conjure a fantastically unfolding spectral illusion out of their otherwise inanimate and fragmentary source material.

The governing conceit here is a connection between the dynamic and disjunctive visual review projected by the magic lantern, the experience of an illustrated anthology, and the notion that Parisian life itself is an ever-shifting visual pageant. The conceit would have had great resonance for contemporary audiences familiar with language that linked the era's new media – including the moving panorama, magic-lantern show, quotidian publications, and theatrical performances (many dubbed *revues*) – with the constant parade of costumes, commodities, and bodies upon the city's boulevards. The Parisian anthologies are rife with such language. Ladvocat's editorial preface declares that the central mission of *Paris ou le Livre des cent-et-un* is to "pass modern Paris in review," and he goes on to associate this review

Graphic Culture

Figure 2.8 Lapierre magic lantern, c. 1860.

with the theatre, "this drama of one hundred diverse acts," as well as with an album or "encyclopedia of contemporary ideas."[43] Janin's Introduction to *Les Français* echoes Ladvocat's theatrical reference exactly, billing the guide as "a comedy in one hundred diverse acts"; he also gives passing reference to fashion magazines as a register expressly designed to transcribe the shifting nuances of everyday life.[44] More importantly, Janin's essay is the first to tout the superiority of the illustrated anthology in creating a living review of modern manners as marvellous as a lantern projection: "In this magic lantern, where we pass ourselves in review before each other, nothing will be forgotten, especially the illumination of the lantern."[45] Gavarni and

Bertall's graphic portraits of a magic-lantern-wielding editor follow in this rich vein, as does one of Hetzel's prospectus drafts for the *Diable à Paris*: "The *Diable à Paris* is the living tableau of the great city unfurling scene by scene; it is the magic lantern where all the nuances of the Parisian world, so thoroughly explored yet so little known, succeed one another."[46]

By foregrounding these new visual media, the Parisian guides emphasize that social representations and social reality are reciprocally structured. Like many popular visual entertainments of the era, the magic lantern both strives to mirror reality and foregrounds the imaginative and anti-veridical qualities of its illusion. It is no different with the panoramic guides. When Texier, for example, declares that on the boulevards of Paris "everything passes before our eyes like an eternal phantasmagoria" (another name for a ghostly magic-lantern show), he is celebrating the artful, ephemeral, and frankly wondrous qualities of urban experience.[47] He does not aspire to a perfect mimesis of urban reality, nor a radical critique of its dominant illusions. Rather, his aim is to craft a rigorously mediated, subjectively illuminated, and pleasurably vicarious experience of it. Far from penetrating the fetish character of Parisian modernity as their later avatars would be said to do, the dandies, ragpickers, and flâneurs of these mid-century anthologies would help to create and promote the phantasmagoria of Parisian life as a diverting commodity experience.[48]

With the help of the editorial ragpickers Flammèche and Hetzel, readers of the *Diable à Paris* could be imaginatively guided through modern Paris without ever looking beyond the pages of an illustrated book, just as Texier's flâneur, both a guide to and consumer of the Parisian "fantasmagorie," could be transported around the universe by visiting the boulevard shops and arcades. "What would you wish him to seek, he, son of the encyclopedic and universal city; he, flâneur by taste, passion, and profession; he, assiduous daily spectator of an eternal *review* that passes in his honour all the imaginable products of our sublunar world? He has no need to travel: it is the universe that travels on his account, that displaces itself item by item to solicit his suffrage, to appeal to his tastes as an enthusiast and consumer."[49] The modern world would increasingly offer itself up to the Parisian consumer in a parade of global commodities, a feat of reification that would be fuelled and celebrated by the makers of artistic guides to Paris.

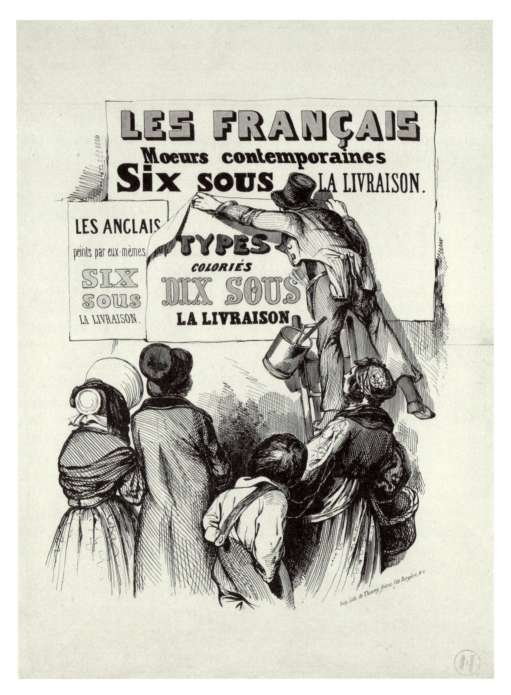

Figure 3.1 Gavarni, poster for *Les Français peints par eux-mêmes*, 1845.

3

Marketing Vision
Publishers, Posters, and Parisian Types

In 1842 publisher Léon Curmer commissioned a lithographic poster (Fig. 3.1) to promote one of his flagship products, a collectively authored study of modern manners entitled *Les Français peints par eux-mêmes* (*The French Painted by Themselves*, hereafter *Les Français*).[1] The poster designed by Gavarni plays with the theme of an advertisement within an advertisement: it depicts a crowd of curious Parisians gathering to watch a billposter who is balanced on a ladder, pasting up posters on a wall or elevated hoarding. Two of these posters within the poster use lettering to announce the book's topic and conditions of sale: "The French, Contemporary manners, six sous per instalment / Hand-coloured Types, ten sous per instalment." A third touts a related publication: "The English Painted by Themselves." Further hints about the book's content and its editors' ambitions are offered in the graphic composition of the scene. The foreground figures exemplify the kind of character "types" that populate this illustrated survey of contemporary French society. Moreover, these onlookers demonstrate how the artist and the publisher intended their products and advertisements to be consumed. Gavarni's poster-viewing scene illustrates the attentive interest expected of the public even as it naturalizes the solicitous address and environmental prominence of the poster, a rather new form of publicity.

This particular lithographic poster was made by modifying Gavarni's original design for the frontispiece included in the first volume of *Les Français* (Fig. 3.2). The effectiveness with which Gavarni's motif could be transferred from illustrated book to advertising poster reveals aesthetic means and social ambitions common to these two forms of representation. *Les Français* and its poster rely on a common

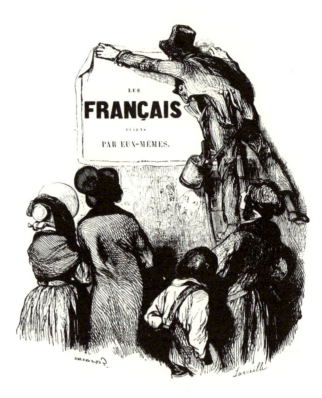

Figure 3.2
Gavarni, frontispiece in *Les Français peints par eux-mêmes*, vol. 1, 1839.

construct of the social type to define the populace, engage audiences, and summarize the stuff of everyday life. And their mutually reinforcing portraits could not help but shape the categories of social experience they purport to describe. As a result, the graphic artists who produced these related forms would become designers as much as chroniclers of current mores and consumer behaviours.

A host of fashionable July Monarchy publications showcased the kind of social typology advanced in *Les Français*, including a few similarly ambitious multi-volume anthologies promising artistic guides to Paris;[2] the slim satirical paperbacks known as *physiologies* (around 130 titles published between 1840 and 1842);[3] and related forms of social caricature found in independent prints, periodicals, and albums. In recent decades these genres have received worthy critical attention, by and large under the umbrella of Walter Benjamin's term "panoramic literature" or as part of a literary tradition of *tableaux de Paris*.[4] The most incisive prior approaches explain the importance of this kind of typical social portraiture in serving an emerging bourgeois public's desires for pleasurable and politically exigent techniques of aesthetic totalization, discursive initiation, or social control.[5] However, these demand-centred theories tend to neglect the practical and strategic determi-

nants of supply and the crucial new role of marketing in shaping demand and mediating the circuitry between production and consumption.[6] What's more, they beg further attention to the pictorial genealogies and visual conditions of these fundamentally graphic genres and related publicity techniques. This chapter considers how Parisian social typologies reflected the marketing strategies of the publishing entrepreneurs, graphic artists, and writers who produced them, and in turn, how these genres and strategies shaped the cultural economy and social environment in which they circulated.

The Business of Publishing

July Monarchy publishers were among the first French entrepreneurs to oversee the industrial fabrication and marketing of ready-made consumer products. By the 1830s, new mechanical technologies had revolutionized the processes of paper and ink manufacture, printing, and image reproduction. Lithography was the new darling of industrial printmaking, requiring less labour and expense than previous imaging techniques. Yet wood engraving would renovate the terrain of illustration, since it could be integrated with text in the new typographic presses. These processes greatly improved publishers' productive capacity and reduced costs through economies of scale, resulting in a surge of inexpensive newspapers, books, and prints.[7] This industrializing expansion did not yet give rise to a truly popular print culture in the sense of mass production for consumption by a great majority of the citizenry. But it did generate a popularizing commercial print culture that both fostered and profited from the increasing purchasing power, literacy, and cultural enfranchisement of expanding middle classes.[8]

In contrast to their predecessors, July Monarchy *libraire-éditeurs* were creative directors, industrial contractors, and booksellers in one. They differed from eighteenth-century publishers who printed limited runs of an author's work only after distributing prospectuses and receiving advance subscriptions. And they differed from traditional booksellers who ordered titles from publishers according to the real and projected demands of familiar clients. The new publishing entrepreneurs oversaw a vertically integrated cycle from conception and composition through manufacture to promotion, distribution, and sales. Although they outsourced many aspects of production – contracting with writers, illustrators, engravers, printers, colourists, and binders on a piecemeal basis according to need – they instituted the supervisory role of the editor and built up in-house resources to handle the marketing of ready-made publications to unfamiliar consumers.[9]

Their business model represents a commercial innovation with significance far beyond the publishing sector because it exemplifies a shift from the interpersonally customized merchant-client negotiations of the early modern economy to the anonymous transactions, fixed prices, standardized products, and sophisticated marketing techniques of modern commerce. Karl Marx's account of commodity fetishism suggests that new kinds of social illegibility inevitably accompanied this shift from subjective to objective interactions in the marketplace: not only are the social relations of production obscurely congealed in commodities, but producers and consumers are estranged from one another.[10] Here I explore how nascent techniques of market research, particularly the profiling of typical constituents and lifestyles as in *Les Français*, would evolve to compensate for the commercially debilitating aspects of that social illegibility.

The new business model embraced by Curmer and his colleagues was extremely risky: these publishers invested substantial amounts of cash up-front, preparing unprecedented inventories of shelf-ready products for retail, and then scrambled to recuperate their costs as sales trickled in. They needed to devise new forms of publicity and display in order to recommend and parade the inventories they could now so rapidly produce. During this era, the shop window and the poster came into their own as vital tools to spur the cognitive purchasing cycle of attraction, attention, and memory. But long before these communication tactics, the publishers – and indeed the writers and artists who collaborated with and relied upon them – had to make strategic decisions about which types of products to manufacture and which types of customers to market them to. What kind of genres and formats should they invest in and how should they be positioned (priced, located, and promoted) within the competitive marketplace? How could they identify and cultivate consumer desires, values, and behaviours?

My postulate here is that certain genres of typical social portraiture may have presented provisional solutions to these vital marketing questions facing July Monarchy publishers and artists. First, representations of contemporary manners had the features of a prudent standardized product. Their amusing topicality would have broader appeal than partisan editorials or erudite texts and more lasting currency than event-driven political satire or news. Furthermore, their rather codified forms were effectively modular; equally at home in literary anthologies, fashion journals, or caricatural albums, they could be lucratively recombined and repackaged to create multiple products and derivatives. Second, the graphic elements of these genres were incredibly well suited to publicity because both typical portraits and advertising images seek to reflect, articulate, and instruct the attitudes of their audience. Publishers quickly realized that topical illustrations developed for their products could

be transferred cheaply, expeditiously, and effectively to promotional materials such as posters and prospectuses, as was the case with Gavarni's title motifs for both *Le Diable à Paris* and *Les Français*. Third, these social typologies compiled useful information about, and had considerable influence upon, the communities that publishers, writers, and artists hoped to serve.

A Collective Self-Portrait

Les Français peints par eux-mêmes was an enormous undertaking. One might expect nothing less of a work that promised a "moral encyclopedia of the nineteenth century." This "most varied, most true, and most amusing portrait of French society in our era" would take the form of an encyclopedic catalog of exemplary national types.[11] Each chapter profiles one character in a short narrative penned by a single writer, embellished with wood-engraved vignettes by up to four illustrators, and prefaced by a full-length graphic portrait of the type. Curmer secured the collaboration of over one hundred writers and artists, soliciting as many celebrity contributors as possible, including Balzac, Charles Nodier, Théophile Gautier, Frederic Soulié, Jules Janin, Gavarni, Henry Monnier, Charlet, Daumier, and Grandville. Remarkably, Curmer also invited submissions from readers, democratizing the national self-portrait by welcoming the participation of any aspiring authors or local informers in the populace who might have specialized insights to lend to the project. Curmer published this open call for contributions along with snippets of dialogue with his subscribers and would-be contributors (on issues ranging from the quality and variety of his French types to the accuracy and currency of the authors' descriptions) in the *Correspondence des Français*, a one- or two-page column issued with each instalment.[12]

Over a production period of three years, this massive anthology was issued in 422 weekly instalments and later compiled in eight volumes: five devoted to Paris and three to the outlying French provinces and colonies. The result was a fairly scattered offering juxtaposing different authorial voices and styles; published in temporally staggered, aesthetically autonomous increments; and available in diverse formats at various prices. Chapters could be purchased in serial instalments for thirty centimes, in softcover volumes for fifteen francs, or in more expensive hardcovers of coloured cardboard or gilded leather. For an additional fee of twenty centimes per instalment or ten francs per volume, the full-page types could be hand-coloured.[13] As complete volumes and sets were too costly for all but a few wealthy bibliophiles, most readers would curate their own personalized editions of

Les Français by purchasing individual chapters to be rearranged and displayed in their own frames, folios, albums, or custom bindings. Derivative products also complicated the mix. The editor assembled *Le prisme*, an "Album des Français," out of various crowd-sourced contributions he was unable to incorporate within the systemic pattern of the type-focused chapters.[14] He also compiled an album of regional costume illustrations by reproducing plates from the Province volumes.[15]

Gavarni's title motif played a key role in unifying these diverse avatars of the project. Notably, he did so at the same time as the commercial identity symbols known as logotypes – originally single plates of type used to standardize the printing of names or trademarks – were first developed for the mastheads of newspapers.[16] Transferred to several related templates, Gavarni's drawing provided a recognizable and repeatable motif across a range of products and publicity mechanisms. These include the larger lithographic stone from which the advertising poster derives and the engraved woodblocks used to print the first-volume frontispiece and the covers of each serial instalment.[17]

Combining standardized and customized elements, the three templates maintain a consistent identity while performing different communicative functions. The pictorial scene of a billposter and attentive crowd remains unchanged, but the poster field that is the object of attention acts as an adaptable placeholder for the insertion of texts highlighting different aspects of the publisher's message. The graphic design of this modular poster field echoes and makes use of the structure of a woodblock, which can accommodate the removal and insertion of subsidiary sections within the original plate.

The technique would prove especially convenient for the weekly replacement of new serial numbers, titles, and author credits on successive instalment covers, as in "No. 1, *The Grocer,* by M. de Balzac / Drawing: M. Gavarni / Engraving: M. Lavieille" (Fig. 3.3). (Notice the descending order of billing from the writer of the chapter, to the graphic artist, and then the wood engraver who created the grocer's full-page portrait; the authors of the embedded vignettes within the chapter are not mentioned.) Lithography was preferable for the poster because it had a larger format and required less manpower (less time and money) to produce than wood engraving.[18]

Exploiting its public exposure, the *Les Français* poster advertises another of Curmer's products. *Les Anglais peints par eux-mêmes* (*The English Painted by Themselves*) was a new French edition based on an English anthology entitled *Heads of the People or Portraits of the English*.[19] *Heads of the People* portrayed the manners of the trendsetting metropolis across the Channel and it proffered superlative examples of the wood-engraved illustration pioneered by English practitioners.[20] What's

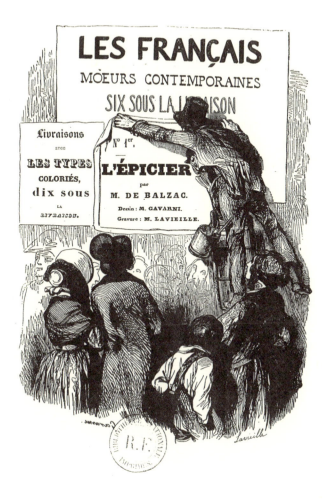

Figure 3.3
Gavarni, cover illustration
for *Les Français*, *No. 1:*
The Grocer, 1839.

more, it was a successful model of artistic and commercial experimentation with the recombination of images and texts to produce a range of related works.[21] This English publication so inspired Curmer that he developed several products related to it: he commissioned a French translation to accompany the original designs by Kenny Meadows, and began production on a similar, and of course superior, portrait of French society to be written and illustrated from scratch by homegrown talent. So it was that *Les Anglais peints par eux-mêmes* and *Les Français peints par eux-mêmes* were published almost simultaneously between 1839 and 1842.[22]

Gavarni created title motifs for both books using variations on the theme of an advertisement within an advertisement: the letters spelling *Les Français* written upon a poster and those announcing *Les Anglais* drawn upon the cloth backdrop of a *parade* or circus sideshow (Fig. 3.4). Whereas the former showcases new print

Figure 3.4 Gavarni, advertisement for *Les Anglais peints par eux-mêmes*, 1839.

Figure 3.5 *Opposite* Daumier and Charles Philipon, *Do you want gold, do you want silver, diamonds, millions and trillions? Come and be served, hurry buy your bonds!* 1838.

media common to the book and its advertising poster, the latter displays a premodern form of popular theatrical publicity that is discontinuous with the product it advertises. Still, the sideshow – a free performance designed to encourage passersby to purchase tickets for the main event – is functionally homologous to the illustrated poster: at once a preview of the product for sale and an attraction in itself.

Gavarni's use of the *parade* as a graphic motif had a number of precedents. In July Monarchy visual culture, the sideshow was already a familiar emblem of both popular boulevard spectacle and commercial speculation. A rich example is a lithograph by Honoré Daumier (Fig. 3.5) in which the charlatan Robert Macaire noisily clamours for attention, juxtaposing the informative allure of illustrated advertisements with the musical and rhetorical bombardment of the *parade*. Here Daumier mocks the self-interested campaigning of the unscrupulous bourgeois entrepreneur

Figure 3.6 *Above*
Raffet, frontispiece in *Album
lithographique par Raffet*, 1835.

Figure 3.7 *Right*
Daumier, *Sideshow of Le
Charivari*, 1839.

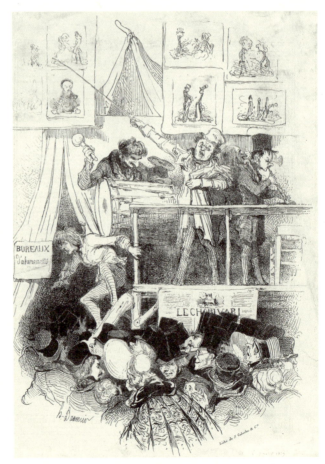

– a stand-in for the newly dominant classes underpinning Louis-Philippe's regime – who plays upon the credulity and curiosity of the public in order to promote his duplicitous money-making schemes. Yet in the same era, evidently despite these associations, the sideshow motif was frequently used by Parisian publishers to tout their wares. Charlet's 1823 "Entrez Entrez / chez Gihaut," the 1835 title page of *Album lithographique par Raffet* (Fig. 3.6), and Daumier's 1839 *Parade du Charivari* (Fig. 3.7) all feature *parades* that simultaneously promote and satirize the promotion of journalistic publications they inhabit.[23]

Why would print capitalists and artists associate their advertising practices with such a loaded and potentially unflattering theme? At the same time as publishers began to formally integrate advertisements within the physical spaces of books and newspapers,[24] they began to represent the subject of advertising within the discursive and pictorial spaces of these same products. Perhaps such explicit treatment enabled cultural producers to be among the first to comment upon their own promotional activities, and thus to define the vocabulary that others (competitors, customers, journalists) would use to characterize or criticize them. It signalled self-consciousness, the publishers and artists wittily acknowledging their own bombastic self-promotion as a potential sore point but also a necessity that could be embraced with playful knowingness at the very least.[25]

Undoubtedly, these self-publicizing themes would also provide the public with a familiar historical context for the disorienting output of novel consumer products and ads. Forging links to traditional modes of spectatorship, leisure, and consumption, the new genres could demonstrate the kinds of sensual and social pleasures they offer, and hint at the expansion of these activities beyond the temporal and spatial limits of the theatre, sideshow, fairground, and feast day.[26] References to the circus, for example, associate the new print genres and ads with a traditional entertainment that is likewise popular and accessible, a means of disseminating information and homogenizing experience across the country and a mode of ordering the world in terms of normative and exotic examples.

Gavarni's *parade* portrays the grotesque contortions of a barker striving to drum up interest in *Les Anglais*. The satirical exaggeration of this showman's grisly invective mockingly amplifies the publisher's own promotions. Moreover, the coarse heads and awkwardly craned necks of the depicted onlookers repel the viewer's identification, just as the obvious disparity between this marginalized audience and the looming stage emphasizes the domineering intention of the performance. Still, this irreverent stance toward publicity does not detract from the effectiveness of the advertisement. The design provides a superb sample of the cutting satire that awaits buyers of the book and at the same time critically distances its own discerning

Graphic Culture

clients and attractions – its cleverly self-reflexive style and sophisticated print media – from the sideshow's vulgar amusements and audiences.

In contrast to the rapaciousness evident in the English barker's apelike face, the nearly faceless billposter Gavarni casts in *Les Français* appears as an unmotivated provider of public information. The crowd around him seems to be made up of mobile, independent, and self-electing individuals. These almost full-figured viewers and the modestly proportioned ads are reassuringly balanced, suggesting the dignity of, and parity between, the two parties. The fact that the pyramid of characters all have their backs turned makes it easy for the viewers of the frontispiece or poster to imagine themselves willingly joining the depicted crowd. The rear view acts as a solicitous *repoussoir* to attract the viewer's attention to the poster field and perhaps spurs his or her curiosity to see the frontal portraits of social types contained within the book. Effacing the satirical distance, commercial ambition, and power disparity apparent in the design for *Les Anglais*, this sketch advertises the ostensibly realistic social portraits on offer in *Les Français*, and it downplays the poster's intrusiveness in public space. There is no sense of the cacophony, clutter, intrusion, inconvenience, and potential violence or disorder that were prevalent elsewhere, especially in British representations of urban poster hoardings and caricature shops before mid-century.[27]

First published with the inaugural instalment of *Les Français* in May 1839, Gavarni's billposter motif was notably preceded by the 1837 title page of *Album lithographique par Raffet* and echoed in Tony Johannot's 1840 poster design for *Le diable boîteux*, as well as Benjamin Roubaud's self-portrait in the "Panthéon charivarique" (Fig. 1.1).[28] All three have a significant forefather in the 1742 title page (Fig. 3.8) of Edmé Bouchardon's *Études pris dans le bas peuple, ou les Cris de Paris* (*Studies Undertaken among the Lower Class, or the Street Criers of Paris*).[29] The billposter appeared only occasionally among the other urban tradesmen typically included in print series of *cris de Paris* or *petit métiers* (street criers, hawkers, and humble tradesmen), but in Bouchardon's time the *afficheur* was becoming an increasingly visible and influential constituent of the street culture these traditional typological genres describe. By featuring the billposter on his title page, Bouchardon provided a specimen of both the social types and the graphic art viewers would find within his publication, and he cleverly used the depicted poster field to add descriptive text about the title and its producers.

A licensed worker whose activities were closely supervised by the state, the billposter gained prominence throughout the eighteenth century as the volume of official and commercial posters increased. His professional role as urban publicity agent both echoed and signalled the eclipse of the mode of ambulant personal

Figure 3.8 Edmé Bouchardon, *The Billsticker*, 1742.

advertising practised by the other traditional street criers and artisans, who vocally proclaimed the wares they carried and sold.[30] The motif was thus aptly chosen to mark the great changes underway in working-class roles, commercial practices, and the urban environment; it worked both to historicize and to recommend the publication's nostalgic theme. Furthermore, the billposting motif proved highly suitable to the summarizing and sampling functions of a title page because it neatly accommodates a communicative textual field in the scene without departing from the sparse compositional parameters of the social type consistent throughout the rest of the series.

July Monarchy billposter motifs were crafted during a significant growth phase in the poster's formal development and diffusion in the urban environment. During this era political posters were prohibited, and all printed materials distributed or installed in public space were subject to prior state authorization, taxation, and strict police surveillance. Nevertheless, Louis-Philippe's regime encouraged the proliferation of commercial posters and the privatization of designated billposting spaces on public walls, which suited both the regulatory ambitions of the state and the commercial ambitions of the first advertising agencies.[31] Although posted images were not foreign to the Parisian street, having flourished particularly in political posters of the revolutionary era, July Monarchy publishers were the first to make innovative graphic art the primary draw of their standard commercial advertisements displayed on the streets.[32] This pioneering role can be partly explained by the fact that illustrations on these publishers' posters were often directly derived from or autographically related to the graphic publications they promoted. In other words, these inaugural advertising images emerged as an extension of fantastic, literary, and journalistic illustration, with the significant result that illustrators like Gavarni, Raffet, Monnier, Johannot, Grandville, Daumier, and Devéria were among the first artists to specialize in advertising images. What's more, French publishers also enjoyed certain legal privileges, some dating back to the sixteenth century, that boosted their leading position as authorized producers, users, and formal experimenters of the *affiche*. While they were exempted from some restrictions by state sanction,[33] they bypassed others by installing their posters within interior spaces. Affixed to the inside of a publisher's storefront vitrines, posters occupied private property technically free from public-stamp duty and police surveillance, yet they were still visible to the public from the street (a legal loophole that would be closed in 1860).[34]

This is how Curmer would have displayed the poster for *Les Français*, although the image suggests otherwise. The appropriate mode of shop-window display is nevertheless illustrated in a poster for *Paris comique* (Fig. 3.9), a caricatural album published by the Maison Aubert. Directed by Charles Philipon, the Maison Aubert was one of the most important and prolific Parisian publishers of lithographic imagery and satirical journals during the July Monarchy.[35] The *Paris comique* poster describes the specific urban and social spaces in which this publisher put his products and ads on view. From 1841, the Maison Aubert, with its windows opening up onto the street, was situated on the place de la Bourse, "just opposite the Stock Exchange, not far from the Boulevard Montmartre and the fashionable *quartier* Chausée-d'Antin."[36] The publisher's wares and posters were put on permanent, rotating display in expansive gridded vitrines of the storefront façade, which faced the street and invited the browsing and gathering of pedestrian traffic. Philipon's

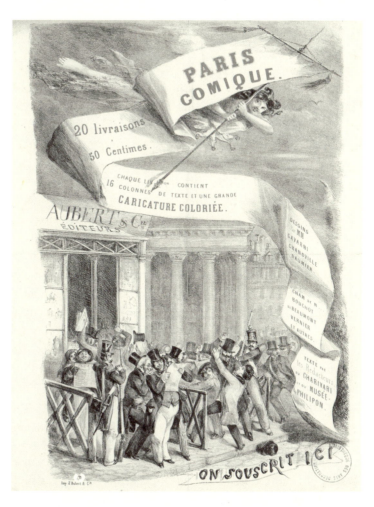

Figure 3.9 Anonymous, poster for *Paris Comique*, 1844.

successful satirical journal *Le Charivari* promised its readers a new drawing every day, and his shop windows did the same, luring crowds with the expectation of daily novelty and commentary on current events, as well as a gallerist's archive of recent highlights, showcased genres, and celebrated artists that would count among the house specialities. The Maison Aubert was strategically located at the intersection of refurbished boulevards and neighbourhoods near the Opera and the recently renovated Palais-Royal, dense with new apartments, shopping arcades, luxury stores, reading rooms, and theatres; these were the spaces where well-to-do Parisians lived, worked, shopped, dined, consumed culture, and took their leisure. Many July Monarchy publishers, Philipon and Curmer included, chose to establish their businesses in this budding commercial epicentre.[37] Billposting firms and advertising agencies would soon follow.[38]

Aubert's connection with a middle-class clientele and fashionable boulevard culture is reinforced in the poster's portrayal of the crowd as a reassuringly legible sea of top hats, waistcoats, and cutaway frock coats, as if the Stock Exchange had just expelled its uniformly masculine and moneyed contents onto the street. The only variations in this stock character are the two bemused ladies at left, an eager youngster elbowing his neighbour off the pavement at centre, and two flanking gendarmes who confirm that the riotous amusement is under control. The make-up of Aubert's target public is clear, as is the appropriate range of curious, giggly, and desperately acquisitive response. This is just one of many images commissioned by Philipon which serve not only to entice and instruct viewers but to amplify the importance of the Maison Aubert within the minds, itineraries, and quotidian practices of Parisians. Philipon's particular marketing savvy can be seen in his repetitious representation of the Maison Aubert – especially its street-facing window displays and the crowds gathered there – within the pictorial and editorial fabric of its diverse publications. To name just a few examples, the vitrines of the Maison Aubert are prominently featured in a scathing political caricature that alludes to Philipon's on-going ridicule of King Louis-Philippe as a pear (Traviès, "You have to admit, the head of government looks pretty funny," published in *La Caricature*, 22 December 1831). The shop is also pictured as the essential haunt of the Parisian flâneur on the title page of the *Physiologie du flâneur*; as a space of traditional street entertainment in an 1832 advertising poster for *Le Charivari*; as one of many sleek boutiques in a medley of picturesque street-scene vignettes depicting Parisian shopping arcades;[39] and as an urban destination frequently mentioned in the fashion reporting of *Les Modes parisiennes*.[40] These repetitions bred familiarity and positioned the print shop as a quintessential urban attraction, reinforcing its association with diverse modes of sociability, attention, and recreation, from radical politics and leisurely observation to shopping and fashion. Philipon was a pioneer of this type of pictorial-editorial advertising, but others soon followed his lead. *L'Illustration* frequently inserted images of its own headquarters among other news features on urban sites, edifices, and current events.

Philipon positioned the Maison Aubert as a prolific producer of opinionated and humorous graphic publications, specializing in satirical newspapers, lithographic prints, Parisian sketches, and inexpensive albums. In contrast, Curmer styled himself as an intellectual patron and artistically sensitive editor of contemporary literature, specializing in deluxe wood-engraved books. Yet the two men competed in the market for caricature and illustration, vying for a common consuming public consisting mainly of bourgeois professionals and leisured elites, along

with a small contingent of petit-bourgeois shopkeepers and employees and the rare well-to-do artisan.[41] In illustrating Aubert's mode of shop-window display, strategic location, and target public, the *Paris comique* poster describes conditions shared by Curmer's business. Yet these details are omitted in Gavarni's poster for *Les Français*: it contains no traces of the city or the shop window, and even the publisher's street address and the customary invitation "on souscrit ici" (subscriptions sold here) are conspicuously absent. The billposting scene might falsely imply that Curmer's announcements were plastered upon an exterior façade. Furthermore, the array of foreground figures departs significantly from *Paris comique*'s portrayal of the consuming public. How to explain these decisions?

From left to right, Gavarni depicts a bourgeois couple arm-in-arm, an impish street urchin, and a woman holding a basket, perhaps a laundress or a domestic servant on her way to market. The spectrum – which includes the poles of leisure and work and between them a mode of indigent subsistence that is outside them both – is aptly distributed to imply the broad and realistic range of social types portrayed in *Les Français*. What's more, this inclusive range also suggests the book's communicative aspirations. Although only a few of these characters would have the means to purchase Curmer's books, he would want his publicity to engross and interest, as much as possible, all passersby (who might view such posters free of charge in the publisher's shop windows). Gavarni's sparse composition underscores this ideal prominence in the social environment. And at the same time, it replaces specific commercial relations and sites with a purged discursive transaction taking place in an imaginary social space. The suppression of contextual details downplays the commercial dynamic between publisher and public in order to emphasize the referential and constitutive dynamic between the social portrait and society, or the poster and book on the one hand and their common subject matter and audience on the other. Dissolving sketchily into the page, the depicted characters are shown to have little relationship to the space they inhabit or to each other beyond the one mediated and commodified by Curmer's publications.

Another publisher's poster mimics Gavarni's composition and in so doing exaggerates and clarifies these categories of social experience (Fig. 3.10). Both images portray a spare environment reduced to interrelated representations of the social environment, on the one hand, and, on the other, an ordered community whose members are differentiated and made legible by those same representations. Serving to promote a competing anthology on Parisian manners entitled *Scènes de la vie privée et publique des animaux* (*Scenes from the Private and Public Life of Animals*),[42] this sketch by Grandville pays ironic tribute to Gavarni's design for *Les Français*,

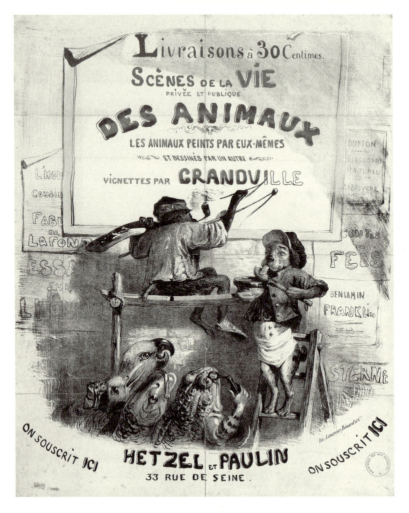

Figure 3.10 Grandville, poster for *Scènes de la vie privée et publique des animaux*, 1842.

just as the book's subtitle, *Les animaux peints par eux-mêmes et dessinés par un autre* (*The Animals Painted by Themselves and Drawn by Another*), declares a fictional premise that would link the two projects in the minds of potential readers.

Whereas Gavarni's poster field is a pure space of advertising in which Curmer's products enjoy unrivalled visibility, Grandville's appears more active and contentious. Yet, rather than suggesting a climate of proliferation and competition, this patchwork of placards serves only to promote *Les animaux* by providing a legitimizing intertextual genealogy for the authors' approach to social portraiture. The peripheral posters summon the names of Buffon, La Fontaine, La Bruyère, Laurence Sterne, and Benjamin Franklin, as well as the titles of Alexander Pope's *Essai sur l'homme* and Charles Perrault's *Contes des fées*. The list juxtaposes moral and literary

treatises on man and his manners, folklore and fairy tales, scientific and fabulist accounts of the animal kingdom, and works illustrated by Grandville. Their pasted interweave recommends the conflation of these categories, as in *Les animaux* or a recent edition of *Fables de la Fontaine* featuring seventeenth-century bestial parables illustrated by Grandville.[43]

Like Gavarni before him, Grandville arranges a few samples of his subject matter, graphic style, and typological approach in the poster's foreground. In this case a dog takes the role of billposter, displaying the professional tools of ladder, apron, and paste-pot, as well as a class-appropriate worker's coat and cap. But this dutiful promoter (who disseminates works he did not create) is upstaged by a simian sign painter, blousily costumed as a bohemian artist. Grandville's trumping insertion of this painterly character alongside the billposter, coupled with his exaggerated hand-crafting of the letters, hint at the graphic artist's struggle to distance himself from the crudest commercial applications and mechanical processes of illustration.[44] Four onlookers, representing various avian and aquatic species, fill out this intro-duction to the artistic feat, fictional theme, and satirical tone of *Les animaux*. This being a compilation of texts by many authors in conjunction with a single illustra-tor, Grandville's portraits of these comically current and humanoid animal types are an appealing common denominator, and a rhythmic element that unites the anthology's otherwise diverse assortment of voices and literary genres.

Social Taxonomy

The most misleading aspect of Grandville's approach is the implication that Parisian social types can be understood in terms of legibly ordered biological species. The animal types may be easily distinguished, but it is unclear which social groups they might correspond to even after consulting the portraits within the book. Similarly, Gavarni's French types leave much room for misreading. Are the couple on the left Parisian or could they be tourists from the country? Might they be an artist, jour-nalist, or medical student with a *grisette*? A wealthy stockholder strolling with his wife? Or is it his mistress: an adulterous wife or perhaps a *lorette*?[45] This lack of clar-ity is partly a solicitous ruse of the title motif, holding out the promise that the por-traits within *Les Français* or *Les animaux* might help the studious reader to parse out the important differences between the carp and the parrot, the provincial and the Parisian, the *grisette* and the *lorette*. But the spectre of ambiguity also reminds us of the indefinite, mutable, and fluctuating nature of the social distinctions that structure the portraits in these books.

However much they play on the theme of taxonomy, these Parisian typologies do not pursue a positivist science of society based in the empirical and taxonomic methods of the natural sciences, the statistical methods of a nascent sociology, or a naturalistic drive to record social reality in art.[46] Rather, they showcase the qualitative, interpretive, and fundamentally subjective judgments of the artists and writers who produce them. Gavarni, Grandville, and their collaborators are concerned not with the universally valid description of fixed and self-evident classes but instead with the nuanced evaluation of changing manners and tastes. Moreover, the ongoing marketability of their social expertise and pseudo-journalistic products depends upon the indefiniteness and the continual transformation of their objects, assessments, and categories.

The categories of social typification forged in these July Monarchy genres depart significantly from those that underlie traditional typological genres, such as the charming, nostalgic broadsheet imagery of urban trades and low-life subjects, updated for the early nineteenth century by Carle Vernet (Fig. 3.11) among others. Collections of *cris de Paris* and *petit métiers* remained popular, and remarkably consistent, from the sixteenth into the nineteenth century, whether they were arranged in grids or as series of single images, packaged as crude woodcuts or fine engravings as in Bouchardon's work. Typically, these compilations present a variety of hawkers and tradesmen, focusing on the picturesque costumes, accessories, and jingles that differentiate subcategories *within* the urban working class.[47] A single labourer's body – whether generic or physically differentiated by the repetitive gestures and tasks of his or her craft – provides a common substrate that is embellished with specific outfits, tools, and cries befitting each occupation.[48] Settings and other contextual details of the hawkers' lives tend to go unrecorded in these relatively inert, isolated portraits. A similarly static taxonomic structure tends to underlie regional typologies, "ethnographic" compendiums, and costume illustrations, including ostensibly modern updated collections such as the volumes of *Les Français* that describe the inhabitants of the French departments and colonies under the outmoded *ancien régime* term *province*. Picturesque variations of local dress inflect otherwise generic figures that are basically classless and timeless, although historicist overtones sometimes seep through in the choice of traditional costumes, premodern modes of labour, and archaic graphic styles. In these cases, the significance of each labouring or non-metropolitan type apparently stems from its relational position of decorative differentiation within a harmonious series of equal social permutations.

By contrast, the new metropolitan typologies of Gavarni and Grandville showcase more nebulous social and aesthetic distinctions both within and *across* hetero-

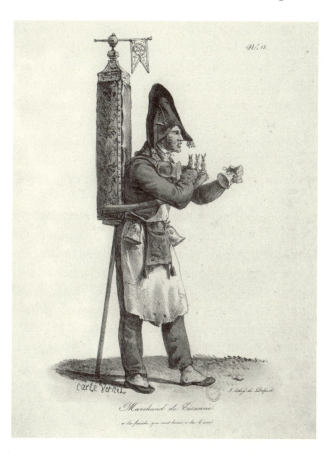

Figure 3.11
Carle Vernet, *Herbal
tea seller. Fresh beverage,
who wants a drink?* 1820.

geneous demographic groups. In the five volumes of *Les Français* devoted to modern Paris, middle-class types take centre stage. But also included are characters associated with the aristocracy, the working class, and the non-working urban poor, and many more that are not defined in terms of class or profession at all, such as debtors, players of boule, adulterous women, and the like. Furthermore, the pairing of graphic portraits with playful descriptive essays about these new metropolitan types extends the domain of analysis outward to include numerous environmental and social factors, and inward to include psychological, moral, and aesthetic factors. These are often cross-referenced with the mapping of specific Parisian neighbourhoods, venues, and constitutive milieus. Finally, public trajectories are superimposed with private narratives and interpersonal dramas that showcase the type's desires, anxieties, ambitions, liaisons, etiquettes, jargons, and affectations. And through all of these, it is the author's ability to discern and describe the distinguishing features of the type that is showcased.

The idea is not just to convey how socially diverse characters differ in their looks and dress and professions but to correlate these differences with detailed descriptions of the objective and subjective conditions that determine them and the symptoms through which initiated interpreters can trace these conditions and construct categories around them. In theory, these diagnostic signs would be clearly visible in images of the type. But in practice the visible pathology of the type had to be invented, codified, and transformed over time, an endeavour shared by the writers and graphic artists of such profiles across a broad intertextual spectrum of current images and publications. The resulting types are palimpsests, built up in the interplay between images and texts, between several authors who may have broached the same topic, and in authorial approaches that tend to be playful, ironic, and self-conscious; all of these elements destabilize legibility along with any serious pretense of scientific objectivity or fixed categories. In the case of *Les Français*, a rhythmic cooperation between images and texts demonstrates how various kinds of information, observation, evaluation, and fluency in current themes can be combined in understanding each character. Acting as a miniature frontispiece, the full-page portrait of the type introduces the subject of the chapter. Then the accompanying narrative and its smaller embedded illustrations enumerate the cluster of familiar representations and visible criteria an expert observer might deploy in reading and recognizing the type, either on the page or in the street.

Gavarni created a unified visual standard for the metropolitan type established in *Les Français*. He not only designed the project's key frontispieces, instalment covers, and poster, but his work dominates and sets the tone for the first three volumes of *Les Français*, and he is the only artist who drew at least one full-length portrait for each of the eight volumes.[49] Gavarni's chief influence on the pictorial codes and classificatory principles of Curmer's seminal project would draw upon his signature specialization in fashion illustration.[50] Soon after *La Mode* hired the artist in 1830, his co-worker Honoré de Balzac wrote an article in praise of Gavarni's early career contributions to the journal, the art of the fashion plate, and the representation of the times. Balzac argued that Gavarni had captured the ineffable essence of modern style, which resided not in the clothes themselves but in the contemporary spirit and artful manner in which they were worn.[51] Pictorially, Gavarni's achievement rested in his infusion of fashion illustration with dramatic and socially incisive elements of domestic genre prints and caricature (as discussed further in chapter 4). The dresses gain dimension from the contextualizing hints of character, narrative, and decor that attach a matrix of social meanings and values to the showcased articles of fashion.

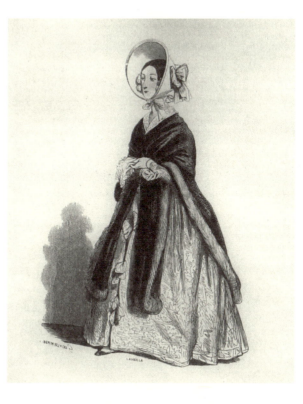

Figure 3.12
Gavarni, *The Proper Lady*
[*La Femme comme il faut*],
in *Les Français peints par
eux-mêmes*, 1839.

This construction of an expansive lifestyle concept around specific consumer products was an excellent and enduring formula for publicity; in some cases, it created value for the businesses whose names and addresses appeared in accompanying columns or in the fashion plate's captions alongside itemized descriptions of depicted articles. And surely it served the producers of *La Mode:* recommending the journal's creative services to advertisers and making its profiles indispensable to consumers of fashion. More important, the formula would prove a potent tool of social stratification and consumer marketing. Just as fashion illustrations increasingly linked costumes and accessories with differentiated constellations of identity, taste, and ways of living, so representations of manners also began to categorize social constituents by aesthetic distinctions rather than professional categories and by consumer behaviours rather than productive activities. If the *petit métiers* had reduced tradesmen to picturesque "vehicles for signs of work" as Anne Higonnet has argued,[52] the new metropolitan typologies constituted lifestyle profiles that transformed subjects into vehicles for signs of consumption and visual connoisseurship.

The methodology and scope of this new categorical schema can be seen in the portrait of "La femme comme il faut" (The Proper Lady) issued in the fourth instalment of *Les Français* (Fig. 3.12). Balzac and Gavarni collaborated in articulating the way this fashionable lady wears her shawl so that it both hides and reveals her figure, the simple elegance evident in the adornment of her hat and the closure of her overdress, the noble affectation apparent in her carriage.[53] Echoing his earlier praise of Gavarni's fashion drawings in *La Mode*, here Balzac insists that the proper lady's manner of wearing and animating her wardrobe is what differentiates her from the common bourgeoise. She could in fact hail from any class or region; what constitutes her type is the dignified self-awareness and artful manipulation of the visible signs of taste. These ensure that, when the *femme comme il faut* is out walking and shopping (on streets precisely specified by the narrator), both men and women turn to get a second glance at her.[54] In other words, she is the object not just of male desire but of female envy, inventory, and estimation. Although the identifying marks of taste do help to place this type in the social and sexual order of modern Paris, more importantly, they help to size her up, perhaps for some as a model for consumer rivalry, but for all, as an object lesson in visual assessment. While it is certainly possible that some viewers identified with (or aspired to emulate) a particular metropolitan type, I believe that the primary function of such drawings and texts was to provide amusement while demonstrating the criteria of social distinction in action. The viewer was more likely to identify with (or aspire to) the witty, knowing gaze of the narrator and illustrator, or to deploy the depicted social categories in order to describe "others" (playfully, critically, or disparagingly) in a language that would be familiar to contemporaries.[55]

Corresponding with this focus on consumption is an emphasis on costume and comportment over physiognomy in depicting the physical appearance of the metropolitan types. Established formulas for reading the features of the face as indices of essential passions and moral character are subordinated to more circumstantial visible expressions of social worth or performative skill. Balzac conveys the attractiveness of the *femme comme il faut* without once touching on facial or bodily features. And Gavarni's depiction leaves her body invisible beneath its fashionable encasements, barely hinting at aquiline facial features tightened into a performative expression of vain indifference.

Most revealing, however, is the echo of this lady's countenance in many other youthful female types Gavarni depicted in *Les Français*. The same slender oval face, bright eyes, and neatly parted dark hair can be detected in a range of Parisienne types spanning the class spectrum from the minor dancer[56] (Fig. 3.13) and the *grisette* (Fig. 3.14) to the *femme comme il faut* and the *habitués* of the Tuileries and

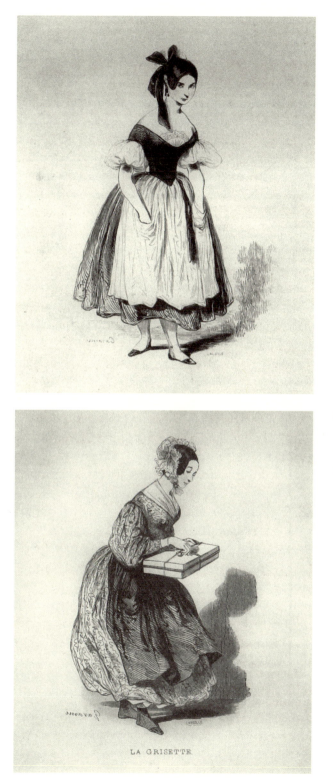

Figure 3.13
Gavarni, *The Minor Dancer*
[*La Figurante*], in *Les
Français peints par
eux-mêmes*, 1839.

LA GRISETTE.

Figure 3.14
Gavarni, *The Grisette*, in
*Les Français peints par
eux-mêmes*, 1839.

Luxembourg gardens. Certainly, the different status of each type is indicated in other ways: levels of gentility and *savoir faire* can be discerned in facial expressions, articles of fashion, and the more formulaic visible markers of carriage (from genuflecting to peacocking), stance (from wide-legged solidity with hands on hips or in pockets to a dainty invisible stride), and bodily exposure (from the short skirts and rolled sleeves that announce low class and sexual availability to total encasement by gloves, neck- and hemlines, and head coverings). Nevertheless, Gavarni's images feature the same standard female figure superficially elaborated with different outfits, postures, airs, and degrees of self-consciousness.

This static seriality is not produced, as with the traditional *métiers*, in order to showcase equal picturesque variations of a single class but rather to offset unequal, mutable social distinctions and their different constitutive signs. By eliminating physiognomy from the equation – along with its aura of biological, ethical, and social fixity – Gavarni is able to accentuate the more malleable, provisional, and performative details of self-fashioning.

Perhaps the blankness of this repeated mannequin-like physique would facilitate the aspirational projections of viewers who might use such typical images as models.[57] As a contemporary print attests (Fig. 3.15), Gavarni was aware that his public might use fashion prints and representations of manners this way. "Now this is how I'll look on Sunday!" declares a young man seated in a tailor's shop wistfully contemplating a fashion plate that features front and rear views of a top-hatted gent. The depicted print (clearly labelled "Modes") evidently serves as an exemplar for a particular outfit the man has instructed the tailor to custom make. But for all but the most wealthy citizens, this type of bespoke purchasing was rapidly declining; by mid-century, the availability of ready-made clothing inspired a revolution in the marketing practices of Parisian specialty shops and department stores, much as mass-produced ready-made inventories had transformed the world of publishing.[58] Where it did not provide publicity for specific products, fashion illustration could provide a more general service to the marketers of ready-made products, namely, the education and standardization of tastes to accord with the standardized product offerings of manufacturers and retailers. Whether in fashion plates or sketches of manners, the illustration of contemporary lifestyle scenes in which certain characters, tastes, and products were legibly associated with each other was an effective way to achieve this categorical alignment.

Gavarni's influence as a tastemaker was a chief concern of his critics. Charles Baudelaire remarked: "Those rascals of Gavarni's are so engaging that young people will inevitably want to imitate them ... he invents as much as he sees, and for that

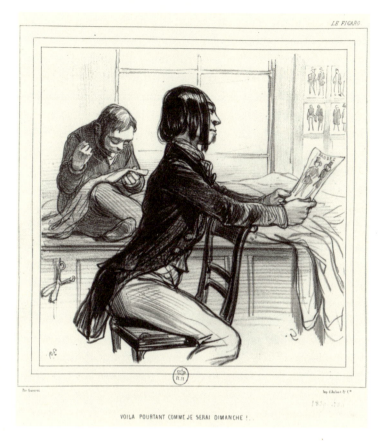

Figure 3.15 Gavarni, *Now this is how I'll look on Sunday!* 1839.

reason he has had a considerable effect upon manners. Paul de Kock created the Grisette, and Gavarni the Lorette; and not a few of those girls have perfected themselves by using her as a mirror, just as the youth of the Latin Quarter succumbed to the influence of his *Students*, and as many people force themselves into the likeness of fashion-plates."[59]

Jules Champfleury would echo Baudelaire's assessment – Gavarni's "spirit became a school and more than one actress learned the French language from his legends" – yet he politicized its terms, portraying Gavarni as a pernicious flatterer of the trivial (read feminine, aristocratic, corrupt) realm of fashionable manners, in caricatured opposition to Daumier, whom he regarded as a penetrating (read masculine, republican) critic of the status quo.[60]

Although Baudelaire and Champfleury attributed this disturbing cultural authority to Gavarni, they were in fact bemoaning historical conditions to which they were themselves subject and from which they also profited. With the increasing distribution of print and journalistic media, writers and graphic artists were gaining influence as cultural commentators and trendsetters. At mid-century, cultural producers began to understand and exploit these growing social powers, just as they were also struggling to market themselves and their wares in new conditions. Walter Benjamin touched on this commercial and social experimentation in his meditations on Baudelaire: "The flâneur plays the role of scout in the marketplace. As such, he is also the explorer of the crowd. Within the man who abandons himself to it, the crowd inspires a sort of drunkenness, one accompanied by very specific illusions: the man flatters himself that, on seeing a passerby swept along by the crowd, he has accurately classified him, seen straight through to the innermost recesses of his soul – all on the basis of his external appearance. Physiologies of the time abound in evidence of this singular conception. Balzac's work provides excellent examples."[61] Here Benjamin intimates a crucial link between techniques of social stratification and the marketing of artistic commodities. The artist's classificatory ability is the signal specialization that buttresses his efforts of poetic composition, self-promotion, and competitive differentiation in the marketplace. Moreover, he uses this talent to identify his public, that is, to discern constituents of the crowd with similar needs, desires, and values, a technique known as *segmentation* in present-day marketing terms. This kind of profiling would help cultural producers to understand the public as typical kinds of consumers and in turn to design and position their wares in relation to legible patterns of consumer behaviour.

Furthermore, such profiling would help to create the very subjects it purports to describe. The artist as social researcher moulds the crowd as he categorizes and represents it. His efforts to describe and differentiate members of the public effectively work to prescribe and standardize their distinguishing features. Not only does his classificatory vision turn each fashionable nuance, particularity, or innovation into a generic type, but the discursive reach of that vision is such that readers might begin to express and measure social behaviours in relation to the exemplars he produces. Hence his mediation facilitates the formation of differentiated social segments and in turn the potential alignment of those segments with the standard variations of differentiated products. Here we should be reminded of Karl Marx's pronouncement that capital does not simply create new objects for unchanged subjects but cultivates new subjects – subjects with newly calibrated sensitivities and inclinations – to suit its objects.[62] More precise in relation to the cultural production

of typical subjects and objects is Theodor Adorno and Max Horkheimer's insight that "the culture industry as a whole has molded men as a type unfailingly reproduced in every product."[63]

My point is not to posit that July Monarchy social typologies provided social-engineering blueprints of target customers and citizens, paving the way for market research to dominate both cultural production and political policy making. Rather, I am interested in how works of light-hearted social typification like *Les Français* anticipate and exemplify certain historical processes involved in the commercialization of social difference. On the one hand, the *criteria* of social differentiation and identity formation are commercialized when they begin to be performed, expressed, and measured through visible signs and consumer behaviours. On the other hand, the *expertise* of social differentiation is commercialized when it is gradually professionalized and commodified by new kinds of cultural observers, producers, and analysts. Indeed, as the anthropologist Kalman Applbaum has argued, consumers and producers must be recognized as co-participants in the modern "capitalist system of provisioning" and its enabling viewpoint on human needs: the shared vision of a "good life" that is achieved and signified "through consumption and identification with 'lifestyle' categories." At the same time, Applbaum rightly stresses the need for more historical research into the heavy-handed role of marketers in steering, disseminating, and validating that system.[64]

Today the terrain of commercially oriented social stratification is monopolized by professional marketing, which effectively integrates the relevant expertise of social and behavioural scientists, cultural anthropologists, psychologists, and trend spotters embedded in the worlds of art and fashion.[65] Marketing would not develop a formal discipline until the 1920s, and the study of consumer behaviour would emerge as a branch of this discipline only in the 1960s.[66] Yet marketing methods became structurally necessary at least a century earlier, and techniques of social stratification (early improvised avatars of the marketing triumvirate of segmentation, targeting, and positioning) appear to have been among the first of such methods to be developed experimentally and provisionally in commercial practice. In her research on the development of billposting and advertising agencies in nineteenth-century Paris, Hazel Hahn points to evidence of these methods: "Targeting specific groups according to gender, class, and profession became commonplace through press ads, catalogues and billposting in specific areas. Agencies possessed censuses breaking down the population by rent and profession. This enabled their clients to select the exact streets on which they wanted to display their posters or the addresses to which they wanted to send their advertisements through

the mail, signaling the emergence of 'niche advertising' already at mid-century."[67] She discovers both rhetorical and tactical examples of market segmentation in the advertising and publishing practices of the period.

The example of *Les Français* suggests that much early experimentation took place in the realm of artistic practices and cultural production. Authors like Gavarni, Grandville, and Balzac certainly capitalized on their expertise in social differentiation, as did the publishers who helped to commodify and disseminate their work. They showcased this expertise in their representations of Parisian manners and in their pioneering advertisements, which both instigated and thematized the enmeshment of quotidian media and current social practices. The narcissistic structure of Gavarni's poster-viewing motif, in which the structures of social representations and social experience are shown to mirror each other, contains a hint of the emergent logic of marketing, which seeks the strategic alignment of product offerings with the legible patterns of consumer lifestyles.

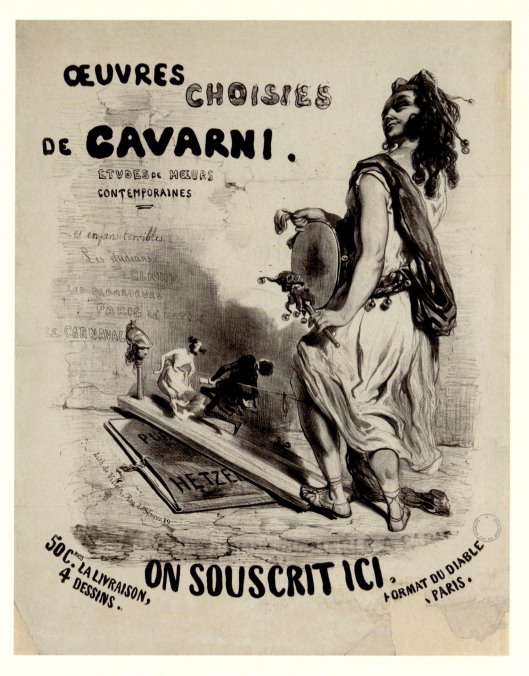

Figure 1.6 Gavarni, poster for *Oeuvres choisies de Gavarni*, 1845.

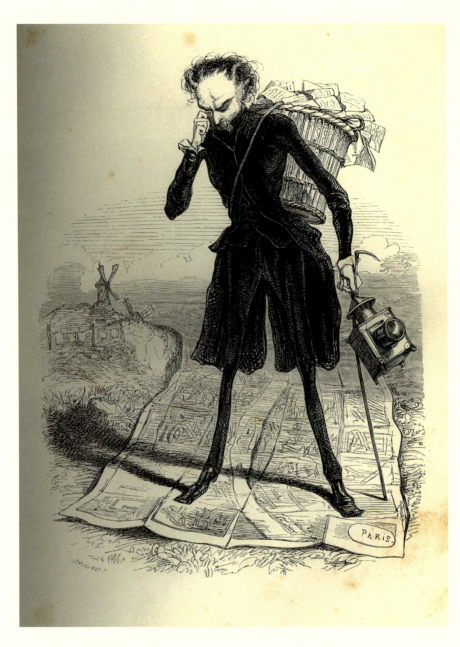

Figure 2.2 Gavarni, frontispiece in *Le Diable à Paris*, 1844.

LE CHIFFONNIER.

Figure 2.7 Traviès, *The Ragpicker*, in *Les Français peints par eux-mêmes*, 1840.

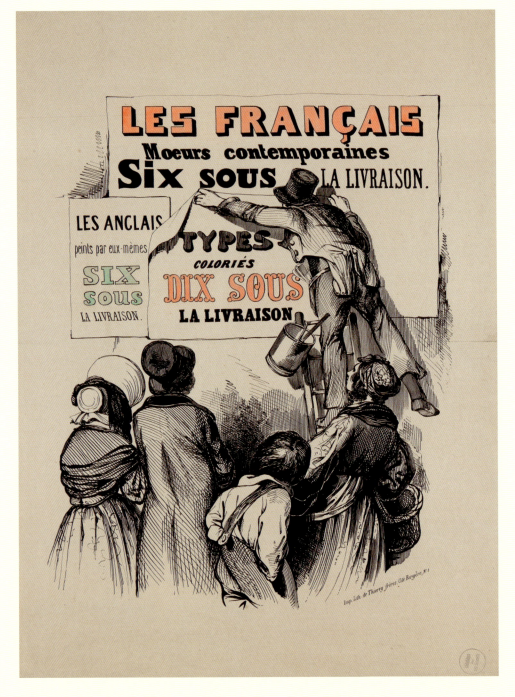

Figure 3.1 Gavarni, poster for *Les Français peints par eux-mêmes*, 1845.

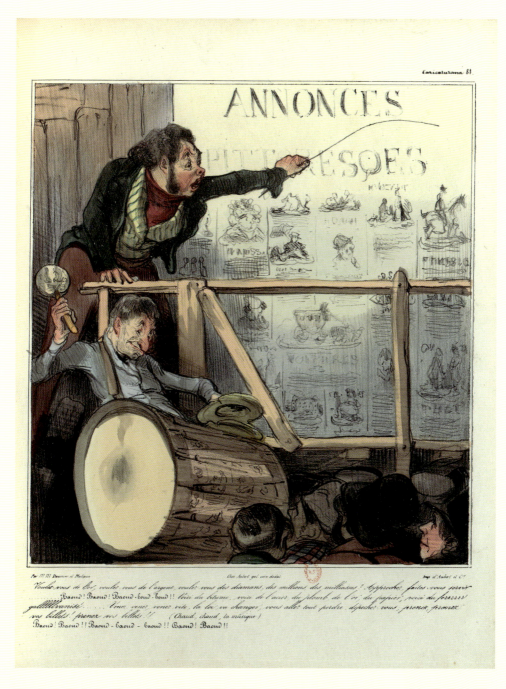

Figure 3.5 Daumier and Charles Philipon, *Do you want gold, do you want silver, diamonds, millions and trillions? Come and be served, hurry buy your bonds!* 1838.

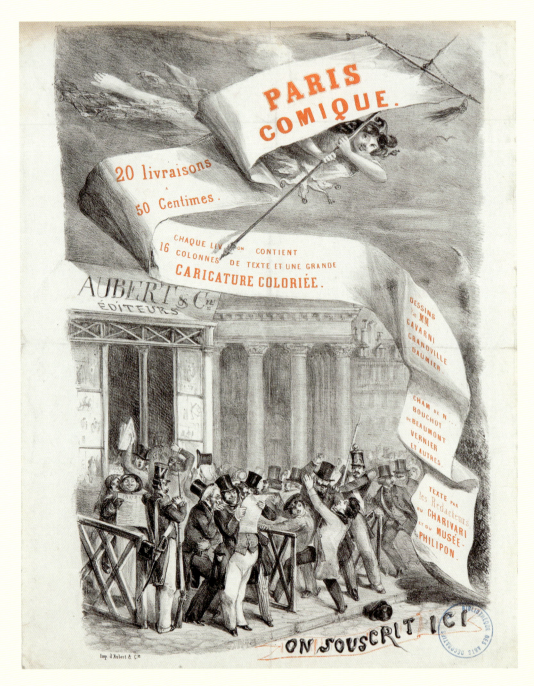

Figure 3.9 Anonymous, poster for *Paris Comique*, 1844.

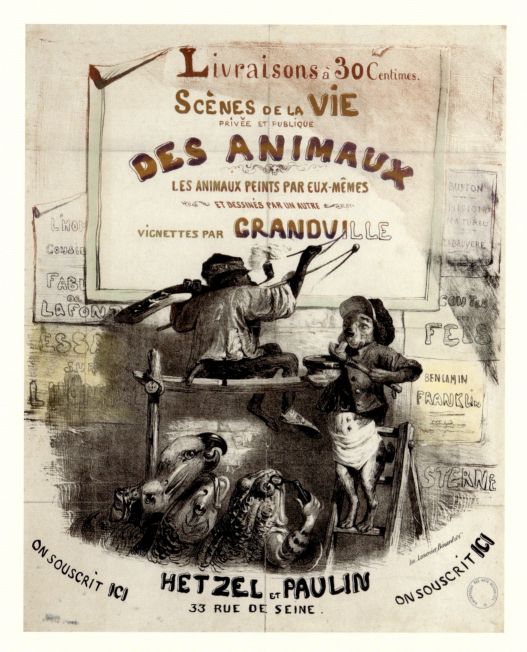

Figure 3.10 Grandville, poster for *Scènes de la vie privée et publique des animaux*, 1842.

Figure 3.11 Carle Vernet, *Herbal tea seller. Fresh beverage, who wants a drink?* 1820.

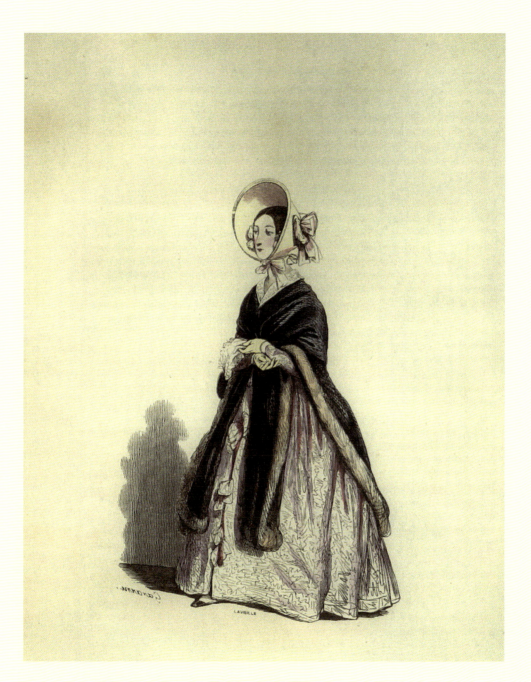

Figure 3.12 Gavarni, *The Proper Lady* [*La Femme comme il faut*],
in *Les Français peints par eux-mêmes*, 1839.

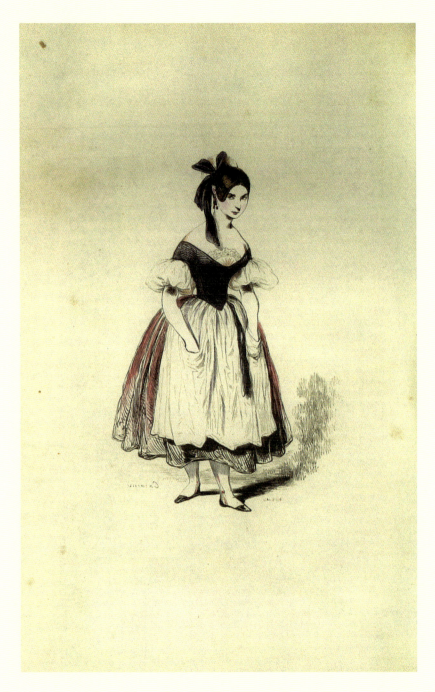

Figure 3.13 Gavarni, *The Minor Dancer* [*La Figurante*],
in *Les Français peints par eux-mêmes*, 1839.

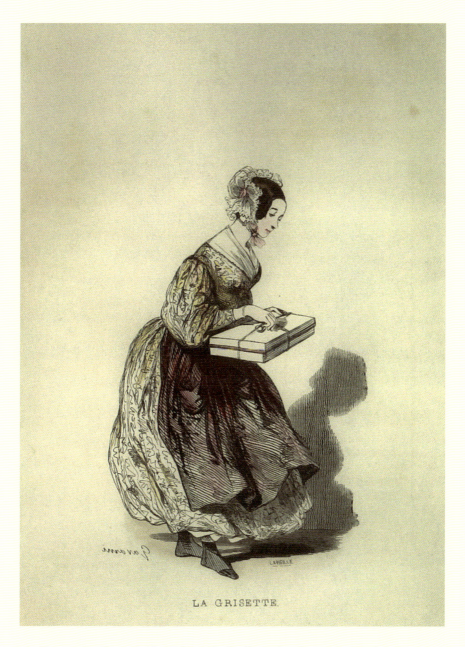

LA GRISETTE.

Figure 3.14 Gavarni, *The Grisette*, in *Les Français peints par eux-mêmes*, 1839.

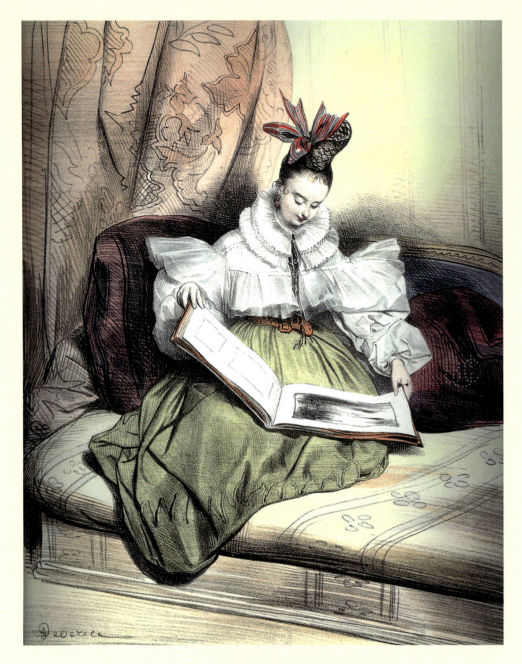

Figure 4.1 Achille Devéria, *9 o'clock in the morning* [portrait of Annette Boulanger], 1829.

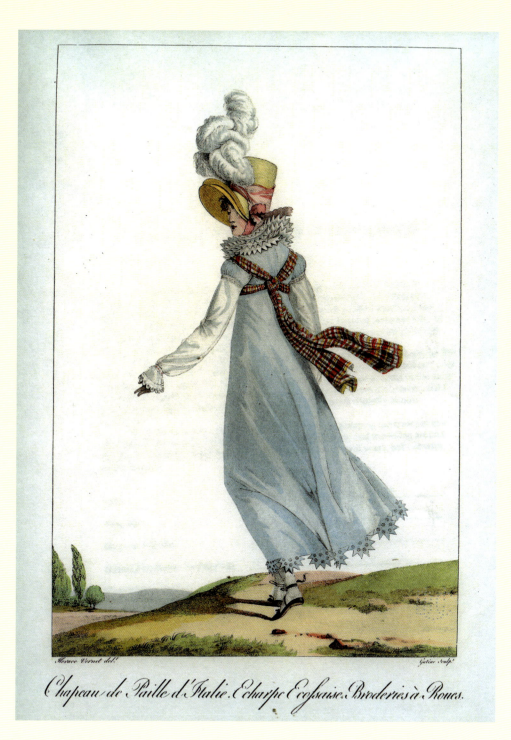

Chapeau de Paille d'Italie. Echarpe Ecossaise. Broderies à Roues.

Figure 4.2 Horace Vernet, *Marvellous Women, no. 13: Straw hat from Italy. Scottish sash*, 1810–18.

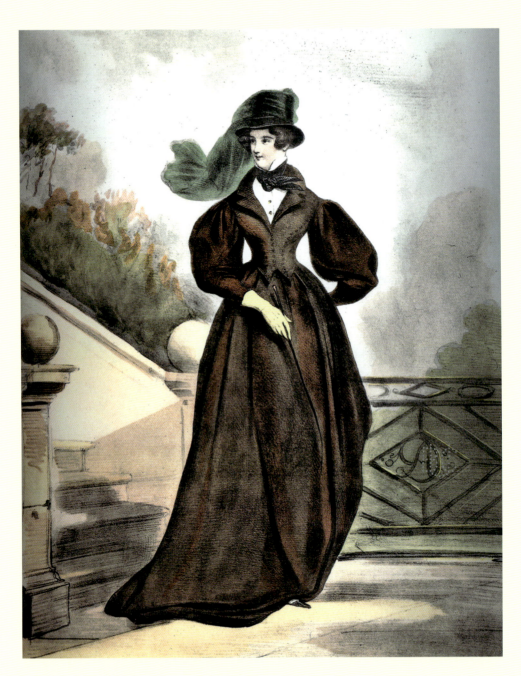

Figure 4.6 Achille Devéria, *7 o'clock in the morning* [portrait of Mademoiselle de Nisdal], 1829.

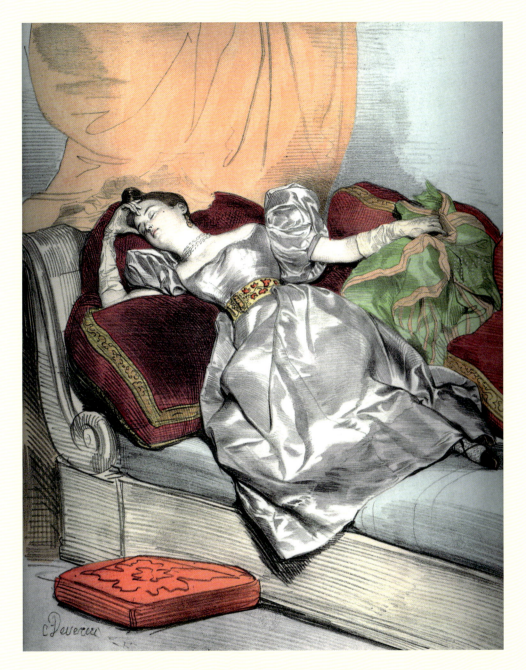

Figure 4.7 Achille Devéria, *5 o'clock in the morning* [portrait of Annette Boulanger], 1829.

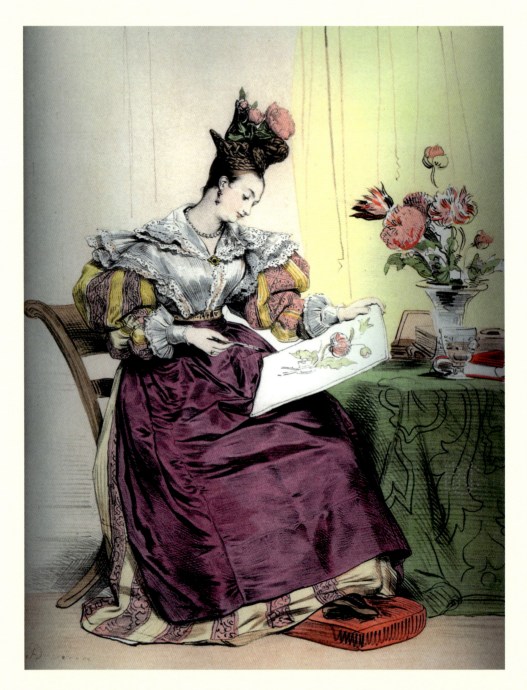

Figure 4.9 Achille Devéria, *4 o'clock in the evening* [portrait of Laure Devéria], 1829.

Figure 4.10 Laure Devéria, *Tulip flowers*, c. 1830.

Figure 4.12 Eugène Devéria, *Portrait of Henri Herz*, 1832.

Figure 4.13 Eugène and Laure Devéria, *Portrait of Laure Devéria*, Salon of 1833.

Figure 5.1 Gavarni, *Me, ever having something with that little journalist!
Oh, Edouard! No! I despise them too much*, 1838.

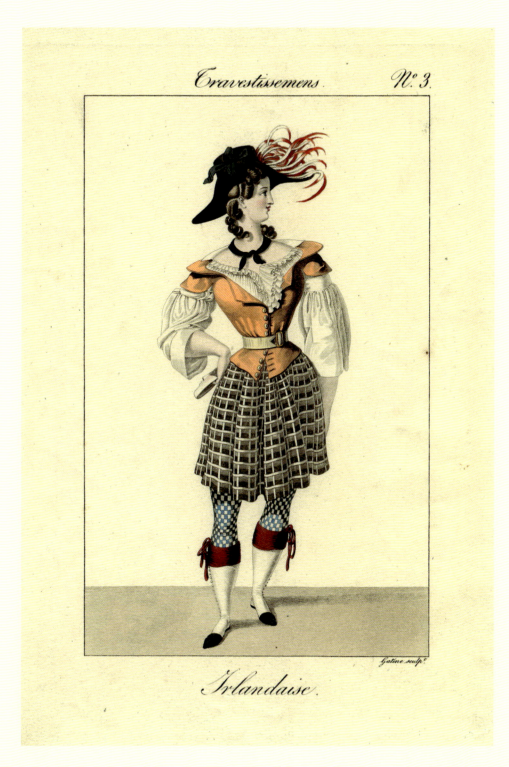

Gatine sculp.ᵗ

Irlandaise.

Figure 5.4 Gavarni, *Irish costume*, 1827.

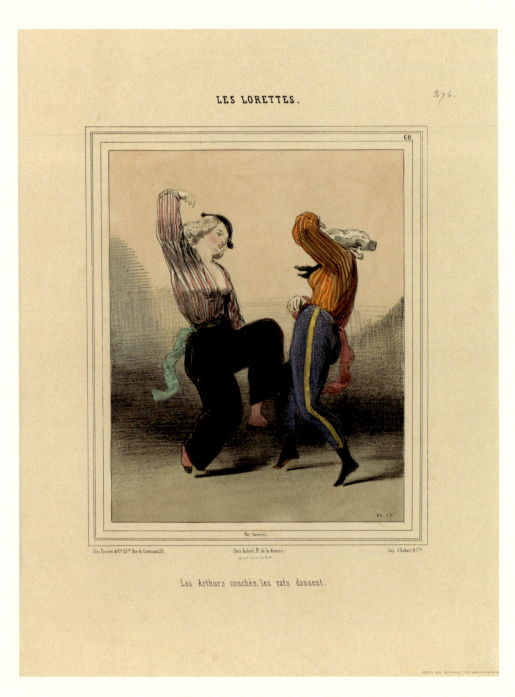

Figure 5.8 Gavarni, *When the Arthurs sleep, the rats dance*, 1843.

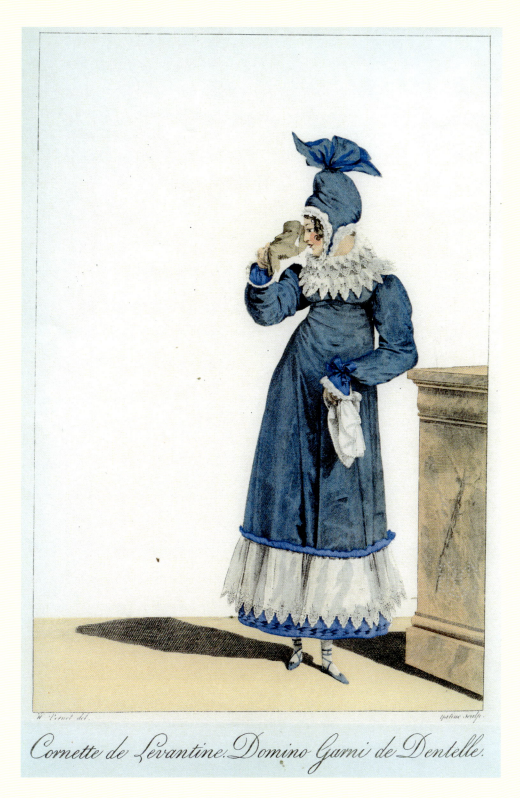

Cornette de Levantine. Domino Garni de Dentelle.

Figure 5.9 Horace Vernet, *Marvellous Women, no. 15: Domino trimmed with lace*, 1810–18.

Figure 5.10 Félix Bracquemond and Maurice Neumont,
poster for Fêtes Gavarni, 1902.

The Hours of Her Day

*Fashion Prints, Feminine Ideals,
and the Circle of Achille Devéria*

In 1829 Achille Devéria composed *Les Heures du jour* (*The Hours of the Day*), a suite of eighteen lithographs that portray successive intervals in the day of a stylish young Parisienne. We admire her poise as she prays, goes riding, relaxes with a book, pays social calls, paints pictures, plays the piano, and attends the theatre and then a soirée where she dances until dawn. We admire her stamina too, for she has a mere two hours to sleep in this round-the-clock journey from 7 a.m. to 5 a.m. Devéria's album is an interesting hybrid work combining fashion illustration, portraiture, and a guide to reigning codes of comportment. The plates indicate the elegant attire, activities, and environments thought appropriate for a particular class of refined women in late Restoration Paris. Moreover, the artist based these typical scenes on portrait studies of his female friends, who were members of an influential artistic coterie anchored by Victor Hugo.

What can we learn from these plates today? The suite proposes a model of bourgeois femininity and consumption that would prevail and evolve for another century. Devéria articulates that model at an early formative moment when coordinates of class and gender, work and leisure, private and public were being redrawn. *Les Heures du jour* can help us gauge some of these changes if we are careful not to treat it as a passive or transparent "imprint of the époque."[1] This is an imprint that actively shaped the material and symbolic world of its readers, and it did so through a curious mixture of recording, prescription, idealization, and imagination.

Secondly, this album reminds us that there were once fashion illustrations with little (or at least vague) commercial utility. Devéria's fashion prints do not promote specific products, shops, or manufacturers. It will not do to dismiss these fashion

sketches as practical and commercial, for *Les Heures du jour* defies these categories and points to the necessity of rethinking them. What exactly was the role of the fashion illustrator and the fashion print *before* the establishment of commercial fashion publications, retail shopping, and ready-made goods?

This chapter examines early-nineteenth-century fashion plates in relation to specific developments in the business of publishing and the business of fashion. It also explores the terrain of bourgeois rituals, feminine ideals and artistic accomplishments, and the commercial organization of everyday life. Finally, our encounter with the world of Achille Devéria and his sitters will lead us to consider issues of artistic sociology and the domestic parameters of Parisian romanticism. This album hints at the tensions between celebrity and typicality in portraiture, and it illuminates the disparate horizons of men and women, professional and amateur artists, and artistic producers and bourgeois consumers.

Album of Fashion

For *9 o'clock in the morning*, Devéria proposes a scene of reading (Fig. 4.1) that divulges how he might have imagined the audience for *Les Heures du jour*. A young lady is curled up comfortably on a low oriental divan, her lips curled in pleasure, a large picture book balanced in her lap. Although she is engaged in a quiet contemplative activity, she has taken great care to craft her outward appearance. Her hair is woven into an elaborate plaited assemblage and she wears an implausible blouse featuring the inflated sleeves, wide drop-shoulder accent, and Elizabethan ruffs that were the rage in 1829. The traces of this lady's taste extend from her trendy clothing and the upholstered surfaces of her home to her chosen reading material, apparently a lithographic album of landscapes or travel images. Her posture signals both tranquility and attentiveness. The illustrated book she peruses is at once a pleasant diversion, a source of knowledge, and a conspicuous possession that signals her affluence and sophistication. This scene – along with four others in the series in which leather-bound volumes are visible – accords a central position to expensive publications among the tasteful objects and proper practices of the Parisienne's day.

Les Heures du jour was available in a deluxe-bound format similar to the one pictured here. While few could afford such a sumptuous edition of the entire lithographic suite, modest buyers might purchase one or two of these beautiful hand-coloured plates to frame or store in a folio. After some delay, selections of the work would also be available to a wider audience in the form of plates reissued in fashion journals.[2] In any case, Devéria seems intent on characterizing his fashion illustra-

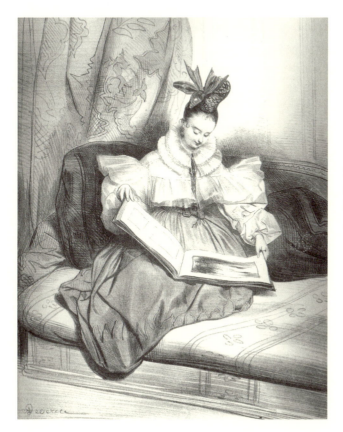

Figure 4.1
Achille Devéria, *9 o'clock
in the morning* [portrait of
Annette Boulanger], 1829.

tions as elite and nostalgic: an art form for discerning individuals rather than an ephemeral or pedestrian product. He brings the graceful, sensual, painterly qualities of eighteenth-century engravings (of which he was an avid collector) to the still new medium of lithography. Devéria's fashion sketches beckon the viewer's aesthetic discernment and imaginative projection; they give priority to visual delectation over instruction or shopping.

Devéria's title recalls the book of hours, a durable genre that had remained popular since the Middle Ages. These prayer books guided family devotions at the canonical hours of the day; often they were ornately decorated and designed as gifts for women. *Les Heures du jour* is like a modern book of hours in the sense of a prized possession that outlines an orthodox partitioning of daily life into recommended rituals and modes of attention. Charting the new sacraments of leisure and polite accomplishments that would structure the lives of well-to-do women in the last years of the Restoration, it indicates how the traditional rhythms of the religious

calendar – along with traditional patterns of women's work – would be replaced by the modern modes and manners *du jour*.[3]

Processes of social and economic modernization underway in early-nineteenth-century Europe would inevitably alter how the hours of the day were measured and conceived. Wolfgang Schivelbusch points to several systemic changes to perceptions of time spurred by the expansion of railways and gas lighting, among other factors. A public synchronized clock-time became necessary in order to coordinate the increasingly complex activity of factories and rail transportation. While national and international time standards were not completely instituted until the 1880s, predictable railroad schedules and labour shifts were established much earlier.[4] Schivelbusch also traces the gradual extension of nightlife in urban centres, as the artificial illumination of streets, shops, and restaurants prolonged the hours of business and entertainment. To keep late hours was a sign of elevated social rank – first enjoyed only by courtiers but steadily adopted by greater swathes of the middle classes – with the result that throughout the nineteenth century the start time for meals, social gatherings, and performances was pushed later and later.[5] It was a conspicuous distinction and pleasure for well-to-do revellers to be heading home to bed at dawn when the labourers were just setting off to work. The tireless rounds of the ladies depicted in *Les Heures du jour* illustrate the changing values attached to nightlife and other regulated daily intervals of metropolitan leisure available to fortunate women.[6] Perhaps Devéria was inspired by Henry Monnier's *Administrative Manners* (1828), a series of eighteen lithographs describing the hourly increments of office routine in a single day around the clock. Monnier inaugurated the subject of bureaucratic manners and brought satirical attention to the significance of an increasingly time-disciplined (if rather unproductive) world of work.[7] Devéria attends to the ways in which new calibrations of time would revise the bourgeois work of leisure.[8]

Surely a central touchpoint for Devéria in compiling this album of fashion was Horace Vernet's *Incroyables et merveilleuses* (1810–18).[9] These elegant engravings (Fig. 4.2) portray ultra-fashionable ladies and dandies as they might be registered by an acute observer making the rounds of public gardens and promenades. Vernet managed to capture the studied demeanour of these incredible fops and marvellous damsels: chic hipster types who flaunted the return of luxury and elitism after the egalitarian austerity of the republic. Vernet's sketches of these types signalled a nuanced attention to the semiotic potency of dress and gesture to communicate currency, knowingness, political opinions, and other affiliations.[10] His work would have stood out as the ultimate painterly precedent in the field of fashion illustration.

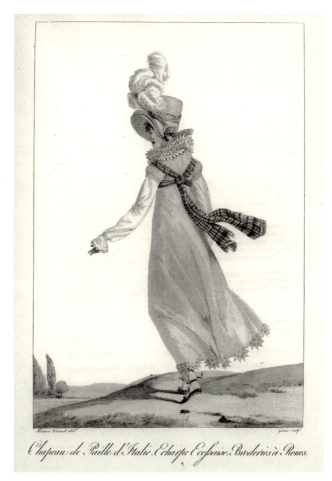

Figure 4.2
Horace Vernet, *Marvellous Women, no. 13: Straw hat from Italy. Scottish sash*, 1810–18.

Like Devéria, Horace Vernet came from a respected artistic family and had a distinctive social network. Throughout the 1820s, his Montmartre studio was a famous gathering place for assorted proponents of romanticism, Bonapartism, and liberal opposition to the Bourbon Restoration.[11] His father, Carle, was an influential painter, teacher, printmaker, and man about town who helped carry the elegant art and manners of the eighteenth century into the nineteenth.[12] Carle and Horace both made hundreds of fashion drawings and, from 1816, were among the first French painters to practise lithography.[13] Household accounts confirm that Horace's prints – fashion illustrations for La Mésangère's *Journal des dames et des modes* chief among them – provided a substantial income for the family to live on.[14] But Horace

also earned official recognition and an academic chair as a painter of battle scenes, historical subjects, and portraits. From Devéria's perspective, Horace Vernet would offer a rare professional prototype: that of an esteemed academic painter who embraced the possibilities of print culture. The Vernets helped to establish a thriving market for prints in which there were important points of crossover (both artistic and commercial) between fine-art engravings and lithographs, eighteenth-century genre pictures and nineteenth-century sketches of manners, fashions, military subjects, and urban scenes.

Devéria hoped to walk a similar line: to mix painterly talent and keen social observation in prints that would appeal to both old and new audiences for print culture, including art collectors and the readers of women's periodicals. While Vernet's *Incroyables et merveilleuses* catalogued male and female walking costumes from the perspective of a gallant man about town, Devéria's compendium offers a more intimate view of women's fashions against the backdrop of domestic spaces, social rituals, and the experiential horizons of private life.[15] Devéria builds upon Vernet's model by treating fashion prints more like portraits or genre scenes, and he adds yet more contextual information by deploying those scenes sequentially to narrate the moments of an exemplary day.

The composition of Vernet's sketches was relatively sparse, as was the norm for fashion plates of the Empire and early Restoration.[16] Typically, a single full-length figure is depicted with no background setting beyond the minimal indication of a low-horizoned stage, such as a patch of grass or parquet floor, that rarely rises above knee-level. The best plates were found in the *Journal des dames et des modes* (1797–1839) until more serious competitors emerged in the 1820s.[17] Arriving in 1821, *Petit courrier des dames* introduced plates with more accessories, furnishings, and paired front and back views.[18] Two other leading journals were founded in 1829: *Le Follet, Courrier des salons*, a ladies magazine reporting on fashion in the context of social life, and *La Mode,* which combined fashion and literature, engaging high-calibre contributors like Honoré de Balzac, Victor Hugo, Delphine Gay, Charles Nodier, Jules Janin, and Eugène Sue.[19] One of the first exhibitions devoted exclusively to fashion drawings also took place in October 1829, when the Musée Colbert showed 200 watercolours (of masquerade costumes) by Gavarni.[20]

These were pivotal years when fashion illustrations began to feature more lifelike figures, choreographed roles, and dramatic settings. It was said that the models in traditional fashion plates looked like paper dolls in comparison to the lifelike and recognizably modern Parisian women in Gavarni's sketches for *La Mode*.[21] If Gavarni's contribution lay in the animated and contemporary quality of his figures,

Devéria deserves credit for fleshing out the social surroundings, beginning with his drawings for *Les Heures du jour*. These were among Devéria's first fashion illustrations and they exhibit a complexity of composition, characterization, and *mise-en-scène* that is rare for 1829.

Devéria's figures in *Les Heures* convincingly inhabit the costumes and social settings in which they are placed. We see these ladies at home, in their natural habitat as it were, surrounded by their possessions and engrossed in their daily activities: reading a book, answering letters, getting dressed to go out. A sense of belonging and comfort is produced by the unusually high horizon lines – meeting each body between hip and shoulder – along with the cushioning presence of draperies, wainscoting, wallpaper, carpets, footstools, and upholstered seats. Furthermore, because each plate portrays one of the artist's friends, we can also glimpse individual traits and self-conscious expressions shining through the type.

Anne Higonnet has shown that Devéria and Gavarni transformed fashion illustration around 1830 by importing aspects of other print genres, effectively merging the fashion plate with *scenes de moeurs* to create "a new commercial hybrid."[22] This hybrid enhanced the visual appeal, social information, and dramatic pitch of the new fashion iconography. Devéria and Gavarni approached these fashion plates as rich and studied representations of modern life. Each sketch is deliberately layered with the kind of narrative implication, anecdotal detail, and graphic emphasis that consumers had come to expect from popular "everyday" genres such as the novel, sketch of manners, caricature, and other journalistic descriptions of Parisian life. Around 1830 these genres were multiplying and gaining spatial proximity to each other in new forms of publication and contexts of display. Hence the enhanced fashion scenes produced by Devéria and Gavarni would be physically adjacent to related modes of social and urban description in middle-class homes, in print-shop windows, and in periodicals like *La Mode* and *L'Artiste*. Devéria's *7 heures du matin* mingled with a range of articles and gossip columns when it was reproduced in *Le Follet* (6 May 1830).[23] Gavarni's fashion plates were interspersed with Honoré de Balzac's "Traité de la vie élégante" in *La Mode* in October and November 1830.[24] Surely this adjacency bred collaborative and competitive exchanges as the makers of these diverse genres approached the representation of contemporary Parisian *moeurs* with highly adaptable, interrelated means. Generic proximity and fluidity might spur artistic invention, give producers a sharper sense of their target audience, and underline the existence of a common terrain of investigation that extends beyond clothing to manners, ideas, and social life.

Commerce, Guidance, Promotion

The tricky bit is how to understand the commercial parameters of these enhanced fashion sketches. Did increasing hybridity make them any more lucrative or appealing to a broad audience? An illustrator like Devéria would be compensated regardless of how many prints were eventually purchased by the public, because his business practice involved selling lithographic stones to his publisher for a fixed price. The publisher then assumed the commercial risk or benefit of printing and selling the images, either as individual prints or bundled into periodicals or albums of various kinds.[25] So how was the business of publishing fashion prints related to the business of shopping for clothing or other goods?

Hazel Hahn has shown that commerce and advertising did not became the dominant content of French fashion publications until the mid-1840s; her research tracks this shift from the 1820s through the 1840s, with increasing coverage of boutiques, emphasis on seasonal *nouveautés*, and the representation of shopping as a middle-class amusement.[26] In the preceding decades, fashion reporting emphasized the description of social mores (noting what aristocratic women were wearing at the key high-society venues), along with cultural matters (articles on the theatre, literature, or history) and current events. Gradually, in the 1830s, there was more emphasis on shopping as a leisure activity and publicity for specific local business, fashion purveyors, and publishers too.[27] Close analysis of the related visual evidence aligns with Hahn's findings. In fact, fashion plates of the 1820s and 1830s have fewer connections to shopping and publicity than one might think.

Surely *Les Heures du jour* provided its readers with some information relevant to getting dressed or evaluating the appearance of others.[28] But to what extent did these fashion plates guide purchasing behaviour? How exactly was the production and consumption of these fashion illustrations related to the production and consumption of clothing? To understand this connection, twenty-first-century readers will have to overcome the assumption that the clothes depicted in fashion illustrations represent matching goods available for purchase from local purveyors. This direct correlation between goods-in-the-image and goods-on-the-retail-shelf would exist only after the widespread adoption of ready-made clothes after mid-century.[29] Early-nineteenth-century fashion plates did not depict or advertise ready-made merchandise available at retail outlets. At the most, they depicted styles that could be custom-ordered from tailors, dressmakers, or the confectioners of hats, ribbons, lace, and accessories. The fashion plate's mediation in this bespoke purchasing process might be rather general – for example, if a customer brought along a fashion

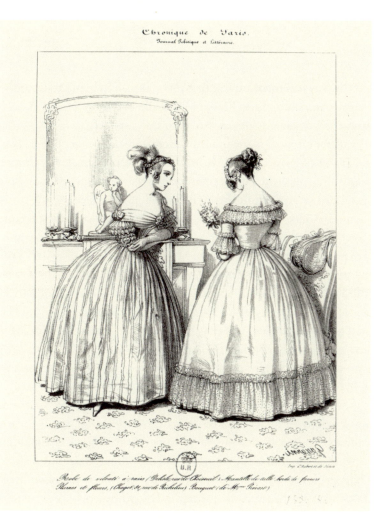

Robe de velours à raies (Delisle, rue de Choiseuil) Mantelet de tulle, bordé de fleurs
Plumes et fleurs, (Chapot, 81, rue de Richelieu) Bouquet (de M^me Prévost)

Figure 4.3 Gavarni, *Dress of striped velvet (Delisle rue de Choiseuil)*, 1836.

plate for the artisan to work from, or made decisions by referring to sample images displayed in the workshop.[30]

Alternatively, from about 1824 onward, fashion plates might provide more explicit promotions for the makers of bespoke fashions, by way of image captions indicating the names and addresses of specific workshops where the showcased styles could be ordered.[31] Some of Gavarni's fashion prints direct viewers to particular businesses in Paris. The earliest example I have found is an 1836 series of fashion plates by Gavarni for *La Chronique de Paris, Journal politique et littéraire* with captions that credit particular dressmakers, haberdashers, and artisans who make ribbons, feathers, and flowers (Fig. 4.3).[32] The legends below these eight

lithographs by Gavarni mention five dresses by Delisle, a man's topcoat by Lacroix, a dress by Minaret, bonnets by Madame Lassalle and Lucy-Hocquet, and a shawl from Rosset et Normand. Addresses are provided for each.

Perhaps better known are the many explicitly promotional plates Gavarni made for the sought-after Parisian tailor Humann, rue Neuve-des-Petits Champs; there were at least thirty published in *Le Charivari* between January 1839 and November 1842 (Fig. 4.4).[33] Gavarni delineates stylish gentlemen in sleek coats, trousers, and dressing gowns attributed to Humann, alongside chemises, hats, and furnishings credited to other purveyors. However, it is interesting to note that these promotional plates were not necessarily drawn from physical models or drawings provided by the tailor. More likely, the arrangement involved Gavarni drawing the dapper, rakish, well-tailored figures he was known for in his work as a sketcher of Parisian types, and later simply adding the tailor's name to the plate. In this way viewers would be encouraged to associate Gavarni's elegant graphic style with the tailor's fine made-to-measure garments. A similar mode of associative advertising was pursued by Balzac, who offset debts to his own tailor Buisson by inserting flattering references to him in his literary descriptions of Parisian *moeurs*.[34]

The captions on the plates of *Les Heures du jour* note only the time of day; there is no acknowledgment of any makers or sellers of clothing. Nor is there a textual accompaniment to this album to provide any editorial advertising alongside the plates. So what, if anything, is being promoted in these images of fashion by Devéria? What species of guidance, advice, or information is included here? And, if the artist does not illustrate products supplied by clothes makers or retailers, where does he find his models? Who invented the costumes that are depicted?

Although they did not promote specific products or makers, Devéria's plates do recommend particular styles of clothing and rhythms of consumption. They show how fashions in clothing function semiotically within a broader matrix of goods, sites, behaviours, and signs that constitute subjectivity and everyday life. Surely the suggestive power of *Les Heures du jour* derives from its encompassing representation of a fashionable woman's experiential horizons, so that the viewer can intuit a meaningful and mutually reinforcing connection between the qualities of the woman and her home, possessions, activities, and attitudes. Even if we leave aside the question of intent, this expanded vision must enrich the album's potential as a vehicle of marketing. For the layering of these connected semiotic values in each scene effectively conjures "a meaningful context for the commerce and consumption of … commodities," which is how the anthropologist Kalman Applbaum defines the mandate of the marketing discipline as a key process of meaning-creation within capitalist culture.[35] Furthermore, the temporal elaboration of *Les Heures* – which

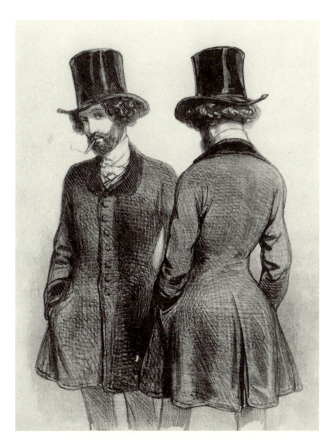

Figure 4.4
Gavarni, *Suits by Humann,
hats by Guitar (101 rue de
Richelieu)*, 1841.

proposes a regular daily rhythm of attention, manners, and pursuits – adds exceptional potency to this context-conjuring effect.

Although Devéria was not being paid to sell clothes, he does sell compelling ideas about clothes and comportment, demonstrating how objects could be deployed to create identities, communicate meanings, and articulate the structure of everyday life. In effect, these fashion illustrations might promote a general ethic of consumption, spurring diffuse (rather than specifically targeted) demand for local businesses dealing in fashions, furnishings, luxury goods, publications, and art supplies. For example, the viewer might be inspired to update or augment her wardrobe to reflect the new style of sleeves, neck-lines, or accessories that were *de riguer* for various social events and moments of the day. She might also purchase an album or hire a drawing instructor.

Nonetheless, it seems that the fashion illustrator's most direct promotional task – circa 1829 – is to market images and ideas. *Les Heures du jour* advertises the artist's range of pictorial products and his particular expertise in the representation of modern manners. It would take a few years for the makers and sellers of clothing to tap into this, to harness the artistic talent and symbolic capital attached to these

topical, knowing, and urbane illustrations by Devéria, Gavarni, and others. Gavarni's "Costumes Humann" plates are an instructive example, for, instead of the tailor providing models for the artist to copy, we see the tailor seeking association with the artist's signature graphic style. Essentially, the clothes maker promises to outfit customers with made-to-measure attire as rakish and form-fitting and elegant as the suits modelled by dandies in caricatures by Gavarni. This was an effective cross-promotional strategy for both Humann and Gavarni. It also underlines the fact that the illustrator and the tailor shared certain skills and value propositions. They were both talented designers and advisors of elegance who traded on their shrewd visual assessment and their ability to cut a good figure (on paper or in cloth) that could flatter and carry legible social nuance.

Design and Invention

This brings us to the matter of how fashion plates were generated if they do not advertise existing models or merchandise. The historical record suggests a few sources from which early-nineteenth-century fashion illustrations were typically drawn.

A fashion illustrator might work from prototypes provided by a dressmaker or industrial draftsman. Fashion sketches by Anaïs Toudouze were modelled on garments sent to her house by couturières.[36] Compte-Calix drew plates for *Les Modes parisiennes* based on technical drawings by Charles Pilatte; the toilettes were advertised in the name of dressmaker Alexandre Ghys, who purchased Pilatte's original designs.[37] Illustrator Jules David and couturier Charles Worth also worked from dress designs made by "dessinateurs industriels en modes."[38] In such cases the fashion illustrator's role is to document and dramatize a toilette designed by another draftsman or artisan. Most of these examples are found after mid-century; however, Raymond Gaudriault furnishes one early example of costume designs by Auguste Garneray, "dessinateur de l'Opéra," which were realized by couturier Louis LeRoy and redrawn by Horace Vernet for *Journal des dames*.[39]

Alternatively, many fashion illustrations are purportedly drawn "from nature." The editors of *La Mode* and *Journal des dames* claim to record attire seen in key arenas of social display such as the Tuileries, the Opera, or Longchamps.[40] Vernet framed the *incroyables* and *merveilleuses* as if captured by a journalist observing promenaders in the city. Many of Devéria's fashion sketches were also drawn from nature, if one is to believe the publication titles. *Le Goût nouveau, Motifs variés pris d'après nature* (*The New Taste, Varied Motifs Drawn from Nature*, 1831) features current fashions worn by Devéria's lady friends.[41] *Costumes historiques pour travestisse-*

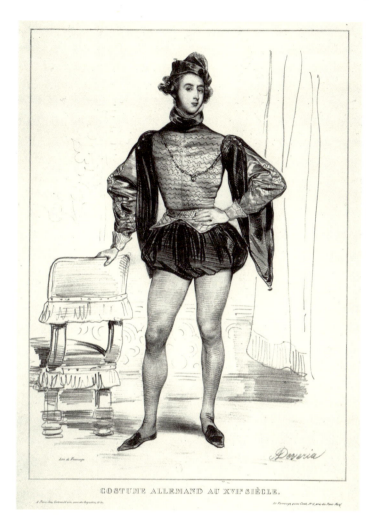

COSTUME ALLEMAND AU XVIᵉ SIÈCLE.

Figure 4.5
Achille Devéria, *Alfred de Musset in sixteenth-century German costume*, 1830.

ments dessinés d'après nature par A. Devéria (*Historic Costumes for Fancy Dress Drawn from Nature by A. Devéria*, 1831–39) documents period costumes worn by famous performers on stage or by the artist's familiars at masquerade parties.[42] For example, Devéria depicted the costume of a sixteenth-century German courtier (Fig. 4.5) worn by Alfred de Musset to a masked ball held by either Alexandre Dumas or Devéria himself.[43] We are given no information about who created these outfits "drawn from nature." Rather than records of signature creations, the plates capture the fashionable taste of the time, memorable public events, or the choices of prominent individuals.

Another principal source of clothing design featured in early-nineteenth-century fashion plates is the artist's own imagination. In fact, many fashion prints should be considered fashion designs (rather than illustrations) because the depicted attire is invented by the artist. As I recount in chapter 5, Gavarni generated costume ideas for the theatre and carnival as well as for prints of historical and regional types. It is likely that Devéria did some inventing as well. Would he have had a hand in creating Musset's courtier costume or the toilettes in *Les Heures*?

Painters were known as specialists in historical costume, since their subject matter often required research into authentic period details and their studios were laden with exotic props and garments. This expertise often led to sartorial innovation, especially in periods when new fashions drew upon historical precedents and allusions. In the 1780s, the painter Elisabeth Vigée-LeBrun participated in fashioning the informal neo-classical garb adopted by Queen Marie-Antoinette and her circle; styles LeBrun tried out in the portrait studio found their way into the fashions of the court and the street.[44] Likewise, Jacques-Louis David's knowledge of classical visual culture was transferred from history painting into both theatrical costume and everyday costume for republican citizens; the Jacobins pronounced him the "couturier of the Revolution."[45]

The late 1820s was another of these moments when artists inspired new directions in fashion. Writers and painters from Devéria's circle made sensational public appearances in theatrical costumes, which they wore not only to fancy-dress parties but also about town. These artists performed their difference from bourgeois modernity by pilfering and transforming historical styles for daily wear.[46] Many commentators point to the spectacle of Victor Hugo's supporters at the premiere of *Hernani* in 1830: "wild whimsical characters, bearded, long-haired, dressed in every fashion except the reigning one, in pea-jackets, Spanish cloaks, in waistcoats à la Robespierre, in Henry III bonnets, carrying on their heads and backs pieces of clothing from every century and clime, and this in the middle of Paris in broad daylight."[47] The appearance of Théophile Gautier with his long hair and scarlet doublet is perhaps the most legendary.[48] Achille's younger brother Eugène Devéria (1805–65) also captured attention with the exotic severity of his look, replete with floppy felt hat, oversize Castilian coat, and devilish forked beard.[49] It was as if these brooding characters had stepped out of history paintings, Gothic novels, and costume plates to walk the streets of Paris.

Soon the *goût môyen age* spread from romantic art and artists to the general public, albeit in less declarative and extreme forms. Medieval allusions marked everything from street fashions to cosmetics, architecture, interior decor, and the design of products such as books and jewellry.[50] One can already detect its traces

in the puff sleeves, neck ruffs, jewel-encrusted belts, and devotional objects featured in *Les Heures du jour*. It is no coincidence that Devéria's album was one of the first fashion publications in which this style was articulated. For the artist and his sitters belonged to the romantic cohort that transformed the *goût môyen age* into the *goût nouveau*. Although aristocratic ladies continued to inspire fashions throughout the Restoration, writers and painters were emerging as a powerful alternative epicentre of trendsetting influence and taste arbitration.[51] By 1833, the *Journal des tailleurs* could declare: "These days, it is artists who set the tone for society."[52]

With their knowledge of historical costume, imaginative dexterity, and fearless sense of the performative, artists were well equipped to create new fashions and produce fashion sketches without the aid of other models. Illustrators were occasionally hired to represent attire created by other artisans, but they also propagated their own creations and ideas, through prints and periodicals or in the form of costumes designed for theatre productions and masked balls.

I presume that Devéria drew the toilettes in *Les Heures du jour* partly from nature and partly from his imagination. We have no record of any transactions with dressmakers or draftsmen, and such exchanges were not common in this period.[53] The women Devéria used as models were sophisticated individuals, who would plausibly arrive at his studio or social gatherings outfitted in some inspired and modish attire for the artist to draw from. It is also plausible that Devéria invented or elaborated upon the ensembles worn by his female friends, who were the protagonists of his series *Les Heures du jour* (1829) and *Le Goût nouveau* (1831). Likely, there was a combination of description and invention as the artist observed the various styles worn by his fashionable portrait sitters, and then embellished certain details with an eye to creating a pleasing composition and a plausible temporal narrative. I imagine he would also seek some female advice and consult a variety of publications in order to fathom the etiquette surrounding what types of attire and activities were appropriate for each time of day.

Private Life, Bourgeois Femininity

When *Les Heures du jour* was produced, the coordinates of private life and bourgeois domesticity were being redefined. A new domestic setting would be created as the family dwelling was physically separated from the shop, the place of business, and the dwellings of extended family and neighbours.[54] Middle-class husbands and fathers carried on the activities of economic production in the public realm, leaving their wives in charge of an increasingly demarcated private domain.

As of the 1820s, it would no longer be thought appropriate for middle-class wives and daughters to engage in paid labour. Well-to-do women gradually exited family enterprises and refocused their energies on household management, social reproduction, and self-cultivation. Their efforts would be invested not only in the domestic realm but in several new tasks of consumption. As Leora Auslander demonstrates, it was through the acquisition of luxury goods and artistic accomplishments (drawing, music) that bourgeois women would learn to "produce themselves as cultural objects" and to arrange a home that would "represent the family's social identity through goods."[55] She reminds us that these emergent consumer practices were not yet conceived as expressions of personal taste; rather, they were still tied to the group identity of family and class.[56]

As mistress of the household and the family's social life, bourgeois women would navigate a complex set of expectations and protocols. Sociability and private life were regulated by "the system of etiquette, the rules of 'Society' and of the 'Season.'"[57] "Each detail took on moral significance ... A woman's life was a language, a ritual, governed by a strict code."[58] How was one to learn these codes? In the 1820s there was a great surge of advice books, novels, and fashion discourses that outlined the new ideals and rituals of bourgeois life. There were many manuals of etiquette, such as Madame Gacon-Dufour's *Manuel complet de la maîtresse de maison, ou la parfait ménagère* (*Complete Manual for the Mistress of the House, or the Perfect Homemaker*, 1826), advising homemakers how to manage money, oversee servants, and orchestrate social occasions.[59] Considerable attention was devoted to the proper arrangement of the day, the year, and the life.[60]

Les Heures du jour shares certain territory with these handbooks, particularly in suggesting how an ideal day might be structured. As Devéria depicts it, the activities of a fashionable Parisienne continue around the clock. She starts her morning with a brisk ride (7 a.m.); prays (8 a.m.); reposes with a lithographic album (9 a.m.); takes a walk (10 a.m.); reads a novel (11 a.m.); attends to her correspondence (noon); surveys her reflection in a full-length mirror (1 p.m.); pays a social call (2 p.m.); strolls in a winter garden (3 p.m.); paints with watercolours (4 p.m.); plays the piano (7 p.m.); dresses for dinner (8 p.m.); sips tea at a formal reception (9 p.m.); attends the theatre (10 p.m.); changes into an evening gown (11 p.m.); presents herself at a ball, fan unfurled (midnight); takes a break from dancing, fan closed (4 a.m.); and, finally, falls asleep in her party clothes (5 a.m.). She'll have two hours to recharge before that morning ride.

In contrast to contemporary manuals of etiquette, Devéria has purged all domestic duties, such as the supervision of household finances, servants, and children. Instead he foregrounds the leisurely aspects of a woman's schedule: rituals

involving social calls, entertainments, and artistic accomplishments. He privileges acts of leisure and consumption over work or management of any kind. Partly this is a function of genre, for a bias toward elegance, pastimes, and luxury goods suits the language and audience of the fashion plate. But it also signals particular class aspirations.

The manners depicted by Devéria suggest a transitional moment in the reorganization of social elites and sumptuary practices. In the words of one commentator, the 1820s was a "decade caught between a nostalgic attitude toward bygone elegance and a consumer consciousness of modern fashion."[61] The rituals of middle-class femininity were still forming in the first decades of the nineteenth century, and they were cobbled together by mixing aristocratic precedents with new domestic and commercial coordinates. Devéria's album indicates some of these mixed, emergent horizons. Following the aristocratic model, we see no evidence of housework or responsibilities beyond social obligations. Yet bourgeois values are evident in the stress on constant activity, lack of idleness, and the active acquisition of culture through private pursuits and educational consumer experiences largely removed from the public sphere.

A subtle shift in emphasis can be seen when one compares *Les Heures to jour* to an earlier fashion publication that also followed a lady through the course of her day. Consider a prose profile featured in the *Journal des dames* in 1817: the journalist describes how a lovely young lady plays the harp, receives the milliner, then lies on the couch and pretends to read, all the while hoping to capture the attention of the male writer-voyeur. The maid brings her a letter and she pens a response, then she moves to the embroidery frame to work on a handkerchief pattern from the *Petit almanach des dames*. The reporter then follows behind as she sets out in a carriage, making stops at the Champs Elysée, the Tuileries, Tortonis café, and the Boulevard de Gand.[62]

Devéria's approach differs significantly in tone and perspective from this account of a woman's schedule. His visual depiction provides a finer grain of information about clothing, hairstyles, furnishings, decor, and the temporal structure of the day. More significantly, Devéria chooses to remove the loaded social interactions – with clothes makers, servants, and the journalistic observer – that were so central to the earlier verbal account. He downplays the flirtatious tension between the female model and her male observer. And he sidesteps the commercial dynamics as well. Unlike his predecessor, Devéria does not describe publications the lady subscribed to or local businesses she frequented. While specific streets and shops were central to the 1817 account, Devéria keeps his ladies well away from carriages, boulevards, boutiques, cafés, and other public venues.

Devéria's plates feature a series of refined interiors that provide no orienting views of the city beyond. Instead we glimpse equivalent realms of quarantined respectability distinguished only by the ritual movements of the proper ladies who frequent them. Devéria's models are "at home" in roughly a third of the plates. In another third they visit the dwellings of relatives and acquaintances. As was customary for the time, these visits include routine social calls (women of good society received guests at home one afternoon per week) and evening gatherings in private residences featuring late suppers, music, and dancing.[63] That leaves a third tranche in which Devéria's ladies venture beyond domestic interiors for the sake of exercise or entertainment.

There are three outdoor scenes in which Devéria's Parisiennes promenade in areas of cultivated nature framed by stone balustrades, iron railings, paving stones, and gridded windows. Each suggests a domestic threshold or extension of the interior and provides an enclosing horizon (generally at hip level) that echoes the decorative backdrops of the indoor scenes. Only two plates could conceivably take place in town. The first is a scene of worship in what appears to be a private chapel, with stain-glass and Gothic arches visible beyond the shelter of a low wall. The second is an outing to the theatre, where our lady views the spectacle from an enclosed box. This was a unique area of the theatre where lady subscribers could receive friends with the same social etiquette that pertained at home. It was considered a decorous private space within an otherwise exposed public realm, an "isolated, protected world unto itself, a home transplanted to the theatre."[64]

Thus, all the hours of this proper lady's day are situated in private domestic spaces or in properly sequestered spaces of the public realm. Indeed, we are given a survey of the bounded, private spaces of bourgeois femininity, which prefigures those pictured by female impressionists such as Berthe Morisot.[65] From our perspective in the twenty-first century, the Restoration ladies depicted by Devéria seem piteously solitary, cut off from the satisfactions of work, motherhood, neighbourly solidarity, and urban adventure. But we would do well to remember that in 1829 this isolation would signal privilege. It would be a mark of social success for wives and daughters to be spared the intrusions of the workshop, the family business, and the village, a sign of the bourgeois elite's inclusion in rituals and pretensions once restricted to the noble elite. Still, it is worth noting that women's rights experienced a setback during the Restoration: an era of royalist reaction, Catholic revival, and social conservatism. Well-to-do women had considerably less freedom and legal protection, as well as diminished public roles and urban itineraries, than under previous regimes.[66]

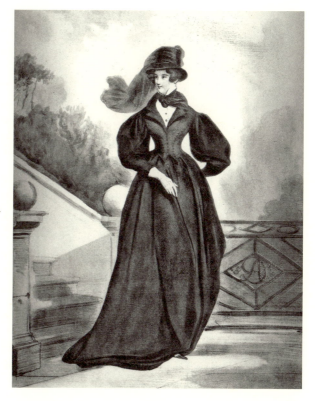

Figure 4.6
Achille Devéria, *7 o'clock in the morning* [portrait of Mademoiselle de Nisdal], 1829.

The Devéria Home

Adding an unusual twist to this typical picture of private life, Devéria hints that the domestic world depicted is his own. Consider the first plate in the series (Fig. 4.6) depicting Mademoiselle de Nisdal outfitted *en amazone*, looking as if she has descended the steps of her home in preparation for a morning ride. One sees a vast green space beyond a stately stone staircase and adjacent metal railing, which is decorated with the intertwined letters A D. These are the artist's initials, wrought in iron with the same curving signature inscribed on the edge of his drawings and lithographic plates. By embedding his recognizable monogram within this scene, Devéria has transformed the album's first fashion plate into a frontispiece of sorts, and he appears to riff on the concept in a punning way. Devéria inserts his signature as a graphic feature in the prefatory space where one might find an author's

portrait at the beginning of a book. Perhaps Devéria also underlined an etymo-logical connection, for *frontispice* was also an architectural term for the decorative facade of a building.

Can we propose that the placement of the artist's initials on this facade indicates that this first scene, or the whole series, takes place at the artist's own Paris home? The park-like setting might seem overly grand for the urban home of an artist. However, the portrayal is consistent with descriptions of the Devéria residence at number 45, rue Neuve-Notre-Dame des Champs.[67] Visitors to the house remarked on its bucolic charm: one arrived by a long path covered with vines through a yard dense with fruit trees.[68] The street boasted a number of venerable old *hôtels parti-culiers* with orchards and deep gardens adjoining the Luxembourg and the convent Chartreux de Paris. Champin depicted the verdant approach to the eighteenth-cen-tury house down the street at number 11, where Victor and Adèle Hugo resided from April 1827 to May 1830.[69]

During these crucial formative years for romanticism, the neighbouring homes of the Devérias and Hugos hosted a regular congregation of painters, writers, mu-sicians, actors, and other companions.[70] Charles Blanc described the Devéria home as the "centre of romanticism, the headquarters of the new poets, the young artists and the *jeunes-France*. There one saw Emile Deschamps, Louis Boulanger, Eugène Delacroix, Alfred de Musset, Paul de Musset, Chenavard, Amaury Duval, Alexandre Dumas, Edgar Quinet, Charton, Larrey, Sainte-Beuve, Henriquel Dupont, Marie Dorval, Mélanie Waldor, Charles Nodier and his daughter, basically all those who have since made a name, a great name. Victor Hugo presided there; Liszt, still a child, made music there … Achille Devéria, the eldest, always with pencil in hand, exerted a great influence on the artists of the group."[71]

Yet another link to the artist's home is evident in the final scene of *Les Heures*: at *5 o'clock in the morning*, we find Annette Boulanger asleep in her party clothes (Fig. 4.7). The sofa she reposes on is one we know belonged in Devéria's studio in the family home. We see the very same canapé featured in a portrait of Alexandre Dumas drawn by Devéria in his studio in February 1829 (Fig. 4.8). Dumas recounted that Devéria instructed him to make himself comfortable on this seat and to imagine he was listening to something, so that his pose would not look effortful. Apparently, it took Devéria about an hour to complete the sketch on a lithographic stone, which he immediately sold to the publisher Ricourt for 100 francs.[72] Perhaps Devéria asked Annette to arrange herself unaffectedly on this same sofa. Or he could have transcribed the 5 a.m. scene "from nature," if Annette had sought out this seat as a place to rest in the midst of a soirée held at the artist's house. We know the

Figure 4.7
Achille Devéria, *5 o'clock in the morning* [portrait of Annette Boulanger], 1829.

Figure 4.8
Achille Devéria, *Portrait of Alexandre Dumas*, 1830.

Devérias hosted many late parties involving dancing, including a string of celebrated Sunday night "sauteries" in which all the romantic youth participated.[73]

Perhaps Devéria is marking his territory on these plates, adjusting the scenes in *Les Heures du jour* to begin and end in his own home. This framework creates a neat bookend effect and indicates a specific social and domestic setting for the exemplary manners outlined in the series. Devéria effectively positions his home at the generative centre of the album and of the leading fashions and ideas of the day. He was one of few artists who was in a position to do this: to create a highly personal, particular picture of his home and circle, and at the same time produce a representative picture of the significant modes, personages, and inner precincts of Parisian romanticism. This was one of the assets that Devéria traded on in selling his lithographic portraits, fashion sketches, and genre scenes to publishers. *Les Heures du jour* combined all three.

It is significant that the Devéria home was more than the private centre from which the public trajectories of men like Hugo, Delacroix, Dumas, and others were charted. This was a domestic setting that hosted the semi-public activities of painter's studio and fashionable literary salon. It was a place of work, of performance, association, and collaboration. New works were exposed here,[74] composed here, critiqued, debated, reworked, and promoted. It was a place of exchanges both intellectual and commercial, among creators, colleagues, patrons, critics, disciples, champions, claquers, followers, and friends. Among the most legendary hubs of Parisian romanticism in the Restoration were the family homes of the Devérias, the Hugos, and the Nodiers.

Visitors to these homes were avid to socialize, debate, theorize, hear new compositions, and network with the celebrated male creators assembled there. The ladies of these households also played a role in creating the enchanting and convivial settings that attracted company to these artists' reunions at the Arsenal and the rue Neuve-Notre-Dame des Champs. Commentators report that the presence of Adèle Hugo, Céleste Devéria, Laure Devéria, and Marie Nodier was a substantial draw for participants.[75] On Sunday evenings at the Arsenal, literary discussions were halted at 10 p.m., when Nodier's daughter Marie took to the piano, singing melodies, improvising poetic verses, and playing lively contredanses.[76] Often Adèle led the company in dance.[77] On winter evenings Laure Devéria (1813–38), otherwise noted for her "oriental beauty," played the piano and sang airs of her own composition.[78] It is clear that these women did not preside over the assembled society, intellectually or socially, nor did they broker political power in the way of old regime *salonnières*.[79] But the familial gatherings chez Nodier, Devéria, and Hugo provided an unusual opportunity for bourgeois wives and daughters to participate in a stimulating and worldly type of

elite sociability, a revived salon culture of sorts, diminished in political import and social centrality but nevertheless one of substantial cultural significance.

These romantic receptions can be seen as a waypoint between the old interior network of manly studios and "feminocentric" aristocratic salons that characterized the late eighteenth century[80] and the urban orientation of artistic life after mid-century, when male artists increasingly made their "home" in the streets, cafés, theatres, and brothels of Paris. In the Restoration and July Monarchy, men of talent would have the run of the studios, the street, and the gathering places of both the *monde* and the *demi-monde*, but most of their wives would not. Only the aristocratic ladies among their circle, like Louise and Cécile de Radepont, would be invited to the receptions of the wealthy and titled elite. Women of high rank belonged to the *monde*, though only to some of its gathering places. By contrast, bourgeois women of the late Restoration were only at home in their own homes, the homes of relatives and social equals, and in a few other urban locales deemed sufficiently respectable if one was in the right company. Devéria's depiction of these locales – the chapel, winter garden, and theatre box – is extremely restrictive. After 1830, fashion columns would place more emphasis on shopping as a leisurely pastime, and on urban destinations, including streets and shops, that were considered both proper and elegant for bourgeois women to frequent.[81] But it would take some time before fashion plates would feature such urban settings as often as domestic genre scenes.

It was a rare privilege for the wives and sisters of romantic artists to participate in domestic entertainments of such intense social caché and cultural import. Laure Devéria and Adèle Hugo were fortunate to have kin who headquartered their vibrant intellectual life in the family home. Their ability to participate also rested on their charm as hostesses and artistically inclined companions who could fill a home with music, dancing, lively conversation, and poetic spirit. And while the ladies of leading-edge artistic households may have had a slight advantage here, in the nineteenth century all middle-class women would be trained for this role, through instruction in the *arts d'agrément* or feminine "accomplishments."

Amateur Art

Artistic accomplishments were tailored for bourgeois women who were released from productive labour yet still expected to engage in some "polite and useful" activities, suitably differentiated from both working-class necessity and aristocratic idleness. By including scenes of painting, reading, writing, music, and riding, Devéria's album charts the key feminine "accomplishments" and indicates the

significance of these acculturating pastimes within the structure of everyday life. By learning to draw or play the piano, a young lady could improve herself, entertain guests, attract suitors, refine her taste, and spend her time appropriately. These pursuits joined health and household management as the mainstays of female education, which aimed to prepare young ladies primarily for marriage and childrearing.

Feminine accomplishments became fertile terrain for commercial development in the early nineteenth century. Diverse businesses catered to growing demand for art supplies, advice manuals, books, musical instruments, and courses of instruction in music or drawing. Ann Bermingham explains: "In the figure of the accomplished woman we see the formation of the middle-class feminine subject under consumer capitalism ... For her part, the accomplished woman's role was to *consume art in order to be exchanged as art*, and it was her very skills as a consumer – her taste and discrimination in choosing and displaying the commodities that would be an extension of her subjectivity – that in turn would determine how she was consumed."[82]

Most well-off women learned to draw and paint in watercolour, as depicted in Devéria's scene for *4 o'clock in the evening* (Fig. 4.9). Here Devéria portrays his sister Laure using watercolour to paint a floral motif observed from a vase of flowers positioned on a table before her. Her drawing board rests in her lap, her body is casually angled away from the worktable, and her feet rest on a pillow. She wears a protective apron, but the silk dress beneath is as glamorous and pristine as those worn for formal afternoon outings. Her bloated sleeves and lace cuffs forbid any possibility of intense, dirty work, but her chosen medium poses no such threat. Watercolours require no laborious preparation, create little mess, and are highly portable, so they were particularly well suited for a female amateur working at home in the parlour for brief intervals between other activities. We must assume the pursuit of flower painting is a pastime, one of many fashionable and respectable ways to fill the hours of an accomplished woman.[83]

Yet for some individuals flower painting could lead to possibilities beyond amateurism and the marriage market. Women were still excluded from the life-drawing classes, academic apprenticeships, and classical learning that provided the surest paths to achievement in history painting and other prestigious artistic careers. But some who were left to hone their talents in the marginal terrain of flower painting managed to emerge as serious exhibitors, botanical illustrators, and drawing mistresses.[84]

Laure Devéria was one of these women who nurtured artistic ambitions through flower painting. She had the advantage of being instructed in drawing and lithog-

Figure 4.9
Achille Devéria, *4 o'clock
in the evening* [portrait
of Laure Devéria], 1829.

raphy by her older brother Achille.[85] In the years before her premature death in 1838, Laure became a successful public exhibitor. Her flower paintings were shown at the Salons of 1836, 1837, and 1838. The Musée du Louvre acquired three of her works on paper – Camarillis, Datura, and Tulip (Fig. 4.10) – and the Muséum national d'Histoire Naturelle owns several of her flower studies.[86]

None of this professionalism is evident in Achille's portrait of Laure for *4 heures du soir*. Granted, in 1829 Laure was only sixteen and had not yet shown at the Salon. In the fashion plate Achille presents his sister as an accomplished amateur, not so much a serious producer of art but a skilful consumer and product of art. He has given Laure an intelligent expression, but she turns away from her work toward the viewer. Her decorous and self-conscious pose discounts her absorption in the act of painting, and distracts the viewer's attention from her art. Her status as an aesthetic object is emphasized by the repetition of voluptuous pink peonies, which are

Figure 4.10
Laure Devéria, *Tulip
flowers*, c. 1830.

arranged in the vase, composed in her unfinished drawing and, tellingly, nestled in
her intricately woven hair. Clearly, she is arranged to be looked at and represented
as much as she is intent on studying the object in front of her. This type of blatant
self-display is a key aspect of feminine accomplishments, which effectively stage a
woman's absorption in culture for the visual pleasure of her suiters, whose looks of
longing or assessment could be decently masked as aesthetic appreciation of her
art.[87] Similarly, this fashion plate stages Laure's absorption in culture for the pleasure
and instruction of the album's consumers, and the reality of her submission to this
proscribed role can be decently masked through an aesthetic appreciation of her
fashionable attire or her brother's art.

Devéria Siblings, Artistic Sociology

There were in fact three talented artists in the Devéria family. Their different career paths make for a fascinating case study of artistic sociology, for one can survey a spectrum of professional opportunities and social limitations that affected their lives and approaches to art. It is as if the divergent trajectories of these siblings were calculated to demonstrate a triangular landscape between amateurism, academic painting, and print publishing.

Laure's path held close to amateur art and the minor genre of flower painting, as was suitable for an unmarried daughter in a bourgeois household. She did have unusual access to training, feedback, and art-world exposure through her social proximity to professional artists. She also had uncommon opportunities to collaborate with her brothers, and encouragement to exhibit her work within the official and public context of the Salon.

Eugène Devéria was groomed for success as an academic history painter. He was mostly trained by Achille, after brief study under the direction of Girodet and Guillaume Guillon-Lethière. In his student days, Eugène distinguished himself through his social connections and distinctive appearance as well as his talent. He shared a studio with Louis Boulanger, a close friend and painter who also studied under Achille.[88] While Eugène's first attempts to garner academic recognition were unsuccessful, he leapt into the spotlight when his history painting *La Naissance de Henri IV* made a sensation at the Salon of 1827. The work received official honours, a state purchase, and resounding critical acclaim. It was the most talked about work in the exhibition, eclipsing even Delacroix's *Sardanapalus*.[89]

Achille's path was largely determined by his role as provider for the family. After 1828 he was the sole wage-earner for a household that included his widowed mother (Anne Marie François-Chaumont), two sisters (Desirée and Laure), and Eugène. He would also have a young wife to support after his marriage to Céleste Motte, daughter of publisher Charles Motte, on 6 July 1829. Achille was able to earn a substantial income making prints, including portraits, book illustrations, costume and fashion plates, genre scenes, and erotic pictures. He could produce a lithographic portrait in an hour and sell it to a publisher for 100 francs.

Many of Achille's friends and supporters reported that he was forced by circumstance to pursue printmaking and sacrifice his talent as a painter. Adèle Hugo claimed that Achille knew very well he was superior to this commerce in lithographs, but he consoled himself with the knowledge that what he lost in reputation his mother and sisters gained in well-being.[90] Alexandre Dumas characterized Achille as a "poor great artist, caged to his desk."[91] Charles Blanc echoed the sentiment:

"By an admirable sacrifice, Achille Devéria resolved to efface himself in order to let his brother Eugène appear in the foreground, and abandoning painting for lithography he applied himself to producing, with a fecundity bordering on the prodigious, those innumerable compositions that subtracted from his glory all that they added to his well-being."[92]

Achille's career choices were considered lamentable for a number of reasons. First, Achille's remunerative pursuit of lithography contrasted starkly with the criteria celebrated by his peers and proponents of romanticism. As Blanc described, it was an epoch of "noble aspirations, hopes for glory, enthusiasm for the beauty of expression and of sentiment, [and] ardent love for liberty in all things ... We were totally inflamed by those un-useful things, that are therefore so necessary in the life of a people: poetry, grace, the ideal!"[93] Achille was pitied and admired by his romantic peers because he chose to befriend the useful, leaving his brother free to seek the beautiful and the true. In other words, Achille worked like a bourgeois so that Eugène could be a real artist.[94]

Second, Achille's decision to put Eugène first gained a tragic dimension with the lack-lustre development of Eugène's career. After his shining success at the Salon of 1827, Eugène faded out, to the great and public disappointment of those around him. He would be remembered as the painter of a single glorious tableau.[95] Naturally this added a dramatic twist to the story of the two brothers. Even Eugène saw it this way: he had failed to deliver despite the fact that Achille "immolated his painterly talent in order to earn our daily bread, concentrating all his dreams of glory on the young brother whose artistic education he undertook and to whom he gave everything he could possibly give."[96]

These onlookers narrate Achille's career as if he were the suffering hero of a sentimental novel: torn between individual vocation and familial duty, artistic ideals and economic realities. The story arc is compelling because it invites popular tropes (duty, sacrifice) and it implies that art and economic necessity, painting (noble, pure, transcendent) and lithography (mercenary, practical, bourgeois), are clear choices or binary categories. Biographical particulars are neatly transformed into sociological abstraction, and larger complex historical conditions and social conflicts are reduced to appear like individual choices.

Frankly, it is hard to separate historical circumstance from legend when it comes to the careers of Eugène and Achille. Partly this is because their story lends itself so well to literary elaboration and an over-simple mapping of "choices" in the artistic field. But it is also due to the fact that their stories are so inextricable. One reads about Achille's life mostly in accounts dedicated to Eugène or to Victor Hugo. And to make things more complicated, the siblings' works are deeply intertwined.

Figure 4.11 Achille Devéria, *Portrait of Henri Herz*, 1832.

Achille made significant contributions to the composition of Eugène's one masterpiece, *La Naissance de Henri IV*, including preparatory drawings, oil sketches, and ongoing counsel as the work developed. Eugène insisted that "it was *our* painting, even if it carried my name alone."[97] Apparently, it was a collaborative effort: "Achille was the head, I was the hands. We lived the same thoughts, the same œuvres, all for the same goal, the good of all."[98] Eugène's choice of words (head and hands) hints that Achille may have contributed the greater part, the conceptual part, of the design. Furthermore, Achille made the widely admired reproductive engraving through which the painting was known by a broader audience.

There are many other examples of collaboration among the Devéria siblings. Some works are signed by both brothers[99] and others appear to be variations of a work in common. Consider, for example, two related portraits of pianist Henri Herz made by the brothers in 1832: a full-length portrait in watercolour by Eugène and a half-length lithographic portrait by Achille.[100] Achille's composition (Fig. 4.11) is typical of his vignette-style portraits of contemporaries: the seated musician is

pictured from the waist up, with heightened visual attention centered on the face. Achille describes the head and facial features in self-effacing marks that provide a fine grain of detail, shading, spatial information, and illusionism. The sitter's upper torso exhibits a looser handling (visible hatch-marks, less suggestion of depth) and the lower body is barely roughed in with simple greasy contours that trail off into the white page.

It seems that Eugène built upon his brother's composition, essentially repeating the portrait bust and developing surroundings for it (Fig. 4.12). He repositions the left hand, fleshes out the lower body, providing a chair and floorboards to support it, and constructs an interior setting replete with a grand piano and wall decoration. Apparently, Eugène transformed Achille's portrait of Herz to suit a different image type and context of display. Many of the features added by Eugène – from the ac-curately transcribed musical score to the specific musical instrument depicted – are ones that William Kloss and Charles Timbrell have shown to be strategically chosen to serve an advertising function: Eugène's portrait promotes Herz and his achieve-ments as a composer and a businessman whose firm manufactured pianos.[101]

Laure also collaborated with her brothers. Eugène painted a watercolour portrait of Laure for which she created a flower border; the work was shown at the Salon of 1833 (Fig. 4.13).[102] She collaborated with Achille on suites of lithographs featuring female national types paired with flower species; likely, she did the hand-colouring and designed the flowers. One suspects that in many cases her contributions were not attributed. At the Bibliothèque nationale de France (BN), Cabinet des Estampes, there are three large folios attributed to Laure Devéria; all are heterogeneous col-lections that mix Laure's work with that of her brothers.[103] Among these is a bound *Album of Flowers Painted and Lithographed by Laure Devéria*, which includes Laure's pencil drawings, watercolour paintings, and lithographs of flowers alongside por-traits of Laure by Achille and lithographs by Achille that are hand-coloured by Laure.[104] It is remarkable that the curator of these folios did not see the need to dis-tinguish between works that Laure Devéria authored and works that feature her likeness. Even more so when we note that Achille must have been the album maker and curator responsible for putting together these collections of his sister's work.

Achille was *conservateur* at this institution from 1848 to 1857.[105] It was his bias that ensured that even minor works by his siblings, pupils, and friends would be preserved. Over his lifetime Achille amassed an enormous personal collection of prints – both works of his own time and eighteenth-century engravings – which he and his heirs passed on to the Cabinet des Estampes. He was responsible for orga-nizing the output of his contemporaries and predecessors at the BN in categories

Figure 4.12
Eugène Devéria, *Portrait of Henri Herz*, 1832.

Figure 4.13
Eugène and Laure Devéria, *Portrait of Laure Devéria*, Salon of 1833.

that are still used today. He also provided a layer of archival information that other conservators may not have known or found relevant. Achille made marginal notations on the borders and versos of various prints; for example, on the back of one version of *Les Heures*, he pencilled in the names of the individual women who modelled for him. Surely, it was Achille who indicated where Laure contributed to borders or hand-colouring on works contained in the folios at the BN, when normally the artists who performed these less important functions were not mentioned at all.

The Devéria siblings obviously worked closely together, learned from each other, and pooled their resources. Some of their projects were signed by all. Some carried only one name but contained obvious traces of the others. Sometimes (as with the Herz project) they transformed materials at their collective disposal. The Devérias continued aspects of the traditional studio model, with many hands working together to build upon existing repertoire and create new works. Given these conditions, it does not make sense to declare that one copied the other, or to assert that the siblings represent distinct polarized positions in the cultural field: the academic painter, the commercial printmaker, the amateur flower painter. In practice, it was so much messier and more interesting than that.

Laure is mostly remembered in accounts of her brothers' lives and work. Owing to his one legendary tableau, Eugène earned academic recognition, was briefly celebrated, and entered the historical record as "one of the grand names of romanticism."[106] By contrast, Achille is remembered as a "witness of Parisian romanticism."[107] It is chiefly through Achille's lithographic portraits that one can see the young visages that belonged to the grand names of romanticism. But he also ensured that we can still see the less celebrated female members, supporters, and intimates of their circle. In the end, it was Achille's work as chronicler of manners and conservator of prints that ensured the place of these lesser notables (his sister and other female friends among them) in the historical record.

Portraits

Devéria's images of his female friends draw upon both the visual forms and historical functions of women's amateur art. The scholarship of Anne Higonnet has illuminated the relevant traditions of feminine visual culture and the crucial transformations they underwent in Devéria's time. In the late eighteenth and early nineteenth century, most well-to-do women were amateur picture makers. Typically, they drew self-portraits, images of friends and relatives, scenes of everyday domestic

life, holidays, and family outings. Around 1830, commercial prints, periodicals, and albums started to replace these forms of self-expression; as well as making their own pictures, women began to purchase, collect, and arrange a growing array of ready-made images. The result was a crucial shift in women's relationship to visual culture: they were transformed from producers to consumers of images, and many of the images they consumed represented woman-as-image.[108]

An artist like Devéria, who made his living churning out domestic and sentimental genre scenes, fashion plates, and lithographic portraits, was a significant contributor to this shift. His print-making practice essentially reproduced and colonized the subjects of female amateur imagery. Less visible perhaps, and all the more fascinating, is that Devéria's work on *Les Heures du jour* also reproduces the social context of female amateur production. For this album of fashion assembles portraits of the artist's friends and family that were sketched in the intimate environment of his own home. Of course, he went on to find commercial outlets for these sketches, but it is worth recalling that Achille's fashion portraits were produced within the same private milieu of familial bonds and domestic sociability that shaped the work of women amateurs.

Les Heures du jour includes three images of the artist's sister, Laure: painting at 4 p.m., sipping tea at 9 p.m., and resting at 4 a.m. Additionally, there are five plates featuring his wife, Céleste, most of them intimate scenes: praying at 8 a.m., writing letters at noon, promenading under a parasol at 3 p.m., and twice at her toilette, dressing for dinner at 8 and for the ball at 11 p.m. Alongside these are three portraits of Annette Boulanger, who was Achille's pupil and practically a member of the household; she lived with her brother Louis who shared a studio with Eugène. It is Annette who browses the album at 9 a.m. (Fig. 4.1), displays her beautiful fan at midnight, and passes out at 5 a.m. (Fig. 4.7). Along with the image of Marie Mennessier-Nodier at the theatre, Mademoiselle de Nisdal *en amazone*, and Madame Gide at the piano, *Les Heures* also contains portraits of Louise and Cécile de Radepont, Clémence Peyron, and Madame Neuhaus. The series features the spouses, sisters, daughters, and friends of the group that gathered around the Devérias, the Hugos, and the Nodiers during the Restoration. The most surprising omission here is Adèle Hugo, who was not only married to the group's charismatic leader but a close friend, and a dedicated amateur picture maker.[109] Perhaps Achille had diplomatic reasons for excluding her, either in deference to the Hugos' wishes to keep this mother of three out of the public eye, or perhaps to shore up the centrality of his own wife and sister. Perhaps he downplays the magnetism of the Hugos in order to assert the prominence of his own household in the formation of this social milieu.

Figure 4.14 Achille Devéria, *Portrait of Victor Hugo*, 1829.

Devéria made pictures of women he knew and loved, from the intimate perspective of a participant-observer familiar with their daily rounds, self-cultivating rituals, social gatherings, and quieter moments of domestic life. Incidentally, he made these particular images of his family and circle in the year of his marriage to Céleste. Thus, in *Les Heures*, Devéria chronicled a pivotal phase of life – the time of engagement, marriage, and the establishment of a shared home – that was often represented in the pictures and albums of women amateurs as well. Higonnet notes that spurts of active picture making often coincided with these transitional phases when individuals redefined themselves and their social role.[110]

Les Heures du jour can be thought of as a domestic pendant to Achille's more public, much admired graphic portraits of artistic celebrities. He produced lithographic sketches of many of the talented creators in his circle, who were beginning to make names for themselves through published works, theatrical productions, and exhibitions. Among the famous portraits Achille produced in 1829 are likenesses of Victor Hugo (Fig. 4.14), Alexandre Dumas (Fig. 4.8), and Camille Roqueplan. He would also depict Lemercier, Grandsagne, Lamartine (1830), Chateaubriand, de Vigny (1831), Liszt, and Juliette and Judith Grisi of the Theatre des Italiens (1833). These portraits amounted to a pantheon of romanticism that traded on the recognizable status and artistic potency of the individuals portrayed. Achille's friendship with the sitters made it easy to produce their likenesses, by inviting them to his studio or simply taking up a pencil or lithographic crayon during social gatherings.

Most of these celebrity portraits were done in the centrifugal vignette style, with in-depth focus on the head and shoulders fading out to languid contours and the blank page. In contrast to his sketches for *Les Heures du jour*, here Achille's attention is intensely concentrated on the face with little to no information about the figure, clothing, or setting. External signs of social or material status are downplayed. This approach brings out the sitter's individual traits and inner qualities such as intellect, poetic feeling, and charisma, which are more easily evoked than shown. Devéria does not let us see much of the physical body but he suggests a relaxed bodily comportment that brims with passion unhampered by strain or affectation. The ease evident in both the sitter's posture and Achille's handling suggests an effortless rapport and genuine affiliation between the two individuals.

In the same years when Devéria produced this gallery of heroic romantic creators, he prepared a fragmentary counter-image of their female relations in works like *Les Heures* and *Le Goût nouveau*. The context of production and medium were the same, only the means of representation and context of display were different. An album like *Les Heures du jour* surely traded on its image of fashion and everyday life, but how much did the element of portraiture contribute to the appeal of the

series? With the exception of a few actresses (the Grisis), the women of Devéria's circle posed for costume sketches, genre images, albums of flowers, and alphabet primers. Achille created all kinds of generic packages to frame his sketches of female friends. The fact that these portraits were consistently presented as fashion illustrations and genre images suggests that they were not marketable as portraits; in other words, they were not interesting as images of individual women but rather held value as images of typical women, or as typical images of women.

The prints of *Les Heures du jour* seem to hover at the infra-thin edge of artistic and commercial production, amateur and professional art. Achille's fashion plates were destined for commercial distribution in albums, folios, and ladies' magazines and yet they hold fast to the intimate perspectives and domestic contexts of women's amateur production. Achille's portraits of romantic celebrities draw the highest aesthetic praise of print connoisseurs – like Henri Béraldi, who insists that one should separate these first-rate artistic kernels from Devéria's otherwise disposable "commercial" output[111] – yet these superb, painterly portraits were among Devéria's most lucrative and widely distributed products. Perhaps more than any other of his works, *Les Heures du jour* – with its hybrid of portraiture, fashion sketch, and *scène de moeurs* – is poised to show the worn-down quality of that mythic razor edge, to reveal the senselessness of the fancied distinctions between the spiritual painter, the female amateur, and the mercenary professional printmaker.

Gavarni's Costumes

Masquerade and the Social Theatres of Paris

Although Gavarni is best known as a caricaturist and fashion illustrator, he was also a sought-after costume designer for Parisian theatre productions and carnival celebrations. In fact, he played a key role in the renovation of masked balls and masquerade costumes in the 1830s and 1840s. His costume work forged vital links between the theatre, print culture, and the social practices of ordinary Parisians. This was a time when Parisian artists and actresses became important public figures, prototypical media stars whose participation in urban life was increasingly performative and culturally authoritative. Several July Monarchy entrepreneurs explored how to leverage this artistic celebrity as a form of publicity.

Here two aspects of Gavarni's activity as a theatrical costumier are analyzed: his invention of the *débardeur*, a travestied stevedore costume, and his collaboration with Virginie Déjazet (1798–1875), an actress famous for racy cross-dressing roles. Gavarni's prints added significance to Déjazet's roles on stage, and Déjazet's performances were instrumental in popularizing Gavarni's *débardeur*. A revealing case of artistic cross-promotion, the history of this transgressive costume also indicates the expansion of gender roles and alternative lifestyles during the July Monarchy.

Masquerade was much more than a form of amusement in nineteenth-century Paris. Among other things, it was a means to understand and experience the shape-shifting potential of modern life. Several aspects of the new society taking shape in post-revolutionary France could be made legible through the vocabulary of carnival, travesty, and performance. Carnivalesque inversion and the well-worn image of the world as a stage were particularly resonant tropes in this era of upheaval, when traditional social hierarchies had been overturned and there was heightened

consciousness about the mutable nature of identity. Participants in the newly renovated social theatres of Paris – understood as both a historical and a metaphorical horizon – had much to gain by seeking out new scripts, roles, and interpretive guides. Gavarni and Déjazet were among the artists keen to adapt their services and try out for a part. They both became known as specialists in travesty, a word that in both French and English slides from clothing and disguise to grotesque imitation and perversion: its means include costume, caricature, pantomime, parody, farce, and the subversion of social norms.

This chapter begins with an introduction to the evolving attractions of the Paris Opera, including the new prominence of female performers, masked balls, and participatory experiences for theatre-goers. It then traces the development of Gavarni's expertise in costume design and his role in the revival of carnival balls in the 1830s and 1840s. The concluding section examines the *débardeur* costume and its migration from the artist's studio to the interconnected spaces of print, the stage, and social practice. Issues to be explored throughout include cross-platform mobility; the social work of travesty in revising gender, sexuality, and class; the blurring of distinctions between performers and spectators; and the passages between social representations and reality.

Venus at the Opera

The Paris Opera was among the capital's most significant spaces of leisure, entertainment, and social activity. People went not just to see the shows but to socialize, manoeuvre for position, and display themselves. In March 1831 the Opera was transformed from a state-sponsored institution to a private enterprise.[1] Under the entrepreneurial direction of Dr Louis Véron (1831–35), significant efforts were made to shore up the Opera's status as the capital's pre-eminent theatre. Véron keenly understood that ongoing relevance was not a matter of aesthetics but of increasing revenue and aggressive audience expansion, especially among the middle classes. He managed to treble the number of yearly subscriptions, wooing new patrons with innovative advertising campaigns and the promise of special privileges.[2] Alongside continued attention to production value, two important strategies helped to dilate the field of attractions at the Opera: the foregrounding of female performers and the expansion of opportunities for audience participation.

A number of coordinated elements encouraged the Opera-goer's active social participation in the spectacle. For starters, audience members partook of the scene by watching other members of the public and displaying themselves to advantage.

The salle Le Peletier, which housed the Opera from 1821 to 1872, was suitably designed to foster these dynamics. Over half of the 1,800 places were situated in the loges: private boxes and shallow balcony seating ringing five upper levels of the auditorium.[3] These seats were the quintessential platform for unobstructed viewing, and they also facilitated movement during the performance, so that subscribers could visit other boxes or make an appearance before slipping off to other engagements. Furthermore, because the auditorium remained brightly lit throughout the production, the audience was incorporated in a visual field continuous with the stage.

Véron also endeavoured to include backstage areas in the experiential package on offer, despite the fact that many of the studios and dressing rooms were only provisionally connected to the main theatre by a series of corridors and alleyways, the *passages de l'Opéra*.[4] Subscribers were invited to enter these backstage warrens, which the management transformed into an exclusive and elegant club. At its heart was the *foyer de la danse*, ostensibly a rehearsal space but in practice an arena for male subscribers to view and pay court to female dancers. By encouraging wealthy men to become "protectors" and seducers of the dancers, Véron profited doubly: he attracted more subscribers while reducing the wages of his dancers, whose meagre earnings were now supplemented by gifts and allowances from male benefactors.[5] Similar backstage privileges were extended to journalists, critics, artists, and publishers, essentially anyone whose reviews or editorial advertising could contribute to the success of dramatic productions.[6]

This interconnected web of cultural, commercial, and social interests was the subject of much commentary in the 1830s and 1840s, perhaps most famously in Honoré de Balzac's *Lost Illusions* (1837–43). Gavarni also took up this theme in many caricatures devoted to the theatre. In one of the sketches from "Les Coulisses" (The Corridors) (Fig. 5.1), Gavarni satirizes the triangular relations between a female performer, a male subscriber, and a journalist. Primping in her dressing room between scenes, a dancer makes a nominal effort to entertain and mollify her unattractive bourgeois protector. She must lead this Edouard to believe he is her only lover, for she depends upon his financial support to furnish the wardrobe, apartments, and entertainment budget necessary for building an artistic reputation. Edouard has made himself at home, apparently secure in his role as provider; she is making herself up at the mirror, paying him heed only to the extent that he is a necessary part of her self-image and professional aspirations. Gavarni's caption has the dancer reassure her portly suitor that her affections are not being shared with a certain "little journalist." Of course, the initiated viewer knows otherwise. One suspects either that the dancer is likewise courting (and misleading) a journalist in order to secure

Graphic Culture

Figure 5.1
Gavarni, *Me, ever having something with that little journalist! Oh, Edouard! No! I despise them too much*, 1838.

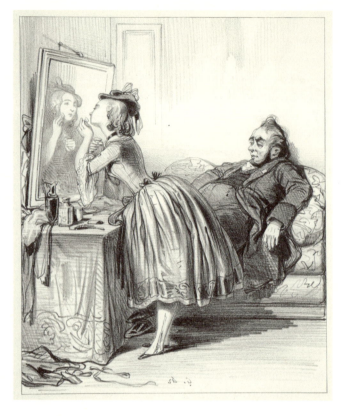

positive reviews and publicity for her current work on stage; or that the journalist is her real lover, a young writer who tolerates the dancer's mercenary seduction of the bourgeois for he must do the same professionally.[7]

Gavarni demonstrates how the interests of the public, the press, and the Opera management converged on the female performer, such that each was a stakeholder in her celebrity. Sketches like these offered more than amusement and clever social analysis; they would also extend an exclusive view of the backstage world to general readers. This was just one of the ways in which graphic artists and writers colluded in extending the field of interlocking attractions offered by Parisian theatres. Every representation of these spaces, actors, and social experiences would generate additional significance and publicity for the Opera.

Another key element in the participatory turn at the Opera in the 1830s was the popularization of winter balls held during the season of carnival festivities each year from Epiphany in early January through Lent. For these occasions, the whole

auditorium was transformed into a stage; planks were placed over the parterre seating to create a theatre in the round that accommodated both performers and spectators and eroded the distinctions between them. At the Opera balls there were both pageants and exhibition dances staged for the enjoyment of the attendees, and, increasingly, music and dancing in which everyone could take part. The Opera balls would become more popular and financially successful (in the late 1830s and early 1840s) to the degree that members of the public were invited to become costumed players, to merge with the professional performers, and to dance with relish and abandon.

Alongside diversified amusements, backstage access, and social mixing with the performers, the entrepreneurial Opera embraced a new woman-centred approach to choreography. Maribeth Clark has shown that Véron's's policies "reshaped the public perception of dance" by foregrounding female bodies and "prurient" interests at the Opera.[8] Dance segments were featured more prominently in the otherwise lyric opera productions, either as a divertissement within a five-act work or as new stand-alone entertainments that showcased the best dancers, popular songs, and spectacular elements extracted from longer productions. During this era the Paris Opera also boasted great innovations in music and stagecraft, with the arrival of composers such as Gioachino Rossini and Giacomo Meyerbeer, and the enchanting illusionistic decors of L.J.M. Daguerre and Pierre-Luc-Charles Cicéri.[9] John Tresch has written convincingly about the centrality of audio-visual effects, shared hallucinations, and techniques of sensory disorientation that characterized an emerging "opera of attractions" and created common ground between mass entertainments and exhibitions of popular science in the second quarter of the nineteenth century. He notes: "Audiences flocked to the opera for its opulent, abundant, and shockingly mobile sights and sounds, seeking surprise, thrills, and gratuitous pleasure. As much as plot and music, these attractions were the object of its creators' obsessions and the focus of its critical reception."[10]

Female bodies and shocking, beguiling forms of dance were effectively deployed within this new field of visceral pleasure, astonishment, and multi-sensory attraction. On the one hand, there were the impossibly graceful, gravity-defying performances of highly disciplined soloists like Marie Taglioni; on the other, a growing array of highly erotic and unconstrained dances such as the *bacchanale*, *contredanse*, *galop*, and *chahut* performed by lower-ranking dancers in the corps de ballet.[11] While the former required exceptional skill, control, and rigorous training, the latter deployed attractive bodies in a manner that maximized physical exposure and sensuality. One of the resounding successes of Véron's first season at the Opera was the

premiere of *Robert le Diable* (21 November 1831), a five-act lyric work so popular it was remounted some 750 times.[12] Critics found much to praise in the sonic innovations of Meyerbeer (including "a demon chorus placed beneath the stage and singing eerily through resonating tubes"), the incredible ghostly atmosphere created by Cicéri ("stunning set changes employing illusions of depth and colour inspired by Daguerre," flickering gaslight, "exploding fireballs"),[13] and the impossible grace of principal dancer Taglioni. The most riveting scene was in the third act when a balletic troupe of debauched nuns rose from their tombs, stripped off their religious habits to reveal near-nude figures, and broke into a deranged *bacchanale*.[14]

Female performers were also foregrounded in the accounts of contemporary novelists, dance critics, and caricaturists. In Balzac's *Lost Illusions* and Zola's *Nana*, Parisians attend the theatre or read the reviews in order to learn how the divas looked and moved, mostly disregarding how they sang or figured in a dramatic whole. Théophile Gautier celebrated the female dancer as both an artist and a work of art, whose ideal beauty was akin to classical sculpture.[15] Gustave Doré's *Opera (the lions' den)* (Fig. 5.2) portrays the lions of Paris fawning over a prima ballerina who has mastered the weightless point technique pioneered by Taglioni.[16] Inundated with bouquets, she plays directly to the impassioned occupants of the *loge infernale*, a private box directly abutting the stage reserved for Opera insiders and journalists such as Emile de Girardin, Balzac, and Dr Véron.[17] The dancer's voluptuous, hovering form – at once an erotic fact and an artistic feat – is admired in isolation from any surrounding narrative, musical, or scenic context.

While a few female stars attracted this type of reverent visual attention, which mixed sensual pleasure and aesthetic appreciation, the minor dancers attracted blatantly erotic attention. These dancers were officially called *marcheuses* and *figurantes* (walkers and posers) because they needed only to show themselves to form a decorative or titillating part of the scene. Unofficially, the dancers of the corps de ballet were called *rats* because they dwelled and multiplied in the Opera corridors, and their social position was that of a wily scavenger preyed upon by various male predators. The Opera management seized on the strategy of extracting the most carnal dances from lyric works to create new showcase productions or exhibition dances for the winter balls: this was the case with the frenzied, undead, and undressed nuns of *Robert le Diable* (1831) as well as the serpentine movements of Fanny Elssler's *cachucha* from *Diable boiteux* (1836).

The most tumultuous and unskilled forms of theatrical dance also migrated to the social dance enjoyed by everyone at the masked balls. Variations of the *quadrille*, *galop*, *chahut*, and *cachucha* were adopted by Parisian carnival revellers who had seen such performances on stage, and the flow between representational and par-

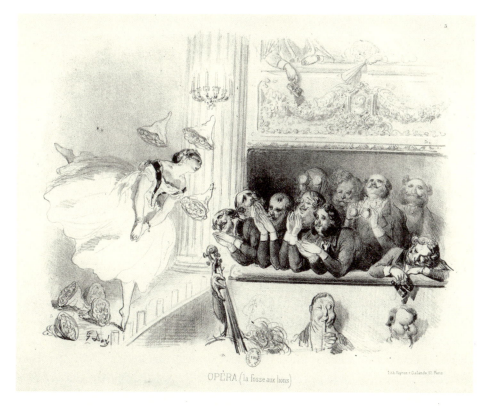

Figure 5.2 Gustave Doré, *Opera (the lions' den)*, 1854.

ticipatory dance went full circle. An interesting example of this movement between art and life was the production of *Gustave ou le bal masqué*, which premiered at the Opera in February 1833 in the midst of Carnival season. The fifth act featured an opulent ball scene with fantastic masquerade costumes, lively music, and a feverish final *galop*. The revelry onstage was based in part on real life, specifically, the unruly behaviour ordinary Parisians had exhibited at public carnival festivities in the city that year, including a recent incident at one of the Opera balls when a bored crowd had commandeered the floor, pushing aside the professional dancers of a ballet pantomime, and burst into an exultant *galop*.[18] That spontaneous communal outburst was represented onstage in the enormously popular fifth act of *Gustave ou le bal masque*, which, in turn, encouraged the public to even more excessive forms of social dance at the carnival balls that year. The masked ball became more closely identified with the Opera, theatrical and social dance were merged, and spectators were physically and experientially incorporated into the entertainments.

Theatrical Celebrity and Publicity

Female stars could draw considerable attention to particular masked balls and the-atre productions, or the urban events and works of art on which they were based. Their celebrity – magnified exponentially through press coverage – also provided social cachet and maximum visibility for the promotion of fashions in clothing. Valerie Steele has shown that designers and fabricators of women's fashions would look to theatre actresses both to discover new costume trends on which to pattern their designs, and to promote their own creations. Stage performers could serve as living mannequins to showcase new toilettes compellingly on the stage, while off-stage they functioned as significant "arbiters of elegance" whose choices were duly noted by the fashion press and its audiences.[19]

Already in the eighteenth century, the Opera's principal dancer, Marie-Madeleine Guimard (1743–1818), was being "assaulted by clothes merchants and tailors who begged her for her opinion on the latest English fashions … [She was] summoned by Marie Antoinette to give her opinion on the shape of the neckline and the height of the hair of the ladies-in-waiting."[20] After her famous appearance in *La Sylphide* (1832), Marie Taglioni became "a propagandist for mechanical corsets, and … a star of the fashion journals of her time … Taglioni's effect upon her audiences caused the creation of a new verb, *taglioniser* (to be 'sylph-like') … A Sylphide Turban was invented, as was the *coiffure à la Sylphide*, just as several generations earlier women wore the *robe à la Guimard*."[21] In some cases, journalists avidly recorded the way an actress's taste was reflected in other areas of consumption – including interior decor, books, and paintings – as evidenced by a tour of the actress Rachel's townhouse in a three-page feature in *L'Illustration* in 1853.[22]

By the mid-nineteenth century, merchants of all varieties displayed pictures of female theatrical stars in their shop windows, counting on the celebrity and taste-making power of these women to attract shoppers to their wares. As Lenard Berlanstein reports: "American novelist Henry James, a Paris correspondent for a New York newspaper in the 1870s, found such pictures [of theatrical stars] in 'every second window.' Most eyewitness accounts mentioned the images of female, rather than male, performers … During the 1867 Universal Exposition, there were reports about the ubiquitous portraits of the three reigning divas, the opera singer Adélina Patti; the operetta singer Hortense Schneider; and the cabaret singer, Thérésa. Shawls, fans, and other souvenirs of the great event were decorated with their faces. One stroller complained that during a casual walk down the Boulevards, he ran into no less than seventy-three images of La Patti."[23] These sources point to a range of ways the iconic power of female stars was attached to local businesses. Celebrity

portraits were used to endorse retailers, even when there was no actual or plausible connection between the individual star and the products being sold; businesses simply used the portraits as generic magnets of attention. In other cases, the names and likenesses of stars were attached to specific products (as in the sylphide garments) or the exemplary tastes of particular female performers were exploited as a form of guidance for clothes makers, fashion consumers, and the readers of women's magazines.

Though couturiers had long amplified their reputations by advertising links to the courts of Europe, by the late eighteenth century associations with actresses became more desirable. *Marchands de modes* found it prudent to disassociate themselves from the politically voluble aristocracy in favour of a "classless but highly gendered taste [that] ... would prove even more attractive to a broader spectrum of women."[24] Thus, Rose Bertin, Marie Antoinette's "first minister of modes," who had an impressive international roster of royal patrons, also counted actresses of the Comédie-Française among her notable clients.[25] And Charles-Frédéric Worth, whose "fame rested in large part on his status as couturier to the Empress Eugénie," lobbied for the exclusive privilege of dressing Sarah Bernhardt for all her performances.[26]

Queen Marie-Amélie regretfully registered this shift in 1831, noting that the appearance of royalty at the theatre had become a non-event: she lamented that the queens of the stage were now better received than the queen of the French.[27] In 1839 Delphine de Girardin explained this "democratization of fame" in her widely read fashion column *Lettres parisiennes*. She gave credit to a successfully transformed post-Revolutionary society led by people of talent – especially those who gain status through literature, art, politics or the theatre – alongside the power of the modern press to "bestow renown, consecrate virtue, impose genius and sell popularity."[28] In fact, the flow of ideas and trends was a multi-directional affair, with intellectuals, artists, quotidian publications, and urban entertainments among the important sources. The range of people who could become celebrities and cultural influencers was growing, and at the same time the spaces and techniques of publicity were expanding too.

Throughout the 1830s, the French fashion press became more commercialized, its discursive power harnessed to the interests of fashion businesses – shops, dressmakers, and manufacturers – and other cultural purveyors such as theatres, publishers, and picture dealers.[29] Hazel Hahn demonstrates that, by the 1840s, advertisements and promotional articles about consumer goods and retailers became the dominant content of fashion magazines; moreover, editorial advertising was prominent in all kinds of illustrated periodicals, from Aubert and Philipon's satirical

journals, to *L'Illustration*'s reporting on current events and Parisian establishments, to reviews of industrial products and decorative arts in mercantile publications like *L'Exposition, journal de l'industrie et des arts utiles*.[30] Print shops, art dealers, newspaper offices, and specific city streets were visualized and promoted in the same manner as books, artisanal *articles de Paris*, the latest industrial manufactures, the shops of perfumers and dressmakers, and department-store interiors. This was a pivotal era for the transformation of cultural production, publicity, shopping, urban diversions, and the grand boulevards; the press helped to foster each of these sectors and knit them together.

Gavarni's Costumes

Graphic artists had a key role to play in amplifying the cultural import of diverse Parisian attractions, and they leveraged the renown of other celebrities and urban experiences to launch their own products. Gavarni, Achille Devéria, Eugène Lami, and Henry Monnier produced numerous drawings and prints about Parisian theatre, including lithographic portraits of actors and actresses; sketches that chronicled particular dramatic performances, including presentation books, albums, gift books and keepsakes; illustrated stories of operas and ballets; and costume plates. Henry Monnier leapt wholeheartedly from illustrations of the theatre (portraits, costumes, caricatures, frontispieces to editions of plays) to performances of his own, ranging from amateur stand-up comedy at parties to dramatic roles at the Variétés and in popular vaudevilles.[31] Gavarni also had direct links to theatre productions and he made countless sketches of manners that featured actresses, costume, travesty, and performance among the most important constituents of Parisian modernity.

As a caricaturist, Gavarni devoted special attention to the characters and social exchanges that characterized the contemporary theatre. One need only review the titles of his series for *Le Charivari*, which published roughly 800 lithographs by Gavarni between 1837 and 1843: *Les Coulisses* (The Opera Corridors, 31 plates, 1838); *Les Actrices* (Actresses, 14 plates, 1839); *Les Artistes* (14 plates, 1838); *Le Carnaval* (27 plates, 1838); *Les Étudiants de Paris* (The Students of Paris, 60 plates, 1839); *Souvenirs du Bal Chicard* (Memories of the Chicard Ball, 20 plates, 1839–43); *Les Débardeurs* (66 plates, 1840); *Le Carnaval à Paris* (40 plates, 1841); and *Les Lorettes* (70 plates, 1841).[32] His contributions to the modish *physiologies* and panoramic anthologies similarly focus on the art world and a wide range of Parisian women, from Opera

dancers, *lorettes*, and *débardeurs* to political activists, prostitutes, duchesses, wet nurses, lovers, and the sellers of used clothing.[33] Fashion, the theatre, and masquerade were the mainstay of Gavarni's graphic satire, along with the mores and aspirations of artists, students, and women, in other words, the types of Parisians who had the most nuanced understanding of trends, travesty, and social performativity.

Gavarni was also directly involved in the staging and marketing of dramatic productions. In the late 1830s and 1840s he took part in the art direction at several Parisian theatres, principally as a designer of costumes. Among Gavarni's biographers, Paul-André Lemoisne provides the most detailed information on his costume work: "Gavarni often frequented the world of theatres: long connected with Déjazet, for whom he had designed costumes, he also saw: Levassor and Arnal, of whom he left two fine portraits; Anicet, the Taignys, Anaïs Fargueil, Laférière, Miss George … He spent the majority of his evenings in the wings and … began to sketch, to draw in watercolour above all, costumes, accessories … soon one could no longer stage a work at the Palais-Royal, the Vaudeville, the Porte-Saint-Martin, or the Renaissance, without this artist who, in a few sweeps of the brush, knew how to lend his originality to all."[34]

Lemoisne goes on to list several watercolour maquettes for particular performers and productions. He mentions costume designs by Gavarni for Virginie Déjazet's roles in *Marquise de Prétintailles* (1836), *L'Oiseau bleu* (1836), and *Indiana et Charlemagne* (1840); those for Mademoiselle George[35] in *Guerre des Servantes* (1837) and *Lucrèce Borgia* (1837); and others for *Peau d'Ane* (1838), *Dagobert* (1839), *Eau Merveilleuse* (1839), and *Zingaro* (1840). There were also several costumes individually requested by actors, and a commission from Balzac to invent costumes for *Vautrin*.[36] In addition, Gavarni was known to have furnished costumes (from his imagination and from his studio props) for Henry Monnier and his wife, Caroline, supporting the couple's appearances in vaudevilles and their tour of provincial theatres.[37] Other artists who tried their hand at creating costumes for the stage include Eugène Lami (pupil of Horace Vernet) and painter Louis Boulanger (pupil of Achille Devéria).[38]

Many of Gavarni's costume sketches survive and they demonstrate how the artist's ideas and instructions were communicated to the costume makers and performers who would try to materialize them. For the role of Paquerette in *Dagobert* (1839) (Fig. 5.3), Gavarni designed a dress of pink wool accented with raven-black fur and trailing sleeves of transparent muslin. Two in-set drawings with notes explain the intricacies of a headdress that incorporates three feathers and a veil in an orbit around the actress's ear. Marginal jottings describe how Mademoiselle

Mlle **CLARISSE**, rôle de Paquerette dans *Dagobert. Aquarelle.* 1839.

Figure 5.3 Gavarni, costume for *Mademoiselle Clarisse, role of Paquerette in Dagobert*, 1839.

Clarisse's hair should be plaited; Gavarni also stipulates that her legs should be bare underneath the dress, and that certain colours and materials of this outfit should be consistent with another costume for the same production ("the queen, no. 2").

Sometimes this work in theatrical costume design led to commissions for graphic art, as was the case with Aubert's *Musée de costumes* (1837–38). This lavish album of coloured plates included 106 lithographs by Gavarni depicting the principal actors of Paris posed according to the attitudes of contemporary dramatic roles; many wear costumes invented by Gavarni.[39] The work combines celebrity portraiture, costume plate, and theatrical souvenir. However, for the most part, the route of professional expertise flowed in the opposite direction, from graphic illustration (and print production) to the material production of costumes for the theatre and masked balls.

Gavarni's first significant entrée to the world of Parisian publishing was as a maker of fanciful costume plates. The artist received a substantial commission from Pierre Antoine La Mésangère, the publisher of several regional and historical costume collections and the landmark *Journal des dames et des modes*, which remained one of the most significant European fashion journals from 1797 through the 1820s.[40] As recounted by Annemarie Kleinert, La Mésangère didn't know what to do with the first set of costume illustrations sent to him by Gavarni in 1827 (Fig. 5.4). Although the publisher considered them beautiful and innovative, Gavarni's drawings were "too imprecise for a series devoted to national costumes and too specialized for his magazine," the *Journal des dames*. La Mésangère relayed that he had consulted with dressmakers and an engraver who agreed that the details, materials, and silhouettes in Gavarni's drawings were too inarticulate to be effectively "realized."[41] La Mésangère's criticisms are instructive (as much for the historian as for the artist) for they communicate clear expectations about the graphic information required of a clothing illustrator, and the different uses of costume and fashion plates. Apparently, more accurate details were required for images of historical or regional costumes, and improved delineation of cut and material was necessary to serve the practical aspects of fashion illustration, which included the material translations of both clothing manufacturers and engravers.

At best, the publisher mused, the imaginative qualities of Gavarni's images were such that they might provide useful inspiration for fancy dress and carnival disguises. Consequently, La Mésangère had twenty-two of the drawings engraved, hand-coloured, and published as a series of *Travestissemens* [sic] from 1827 to 1830. According to reports in the *Journal des dames*, the series was received extremely well, so well that it inspired the costumiers of the ballet *Clarisse* at the Théâtre Ambigu-Comique and found echoes in the dress of carnival revellers throughout the season.[42]

Figure 5.4
Gavarni, *Irish costume*, 1827.

Gavarni's success with this early series demonstrates that his earliest costume ideas (publicized through print) were immediately adopted by both theatre professionals and private individuals preparing their outfits for masked balls. Surely, this helped Gavarni to attract more costume commissions for the press and the stage, and contributed to his reputation as a costume innovator who would come to define the transgressive styles of modern carnival. Ongoing success lay in his ability to work across platforms and to magnify the importance of each by bridging the worlds of publishing, the theatre, and urban entertainments.

Nancy Olson reminds us that Gavarni had already begun engaging the theme of masquerade in 1826. His journal records grand ambitions to do away with the standard masked-ball costumes that had prevailed unchanged since the seventeenth century: the ubiquitous characters of Pierrot, Polichinelle, and Arlequin from the Comédie-Italienne. Gavarni dreamed of replacing these with new creations inspired

by Spanish, Basque, and antique French costumes.[43] He published a steady stream of such fancy-dress creations, beginning in 1827 with the *Travestissemens* and continuing on through the early 1840s. Gavarni's disguises tended to be related to traditional occupations (page, fisherman, farmer, shepherdess), regions (Basque peasant, Aragonais), or combinations of both (Scottish page, Spanish bargeman, Spanish constable). Several publications were devoted to his masquerade costumes, among them the *Nouveaux Travestissements*, with seventy-eight plates by Gavarni (plus twelve by Achille Devéria), issued from 1830 to 1841.[44] Some of these plates are notable for dating the appearance of significant costume types (including the *débardeur* as early as 1830; see Fig. 5.6 and discussion below) and for the inclusion of captions detailing the constituent features that define each type and provide guidance for individuals who might try to recreate it. The instructive captions make these plates function more like costume *maquettes* for the stage as opposed to plates in fashion journals.

Gavarni continued to develop as a reputed specialist of masquerade, acting not only as a costume designer and satirist but as a host and consultant who was instrumental in re-envisioning carnival celebrations. He began to hold his own soirées on Saturday evenings, "first in his studio, in the rue Blanche between 1835 and 1838, and then for seven years in his famous apartment, rue Fontaine-Saint-Georges."[45] The inner circle that gathered in his rooms included Balzac, Théophile Gautier, Laurent Jan, Léon Gozlan, Eugène Sue, Roger de Beauvoir, Albéric Second, Comte d'Orsay, Henry Monnier, Gigoux, Traviès, Virginie Déjazet, Mademoiselle George, Anna Thillon, Prévost, Carlotta Grisi, and Madames Taigny, Grassot, Dorsy, and Fargueil. In other words, the group consisted of "his most brilliant comrades in the arts and letters … a few ladies who were required above all to be beautiful; women of letters, and several of the most celebrated actresses in Paris."[46]

As the Goncourt brothers would later describe it, Gavarni's apartment was "the studio, the shop, the taproom, and the antechamber of carnival."[47] Friends gathered there before carnival events to reap costume ideas and materials, and to imbibe and connect as a group before heading off together to the masked balls, which typically began at midnight and lasted until 5 a.m.[48] Beforehand the group drank, conversed, tried on disguises, and played parlour games, some of which showcased the dramatic specialties of the participants, for example, in charades, improvisations, and comic monologues by friends like Henry Monnier.[49] Inventiveness, irreverence, witty competition, and crossovers between caricature and social performance were the order of the day.

The group who gathered for Gavarni's soirées raided his horde of studio props and apparel, riffing on each other's ideas or letting the host have his way in styling

them. Gavarni's masquerade inventions became legendary, but we should note that other graphic artists generated costume ideas that were among the most storied from this era. For instance, Gustave Doré draped himself with plants and glued insects to his nose to appear as "the countryside after the rain."[50] Arriving at a masked ball in an ordinary black suit, Henry Monnier avowed this was not a failure to adopt fancy dress but instead the guise of "one who is bored to death."[51] Effecting a fascinating collapse of graphic art, theatre, and social life, Monnier's disguise and his experience of this particular party involved performing a caricature of the bourgeois as travesty. Some of Honoré Daumier's most successful graphic characters, Robert Macaire and Bertrand, also migrated between the theatre, caricature, and carnival, becoming popular disguises worn by Parisians at masked balls from as early as 1835.[52] This rooting of costume in graphic imagination appears to have diminished by the Second Empire, when fancy-dress costumes were more likely to be designed by important couturiers like Worth, and in some cases assigned to party-goers by him.[53]

Threads between the spaces of print, theatre, carnival, and the everyday were increasingly knit together, in a manner that gave peculiar prominence to themes, vocabularies, or players that could easily slide between them. These included characters like Joseph Prudhomme, Robert Macaire, Mayeux, Arlequin and Pierrot, Calicot, even the *lorette* and *grisette*, who were equally at home in caricature, in vaudeville, and at masked balls.[54] Jennifer Terni gives a wonderful account of the polka – a wildfire trend that was rapidly propagated through an interlocking network of Parisian dancehalls, vaudevilles, prints, articles, products, and advertisements – as an early example of how both the material and imaginary elements of Parisian modernity were built up, already in the July Monarchy, through intense spatial, economic, and semiotic exchanges between media apparatuses and social practices.[55] As we shall see, some of the characters and graphic currencies invented by Gavarni held enduring appeal as fodder for this type of interspatial and intermedial exchange, convergence, and hybridity.

Several of Gavarni's costume creations were born and transformed in the playful social environment of his carnival soirées; the two most prominent guises paraded around town by this troupe were the *patron de bateau* and the *débardeur*. Apparently, Gavarni designed the former for himself and his friend Tronquoy in 1836;[56] it consisted of "black velvet trousers fastened with brass buttons, a shirt worn open at the neckline, a short vest in either red or white, a powdered wig, and a large hat trimmed with gold piping and a willow branch."[57] The Goncourts reported that Gavarni was so wed to his *patron de bateau* costume that he kept one with him until the end of his life, as a souvenir of his youth and his legacy as renovator of the masked balls.[58] Typically the *débardeur*, an outfit based on the traditional attire of

male dockworkers, wore the same wide trousers, blouse, and wig as the *patron de bateau*, combined with a policeman's hat and a long fringed sash.

It was not long before the hosts of carnival festivities around town sought to secure the participation of Gavarni and his friends, recognizing that this group could function as a sort of carnival claque. Instead of scripted applause, they brought unbridled pleasure, chaos, rebellious behaviour, wild dancing, and unique, imaginative costumes that made for a spectacular visible presence. The conspicuous appearance of this rowdy and flamboyantly attired artistic troupe could give an event a winning vitality and social caché (today we might call it a cool factor). The lusty participation of this troupe could endorse and promote an event. It also worked to publicize several of Gavarni's costume creations and to mark him out as a sought-after participant and guide to carnival events.

There is evidence that Gavarni began to be consulted by private hosts, theatre directors, and other carnival entrepreneurs, who considered him an expert on costumes, dancing, entertainments, and party planning. For example, Gavarni received several letters from D'Anténor Jolly, director of the Renaissance theatre, requesting meetings and ideas for dances, cortèges, and costumes; Jolly also stipulated the hour at which Gavarni and his friends were expected to make a spectacular entrance at his carnival events.[59]

Although Gavarni was a major contributor, there were many other important players in the revival of masked balls in the July Monarchy. Momentum was gathered first in private circles, predominantly aristocratic and artistic, and spread outward to transform more public manifestations of carnival. The revival of masquerade balls began in the 1820s, to a great extent motivated by interest in recreating the pageantry and aesthetic pleasures of the eighteenth century. Many artists associated with the romantic movement followed the lead of a small aristocratic elite in bringing back a taste for the Rococo and arranging entertainments associated with the ancien régime. At the end of the Restoration, the Duchesse de Berry held a series of costume balls, the most famous of which, a *Quadrille de Marie Stuart*, involved a programmed masquerade modelled on the fêtes of Louis XV. The duchess also employed artists to record the festivities, reinvigorating the *petit maître* tradition, where court artists recorded important social events (and the attire of notable attendees or performers) in watercolour or print.[60]

The cult for the eighteenth century was furthered by members of the "petit cénacle" who set up house in a dilapidated Rococo mansion in the Impasse du Doyenné around 1833. The house was inhabited by Camille Rogier, Gérard de Nerval, Arsène Houssaye, and Théophile Gautier and visited by Gavarni, Nestor and Camille Roqueplan, Eugène Delacroix, Jean-Baptiste-Camille Corot, the

Graphic Culture

Devéria brothers, Alfred de Musset, and Alexandre Dumas. In a salon decorated with Fragonard panels, they held parties, staged pantomimes, studied the bygone elegance of Rococo design, and sought to live more sensuously and aesthetically. At a famous event in 1834, the friends painted the walls with gallant scenes, nudes, and landscapes recalling the art of François Boucher and Jean-Antoine Watteau.[61] Bristling against bourgeois conformity, the decline in artistic patronage, and the effects of the modern market on art, these artists hoped to resuscitate the prominent role, collaborative design approach, and interdisciplinary expertise of old regime painters and artisans. It had been the responsibility of the royal *peintre-dessinateur* to direct the theatrical pageantry of life at court, overseeing the details of costume, decor, and choreography that were essential to the planning of diverse processions, parties, official ceremonies, and entertainments. The subsequent fracturing of design competencies, along with the decline of patronage, taste, elegance, and sensual gratification, were elements that these artistic collaborators of the 1830s hoped to combat.

To some extent, graphic artists who bridged the worlds of print, theatre, and carnival in the July Monarchy followed the model of old regime painters who directed court fêtes and entertainments including the opera and ballet. The design of a court costume had begun and ended in the drawing of a painter-designer, who typically sketched both the original costume maquette (which, after approval by the sovereign, was handed to a tailor, made into a garment, and worn to the event or performance in question) and the subsequent commemorative illustrations that recorded the costumes worn by important personages.[62] Auguste Garneray, Hippolyte Lecomte, and Alexandre-Evariste Fragonard were among the artists who updated this tradition in the early nineteenth century, merging the expertise of royal *peintre-dessinateur*, *peintre-décorateur*, and *ordonnateur des fêtes* into the office of *dessinateur de l'Opera*. Garnery designed costumes and sets for the Opera and the Théâtre Français, and he also served as a dress designer for the Empress Josephine and her courtiers, notably contributing to the art direction of Napoleon's coronation.[63] While the illustrators of Gavarni's generation, untethered from the court, would shift focus to a broader range of urban stages and print formats, some would continue to serve as *dessinateurs de costume* with connections to the Opera and the masked ball. By the 1840s, there were more legible distinctions between artistic and industrial *dessinateurs* who specialized in costume or fashion illustration. Françoise Tétart-Vittu indicates that, while fashion journals might still pay more to acquire sketches by Gavarni, Numa, or Jules David, they might also join department stores, fashion houses, and couturiers in using "advertising lithographs" or hiring less expensive "industrial engravers," "dress-designers," and "modelists."[64]

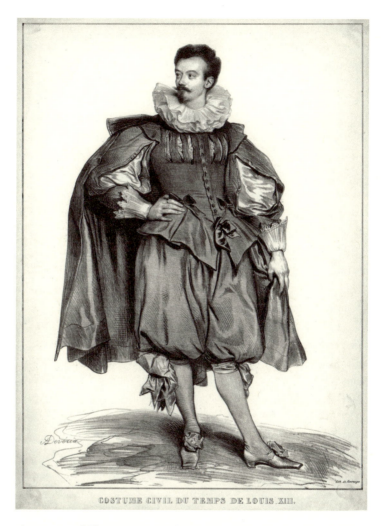

COSTUME CIVIL DU TEMPS DE LOUIS XIII.

Figure 5.5 Achille Devéria, *Civilian costume from the era of Louis XIII* [portrait of Eugène Devéria], 1830.

Achille Devéria was also a costume specialist and early participant in Parisian masquerade. He hosted a seminal masked ball on 22 February 1830, attended by family members and notable friends, many from the circle of Victor Hugo. Soon thereafter he published an album of fourteen plates recording the elaborate historical costumes worn by his guests, such as the sixteenth-century German costume worn by Alfred de Musset (Fig. 4.5) and the seventeenth-century garb worn by Eugène Devéria (Fig. 5.5).[65] Notably, Devéria's costume ball was held just three

days before the première of Hugo's *Hernani*, an evening that has become deeply etched in history owing to the flamboyant clothing and comportment of Hugo's supporters. Gautier's outfit at this event is perhaps the most memorable: it centred on a remarkable red satin vest, styled like an early modern doublet, set off by a black coat with wide velvet lapels; pale green pants edged with a strip of black velvet; a necktie of black ribbon; a loose grey overcoat lined with green satin; and long hair flowing out under a wide brimmed hat.[66]

It does not take much to imagine that some of the dramatic fashions flaunted at the première were in fact lingering holdovers from Déveria's party. There is little to distinguish this group's fancy-dress choices from their daily wear, which incorporated elements of medieval and Renaissance costume. Achille Devéria published several collections of costume plates, depicting either theatrical costumes worn by individual performers in celebrated roles on stage or historical costumes worn by his own family and friends at costume parties.[67] In other words, these images double as costume plates and portraits, commemorating both costume ideas and important social events in the lives of artistic celebrities. Maximilien Gauthier suggests that the public might seek in these plates a souvenir of an evening spent at the theatre or a repertoire of styles and attitudes that might inform the reader's own appearance or behaviour. "In this manner the costume of the theatre, little by little, imposed its tone, form, and colour on the costume of the town ... and the medieval genre determined the taste of the day ... By way of the theatre, then the ball, the romantic revolution, exclusively literary at its origin, was extended to feminine fashions, masculine dress, architecture, furniture, and all the decorative arts."[68] It is unclear whether Devéria designed the masquerade costumes himself or merely recorded the inventions of his peers, but he undoubtedly served as a crucial disseminator of sartorial innovations from the private to the public realm.

After holding his own private costume ball in 1833, Alexandre Dumas helped to organize a masked ball at the Opera in 1835.[69] Many of his colleagues contributed to the cause: Célestin Nanteuil did an etching for the program; Camille Roqueplan directed a series of *tableaux vivants* representing historical genre paintings by Paul Delaroche (the immensely popular *Cromwell* and *The Execution of Jane Grey*); Henry Monnier (in his guise as "one who is bored to death") organized a few entertainments and comic scenes. Many of the costumes worn were long remembered, although the names of the designers were not: one of the Déveria brothers made an incredibly elaborate Louis XIII cavalier, Madame Mars came as an Italian dancer, and several Robert Macaires were in attendance. This ball of 1835 is often said to have resuscitated the Opera balls and spread the vogue from private parties to the general public; the artistic elite helped by recrafting every aspect from the costumes

and entertainments to the marketing communications (Nanteuil's program). And note that graphic art was extremely prominent here, with the participation of Nanteuil, Devéria, Monnier, and characters popularized by Daumier.

The Opera had been hosting balls irregularly since 1715; during the Restoration they were institutionalized, held each Saturday during the carnival season.[70] The theatre space would be transformed for the occasion with the creation of a dance floor over the parterre; the boxes and galleries were festooned with draperies and gold and silver decorations of all kinds, and mirrors were installed throughout.[71] The organizers of the balls could draw upon the substantial resources of the Opera, including its theatrical talent, sets, and atmospheric effects. The Opera dancers might perform as part of the showcase entertainments. Occasionally, elements of decor were commandeered as well. For example, the famous ball of 1835 directed by Dumas made use of scenic wall panels taken from the recent plays of *Lucrèce Borgia*, *Sire du Giac*, *Cinq Mars*, and *La Esméralda*. These panels invoked the novels of Hugo, Dumas, and Alfred de Vigny and bore the traces of many talented hands, including those of the Johannot brothers, Louis Boulanger, Alexandre Decamps, Antoine-Louis Barye, Jules-Claude Ziegler, Nanteuil, Grandville, Delacroix, and the Cicéris.[72]

For several years in the early 1830s, the Opera balls had struggled to attract crowds; they were thought of as overly formal, quiet, and boring in comparison to the more racy, popular entertainments at less stuffy theatres, such as the Palais-Royal, the Théâtre de Variétés, the Salle des Concerts Musard, and the Renaissance.[73] The Opera balls were simply too restrictive at the outset: there were few costumes, only women were allowed to wear masks, and the music and dancing were far too civilized. The tide would turn for the Opera when it finally embraced more farcical costumes, spirited music, and rowdy dancing.

Véron had a hand in introducing more spectacular and exotic exhibition dances that helped to make the Opera balls more popular.[74] The elegant civility of the traditional French *quadrille* was left behind in favour of more seductive Spanish dances and a more improvised, participatory approach.[75] The most brilliant stroke was to engage Napoléon Musard as orchestral director in 1837.[76] Musard is credited with transforming the cloister-like atmosphere of the Opera into a true bacchanalia.[77] Apparently, he played familiar music but created waves of intensity by extracting the most memorable, enchanting, and feverish bits from famous operas, including *Robert le Diable*. Not only was the music he produced extremely lively, but Musard punctuated its performance with his own frenetic movements and chaotic outbursts that included smashing furniture, firing a pistol into the air, and being borne aloft by the crowd.[78] This energized musical performance encouraged

ever-more excessive and improper forms of dancing among all the participants. The wild gyrations of the *galop* and the *chahut* encouraged the pleasurable abandon and eroticism of the balls: they featured athletic and individualistic movements, incorporating aspects of pantomime and more sensual social dances borrowed from the working classes or neighbouring countries.[79] Those who attempted to portray the ensuing revelry used the vocabulary of pandemonium, tempest, orgy, ecstasy, and climax followed by exhaustion.[80] Gavarni described the dancing inspired by Musard as a savage pleasure: primitive, turbulent, and disorienting, transgressive movement accompanied by the "roars of panthers."[81] His visual depictions of carnival revellers emphasize wild gesticulations – outstretched arms, bow-legged stances, energized hands with thumbs extended – and a scene of disorder where bodies are clustered rather than coupled, some airborne or hunched, some riding on each other's backs. Of course, these forms of dance were calculated to signal the abandonment of courtly grace, composure, politeness, self-control, and artful choreography. Taxile Delord diagnosed them as parody and pantomime, a deliberate travesty of dance: instead of dancing, one acted, one attacked with gesture and utterance, converting bodily contortions and cries into *emblems* of pleasure and release.[82] This was another phenomenon shaped by the circuitry of media and social practices, for each caricature, essay, ballet, vaudeville, performance, and experience of the *galop* or the *chahut* would intensify the collapse of bodily gesture, rhetorical figure, and graphic expression.

Although all the attendees joined in this kind of dancing, the Opera also engaged famous starlets like Fanny Elssler to perform the *cachucha* and the *chahut* for the crowd.[83] These dances were perfectly suited to the excess of carnival because they were considered raw, primitive, and uncontrolled; they "provided a flexible frame for self-expression"; their emphasis on freedom of movement and lack of control signified the potential for revolution and political chaos.[84] The new forms of dance were considered so incendiary that police commissioners were always present on site to make sure the crowd would not get out of hand; people who danced too indecently were taken aside, fined, or thrown out.

Following the artistic reinvestment in masquerade in the 1830s, we can see signs of its gradual popularization and commercialization in the 1840s (which in turn led the artistic elite to discontinue their patronage of these events). There was a shift from invited parties to semi-private balls attended by subscription and large public galas with paid admissions. As hosts and venues for masked balls began to proliferate, competition increased and the productions became more elaborate. A *Physiologie of the débardeur* lists a variety of novelties tried out by entrepreneurs in the hopes of attracting the public: wax figures and hordes of under-clad nymphs, mu-

sicians installed on top of a bridge, and giveaways of painted paper flowers for the ladies.[85] There was also segmentation in the market, with events geared toward different pocketbooks. The price for an evening's entertainment, usually including food or drink of some kind, ranged from 10 francs to 25 centimes, with Opera balls at the top end, attended by *viveurs* of all sorts, and the festivities *Au Sauvage* at the bottom, attended by very few women and ragpickers of every class and sex.[86]

We might also consider the standardization of costumes to be another indicator of commercialization. It is said that, by 1840, Gavarni's *débardeur* reigned everywhere, with the only difference that the ribbons and velvet were of higher quality at the Opera than the other venues.[87] I have found very little evidence of how masquerade costumes were manufactured and purchased in this era, though there is some anecdotal testimony in the *physiologies*. Apparently, those who had the money would order a first-rate bespoke *débardeur* costume from a tailor or theatrical costumer, while those with lesser means could find a used *débardeur* outfit for purchase or rent from an old-clothes merchant. We are given the example of a *lorette* who had bought her *débardeur* costume from Madame Barthe, costumière at the Vaudeville, for 120 francs. Later she sold it to a *friperer* for only 11 francs because she really needed the money. After that "it fell into the banal terrain of rentals: from the Lorette, it passed to the grisette, and later still the women who wore it had no name; while its good days began at the Opera, they would finish at the Porte d'Italie or the ball du Boeuf-Rouge."[88]

The *Débardeur* and Déjazet

The most conspicuous example among the many enduring costume types invented by Gavarni is that of the *débardeur*, which was based on the professional outfit of dockworkers who unloaded barges on the Seine. The *débardeur* would go on to become one of the most popular and emblematic costumes of Parisian carnival in the July Monarchy, and the trajectory of its spread reveals Gavarni's influence as a shaper of current manners and the considerable appeal of products and experiences that provided playful alternatives to gender norms and social conventions.

The *Nouveaux Travestissements* documents an early appearance of the *débardeur* as one of many women's masquerade costumes sketched by Gavarni for this print series in 1830 (Fig. 5.6). The image and caption show some elements that would not endure, including a stiff hat and a fur-trimmed jacket. This iteration features an ornate patterned shawl fashioned at the waist. It is a cashmere shawl, a richly evocative element that collapsed allusions to military conquest, colonialism, and female

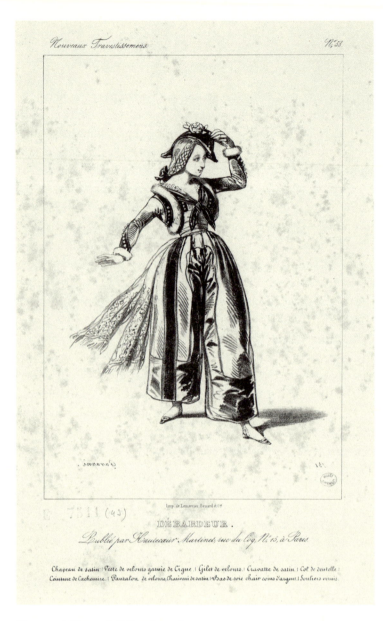

DÉBARDEUR.

Publié par Hautecœur Martinet, rue du Coq, N.º 15, à Paris.

Chapeau de satin. | Veste de velours garnie de Cigne. | Gilet de velours. | Cravatte de satin. | Col de dentelle. |
Ceinture de Cachemire. | Pantalon de velours. Charivari de satin. | Bas de soie chair coins d'argent. | Souliers vernis.

Figure 5.6 Gavarni, *Débardeur*, 1830.

seduction. To wear it as a belt would casually recover and expand the significance of the *cachemire* shawl, which, as Susan Hiner so ably illuminates, was not only the must-have feminine accessory of the era (normally worn about the shoulders) but an "oriental luxury garment par excellence" that harked back to an Empire military fashion, for cashmere scarves plundered from the Egyptian Mamelukes were worn by French soldiers as belts.[89] A simpler (and less expensive) form of this belted sash would remain essential to the *débardeur* costume, as would the dark satin cravat,

the wide-legged pant, and the unmistakable raciness of a woman wearing the attire of a male labourer and soldier.

After this early graphic appearance in 1830, the *débardeur* was exhibited publicly as a disguise worn by Gavarni's friends at intimate gatherings and carnival amusements, especially in 1836 and 1837. Beginning as an insider phenomenon, recognized by a small group of acquaintances and early adopters, it was publicized by these notable Parisians through the mechanism of their visible public sorties and through the re-presentation of these appearances in works of caricature, journalism, and theatre.

The costume truly "attained celebrity in 1840, when a popular actress, Miss Virginie Déjazet, appeared *en Débardeur* for her role in *Indiana et Charlemagne* at the Palais Royal."[90] Gavarni designed this stage costume for Déjazet, and his watercolour sketch (Fig. 5.7) shows slight alterations to the type since 1830: he has replaced the original tight-sleeved jacket with a loose blouse that has billowing sleeves and a plunging neckline. Déjazet's outfit retains the original lace collar and omits the cravat, although the reverse is true of the *débardeur* outfit that would become standard in the 1840s. The striped satin pant has become solid velvet (apparently red velvet for Déjazet), trimmed with tiny silver buttons, and hiked up to reveal more of the ankle and leg.[91]

Virginie Déjazet was one of the most celebrated actresses of her day, particularly known for audacious performances in drag, in which she not only wore men's clothes but brazenly emulated masculine behaviours such as smoking, drinking, fighting, and swearing. She was also closely associated with Rococo revival, favouring plots of intrigue and gallantry, eighteenth-century settings, powdered wigs, and tight silk breeches.[92] By 1840, she had been acting for over thirty years, and *rôles travestis* had been central to her repertoire since at least 1830 when she famously impersonated Emperor Napoleon at the Nouveautés.[93] In *Indiana et Charlemagne*, Déjazet was not crossing over to play a male character; she portrayed a young woman, Indiana, who had returned home from a masked ball wearing the costume of a *débardeur*.[94] The nuances of this shift made the act of cross-dressing somewhat less transgressive, for Déjazet's appearance as a woman in carnival drag would make her comportment on stage less indecent and socially confounding than her celebrated male impersonations. Yet Déjazet's appearance would attach scandalous frisson to the *débardeur* disguise and emphasize the fact that gender performativity was paramount, both on and off the stage.

This notoriously impudent actress was the perfect spokesmodel for Gavarni's costume creation. Her performance would root the *débardeur* in an established tradition of theatrical cross-dressing, advertising its connections to the saucy starlet's

DÉJAZET DANS INDIANA ET CHARLEMAGNE

Aquarelle. (1840).

Figure 5.7 Gavarni, costume for *Déjazet in Indiana and Charlemagne*, 1840.

transgressive roles along with the creative carnival antics of Gavarni and his asso-
ciates. Thus, the *débardeur* was allied with two types of artistic innovation and with
the alternative lifestyles and celebrity equity being generated by new elites of the
demimonde, bohemia, and romanticism.

It would not be long until the *débardeur* became one of the stock characters of
the Parisian press and public carnival celebrations. Around the time of Déjazet's
appearance *en débardeur*, Gavarni began to feature *débardeurs* more frequently in

caricature and illustration. Alongside two extended series in *Le Charivari* – *Les Débardeurs* (1840) and *Les Lorettes* (1843) – Gavarni depicted the shockingly liberated habits of female *débardeurs* in the *Physiologie du Débardeur* and the *Physiologie de l'Opera* (both 1842). It was in these years that the outfit was widely adopted by Parisian carnival revellers. The *débardeur* was worn by both men and women of varied backgrounds, but it was particularly associated with women whose status was defined in opposition to the respectable married bourgeoise, in other words, female workers, mistresses, or "public women" of one kind or another. Central here are the *rat* and the *lorette*, both already stock characters of Parisian print culture as well as important segments of its target market.

Gavarni himself had a central role in picturing and codifying these types. The *rat* was a minor Opera dancer who courted male protectors, her bestial moniker suggesting the ubiquity, degradation, and desperation of these preyed-upon scavengers. The *lorette* was a young woman of easy virtue, not a prostitute in the strict sense but someone who used her feminine charms and wiles to support her lifestyle. She could live a rather independent and leisured existence once she had successfully convinced a wealthy lover (or lovers) to set her up in a furnished apartment, apocryphally in the area near the church of Notre-Dame de Lorette, where Gavarni also lived.[95] *Rats* and *lorettes* were often depicted as mannish *viveurs* with the audacity to smoke cigars or wear men's suits: outward signs that these women had thrown off the expectations of bourgeois morality (which dictated female humility, monogamous marriage, and motherhood) to seize instead the pleasures and privileges available to male lions in public life.[96] Paramount among these privileges was the ability to choose for oneself a lover or temporary object of desire. The *débardeur* costume was a fitting sign and vehicle of these women's relative independence (from husband or father or social compunction) and their libertine approach to life.

Many of Gavarni's representations celebrate the sexual liberation of the *rats* and the *lorettes en débardeur*. For example, in *When the Arthurs sleep, the rats dance* (Fig. 5.8), Gavarni seems to share these women's merrymaking, to relish their carefree inversion of the conventional gender expectations, power asymmetries, and predatory pleasures.[97] While many contemporary depictions of the *lorette* concentrate on the practical and mercenary dimensions of her love – these women whose "boudoir is a deli counter where they sell pieces of their hearts as if they were slices of roast beef"[98] – this sketch by Gavarni foregrounds raw hedonism and delightful release from any schemes or affectations.[99] These two *rats* who happily frolic while their Arthurs (their sponsors) sleep clearly do so for their own full-blooded pleasure. All other motives, plots, scripts, constraints, and necessities have vanished, at least for the moment. Perhaps to underline this point, Gavarni has portrayed these

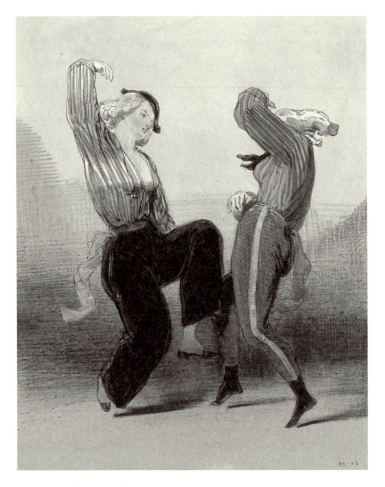

Figure 5.8 Gavarni, *When the Arthurs sleep, the rats dance*, 1843.

two exaltant *débardeurs* in a vacuum, with no other dancers, onlookers, or background elements around them. But the sparseness of his composition makes another point as well: everything that we need to know about these typical women, about the carnival balls circa 1843, and the behaviours and attitudes of the time, is powerfully and economically signalled in these women's bodies (their attire, expressions, postures) and in the graphic vocabulary and the idiomatic caption with which Gavarni articulates them. The *rats* and the Arthurs, the *lorette*, the *débardeur* costume, the revived masked ball, and the feverish *galop* are already heavily layered with meaning for the viewer, much of it attributable to the graphic output and the social performances of Gavarni.

Surely, the renegotiation of social boundaries was a significant factor in the appeal of the *débardeur* costume. The cross-dressing of Déjazet and female *débardeurs* reverses both gender and class relations. It was provocation enough that women who wore trousers parodied gendered codes of comportment and revealed the female form in shocking ways. They also converted a traditional worker's uniform (along with elements of authoritative masculine military dress such as the cashmere sash and the policeman's hat) into a play-suit for their own diabolical amusements. They transferred the signs of hard manual labour and male power to a world of leisure, physical pleasure, consumption, excess, and escape from workaday necessity. A fusion of the working girl and the working man, the *débardeur* as leisure suit was a potent foil to the black habit and top hat of the moneyed gent who was the typical Opera subscriber, perhaps a "protector" of working girls or a merchant whose goods were moved by stevedores from barges on the Seine into the streets and shops of the city. The *lorette* effected a "sacreligious mutilation of the primitive costume" in her efforts to make the *débardeur* outfit more attractive with perfume, ribbons, and exposed female flesh; but she kept it in the male register, and the working-class register too, by her "severe observance of the pipe."[100]

To wear trousers and smoke and swear as Déjazet did was to commandeer a male prerogative,[101] and so too was the decision of female revellers to embrace fully the debauchery and philandering of carnival. While the actress could play the male rake on stage, similarly impudent female carnival revellers could play the male rake at the masked balls, and many of the women who did so were particularly attracted to the *débardeur* costume as a way of announcing their approach to the festivities and life beyond. In this way, the exceptional licence of the cross-dressing actress became common freedoms and pleasures enjoyed (at least temporarily) by courageous Parisian *lorettes, rats,* and other carnival celebrants. As Terry Castle argues, travesty was not innocent: often it expressively revealed hidden needs, providing access to other sensual and ethical realms or cathartic escape from the self and social constraints. As a suggestive revision of ordinary experience, travesty was particularly significant for women and homosexuals, dominated groups who could experiment with a new body and its pleasures, try out a "polymorphous" self, and enjoy "a subversive – if temporary – simulacrum of sexual autonomy."[102]

The *débardeur* costume became popular at a time when women began to participate more fully in the licences and transgressions of carnival. Changing preferences in female masquerade costume are emblematic of paradigm shifts in these attitudes and behaviours. For much of the early modern era, the domino (Fig. 5.9) was the costume of choice for respectable women who attended masked balls. Typically, a long dress, head covering (such as a cap or hooded cloak), and half-mask

Figure 5.9
Horace Vernet, *Marvellous
Women, no. 15: Domino
trimmed with lace*, 1810–18.

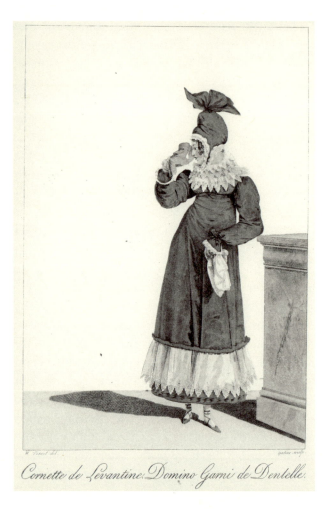

Cornette de Levantine. Domino Garni de Dentelle.

provided a safe screen from which to observe the proceedings or engage in the for-
malized "intrigue" of guessing identities and shielding flirtations. Some of the
women's costumes of the late eighteenth and early nineteenth centuries were more
revealing of the wearer's identity and body: masks began to disappear and erotic
attention was often invited with an exposed décolleté. While there were holdovers
of Rococo *fêtes galantes* in the form of sexy milkmaids, peasants, and *camargos*, the
ladies of the Restoration also tried on elaborate historical costumes, dressing as a
marquise, a Turk, or a Chinese empress.

The *débardeur* of the 1840s represented a significant change in women's mas-
querade not only because of its transvestism but also because of its eroticism and

facilitation of libertine behaviour. The *débardeur* trousers called attention to the shape of a woman's belly, hips, legs, and bottom in a manner that was extremely unusual for contemporary dress. The costume was also remarkably non-confining, allowing for new mobility and erotic exchanges. The heavy, structured dresses and headdresses of the previous era would have to be worn with great care, and with a stiff apparatus of undergarments including corsets, stays, and petticoats if not also panniers or hoops. By contrast, the *débardeur* was worn without any of the usual protective, architectural underlayers. It was lightweight, loose, and enabling, making it easy to dance the *galop* with feverish abandon, to fondle the flesh underneath (or observe how that flesh moved), and to undress or redress in an instant.[103] For these reasons it was associated with seductive dancing, spontaneous hook-ups, parties that bordered on orgies, and the new legions of women who operated outside of the confines of bourgeois domestic virtue; it was the uniform and calling card of the *lorettes*, the *grisettes*, the *rats*, the "women for rent," and the "women without names."[104]

Certainly, Déjazet's role in the popular dissemination of the *débardeur* also points to the rising promotional power of the actress and the vaudeville. Jennifer Terni has shown that the vaudeville, the most popular theatrical form during the July Monarchy, was used to promote all sorts of goods and ideas, often including publicity within the internal structure of the scenarios. Just as there were productions about masked balls (as was the case with *Gustave*, and with *Indiana and Charlemagne*), there were vaudevilles about gaslight, hashish, cashmere, crimes, and other sensational news items, as well as plays that featured specific shops, restaurants, horse races, and dance gardens.[105] There was even a play at the Théâtre des Variétés, replete with a masquerade scene, that dramatically enlarged upon the characters and intrigues of Gavarni's lithographic imagery: *Les Femmes de Gavarni, Scènes de la vie parisienne* (Gavarni's Women, Scenes of Parisian Life).[106] Terni demonstrates how values and trends were amplified by the layering of mutually reinforcing representations across different branches of the theatre, press, and advertising, just as these very media were being expanded and aggregated in the 1830s and 1840s. The *débardeur* is another prime of example of this process by which ideas, expectations, and consumer behaviours migrate between different Parisian sites, connecting the experiential horizons of pictorial, textual, and dramatic representations with the social practices of everyday life.

The historical trajectory of the *débardeur* costume marks the achievement of Gavarni's dream to renovate the art of masquerade and replace the standard costume types of Italian opera. It also demonstrates the growing taste-making power of new kinds of artistic celebrity associated with illustrated print culture and the

theatre. Whereas the Italian opera types had drifted from the stage to fancy-dress events at court and in town, Gavarni's costume inventions spread through the reach of graphic journalism, artistic social networks, theatre productions, caricature, and the celebrity of a particularly scandalous female star, eventually shaping the experience of carnival revellers throughout the city. The boundaries between media, between performers and spectators, representations and reality, were fluid indeed.

Parisian artists were known to use their expanding powers of representation and publicity in support of their colleagues and community, banding together in times of financial need or to vouchsafe important legacies. In 1857, already fifty years into her acting career, Déjazet established her own theatre. When this Théâtre Déjazet faltered and closed in 1870, the artistic community held a benefit in her honour, restaging excerpts from her career successes, with performances by Sarah Bernhardt among others.[107] Likewise, decades after Gavarni's death, Parisian artists offered a heartfelt testament to him, recognizing his enduring impact on Parisian art, manners, and the imaginary of carnival. In 1911 a monument to Gavarni was erected on the Place Saint-Georges: a sculpture by Denys Puech featuring a bust of Gavarni atop a column decorated with bas-relief figures of a *débardeur*, a *lorette*, a *rapin*, and an *arlequin*. The monument was funded by public subscription, conceived and promoted by the newly formed Société des Peintres-Lithographes, which held its first exhibition in 1897. Here the gestures of homage and self-promotion were fused, as this new generation of painterly print- and poster- makers sought to bridge the spaces of high art and advertising and to create a venerable lineage for themselves, joining collectors and iconophiles in the rediscovery of Gavarni, Daumier, and their peers as modern "painter-lithographers."

In a wonderful example of cross-platform and cross-generational fluidity, the Société des Peintres-Lithographes launched a fundraising campaign for the Monument to Gavarni that involved the creation of advertising posters, exhibitions, and a masked ball, the "Fêtes Gavarni," held at the Moulin Rouge in 1902. In honour of and in the manner of Gavarni, the lithographic poster touting the *Fêtes Gavarni* (Fig. 5.10) was strategically designed to capitalize on the name, the visual imagination, and the professional example of Gavarni, and thus to revive the vital graphic culture of the July Monarchy. "Costume is Obligatory," it announced. Attractive and typical Parisian women had since become the most prominent multivalent icon used to sell any manner of goods and pleasures in the advertising posters of the *fin-de siècle*.[108] This one acknowledges the enchanting prototype of Gavarni's voluptuous *lorette en débardeur*: a July Monarchy original and her graphic signs, which evidently needed no modification to look innovative, desirable, transgressive, and enticing on an advertising poster in 1902.

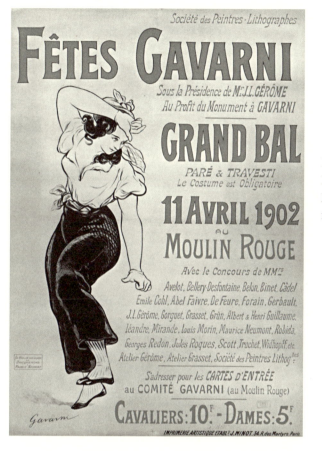

Figure 5.10
Félix Bracquemond and
Maurice Neumont, poster
for Fêtes Gavarni, 1902.

Artistic Identity and Travesty as a Social Phenomenon

Mary Gluck has argued that masquerade became the very model of artistic identity and modernity for the pioneering subculture of romantics that gathered around Victor Hugo and Théophile Gautier in the 1830s. She considers the "Battle of *Hernani*" as both a theatrical event and the founding act of bohemia, emphasizing important links between performance, fashion, and the invention of artistic lifestyles. Hugo's supporters ensured the immediate and enduring significance of *Hernani*'s theatrical debut by making a spectacle of themselves as a new kind of audience: a motley band of artists and students whose fervent applause and anarchic behaviour were strategically deployed during the performance to attract publicity and vanquish conservative criticism. Outfitting themselves for the occasion in extravagant theatrical

costumes, these "artists of the 1830s were identified for the first time not by what they did, but by how they lived and what they looked like. They performed their identities through outrageous gestures, eccentric clothes and subversive lifestyles."[109]

Gluck aptly stresses the importance of carnivalesque performance and extreme visibility in the emergence of this new type of artistic identity. But I believe she puts too much store in the idea that the ironic or distinctive behaviour of these "subversive" groups functions to destabilize bourgeois modernity or operate outside of it.[110] Their public performance of rebellion and difference was inseparable from their activity as a new kind of celebrity claque whose clapping shifted from the audible forms and limited occurrences of the theatre to more mobile, constant, and visible forms of endorsement played out in the street, in the press, and in everyday life. These artists did not transcend the nascent capitalist market but knowingly operated at its vital centre. Their products were not incendiary or "popular" (in the sense of working class or radical) but decidedly geared toward and constitutive of middle-class audiences.

The carnivalesque performance of Hugo's entourage at the Battle of *Hernani* and beyond reveals how the creation of art became inseparable from the creation and marketing of artistic identity. The value of an artistic product would be increasingly determined by the symbolic equity that could be invested in the artist's life and public persona. And this individual equity was also linked to the collective equity of the groups with whom he or she was affiliated, so that the artist's social network became an essential aspect of their perceived lifestyle, promotional apparatus, performative identity, and celebrity. The real story is not how these artists transcended the market but how they exploited tropes of rebellion and transcendence to competitively position themselves and their products within it.

One of the more interesting biographical details about Gavarni is that he eschewed the performative and transgressive in his own self-styling. His personal appearance was precisely calculated to be much less flamboyant and obvious than the bohemian, yet also more distinguished and knowing than the bourgeois. In contrast to the theatrical, historical attire of Eugène Devéria or Théophile Gautier, Gavarni was known for his cool reserve and an understated elegance that was resolutely of the time (Fig. 5.11). This great renovator of masquerade chose for his everyday attire a simple black habit, nuanced only with his impeccable sense for tailoring, posture, and comportment. A self-portrait of 1843 shows that he wore his hair long and avoided the clean-shaved look; instead of a formal frock coat with tails, he chose a loose hip-length coat, carefully buttoned at the neck but open at the waist to reveal another undone jacket or waistcoat beneath. The garments are generously cut and casually rumpled, the sleeves pushed up to accentuate several folds and layers at his

Figure 5.11 Gavarni, self-portrait, 1842.

cuff, the fabric across his shoulders more smooth and taut, drawing the eye up toward the flourish of linen at his throat. With one hand buried in his pocket and the other self-consciously posed with a cigarette, he holds his head rather haughtily and his gaze, which looks down upon us, is aloof and skeptical, the brows knit slightly together to signal intelligent reflection and aesthetic discernment.

Like his bohemian colleagues, Gavarni understood the importance of marketing artistic identity and producing himself as a work of art. Instead of allusions to historical paintings and Gothic novels, however, Gavarni's appearance invoked the fashion plates and social caricatures he was known for. Biographers described him as "a dandy of the Brummel or Alfred de Musset type,"[111] meaning an exceptionally well-dressed man with unrivalled skill for manipulating the visual signs of social distinction and controlling the effect he made in public. Yet the phrase "a dandy of the Brummel or Alfred de Musset type" also admits a governing dilemma, for a dandy is both a historical individual who is by definition singular and inimitable, and at the same time a social type, a fictional character, and a model to be emulated by others. Rhonda Garelick deftly explores this conundrum of originality and reproduction, biography and fiction. Analyzing the seminal texts on dandyism – including Balzac's "Traité de la vie élégante," which appeared in *La Mode* in 1830 alongside fashion illustrations by Gavarni – she shows how frequently authors confuse themselves with their protagonists, identifying with these dandies who influence rather than act, who collapse art and life, and navigate the modern city by self-consciously playing the part of themselves. She argues that the dandies and female performers of the nineteenth century were the prototypical media stars because they commodified, aestheticized, and dramatized a highly artificial and stylized self. [112]

Superficially, the dandy's attire would look like that of any other well-to-do Parisian, but an initiate could detect minute differences in elements of the cut, perhaps the choice of stitching or jacket lining, the precise tapering of the legs, or the careful looping of the cravat so it would appear unstudied. An initiated viewer could also notice points of emphasis in how the ensemble was worn, how the wearer held his body, and how he used its surfaces and lines to create meaning. These visible criteria were the source of the dandy's superiority, and of the public estimation of his superior skills of display and visual communication. His was a look that could only be properly signalled, inflected, recognized, and evaluated by those who shared his particular skills of visual connoisseurship. But these were skills and sign systems, graphic emblems that Gavarni, Balzac, and other Parisian sketch artists and fashion journalists were rapidly disseminating to a broad public. This democratization of codes would create new challenges and opportunities for would-be dandies and

fashion innovators, accelerating the chase of originality and reproduction, life and art, as each moment of elegant singularity an individual achieved quickly became a model for others, and a type propagated through representation. As larger swathes of the populace were capable of mastering the codes of fashionable currency, successful dandies and artistic celebrities would have to distinguish themselves by stressing their agency to initiate new distinctions, interpret or rework existing codes, or creatively reformulate or sidestep the rules of the game. If the everyday had become a masked ball, a condition of permanent disguise, then these performers would avoid the costumes that could be instantly recognized as such – at least for a moment, since any initially unremarkable attire was just another costume whose significance had yet to be codified.

In choosing to style himself as a dandy, Gavarni might simply have demonstrated his particular intimacy with and self-conscious mastery of these codes. But it is also possible that there was some irony or parody in his adoption of this pose. Gavarni's caricatures had ridiculed the pretensions and vulnerabilities of the dandy type alongside those of the bohemian and bourgeois, his sketches and captions rife with satire, innuendo, and double entendre. If Monnier had famously come to a party disguised as "a man who is bored to death," performing a caricature of the bourgeois as travesty, perhaps Gavarni was performing a caricature of the dandy as travesty, adopting the costume of a wilfully artificial person who played the part of himself. This was an effective way to pantomime his own signature capacity to *faire figure*, to cut a fine figure, which could mean to make a favorable impression in public, project a specific character, or produce a particular visual effect.[113] In other words, Gavarni's everyday costume caricatured (or graphically exaggerated) a visual expertise common to the dandy, the fashion illustrator, and the tailor.

Among those who appreciated Gavarni's knack for self-styling and visual discernment was the Parisian tailor Humann, whose skill in crafting chic made-to-measure men's suits was unrivalled. Humann was wise enough to solicit Gavarni's custom, his personal endorsement, and his work as a fashion illustrator. All of these were visible currencies that held promotional value for the tailor. It was said that Gavarni knew how to wear a black suit better than anyone else. Because, of course, he knew better than anyone else how to draw one.

Conclusion

Industrial capitalism was slow to develop in France, where the more extensive structural reorganizations of production, capital, and markets did not occur until the late nineteenth century. Before mid-century the national economy was still predominantly agrarian and political power still dominated by landowning elites. Nonetheless, during the July Monarchy there were significant developments in the cultural field (in the ways art and literature were produced and circulated) and in the urban habits and environments of consumption. These were developments rather than radical ruptures, produced through the expansion, adaptation, and intensification of extant forces, including the gradual enmeshment of media and social practices. Already in the eighteenth century, Paris was known for its luxury goods and fashions, its arts and letters, and with each successive decade it could boast an increasingly networked boulevard culture in which promenades, gardens, shopping, art, and entertainments were woven together. During the July Monarchy, Paris secured its position as an important centre of commercialized leisure, its vitality and dynamism fuelled in large part by cultural entrepreneurship, by the multi-levelled interconnection of urban attractions, and by the ever-changing visual promotion and visual assessment of goods, people, images, and ideas.

I have attempted to show how graphic artists were among the important cultural producers and commentators whose products were key to this environment, both as objects of material and social prominence, and as representations with considerable discursive, critical, and emblematic power. Prints, books, journals, and posters were among the central sites where Parisian culture and its attendant modes

of sociability and visuality were formed and fused together in the 1830s and 1840s. Caricature, fashion illustration, and graphic advertisements proposed multiple interpretations of local diversions, current attitudes, and exemplary metropolitan characters, and in so doing they worked to define urban modernity, to make sense of it, to make it legible, even measurable. Of course, these images were not wholly determining, not unavoidable, and not for everyone, but the growing numbers of people who engaged with this print culture – which had steadily infiltrated reading materials, homes, shop windows, theatres, and cafés – might perceive their world with reference to a changing matrix of graphic emphases and distinctions.

The flourishing of July Monarchy print culture brought new possibilities for visual artists, and for writers and publishers too. There were new ways of making art, making a living, making a name for oneself, making oneself heard by diverse audiences. There were also new opportunities for participating in, and shaping, contemporary social life. One of the effects of this aesthetic experimentation was that artists contributed to the gradual commercialization of art, entertainment, and everyday activities. They also propelled a visual social dynamic in which everyday images and everyday experiences would chase and feed off each other, so that relations between people (and people's relations with themselves) were increasingly self-conscious, performative, and mediated by images. Some of the roots of a visual culture rife with spectacular realities and spectacular histories can be found here, but it would take a long time before this work of mediation was effectively colonized by capital to the extent it could be plausibly characterized as a "society of the spectacle."[1]

I have only scratched the surface of this vast and infinitely layered terrain of graphic culture and quotidian images. As Patricia Mainardi remarked, the world of nineteenth-century illustrated print is like "a submerged continent that we are just beginning to discover, but which, when better known, will significantly remap our understanding of the role of the visual in that century."[2] Perhaps my limited foray will provide some useful insights and coordinates for further study of July Monarchy artists and print networks, and the wider constellations of celebrity, publicity, cultural economy, social history, and visuality in which they are embedded.

While some of the threads examined here were soon abandoned, many were vigorously woven into the tapestries of the later nineteenth century and beyond. By the second half of the nineteenth century, the markets for print, illustration, and everyday images had changed significantly. The vogue had faded for imaginative lithographic sketches in the early image-centred formats such as artist's portfolios, albums, and single sheet prints to be framed or savoured. So too the fad for *physiologies*

soon disappeared, as did the ambitious editorial endeavours to produce lavishly illustrated editions of contemporary literature and collectively authored anthologies aspiring to panoramic representations of Paris. At mid-century, contemporary novels were more likely to be issued in inexpensive formats and newspaper serials, with few or no illustrations. Illustrated books showcasing innovative handmade art or fine engravings would become a specialty item, reserved for niche markets like children's literature, luxury publications, and the artist's book. Miscellaneous collections of sketches and texts persisted in illustrated magazines, and in the form of scraps, keepsake albums, and New Year's gift books, typically geared toward women. Album culture slowly migrated from print to photography, gaining new life in the 1860s and 1870s when *carte-de-visites* made it easy for consumers to assemble and display their own portrait collections.

Caricature and graphic satire were carried forward in specialized journals (*Le Charivari, Le Musée Philipon, Le Journal pour rire, La Revue comique à l'usage des gens sérieux*) and found new formats such as comic strips and satirical reviews of art exhibitions or yearly events pioneered by Rudolf Töpffer, Cham, Gustave Doré, Bertall, and Nadar (Gaspard-Félix Tournachon) among others.[3] The more earnest forms of topical illustration lived on in specialized newspapers, chiefly the educational illustrated survey magazines disseminated to ever growing audiences. *Le Magasin pittoresque*, *L'Illustration*, and the *Illustrated London News* successfully pursued this model well into the twentieth century. Such periodicals would continue to feature wood engravings – informative depictions of urban streets and edifices, current events, portraits, and showcases of artisanal goods and manufactures – until photomechanical and halftone processes were introduced in the 1880s.

Specialized fashion journals continued to thrive after mid-century, but the task of illustration was transformed and transferred to different types of artist. While the early nineteenth-century fashion plates were rooted in the graphic imagination and social observation of visual artists like Vernet, Devéria, and Gavarni, in the Second Empire dressmakers, couturiers, and the retailers of ready-made fashions would take the lead, providing physical garments or dress designs for fashion illustrators to transcribe in detail. As a consequence, we see the predominace of two types of professional fashion illustrators after mid-century: *modélistes* who sketched dress designs (providing source material for both clothes makers and the makers of fashion plates) and artists who specialized in producing plates for the fashion press, such as Jules David (1808–1892) and Anaïs Toudouze (1822–1899).[4] The fashion plate crossed over from the broader domain of painting, theatrical design, and genre pictures to the more specialized expertise of graphic design and illustration more directly commissioned or underwritten by the fashion industry.

After mid-century, the art of the printed handmade sketch could still be found in specialized journals,[5] in artist's books (such as those wrought collectively by Edouard Manet and Stéphane Mallarmé),[6] and in the work of painter-printmakers firmly connected to the world of high art. The 1860s saw a vibrant revival of etching and original printmaking; the term "original" denoted innovative, self-sufficient designs as opposed to painstaking reproductions or illustrations of other sources, and the investment of value in each individual state or impression of a print. Diverse printmaking techniques (etching, engraving, lithography, aquatint, drypoint, woodcut) were taken up by a wider range of artists including esteemed painters, and new emphasis was placed on the expressive, painterly potential of prints as forms of experimental art and signature mark-making. Artistic and commercial value was augmented through the redefinition of prints as handcrafted original works, and the spectre of mechanical multiplication was mitigated by the marketing of numbered, limited editions and hand-signed, distinguished impressions. Félix Bracquemond, Alphonse Legros, James McNiel Whistler, Henri Fantin-Latour, and Edouard Manet were among the prestigious painter-printmakers whose work was supported by the newly formed Société des Aquafortistes (1862) – later by the Société des Peintres-Graveurs Français (1890) and the Société des Peintres-Lithographes (1897) – and also by a thickening nexus of dealers, collectors, and critics who made key purchases, published catalogues and essays, and mounted exhibitions.[7]

Looking back from 1889 on the development of French print culture since the revolution, Henri Béraldi noted that burin engraving, academic work, and reproductive practice held artistic and institutional priority among printmaking forms until at least 1855, when Paris held its first universal exhibition and mounted a thirty-year review of the fine arts in which the work of painter-lithographers and illustrators was entirely ignored.[8] However, he recounts that the 1860s inaugurated a sweeping reevaluation of nineteenth-century print and its history. Alongside the revival of original printmaking, other major factors were an iconophilic culture of collecting that instigated a passionate rediscovery of July Monarchy print, and the development of modernist painting, which valorized the representation of the present. Underwriting all of these factors was a thriving commercial art market (and the associated apparatus of independent exhibitions, art criticism, and art-historical periodicals such as the *Gazette des Beaux-Arts*, founded in 1859), which provided artists with substantial – and financially sustainable – alternatives to official art and encouraged investment in both old and new prints along with contemporary painting.

Collecting practices changed significantly, beginning in the 1860s and gaining momentum through the 1880s and 1890s, as French amateurs began to research the

history of print and pursue an archaeology of modern life. Late-century "icono-philes" were known for their inclusiveness: they looked for aesthetic quality and historical evidence of bygone fashions, manners, and Parisian street culture, while ignoring traditional hierarchies of art.[9] These amateurs discovered the roots of modern iconography and the original print in July Monarchy print culture, espe-cially in the early painterly lithographs of Charlet, Vernet, Devéria, Gavarni, and Daumier, with fashion plates, sketches of manners, and genre scenes at the forefront. Among the passionate amateurs who found the graphic currencies of modernity in these works were writers Baudelaire, Champfleury, and the Goncourt brothers, and collectors and historians like Philippe Burty, Hector Giacomelli, Marie Joseph François Maherault, Ernest Maindron, and Henri Béraldi.[10] Béraldi himself reflected on the crucial work of cataloguing, archiving, and explanation pursued by these print amateurs, who discovered their quarry in old books and estate sales, or exca-vated it from state repositories, magazines and hoardings, and thus exponentially expanded the range of what was included in the history of nineteenth-century print.

There were painters too among this group of significant collectors and torch-carriers. Throughout the 1870s and 1880s, Edgar Degas amassed a huge collection of lithographs and drawings by Daumier and Gavarni, along with Japanese prints,[11] all significant sources of inspiration for his practice as a printmaker and painter. Indeed, modernist painting is one of the prominent sites where Parisian sketches and everyday images resurfaced in the later nineteenth century. Both the themes and formal strategies of July Monarchy illustrators were carried forward by self-consciously modern, anti-academic painters working in the orbit of realism, im-pressionism, and postimpressionism.

Responsive and prolific representations of the present – whether journalistic, celebratory, or critically charged – also continued to evolve in photography and advertising. Key elements of July Monarchy graphic culture that were taken over and extended in photographic practices include portraiture, social panoramas, urban scenes, and representations of diverse peoples and far-flung places for the benefit of armchair travellers. Photographic portraits expanded the range of people (of all classes and nations) who entered the space of representation. While camera portraits brought individual countenances to the fore (whether commoners, dig-nitaries, or celebrities), they also continued to traffic in typicality (like their graphic precedents), with the working classes and the poor, women, provincials and for-eigners, criminals and medical patients often figuring in photographic images as generic specimens rather than notable individuals. In the July Monarchy, non-Western cultures were often figured through their arts and manufactures, or through

the representation of generic and possessable female bodies clothed in exotic packaging. After mid-century, non-Western people continued to be portrayed in the European photographic framework of regional types and races and in displays of global arts and industries mounted at the world's fairs. These images and exhibitions carried the legacy of panoramic representation, but as they moved beyond the topic and topography of Paris or London, seeming to bring the whole world into view, they tended to trade insight for mere proximity, magnifying mythic and myopic visions of otherness.

Graphic advertisement expanded steadily from the localized forms of fashion plates and publisher's posters, visible in the vitrines of printers and booksellers, to a more diverse range of formats and urban spaces. Designated advertising spaces rented and managed by specialized agencies cropped up in many more urban locations, becoming a ubiquitous feature of building facades, construction fences, street furnishings, and public transportation, and expanding outward from Paris and London to other urban centres. Lithographic posters enjoyed a bold resurgence in the late nineteenth century, adapting many of the themes and visual strategies of their July Monarchy predecessors for more massive colourful formats that competed well for attention in both city streets and avant-garde art. The bold graphic style and social charge of mobile first-hand Parisian sketches was an idiom that bridged these domains effectively and revealed their common circuitry.

＊

How might this study of nineteenth-century graphic culture inform our situation in the present? Our current state of media culture and image saturation tends to be narrated in terms of innovation, disruption, and breakthrough, such that deeper historical perspectives are urgently needed, along with more nuanced discussions of continuity, adaptation, and appropriation in cultural forms and historical processes. Historical case studies can help us understand how "new media" are formed and to grasp the complex forces and systemic structures involved in shaping them, and in turn, shaping our experience. It is rarely the case that new technologies change everything, or function in isolation, or totally eclipse older forms and behaviours; more often they are embedded in larger configurations that gather, reconfigure, colonize, and diminish existing elements in the mediascape and the lifeworld. Furthermore, it is worth remembering that new cultural products and industries do not simply cater to the pre-existing tastes and needs of static preformed audiences. Instead, they call publics into being, actively inflecting and cultivating

particular modes of attention, discernment, participation, self-regulation, inter-action, and separation. In turn, they must research and adapt their offerings to au-diences that are active, resistant, and ever-changing.

The history of print culture may seem beside the point now that we have entered a digital era in which the death of print, of the book, and of analogue media has been so broadly proclaimed. The shift from print to digital may have serious con-sequences for the traditional book form. But this study should remind us that the book form has long been multiple and mutable, the departure point for tremendous formal and commercial experimentation and nimble adaptation to new talent, tech-nologies, and markets. The wave of new serials, periodicals, instalment and sub-scription models, anthologies, *éditions de luxe à bon marché* (low-cost luxury editions), editorial advertising, pamphlets, albums, and image/text collaborations researched here should provide a glimpse of the plurality and porosity to be found in the history (and likely the future) of publishing.

One of the more important aspects of the present presaged and prepared in July Monarchy print culture is the centrality of images: exchangeable pictures not only decoupled from public institutions and elite collections but gradually unmoored from their makers and contexts of production, and from their original physical for-mats too. Both artistic culture and the social environment are substantially trans-formed when images become multiple, ubiquitous, mobile, ephemeral, responsive, and widely accessible. Such an image culture invites acts of manipulation, extrac-tion, hybridizing, and recontextualization on the part of both producers and con-sumers. It can generate a set of themes, references, characters, and criteria that are familiar to a range of people who otherwise inhabit very different social strata, local communities, and knowledge horizons. While this type of common culture may enable greater access to a shared habitus and an expanded public sphere, it simul-taneously fragments, flattens, and homogenizes the ways people participate in pub-lic life, while alienating vast numbers of "other" people who are excluded from its common but by no means universal horizons. Nineteenth-century graphic culture laid some of the foundations for our own digital culture of celebrity, publicity, and performativity; of revolving topicality, echo chambers, and information bubbles; of decontextualized, degraded, and seemingly autonomous image files that are ef-fortlessly multiplied, repurposed, recirculated, emptied out, and opened up for new projections. The more we float in a world of floating images, it will become more challenging, and more necessary, to bring historical understanding and sustained visual-critical attention to the particular forms that serve and entice us.

Illustrations

Illustrations

2.3 Gavarni, *Put that in your eye, innocent! … it's better and more useful* [*Tiens donc ça dans l'oeil, innocent! … c'est mieux est plus commode*]. "Les Gens de Paris, Parisiens de Paris," in *Le Diable à Paris*, vol. 1. Wood engraving by Leblanc. Bibliothèque nationale de France. / 55

2.4 Bertall, [Flammèche with writers] "Prologue" vignette in *Le Diable à Paris*, vol. 1. Wood engraving. Bibliothèque nationale de France. / 56

2.5 Charles Nègre, *The Vampire* [*Le Stryge*, portrait of Henri le Secq], 1853. Salt-paper proof. Musée d'Orsay, Paris. © RMN-Grand Palais / Art Resource, NY. / 57

2.6 Bertall, [Flammèche as ragpicker] "Table of Contents," in *Le Diable à Paris*, vol. 1. Wood engraving. Bibliothèque nationale de France. / 61

2.7 Charles-Joseph Traviès, *The Ragpicker* [*Le Chiffonnier*]. In *Les Français peints par eux-mêmes*, vol. 3. Wood engraving by Lavieille, hand-coloured. John Hay Library, Brown University. / 62

2.8 Lapierre magic lantern, c. 1860. University of Exeter Library, Bill Douglas Centre. / 66

3.1 Gavarni, advertising poster for *Les Français peints par eux-mêmes*, 1845. Lithograph, stencil-coloured, Thierry Frères, 72 x 49.4 cm. Paris, Les Arts Décoratifs, Musée des Arts décoratifs. © Paris, Les Arts Décoratifs / Jean Tholance. / 68

3.2 Gavarni, frontispiece in *Les Français peints par eux-mêmes,* vol. 1, 1839. Wood engraving by Lavieille. Bibliothèque nationale de France. / 70

3.3 Gavarni, cover illustration for *No. 1: The Grocer* [*L'Epicier*], 1839. First instalment of *Les Français peints par eux-mêmes*. Wood engraving by Lavieille. Bibliothèque nationale de France. / 75

3.4 Gavarni, advertisement for *Les Anglais peints par eux-mêmes*, 1839. In *Les Français peints par eux-mêmes,* no. 1. Wood engraving by Lavieille. Bibliothèque nationale de France. / 76

3.5 Honoré Daumier and Charles Philipon, *Do you want gold, do you want silver, diamonds, millions and trillions? Come and be served, hurry buy your bonds!* [*Voulez-vous d'or, voulez vous de l'argent …*] In *Le Charivari*, 20 May 1838. Hand-coloured lithograph. Album Robert Macaire, Bibliothèque nationale de France. © BnF, Dist. RMN-Grand Palais / Art Resource, NY. / 77

3.6 Denis Auguste Raffet, frontispiece in *Album lithographique par Raffet*, 1835. Lithograph, Gihaut frères. Metropolitan Museum of Art. / 78

3.7 Honoré Daumier, *Sideshow of Le Charivari* [*Parade du Charivari*]. In *Le Charivari*, 6 January 1839. Lithograph, J. Caboche and Cie. Bibliothèque nationale de France. / 78

3.8 Edmé Bouchardon, *The Billsticker* [*L'Afficheur*], 1742. Title page in *Études pris dans le bas peuple, ou les Cris de Paris*. Etching by Count Caylus. Miriam and Ira D. Wallach Division of Art, Prints and Photographs, New York Public Library, Astor, Lenox, and Tilden Foundations. / 81

3.9 Anonymous, advertising poster for *Paris Comique*, 1844. Colour lithograph, Aubert and Cie, 36 x 27.5 cm. Paris, Les Arts Décoratifs, Musée des Arts Décoratifs. © Paris, Les Arts Décoratifs / Jean Tholance. / 83

Illustrations

4.11 Achille Devéria, *Portrait of Henri Herz*, 1832. Lithograph, Charles Motte, 41.5 cm x 30.5 cm. University of Michigan Museum of Art. / 127

4.12 Eugène Devéria, *Portrait of Henri Herz*, 1832. Watercolour and ink over pencil. University of Michigan Museum of Art. / 129

4.13 Eugène and Laure Devéria, *Portrait of Laure Devéria*, Salon of 1833. Watercolour. Private Collection, Jacque Devéria. Reproduced from Maximilien Gauthier, *Achille et Eugène Devéria* (Paris: Floury 1925), 14. / 129

4.14 Achille Devéria, *Portrait of Victor Hugo*, 1829. Lithograph, Charles Motte, 38 x 30 cm. © The Trustees of the British Museum. / 132

5.1 Gavarni, *Me, ever having something with that little journalist! … Oh, Edouard! No! I despise them too much* [*Moi, avoir jamais quelque chose avec ce petit journaliste! … Ah Edouard! Ô non! Je les déteste trop … et faut-il être assez malheureuse pour être obligée de faire la gentille avec des paltoquets comme ça! … mais ils vous abimeraient, dam!*]. "Les Coulisses," *Le Charivari*, 7 July 1838. Lithograph. Bibliothèque nationale de France. / 138

5.2 Gustave Doré, *Opera (the lions' den)* [*la fosse aux lions*], 1854. Lithograph, Vayronde, and Galande. Bibliothèque nationale de France. / 141

5.3 Gavarni, costume design, *Mademoiselle Clarisse, role of Paquerette in Dagobert*, 1839. Watercolour and pencil. Reproduced from Paul-André Lemoisne, *Gavarni, peintre et lithographe* (Paris: H. Floury 1924–28). / 146

5.4 Gavarni, *Irish costume* [*Irlandaise*], 1827. In *Travestissemens* [sic], no. 3 (Paris: Pierre la Mésangère 1827–30). Engraving by Georges-Jacques Gâtine, hand-coloured. © The Trustees of the British Museum. / 148

5.5 Achille Devéria, *Civilian costume from the era of Louis XIII* [portrait of Eugène Devéria], 1830. In *Suite de déguisements pour un bal masqué*. Lithograph. © The Trustees of the British Museum. / 153

5.6 Gavarni, *Débardeur. Satin hat. Velvet vest with swansdown trimming. Velvet waistcoat. Satin tie. Lace collar. Cashmere belt. Velvet trouser striped with satin. Stocking of flesh-coloured silk, silver accents. Polished shoes.* [*Débardeur. Chapeau de satin. Veste de velours garnie de Cigne. Gilet de velours. Cravatte de satin. Col de dentelle. Ceinture de Cashemire. Pantalon de velours, Charivari de satin. Bas de soie chair coins d'argent. Souliers vernis.*] In *Nouveaux travestissements*, no. 58 (Paris: Hautecoeur-Martinet 1830). Lithograph, Lemercier. © Musée Carnavalet, Paris / Roger-Viollet. / 158

5.7 Gavarni, *Déjazet in Indiana and Charlemagne*, 1840. Watercolour and pencil. Reproduced from Paul-André Lemoisne, *Gavarni, peintre et lithographe* (Paris: Floury 1924–28). / 160

5.8 Gavarni, *When the Arthurs sleep, the rats dance* [*Les Arthurs couchés, les rats dansent*]. "Les Lorettes" no. 60, *Le Charivari*, 9 July 1843. Hand-coloured lithograph, Aubert. © Musée Carnavalet, Paris / Roger-Viollet. / 162

Notes

INTRODUCTION

1 On illustrated periodicals and books, comics, and popular prints, see Mainardi, *Another World*. On fine art and reproductive engraving, see Bann, *Parallel Lines* and *Distinguished Images*. On illustrated magazines, see Gretton, "The Pragmatics of Page Design," and Jobling and Crowley, "A Medium for the Masses I." On literary and historical vignettes, see Le Men, "Book illustration"; Adhémar and Seguin, *Le livre romantique*; Melot, *The Art of Illustration*; Bann, "Achille Devéria and French Illustration"; Rosen and Zerner, *Romanticism and Realism*; Chu and Weisberg, *The Popularization of Images*; Wright, "That Other Historian, the Illustrator"; and Samuels, *Spectacular Past*. The scholarship on political caricature is discussed below.

2 Among the driving forces of the July Revolution were the press ordinances of 26 July 1830 requiring governmental authorization of newspapers. The new laws resulted in the closure of some Parisian presses and sparked protests from publishers, journalists, and press workers. Felkay, *Balzac et ses éditeurs*, 82–5. The new constitutional Charter of 14 August 1830 re-established the liberty of the press and avowed that censorship could never be reinstated. Pierre Caselle, "Le régime législatif," in *Histoire de l'édition française*, vol. 3, 47.

3 See Felkay, *Balzac et ses éditeurs*, 82, and Madeleine Rebérioux, "Les ouvriers du livre," in *Histoire de l'édition française*, vol. 3, 91.

4 For debates about the formation of elites and ascendancy of the middle classes, see Maza, *The Myth of the French Bourgeoisie*; Garrioch, *The Formation of the Parisian Bourgeoisie, 1690–1830*; and Daumard, *Le bourgeoisie parisienne de 1815 à 1848*.

5 Early in their careers, Gavarni and Balzac issued mutual praise and recognized commonalities in their approaches. Duplessis, *Gavarni*, 27. Twenty years later, Baudelaire remarked: "The veritable glory and the true mission of Gavarni and Daumier were

to complete Balzac, who, moreover, was well aware of this, and reckoned them his auxiliaries and commentators." "Some French Caricaturists," 183.

6 Lauster, *Sketches of the Nineteenth Century*, 1–22, 58.

7 Pivotal early texts include Saint-Beuve, "De la littérature industrielle" (1839); Elias Regnault, "L'Editeur" (c. 1840), in *Les Français*, vol. 4; and Baudelaire, "Some French Caricaturists" (1857). Karl Marx also broached the topic of serial literature in chapters 5 and 8 of "La Sainte Famille" (1845), where he questions the relationship of literary realism and socialism through a critique of Eugène Sue's *Mystères de Paris*.

8 Benjamin, *Charles Baudelaire*, 14.

9 Baudrillard, *La société de consommation*, as discussed in Crary, *Techniques of the Observer*, 11.

10 Some of these challenges have been ameliorated by digital resources, notably those made available by the BNF/Gallica, the British Museum, the British Library, Brown University Digital Repository, and the Getty Open Content Program.

11 On "counter-discursive" commitment in graphic satire, see Terdiman, *Discourse/Counter-Discourse*. For an example of the art-historical celebration of resistance, see T.J. Clark, *Image of the People* and *The Absolute Bourgeois*.

12 On Daumier, Philipon, and July Monarchy political caricature, see Cuno, "Charles Philipon, La Maison Aubert"; Terdiman, *Discourse/Counter-Discourse*, 149–97; Petrey, "Pears in History"; Childs, "Big Trouble" and "The Body Impolitic"; Weisberg, "The Coded Image"; and Kerr, *Caricature and French Political Culture*.

13 On Daumier as anti-phantasmagoric flâneur, see Harvey, *Paris, Capital of Modernity*.

14 See Marcus, *Apartment Stories*; Lauster, *Sketches of the Nineteenth Century*; Thornton, *Advertising, Subjectivity, and the Nineteenth-Century Novel*; Preiss, "Les Physiologies"; Prendergast, *Paris and the Nineteenth Century*; Yousif, *Balzac, Grandville, and the Rise of Book Illustration*; Berg, "Fighting for the Page"; de la Motte and Przyblyski, eds., *Making the News*; Schwartz, *Spectacular Realities*; Samuels, *Spectacular Past*; Gill, *Eccentricity and the Cultural Imagination*; and Hiner, *Accessories to Modernity*.

15 See Hahn, *Scenes of Parisian Modernity*, and Terni, "A Genre for Early Mass Culture" and "Paris Imaginaire."

16 See Le Men, "Balzac, Gavarni, Bertall," "De l'image au livre," "La vignette et la lettre," "*Les français*," and *L'affiche de librairie*; Melot, *The Art of Illustration*; Farwell, *The Charged Image* and *French Popular Lithographic Imagery*; Kleinert, "Les débuts de Gavarni"; Olson, *Gavarni: The Carnival Lithographs*; Wechsler, *A Human Comedy*; Chu and Weisberg, eds., *The Popularization of Images*; and Iskin, *The Poster*. The work of Susan Siegfried, Richard Wrigley, and Beth Wright also deserves mention.

17 Mainardi, *Another World*, 10.

18 Maidment, *Comedy, Caricature and the Social Order*, esp. 3–14 and 47–61.

19 Baudelaire, "Some French Caricaturists," 182–3. As one of the anonymous readers of this manuscript noted, there may have been a media-specific bias to this quip,

expressing Baudelaire's nostalgic preference for the "bite" of traditional intaglio techniques (burin engraving and etching) as opposed to the easy flattery of the "superficial" planographic newcomer, lithography. He could thus distinguish himself as an elite amateur who studied and collected older prints in contrast to the broader unsophisticated audience that was familiar with (without having to be knowledgeable about) the inexpensive printed images now available to everyone as periodical fare.

20 Champfleury, *Histoire de la caricature moderne*, 312–13.

21 The *lorette* is one of the most prominent female types that emerged in the July Monarchy, and was defined in its print culture. This type – generally a clever, attractive, sexually promiscuous, and self-interested young woman who trades her love for a comfortable lifestyle and high living – is discussed at length in chapter 5. See also Yousif, "Word, Image, Woman."

22 "Gavarni created the *Lorette*. She existed, indeed, a little before his time, but he *completed* her … he is so swept along by his literary imagination that he invents at least as much as he sees, and for that reason he has had a considerable effect upon manners. Paul de Kock created the Grisette, and Gavarni the Lorette; and not a few of those girls have perfected themselves by using her as a mirror, just as the youth of the Latin Quarter succumbed to the influence of his *Students*, and as many people force themselves into the likeness of fashion plates." Baudelaire, "Some French Caricaturists," 183. Emphasis in original.

23 Champfleury, *Histoire de la caricature moderne*, 313.

24 Bourdieu, *The Logic of Practice*, 56.

25 Prendergast, "Balzac and the Reading Public," 20–4.

26 Maza, *The Myth of the French Bourgeoisie*, 13.

27 See Stuart Hall, "Notes on Deconstructing the Popular."

28 Fifty per cent of the rural population and 70 per cent of the urban population were indigent, while 39 per cent of men and 54 per cent of French women were still illiterate. Chu and Weisberg, "Introduction," in *The Popularization of Images*, 9.

29 Ibid., 4–5.

30 On the widespread practice of exhibiting (pinned, pasted, or framed) prints as decoration in nineteenth-century homes, see Renié, "The Image on the Wall."

31 On the production of imagined communities in print culture, see Anderson, *Imagined Communities*, 9–36.

32 On July Monarchy fashion periodicals, see Gaudriault, *La Gravure de mode feminine*; and Hahn, "Fashion Discourses" and *Scenes of Parisian Modernity*, 63–80. Subscription numbers for *La Mode* are given in de Young, "Not Just a Pretty Picture," 113–14.

33 See *Physiologie de la Presse* and Cuno, "Charles Philipon, La Maison Aubert," 347–54.

34 Preiss, "Les Physiologies," 148–9.

35 There was wide fluctuation in the copies printed for each of the 422 weekly instalments of *Les Français*. After six months, the editor Léon Curmer claimed to have sold 18,000 copies and produced translations in English, German, and Dutch.

However, the official declarations show an average print run of 6,000 per instalment. See *Declarations des imprimeurs* and my dissertation, "Panoramic Literature," 198–242.

36 Berg, "Taming the Bourgeoisie," 44.

37 While bound volumes of illustrated works like *Les Français*, *Scènes de la vie privée*, and *Le Diable à Paris* sold for 15 francs or more, generally instalments cost 30 centimes.

38 Stephen Bann demonstrates that burin engraving (highly skilled, labour-intensive work focused on the reproduction of art) enjoyed a renaissance and a well-established international market in the 1830s. The most costly and prestigious technique, burin engraving, remained at the summit of the printmaking hierarchy until the revival of etching and "original printmaking" in the 1860s. The most celebrated reproductive engravers working in France were Calamatta, Mercuri, and Louis Henriquel-Dupont. *Parallel Lines*, 5–7.

39 Both were illustrated with wood engravings, which, though more expensive and time-consuming to produce than lithographs, could be integrated with type in the printing press. Mainardi, *Another World*, 82–95, 101–13.

40 Bellanger et al., *Histoire générale de la presse française*, vol. 2, 120. On the launch of *La Presse* and *Le Siècle* (both 1836) entailing a shift from political opinion to profit-oriented news for a wider audience, see Adamowicz-Hariasz, "From Opinion to Information." On the role of serialized novels in attracting subscriptions to these newspapers, see Yousif, *Balzac, Grandville, and the Rise of Book Illustration*, 8–12. On the new approach to advertising, see Hahn, *Scenes of Modernity*, 82–3.

41 Reading rooms in Paris grew from 23 in 1819 to 150 in 1833, 215 in 1844, and 146 in 1870. Witkowski, *Monographie des éditions populaires*, 14, 25.

42 See Barbier, "Industrialisation des techniques" and "Les imprimeurs," in *Histoire de l'édition française*, vol. 3, 57–67, 69–89.

43 See Felkay, "Les Libraires de l'époque romantique," 31–86. On bailouts and subsidies (including a government disbursement of 3 million francs to publishers in October 1830) see Felkay, *Balzac et ses éditeurs*, 86–8, and *Histoire de l'édition française*, vol. 3, 14.

44 Cohen and Higonnet, "Complex Culture," 24.

CHAPTER ONE

1 See, for example, the resentful aging *rapin* Gavarni depicts in *Ne lui parler pas des bourgeois!* (*Don't talk to him about the bourgeois!*), "Mœurs d'atéliers-3" in *Le Diable à Paris*, vol. 1. See also Harrison and Cynthia White's sociological analysis of the "rejected artist" and the *rapin*. "The widespread caricaturing of 'artistic types' must have been a reflection of real public interest in the definition of the artist's role and

profession ... In the early nineteenth century, the figure of the painter as a social exception became more prevalent: the art student or 'dauber' (*rapin*) became a stock character of comedy and the hero of melodrama, as later in Balzac, the Goncourts, and Zola ... Many painters became, in their own and other eyes, isolated figures oppressed by the heavy-handed Academy." *Canvases and Careers*, 82–3.

2 On celebrity galleries, see Guillaume and Le Men, *Benjamin Roubaud et le Panthéon charivarique*, 9.

3 Portraits of Gavarni and Monnier adorn the table of contents in vol. 1; Charlet is featured at the end of vol. 2; Français, Baron, and Tony Johannot are depicted in vol. 3. See Brivois, *Guide de l'amateur*, 157–61.

4 Bertall's three other compositions in the "Panthéon du *Diable à Paris*" represent Literature, the Theatre, and Society [Le Monde]. See chapter 1 of my dissertation, "Panoramic Literature."

5 See my article "Nadar's Signatures"; McCauley, *Industrial Madness*, 113–22; and Chotard, "Histoire de la grandeur et de la décadence du Panthéon-Nadar," 66–85.

6 See Bermingham, "Reading Constable"; Batchen, *Burning with Desire*; Pinson, *Speculating Daguerre*; and Rosen and Zerner, *Romanticism and Realism*, 49–70.

7 This constitutive circuitry between social representations and social reality was a central theme in *Les Français peints par eux-mêmes*. It is foregrounded in the title and manifest in the design of Gavarni's title image (as discussed in chapter 3). It is also echoed in the opening line of Janin's introduction: "It is always good when the writers of an age return to the public what the public has lent them, and the writer is never so happy and so popular as he is when the public has asked a lot of him, and he has given it much in return. The more numerous his borrowings, the more he becomes a man of genius. [Il faut bien toujours que les écrivains d'une époque rendent au public ce que le public leur a prêté, et l'écrivain n'est jamais si heureux et si populaire que lorsque le public lui a beaucoup demandé, et lorsqu'il lui a beaucoup rendu. Plus ses emprunts sont nombreux, et plus il est lui-même un homme de genie.]" Vol. 1, iii.

8 See Schwartz, *Spectacular Realities*, and Crary, "Géricault, the Panorama, and Sites of Reality."

9 The exceptions include Bertall and Cham, who were both aristocrats (Cham's father was a peer of France), and Monnier, a bourgeois whose father held a government position. Central sources for the biographical information in this chapter are Kaenel, *Le Métier d'illustrateur*; Farwell, *The Charged Image*; and Béraldi, *Les Graveurs*.

10 Farwell, *The Charged Image*, 55. On Daumier's life and work, see *Daumier, 1808–1879*.

11 On Philipon, see Farwell, *The Charged Image*, 119, and Cuno, "Charles Philipon and La Maison Aubert."

12 On Charlet, see Bann, *Parallel Lines*, 43–87; Driskel, "Singing 'The Marseillaise' in

1840" and "The Proletarian's Body: Charlet's Representations of Social Class during the July Monarchy," in Chu and Weisberg, eds., *The Popularization of Images*, 58–89; Walker, "Order and the Abject in Charlet's Suite"; and La Combe, *Charlet, sa vie*.

13 On Gavarni's background, see Béraldi, *Les Graveurs*, vol. 7, 5–18; Kaenel, *Le Métier d'illustrateur*, 147–8; and de Goncourt, *Gavarni, l'homme et l'œuvre*, 1–5.

14 Béraldi, *Les Graveurs*, vol. 10, 23.

15 On Devéria, see Béraldi, *Les Graveurs*, vol. 5, 210–25; *Achille Devéria: témoin du romantisme parisien*; and Gauthier, *Achille et Eugène Devéria*.

16 The Johannot brothers were born in Offenbach-am-Main; their father was also a *dessinateur*. The family was ruined around 1800. Kaenel, *Le Métier d'illustrateur*, 147–50.

17 Farwell, *The Charged Image*, 149. On Traviès, see the essays by James Cuno, Elizabeth Menon, and Gabriel Weisberg in Chu and Weisberg, eds., *The Popularization of Images*.

18 Raffet studied with Charlet and Gros. Farwell, *The Charged Image*, 139. On Monnier, see Béraldi, *Les Graveurs*, vol. 10, 78–85; and Melcher, *The Life and Times of Henry Monnier*.

19 Farwell, *The Charged Image*, 71.

20 Daumier also enrolled for a short time in the studios of Suisse and Bousin. Farwell, *The Charged Image*, 55.

21 Béraldi, *Les Graveurs*, vol. 7, 5–18. Farwell, *The Charged Image*, 83.

22 This applied to burin engravers too: "This process involved the printmaker in working for years on a single plate, with a corresponding necessity for monetary support by a patron or the French state." Bann, "Horace Vernet and Paul Delaroche," 231.

23 See Haynes, *Lost Illusions*, 1–47. She argues that a "new breed of publishers" emerged in the July Monarchy: modern "producers" who were financiers and entrepreneurs of print.

24 Maidment, *Comedy, Caricature and the Social Order*, 3–14, 47–61.

25 Among the notable lithographic printers in Paris were Aaron Martinet, Godefroy Engelmann, Charles de Lasteyrie, François-Séraphin Delpech, the Maison Aubert, Antoine-François Gihaut, and Charles Motte. Mainardi, *Another World*, 37–9, 49.

26 Béraldi, *Les Graveurs*, vol. 5, 210–25.

27 On Gavarni, see de Goncourt, *Gavarni, l'homme et l'œuvre*; Armelhaut and Bocher, *L'Œuvre de Gavarni*; Béraldi, *Les Graveurs*, vol. 7, 5–82; and Lemoisne, *Gavarni, peintre et lithographe*. *Fantasies* and *diableries* denote whimsical arrangements of fantastic imagery; *abécédaires* are alphabet primers.

28 Béraldi, *Les Graveurs*, vol. 7, 6, 36.

29 Kaenel, *Le Métier d'illustrateur*, 143. On the crossovers between caricature, illustration, and commercial photography, see McCauley, "Caricature and Photography in Second Empire Paris."

30 Alongside his print production (approximately 4,000 plates) Daumier made 231 paintings and 826 drawings. A retrospective exhibition of Daumier's work held at Durand-Ruel's gallery in 1878 included 94 paintings, 138 drawings, clay busts, and a handful of prints. Henri Loyrette, "Situating Daumier," 12–14.

31 Doré showed his painting of *Dante and Virgil* at the Salon of 1861. His sculpture *Fate and Love* was included in the Salon of 1877.

32 Béraldi, *Les Graveurs*, vol. 10, 78–85; Kaenel, *Le Métier d'illustrateur*, 151.

33 Octave Uzanne, "Gavarni as a Painter" and "Gavarni the Writer," in *Daumier and Gavarni*, G xxiii–xxv. One of Gavarni's short stories, "Une aventure d'omnibus," was published in *Le Charivari*, 26 August 1840. See Amann, "The Devil in the Omnibus."

34 Baudelaire's "Quelques caricaturistes français," published in *Le Présent* (1857), discussed the work of Carle Vernet, Pigal, Charlet, Daumier, Monnier, Grandville, Gavarni, Trimolet, Traviès, and Jacque. Translation in Mayne, *The Painter of Modern Life and Other Essays*, 166–86.

35 Kaenel, *Le Métier d'illustrateur*, 81.

36 Romantic book illustration is highly valued by historians of art and the book, presumably because it is tied to prestigious writers and romantic aesthetics. It is also the form of graphic art most similar to history painting, which also selects and illustrates significant moments from history or literature. See Carteret, *Le trésor du bibliophile romantique*; Le Men, "Book Illustration"; Melot, *The Art of Illustration*; Rosen and Zerner, *Romanticism and Realism*; Yousif, *Balzac, Grandville, and the Rise of Book Illustration*; and Bann, "Achille Devéria and French Illustration in the Romantic Period."

37 "La majeure partie des artistes français actifs entre 1830 et 1880 ont tôt ou tard donné des dessins pour la librairie." Kaenel, *Le Métier d'illustrateur*, 138.

38 Ibid., 138–41.

39 Janin, "Introduction," *Les Français peints par eux-mêmes*, vol. 1, xv. His chosen terms "drame" (or theatrical drama) and "tableau" (painting) conjure a venerated lineage for lowly forms and marginal cultural producers.

40 In his sales catalogues from 1841 to 1845, Curmer pitched *Les Français* as a tableau: "le tableau le plus varié, le plus vrai, et le plus amusant de la société française à notre époque" [the most varied, the most true, and the most amusing picture of French society in our epoch]. *Catalogues de la librairie*, BN Serie Q-10, T4-N8 MAG.082 (CURMER). Likewise, note Hetzel's use of tableau in his title: *Le Diable à Paris … tableau complet sur leur vie privée, politique, artistique, littéraire, industrielle etc. etc.*

41 See Roth, "'L'Artiste' and 'L'art pour l'art.'"

42 "Théophile Gautier, first sentence of the introduction to *Paris et les Parisiens au XIXe siècle* (Paris, 1856), i." Qtd. in Benjamin, [The Streets of Paris: P4,3] *The Arcades Project*, 524.

43 Kaenel, *Le métier d'illustrateur*, 139.

44 Béraldi, *Les Graveurs*, vol. 5, 210–25.

45 Renonciat, "P.J Hetzel et J.J. Grandville," 28. Renonciat argues that Grandville's bid for artistic status was realized in the terrain of the illustrated book, relative to the status of writers, but could not be recognized by the Academy, relative to the status of history painters. However, Kaenel argues that Grandville had no aspirations toward academic painting. *Le métier d'illustrateur*, 99.

46 Goncourts, qtd. in Béraldi, *Les Graveurs,* vol. 7, 16.

47 Ibid., vol. 7, 5.

48 On Daumier: "One of the most important men, I will not say only in caricature, but in the whole of modern art … The veritable glory and the true mission of Gavarni and Daumier were to complete Balzac, who, moreover, was well aware of this, and reckoned them his auxiliaries and commentators." Baudelaire, "Some French Caricaturists," 171, 183.

49 On this "position dominée," see Kaenel, *Le Métier d'illustrateur*, 39. On the *banlieues*, see page 145: "Le développement de la presse et du livre illustrés au début de la Monarchie de Juillet crée donc un nouveau marché bienvenu pour la plupart. Ce marché soutient un nombre considerable de vocations en leur donnant des moyens de vivre dans ces banlieues de l'art que sont les caricatures et les vignettes."

50 Bann, *Parallel Lines*, 3–6.

51 Gretton, "The Pragmatics of Page Design," 707.

52 In 1816 there were forty chairs with membership for life: fourteen painters, eight sculptors, eight architects, four engravers, six composers of music. White, *Canvases and Careers*, 17. Lithographers "never achieved the status that engravers enjoyed, and never were accepted as members of the Academy." Mainardi, *Another World*, 16.

53 On Bervic, who was elected to the Academy in 1803, see Bann, *Parallel Lines*, 51, 57–8.

54 On exchanges between painters and printmakers, and the case of Delaroche and Mercuri, see ibid., 1–7, 30–41.

55 Carle was elected to the academy in 1815, Horace in 1826. On the Vernets' work in painting and print, see Bann, *Parallel Lines*, 43–87, and "Horace Vernet and Paul Delaroche," 234–5. On lithography at the Salon, see Mainardi, *Another World*, 14–21.

56 1817 marked the first entry of lithographs – by Carle Vernet and Thiénon – to the Salon. Rosen, "The Political Economy of Graphic Art Production," 41. "Most early lithographs exhibited at the Salon were portraits, views of landscape or cityscape, or reproductions of esteemed works of art; there was little genre imagery and no caricature at all although these categories were rapidly becoming predominant in lithographic production. Prints were listed under the name of the lithographer or publisher (often the same individual), while the artist who produced the lithograph was mentioned only secondarily, if at all. This is in the tradition of engraving, which always appeared in the Salon as the work of the artist who produced the print, not the artist who produced the drawing or painting from which the print was made." Mainardi, *Another World*, 14–15.

57 White, *Canvases and Careers*, 20.

58 Ibid., 27–33.

59 Rifkin, "Ingres and the Academic Dictionary," 162–4.

60 On the dealer-critic system, see White, *Canvases and Careers*, 88–99.

61 During the Empire and Restoration, Ingres's "potential market was a nascent free market of a bourgeois commodity type; none the less many of the individuals who made up that market came not from a new bourgeoisie, but from some remnants of the old aristocracy ... he found his own success in a new kind of art market largely made up of an old kind of client. The mixture ... is a characteristic of France before 1830." Rifkin, "Ingres and the Academic Dictionary," 158–60.

62 Green, "Circuits of Production," 30–1.

63 Hahn, *Scenes of Parisian Modernity*, 36–8.

64 Crary, *Techniques of the Observer*, 20. This is a seminal study of how the modern observer was historically constituted and made adequate to a new constellation of economic and institutional imperatives.

65 Ibid., 23.

66 These new historical genres offered up more relatable histories in the form of "small consumer paintings." Rifkin, "Ingres and the Academic Dictionary," 58.

67 Boime, "Declassicizing the Academic," 50–1.

68 Rifkin, "Ingres and the Academic Dictionary," 43–4.

69 On the military portraits as magnified vignettes, see Rosen and Zerner, *Romanticism and Realism*, 23–8, 37–48. On *Raft of the Medusa*, see Crary, "Géricault, the Panorama, and Sites of Reality"; Simon, "The Axe of the Medusa"; *Théodore Géricault: The Alien Body*; and Eitner, *Géricault: His Life and Work*.

70 *Various Subjects Drawn from Life and on Stone* comprised twelve lithographs plus a frontispiece. Boime comments that Géricault hoped lithography could earn him "a considerable fortune," commissions from amateurs, and freedom from the French fine-arts establishment. "Lithography offered an alternative market for would-be independents, whose agenda put them on a collision course with the government." *Art in an Age of Counterrevolution*, 164–8.

71 See Pinson, *Speculating Daguerre*, esp. 93–121.

72 On Daguerre's lithographs, see ibid., 220. The reference to "the greatest compilation" or the *Voyages pittoresques et romantiques dans l'ancienne France*, 23 vols., edited by Charles Nodier, Justin Taylor, and Alphonse de Cailleux (Paris: Gide fils, A.-F. Lemaître, Thierry frères, 1820–78), is in Mainardi, *Another World*, 3.

73 Baudelaire, "The Painter of Modern Life," 4–5. Baudelaire's essay was written between November 1859 and February 1860. It was published in three instalments of *Figaro* in November and December 1863. Mayne, *The Painter of Modern Life*, xviii.

74 See, among others, Hanson, *Manet and the Modern Tradition*; Fried, *Manet's Modernism*; Lajer-Burcharth, "Modernity and the Condition of Disguise"; and Krämer, "Mon tableau."

75 Stierle, "Baudelaire and the Tradition of the Tableau de Paris." Stierle's genealogy does not distinguish between purely literary manifestations of the *tableau de Paris* and work in which illustration is essential.

76 In a letter to his mistress, Balzac grumbled that illustrations rather than literary merit procured the greatest profits: "Je vous sacrifie un billet de mille francs qu'on me donne pour un de ces ouvrages stupides comme *La vie privée des animaux* qui se vendent à 25000 exemplaires à cause des vignettes." Balzac to Madame Hanska (22 January 1843), qtd. in Renonçait, "P.J. Hetzel et J.J. Grandville," 28.

77 Stierle, "Baudelaire and the Tradition of the Tableau de Paris," 348.

78 Cohen and Higonnet, "Complex Culture," 15.

79 Wolfarth, "Et Cetera? The Historian as Chiffonnier," 146.

80 Benjamin, [On the Theory of Knowledge, Theory of Progress: N1a,8] in *The Arcades Project*, 460. On Benjamin's method and montage, see Doherty, "The Colportage Phenomenon of Space."

81 Benjamin, [On the Theory of Knowledge, Theory of Progress: N2,6] in *The Arcades Project*, 461.

82 Ibid., [N1a,6] 460.

83 "A central problem of historical materialism that ought to be seen in the end: Must the Marxist understanding of history necessarily be acquired at the expense of the perceptibility of history? Or in what way is it possible to conjoin a heightened graphicness [Anschaulichkeit] to the realization of the Marxist method? The first stage in this undertaking will be to carry over the principle of montage into history. That is, to assemble large-scale constructions out of the smallest and most precisely cut components. Indeed, to discover in the analysis of the small individual moment the crystal of the total event. And therefore, to break with vulgar historical naturalism. To grasp the construction of history as such. In the structure of commentary." Ibid., [N2,6] 461.

84 "The words are Rudolf Borchardt's in *Epilegomena zu Dante*, vol. 1 (Berlin, 1923), 56–7." Ibid., [N1,8] 458.

CHAPTER TWO

1 Odile and Henri-Jean Martin note that emerging editors were more likely to secure short essays from reputable writers rather than full-length book contracts. Martin, "Le monde des editeurs," in *Histoire de l'edition francaise*, vol. 3, 178. On editors' open-ended solicitations to writers and artists, see chapter 2 of my dissertation, "Panoramic Literature."

2 Hetzel to de Musset: "On peut faire des drames, des comedies, des nouvelles, des discours, des essais, des meditations, des considerations, des confessions, des voyages,

des lamentations, des revues, des contes vrais ou fantastiques, des memoires, des confidences, etc. etc. quoi que vous faissiez, monsieur, je sera bien heureux que vous veuillez bien faire quelque chose." Parménie, *Histoire d'un éditeur et de ses auteurs*, 23.

3 *Scènes de la vie privée et publique des animaux* sold 14,000 copies. Berg, "Taming the Bourgeoisie," 44. In 1841 Hetzel formed a limited partnership with Dubochet and Furne to publish Balzac's collected works as *La Comédie humaine*; the multi-volume edition would be edited by Hetzel and illustrated by Meissonier, Gavarni, Henri Monnier, Traviès, Daumier, Célestin Nanteuil, and Bertall. Meanwhile, Hetzel published *Scènes de la vie privée et publique des animaux* (1840–42) and *Le Voyage où il vous plaira* (1843). While *Le Voyage* was a smaller-scale collaboration between Hetzel (writing for the first time under the pseudonym P.J. Stahl), Alfred de Musset, and Tony Johannot, *Scènes de la vie* gathered the work of many authors (including Balzac, Charles Nodier, and Alfred and Paul de Musset) to be illustrated by a single artist, Grandville.

4 One hundred and six instalments of *Le Diable à Paris* were produced and sold at thirty centimes a piece; the two volumes cost fifteen and seventeen francs respectively. The total issue included approximately 800 vignettes and 212 full-page caricatures. See Brivois, *Guide de l'amateur*, 124–8.

5 Other contributing authors include Eugène Briffault, Taxile Delord, Alphonse Karr, and Octave Feuillet.

6 "Tu y seras, sous la forme qu'il te plaira de choisir, mon correspondant et mon ambassadeur, et tu auras soin, si tu tiens à mes bonnes grâces, de m'écrire toutes les semaines pour m'en donner des nouvelles. Je prétends apprendre de toi tout ce qui s'y passe, et qu'un fois tes notes envoyées, on sache ici de Paris tout ce qu'il est bon, tout ce qu'il est, diaboliquement parlant, possible d'en savoir." P.-J. Stahl [Hetzel], "Prologue," *Le Diable à Paris*, vol. 1, 23.

7 "Sire, Paris est le plus beau fleuron de votre couronne, et je serai bientôt en mesure d'envoyer successivement à Votre Majesté un compte rendu fidèle de ces mille choses gaies et de ces mille choses tristes dont se compose l'univers parisien, – tout choses contre lesquelles votre ennui ne saurait tenir, – sans oublier ce que vous aimez tant, – et images à toutes les pages!" Ibid., 29.

8 The term "panoramic literature" was coined by Walter Benjamin to describe new literary genres and multi-authored anthologies boasting encyclopedic representations of modern life in Paris. Benjamin, "Paris, the Capital of the Nineteenth Century" (1935), in *The Arcades Project*, 3–13. See also Le Men and Abélès, eds., *"Les français peints par eux-mêmes": panorama social du XIXe siècle*; Cohen, "Panoramic Literature"; Marcus, *Apartment Stories*, 17–50; and Ferguson, *Paris as Revolution*.

9 Two different lithographic advertising posters featuring Gavarni's frontispiece motif are preserved at the Musée des Arts Décoratifs, Paris. Presumably, a version of this motif would also have adorned the serial instalment covers.

10 In his reading of Flaubert's *Sentimental Education*, Bourdieu interprets the city as a game board on which the characters' struggle for social power is played out. See *The Rules of Art*. Walter Benjamin had earlier pointed to such a dynamic in the novels of Balzac: "Balzac has secured the mythic constitution of the world through precise topographic contours. Paris is the breeding ground of this mythology – Paris with its two or three great bankers (Nucingen, du Tillet), Paris with its great physician Horace Bianchon, with its entrepreneur César Birotteau, with its four or five great cocottes, with its usurer Gobseck, with its sundry advocates and soldiers. But above all – and we see this again and again – it is from the same streets and corners, the same little rooms and recesses, that the figures of this world step into the light. What else can this mean but that topography is the ground plan of this mythic space of tradition, as it is of every such space, and that it can become indeed its key." *The Arcades Project*, [C1,7] 83.

11 Hugo's novel was first published in Paris by Gosselin in 1831 and then augmented with two extra chapters to form the "definitive edition" published by Renduel in 1832. The chapter "A Bird's-Eye View of Paris" was included in both editions. My citations are from Hugo, *Notre Dame de Paris*, trans. Alban Krailsheimer, 128–33.

12 From Hugo's "Note Added to the Definitive Edition" (1832): "Let us inspire the nation, if possible, with a love of our national architecture. Such, the author declares is one of the main aims of this book; such is one of the main aims of his life … On more than one occasion he has already pleaded the cause of our old architecture, he has already spoken out loudly to denounce many a profanation, many a demolition, many an impiety." *Notre Dame de Paris*, 10. The translator notes: "From 1835 until 1848 … [Hugo] served continuously and actively on a government committee for ancient monuments." Krailsheimer, "Introduction," *Notre Dame de Paris*, x.

13 This quotation's ellipses and editorial projections indicate my inability to decipher portions of Hetzel's original handwritten manuscript, which appears to be a draft of an introduction or prospectus to the *Diable à Paris*. Papiers Hetzel, BN, Manuscrits: NAf. 17014, F. 1–4.

14 *Le Diable à Paris. Paris et les Parisiens. Moeurs et coutumes, caractères et portraits des habitants de Paris, tableau complet sur leur vie privée, politique, artistique, littéraire, industrielle, etc. etc.*

15 "Voulez-vous la voir dans toute sa grandeur, cette fière cité étendue à vos pieds et déroulant sous vos regards son vaste panorama? Montez la rue des Martyrs, les degrés du Panthéon, les sentiers du Père-Lachaise … Paris est le rendez-vous des monuments de tous les styles et de toutes les époques. Vus à vol d'oiseu, on dirait que ces édifices se touchent … Mais laissons là le pinceau du paysagiste; aussi bien il nous faudrait tout au moins le burin de Callot, la palette de Salvator Rosa, et les toiles gigantesques de Martin. Ce qu'il nous reste à décrire, c'est l'âme de ce grand corps … c'est le Paris de chair et d'os, le Paris d'hommes après le Paris de pierre. Entrez dans

la grande ville: voici la foule … cet immense et populeux bazar, à ce rendez-vous universel de l'espèce que Buffon a classée entre le singe et Dieu." Texier, "Introduction," *Tableau de Paris*, vol. 1, iii.

16 In 1840 a new edition of Le Sage's *Le Diable boîteux* (1707) was published in Paris by Bourdin and Cie with illustrations by Tony Johannot. On representations of the devil and Asmodeus in nineteenth-century European panoramic literature, see Lauster, *Sketches of the Nineteenth Century*, 129–72.

17 In *Paris, ou le Livre des cent-et-un* [hereafter *Paris*], Asmodeus is mentioned as a personification of authorial agency in both the editor Ladvocat's preface and the compilation's first essay, "Asmodée," by Jules Janin. Asmodeus was also depicted on the title page of the book's first volume in a vignette by Henri Monnier.

18 "Je vous conduira dans les salons et dans les mansardes, dans les réunions politiques et dans la rue et comme son frère ainé le diable boiteux, il fera sauter, s'il le faut du bout de sa béguille, le toit des maisons pour vous initier aux secrets les plus cachés, aux plus intimes, mysterieux de cette vie étrange et exceptionnelle." *Papiers Hetzel*, NAf. 17014, F. 10–13. Note that in the haste of the draft Hetzel has elided his own agency with that of the two diabolic guides to the city (Flammèche and Asmodeus), crossing over from the first to the third person. Diabolic focus notwithstanding, Hetzel abandoned any direct references to Asmodeus in the published form of *Le Diable à Paris*.

19 Williams, *Dream Worlds*, 114.

20 "De Marsay, with his ready wit, the certain knowledge of his own attractions, and the right clothes, eclipsed all rivals within his range" (176). "Although he was only two feet away from the newcomer, de Marsay raised his eye-glass in order to see him … he examined them as if they had been animals of some strange species" (178). "A deadly chill seized the poor poet when he saw that de Marsay was eyeing him through his glass; this lion of Paris let his eyeglass drop in such a way that to Lucien it suggested the blade of the guillotine." Balzac, *Lost Illusions*, 188.

21 Foucault, *The Order of Things*, esp. "Man and His Doubles," 303–43.

22 Crary, *Techniques of the Observer*.

23 Clifford, "On Ethnographic Authority."

24 "The spectator is a prince who everywhere rejoices in his incognito … Thus, the lover of universal life enters into the crowd as though it were an immense reservoir of electrical energy … an 'I' with an insatiable appetite for the 'non-I.'" Baudelaire, "The Painter of Modern Life," 9.

25 Schwartz, *Spectacular Realities*, 10. Ferguson argues that Balzac is the first to characterize the flâneur as an artist who is both in and above the inferno of Paris. *Paris as Revolution*, 80–93.

26 Despite the title of the article on the flâneur in the *Livre des cent-et-un*, the anonymous author insists that the type is a consumer rather than a producer of Parisian

representations: "Le flâneur, tel qu'il se développe à nos yeux, n'est plus ni poète, ni philosophe. C'est un des effets de la division du travail dans nos sociétés … Le flâneur du dix-neuvième siècle, est flâneur, et rien de plus." "Le Flaneur à Paris, par un flaneur," *Paris*, vol. 6, 98. On the flâneur as spectator rather than an artist, see also Wrigley, "Unreliable Witness."

27 "Il s'avance librement au milieu de cette foule dont il est le centre, et qui ne s'en doute pas!" "Le Flaneur à Paris, par un flaneur," *Paris*, vol. 6, 101.

28 In previous series depicting Parisian street criers and tradesmen extending back to circa 1500, the chiffonnier was occasionally included under related rubrics such as *le chiffonnier-ferrailleur* (rag and scrap-metal merchant).

29 "Connaissez-vous un signe plus approprié à son idée, un mot plus exclusivement français pour exprimer une personification toute française? … Le flâneur est essentiellement national … grâce à une merveilleuse perspicacité, il sait moissonner encore d'incroyables richesses dans ce vaste champ de l'observation où le vulgaire ne fauche qu'à la surface." August de Lacroix, "Le Flâneur," in *Les Français*, vol. 3, 65.

30 "Voici les types monstreux, d'ignobles figures, d'abominable mœurs: la forme, le fond, le dessus, le dessous, tout est pourri chez les chiffonniers … ils parlent l'argot, l'idiome des voleurs et des assassins … Comme si le choléra y soufflait toujours, l'air que l'on respire dans ces tristes quartiers est chargé de miasmes putrides et infects … [Bien] que l'imagination ne conçoive pas d'inégalités possibles parmi eux, les chiffonniers subissent comme la société supérieure, toutes les conditions de notre organisation fatale; il y a chez eux des pauvres et des riches, des grands et des petits, tout comme il y en a au-dessus d'eux." L.A. Berthaud, "Les Chiffonniers," in *Les Français*, vol. 3, 332–4.

31 It is also worth noting that the editor commissioned this particular portrait from Traviès, who specialized in depictions of the urban poor. Gavarni, who was celebrated for his sketches of fashion and women, had set the pictorial tone for the other metropolitan types in *Les Français*.

32 *Tableau de Paris, par L.S. Mercier*. For a literary genealogy of Parisian descriptions from Mercier through the July Monarchy anthologies and beyond, see Stierle, "Baudelaire and the Tradition of the Tableau de Paris."

33 Curmer, *Note presenté*.

34 "Plus tard il [Asmodeus] s'est chargé d'une hotte de chiffonnier. Il a cherché les mœurs et les histoires dans tous les égouts de Paris … Même dans sa hotte il a trouvé des choses charmantes, même sur la borne il a écrit des chefs-d'oeuvre!" Janin, "Asmodée," *Paris*, vol. 1, 10–11. Janin's mention of the border is a likely reference to Mercier, who wrote his *Tableau de Paris* in exile.

35 For Curmer, the intellectual role of the editor demanded by illustrated books is what separates the modern publisher from the mere manufacturer or merchant (4): "Le commerce de la librairie, comme on le prend en général, ne consiste en rien autre chose qu'en un échange d'argent contre des feuilles imprimées, que le brocheur livre

ensuite en volumes. La librairie prise de ce point de vue avait perdu la caractère intellectuel que nos devanciers avaient su lui donner; ce n'était plus qu'un négoce dans l'acception la plus stricte du mot. La librairie a acquis aujourd'hui une autre importance, et elle la doit à la profession d'Editeur qui est venue s'implanter chez elle depuis l'introduction des livres illustrés." As for the profession's economic contributions: "L'éditeur étant, par sa position, le point vers lequel convergent une foule d'industries qu'il alimente." Curmer, *Note presenté*, 6.

36 See Le Men, "De l'image au livre: l'éditeur Aubert et l'abécédaire en estampe," 21; Preiss, "Les Physiologies," 15–17; and my "Panoramic Literature," chapter 2.

37 For the contract between Balzac and Hetzel for *Diable à Paris*, see *Papiers Hetzel*, NAf. 16933, F. 84. A contract between the two men for the *Comédie humaine*, NAf. 16933, F. 85, establishes that Hetzel will pay Balzac 3,000 francs for the right to republish "chaque ouvrage paru dans les journaux ou revues."

38 On the book by Lavallée, see Martin, "Le Monde des éditeurs," in *Histoire de l'edition francaise*, vol. 3, 180.

39 *Papiers Hetzel*, NAf. 16953, F. 11.

40 "Paris, ô Parisiens! est moins connu de vous et des autres que les villes moins explorées, que les plus impénétrable déserts … Paris demandera encore des études, des physiologies, des descriptions de toute sorte à la plume éternellement insuffisante du romancier, du poëte comique, du moraliste et du feuilletonniste … Paris, échappant à la loupe de l'observateur, gardera sa physiognomie insaisissable et ses mystères." Texier, "Introduction," i.

41 Ibid., ii.

42 Foucault, "Fantasia of the Library," 92, 104.

43 "Le plan de ce livre est très simple. Il faut passer en revue le Paris moderne" (vi). "Ce drame à cent actes divers" (ix). "Voici donc un livre neuf, s'il en fut jamais; neuf par la matière, neuf par la forme, neuf par le procédé de la composition qui en fait une espèce d'encyclopédie des idées contemporaines, le monument d'une jeune et brillante époque, l'*album* d'une littérature ingénieuse et puissante." Ladvocat, "Au public, le libraire-éditeur," *Paris*, vol. 1, ix.

44 "Une comédie en cent actes divers" (xv). "Un registre tout exprès pour y transcrire ces nuances si fines, si déliées, et pourtant si vraies, de nos mœurs de chaque jour." Janin, "Introduction," *Les Français*, vol. 1, iii–iv.

45 "Dans cette lanterne magique, où nous nous passons en revue les uns et les autres, rien ne sera oublié, pas même d'allumer la lanterne." Ibid., xvi.

46 "Le Diable à Paris est le vivant tableau de la grande ville déroulé scène par scène; c'est la lanterne magique où viennent se suivre toutes les nuances de ce monde parisien tant exploré et si peu connu." *Papiers Hetzel*, NAf. 17014, F. 10–13.

47 "Tout passe sous nos yeux comme une éternelle fantasmagorie." Texier, "Introduction," iv.

48 Both the chiffonnier and the flâneur have been historiographically transformed

since these early- and mid-nineteenth-century portrayals, often as the focus of cultural theorists' desire to locate emblems of their own critical activity. Many accounts radicalize these figures as counter-discursive heroes who undermine hegemonic representations of the modern city, or reveal the political reality buried beneath the instrumental configuration of bourgeois representations and discourses. On critical transformations of the chiffonnier (especially in the work of Walter Benjamin), see Wohlfarth, "Et Cetera? The Historian as Chiffonnier." For a retrospective transformation of the July Monarchy flâneur into an agent of critical subversion, see Harvey, *Paris, Capital of Modernity*, 23–57.

49 "Que voulez-vous donc qu'il cherche, lui, fils de la cité encyclopédique et universelle; lui, flâneur par goût, par passion, par métier; lui, spectateur assidu et journalier d'une *revue* éternelle que passent en son honneur tous les produits imaginables de notre monde sublunaire? Il n'a pas besoin de voyager: c'est l'universe qui voyage pour son compte, qui se déplace pièce par pièce pour venir solliciter son suffrage, faire appel à ses goûts d'amateur et de consommateur." Texier, "Introduction," iv. Emphasis added.

CHAPTER THREE

1 The first instalment of *Les Français* was published in 1839. The anthology eventually comprised 422 installments, or eight volumes issued from 1840 to 1842.

2 Alongside *Les Français*, one might include *La Grande ville*, 2 vols. (1842–43); *Scènes de la vie privée et publique des animaux*, 2 vols. (1840–42); and *Le Diable à Paris*, 2 vols. (1844–46).

3 See Preiss, "Les Physiologies," and Lhéritier, "Les Physiologies."

4 Benjamin, "Paris, the Capital of the Nineteenth Century [Exposé of 1935]," in *The Arcades Project*, 3–13. On the literary genealogy of these forms, see Stierle, "Baudelaire and the Tradition of the *Tableau de Paris*."

5 See *"Les français peints par eux-mêmes": panorama sociale*, ed. Le Men and Abélès; Cohen, "Panoramic Literature and Everyday Genres"; Sieburth, "Same Difference: The French Physiologies 1840–42"; Marcus, *Apartment Stories*, 17–50; Terdiman, *Discourse/Counter-Discourse*, 85–116; Ferguson, *Paris as Revolution*, 36–79; Green, *The Spectacle of Nature*; and Cuno, "Charles Philipon and La Maison Aubert."

6 Where supply is addressed the tendency is to focus on censorship – for example, to posit that publishers turned to social caricature only as an acceptably lightweight alternative to political caricature in a time of state repression. Missing from this line of argument is consideration of the greater market potential of non-partisan social caricature.

7 Whereas the old hand presses produced at most 250 pages per hour, the Nicholson mechanical press of 1790 could produce 1,000 pages per hour, and the Koenig/Taylor

press of 1834 increased the hourly output to 36,000 pages. Allen, "Le commerce du livre romantique à Paris (1820–1843)," 80. On the increasing adoption and integration of industrial processes in publishing, and the corresponding reorganizations of capital, the workplace, and labour, see Martin and Chartier, eds., *Histoire de l'édition française*, vol. 3.

8 In the publishing sector, mass production and consumption would not exist until the Second Empire. See Witkowski, *Monographie des éditions populaires*. On the emergent contours of industrialization and consumer culture in the July Monarchy, see Pinkney, *Decisive Years in France, 1840–1847*; Williams, *Dream Worlds*; Hahn, *Scenes of Parisian Modernity*; and Terni, "A Genre for Early Mass Culture" and "Paris Imaginaire."

9 Allen, "Le commerce du livre romantique à Paris," 70. Léon Curmer described the new profession of the editor – "le point vers lequel convergent une foule d'industries qu'il alimente" [the point of convergence for a crowd of industries that he nourishes] – at the French industrial exhibition of 1839. *Note presenté*, 6.

10 "The commodity reflects the social characteristics of men's own labour as objective characteristics of the products of labour themselves … It is nothing but the definite social relation between men themselves which assumes here, for them, the fantastic form of a relation between things." Marx, *Capital*, vol. 1, 163–5.

11 The subtitle *encyclopédie morale du dix-neuvième siècle* was added later in the production cycle, causing Curmer to reissue title pages for the first three volumes. The boastful description, "le tableau le plus varié, le plus vrai, et le plus amusant de la société française à notre époque," was a standard feature in many of Curmer's sales catalogues from the 1840s, preserved at the BN: *Catalogues de la librairie*, Serie Q-10, T4-N8 MAG.082 (hereafter referred to as Curmer, *Catalogues*).

12 An almost complete record of the *Correspondence des Français*, along with the covers and front matter of each instalment, is preserved as a "tome x" of *Les Français* in the BN (mfm. 11372).

13 "Prix de chaque volume grand in 8': broché, gravures noires, 15 fr; colorié, 25 fr; cartonné avec une très-élégante couverture en plusiers couleurs, 17 fr; demi-reliure, 20 fr; relié en maroquin chagrin riche, doré sur tranche, 25 fr." Curmer, *Catalogues*, 1841, 1844.

14 *Le prisme: Encyclopédie morale du dix-neuvième siècle* (Paris: Curmer, 1841). Before *Le prisme* was collected as a volume, it appeared serially as a half-page insert within each regular instalment of *Les Français* from no. 95 to no. 262. On the use of albums and anthologies for the commercial recombination of heteroclite texts and images, see my dissertation "Panoramic Literature," chapter 2.

15 As advertised in 1841, each instalment of *Les Français: Costumes des principales provinces de France* included two lithographs coloured with aquarelle and captioned in French, English, German, and Italian. A silk-bound volume sold for 60 francs in 1842 and 45 francs in 1844 and 1847. Curmer, *Catalogues*. Ségolène Le Men records

that only eight instalments were realized, costing 5 francs a piece. *"Les français peints par eux-mêmes,"* 57–8.

16 Definition: "logotype *n* (1816) 1: a single piece of type or a single plate faced with a term (as the name of a newspaper or a trademark) 2: an identifying symbol (as for advertising)." *Webster's Ninth New Collegiate Dictionary* (Springfield, IL: Merriam-Webster 1990), 708.

17 Le Men notes that Gavarni's motif was also modified for the frontispiece and advertising poster of the *Costumes* series. *"Les français peints par eux-mêmes,"* 58. In addition, the motif was adapted for printed advertisements, as in the miniature replica of the *Les Français* frontispiece in a small, illustrated catalogue of 1844. Curmer, *Catalogues.*

18 Lithography also enabled easy copy transfer: a freshly inked print pulled from an original woodblock could be transferred, in reverse, to a lithographic stone ready for printing. However, the poster for *Les Français* is an exception to this logic of transfer: it is not printed in reverse, and closer examination reveals discrepancies in the draftsmanship and composition that indicate the motif was redrawn by hand (see especially the gamin's stance and the treatment of the fabrics on the figures at left).

19 *Heads of the People, or, Portraits of the English: Drawn by Kenny Meadows, with Original Essays by Distinguished Writers,* 2 vols. (London: Robert Tyas 1840–41). The first instalment appeared in November 1838.

20 Thomas Bewick is credited with perfecting the technique of wood engraving for illustration, using a burin on an end-grain block rather than a knife and gouge with the grain as in traditional woodcut prints. Melot, *The Art of Illustration,* 130. During the July Monarchy, British wood engravers brought the technique to Paris, working for French publishers and training French practitioners. See Le Men, "Book Illustration," 96.

21 See Maidment, *Comedy, Caricature and the Social Order,* 31–2.

22 *Les Anglais peints par eux-mêmes: par les sommités littéraires anglaises, dessins de M. Kenny Meadows, traduction de M. Emile de la Bédollierre,* 2 vols. (Paris: Curmer 1840–41). According to Brivois, Gavarni and a M. Malapeau added to Meadow's original illustrations, and the publication was first announced in the *Journal de la librairie* in 1839. *Guide de l'amateur,* 5–8. The first instalment of *Les Français* was issued in May 1839 and the last (no. 422) in August 1842. The two works were priced identically (instalments 30 cents; basic volumes 15 francs) and had the same format: each instalment or chapter comprising one full-page portrait plus eight pages of text.

23 These three works, all in the collection of the BN Estampes, are reproduced in microfiche in Farwell, *French Popular Lithographic Imagery,* vol. 12.

24 Allen notes that, by 1835, publishers' ads had moved from their own prospectuses and industry journals to the fourth page of the newspapers where they were promoted alongside other consumer goods. "Le commerce du livre romantique à Paris,"

77. Curmer boasted that his significant advertising budget essentially underwrote the newspaper business: "C'est à la librairie pour la plus grande partie que les journaux doivent ces produits qui sont la meilleure partie de leurs recettes; il n'est pas rare qu'un éditeur un peu occupé fasse dans les journaux pour 30 à 40,000 francs d'annonces par an." *Note présenté*, 22.

25 This combination of advertising, *réclame* (or editorial advertising), and criticism or self-parody was also a strategy pursued in the newspaper *Le Tintamarre*. See Hahn, *Scenes of Modernity*, 81–106.

26 Here I build upon Erika Rappaport's analysis of late-nineteenth-century department-store advertisements. She suggests that connections between shopping and the theatre promote familiar models of spectatorship, visual pleasure, and entertainment and "invest ordinary goods with cultural and social meanings." "A New Era of Shopping," 152.

27 See Maidment, *Comedy, Caricature and the Social Order*, 113–43.

28 Raffet's title page is reproduced in Farwell, *The Charged Image*. The lithographic poster for Bourdin and Cie's 1840 re-edition of Alain René Le Sage's *Le diable boîteux* is in the MPUB (no. 8921).

29 *Études pris dans le bas peuple* contains sixty plates etched by Count Caylus (Anne-Claude-Philippe de Grimoard de Pestels de Tubières) after red-chalk drawings by Edmé Bouchardon. The work was published in five *cahiers* of a dozen plates: two in 1737 then one each in 1738, 1742, and 1746. The *afficheur* adorns the cover of the fourth series in 1742.

30 For an exploration of performance, musical significance, and auditory/visual rhythms in Bouchardon's series, see Scott, "Edmé Bouchardon's 'Cris de Paris.'" The *afficheur* can be thought of as a precursor of the sandwich man analyzed by Buck-Morss in "The Flaneur, the Sandwichman, and the Whore." Both are wage labourers hired to advertise the products of a political and commercial culture in which they are marginally positioned. As middlemen distanced from both the producers and consumers of the goods they advertise, they differ from traditional artisans and criers who hawk their own wares, and also from modern cultural producers who market their public identities and subjective perspectives.

31 On the history of advertising and the laws pertaining to commercial billposting in the July Monarchy, see Hahn, *Scenes of Parisian Modernity*, 16–20, 42–4, 136–9, 143–60.

32 See Noriez, "Les Affiches de librairie," and Bargiel and Le Men, *L'affiche de librairie au XIXe siècle.*

33 "Les libraires qui ont toujours conservé le privilège d'imprimer et d'afficher librement pour leurs propres besoins sont conduits à annoncer leurs publications sans cesse plus nombreuses par l'affiche et le prospectus. Ils ne sont pas soumis aux demandes d'autorisation d'afficher délivrées par la préfecture de Police, puis le ministère de l'Intérieur. En outre, ils impriment sur un papier blanc, réservé à l'affiche

officielle. L'une des caractéristiques de l'affiche de librairie, jusque vers 1870, est précisément de n'être apposée qu'à l'intérieur de libraires, ne pouvant donc pas se confondre avec l'affichage officiel." Bargiel and Le Men, *L'affiche de librairie au XIXe siècle*, 22. "Bookshops had the privilege of displaying posters for books without having to obtain prior authorization, and these posters could be printed on white paper, otherwise reserved for official announcements." Hahn, *Scenes of Parisian Modernity*, 21.

34 "Such a conflict [namely, the authorities' inability to tax the private shop interior] was resolved in 1860, when the administration of Stamp and Registration defined public space as all localities accessible to an assembly of citizens or even one class of citizens. Subsequently *tabacs*, schools, train stations, hotels, cafés, restaurants, theaters, spectacles, shops and public transportations vehicles were reclassified as public spaces and therefore liable for taxation." Hahn, *Scenes of Parisian Modernity*, 157.

35 The Maison Aubert produced one-fourth of all lithographic imagery printed in Paris during the July Monarchy. Best known for the satirical journals *La Caricature* and *Le Charivari*, Aubert was also one of the biggest producers of *physiologies* and albums. See Cuno, "Charles Philipon, La Maison Aubert." The Maison Aubert "was producing no less than 4.2 million pages a year." Hahn, *Scenes of Parisian Modernity*, 27.

36 The Maison Aubert had moved to this location in 1841. When it was first established in 1829, the shop was located in the street-facing section of a shopping arcade, the passage Véro-Dodat. Cuno, "Charles Philipon, La Maison Aubert," 347.

37 On the migration of publishers and booksellers from the scholarly hub of the Left Bank and the city to the Right Bank beginning in the 1780s, see Mollier, *Le commerce de la librairie*, 23–4. Curmer moved to 47–49 rue de Richelieu in 1838. Martin, "Le monde des éditeurs," in *Histoire de l'édition française*, vol. 3, 178.

38 Hahn, *Scenes of Parisian Modernity*, 32–3, 144.

39 The Maison Aubert is pictured in *Petites macédoines d'Aubert*, no. 95 [BN Est: Dc 129 fol., t.2]: a medley of urban views on a single page devoted to Parisian "Passages." "The Entrée du Passage Véro-Dodat" (Aubert's location) appears here alongside the Messageries Générales, Passage du Pont Neuf, Passage de Choiseul, and Passage Vivienne. Farwell, *French Popular Lithographic Imagery*, vol. 4, [1f1] 37.

40 "The shop publicized in *Les Modes parisiennes* [a fashion journal launched by La Maison Aubert in 1843] as being the most *à la mode* was none other than La Maison Aubert, 'the rendezvous of all the fine Parisian society.'" Hahn, *Scenes of Parisian Modernity*, 71. On the publicity strategies of the Maison Aubert, including editorial advertising, see ibid., 22–7 and 69–71.

41 Deluxe volumes of *Les Français* were within the reach of only the upper bourgeoisie. The instalment format attracted mostly middle-tier subscribers, although petit-bourgeois readers could probably afford to purchase one or two instalments or articles on special occasions. The *cabinets de lecture* also provided alternative means of access to humbler readers.

42　*Scènes de la vie privée et publique des animaux* features illustrations by Grandville and texts by Balzac, Alfred and Paul de Musset, Nodier, and Janin among others. Prices matched those of *Les Français* at 30 cents per instalment and 15 francs per volume.

43　*Fables de la Fontaine*, 2 vols. (Paris: Fournier 1838).

44　Apparently, Grandville preferred the term *artiste-créateur* to that of illustrator. Renonciat, "P.J. Hetzel et J.J. Grandville," 28.

45　In July Monarchy typologies, the *grisette* is typically a young working woman such as a shop girl or seamstress who lives frugally, independently, and for the most part virtuously, often enjoying the company of other garret-dwelling artists and bohemians. By contrast, the *lorette* is a kept woman, living comfortably and showily at the expense of wealthy lovers, often in a well-appointed Parisian apartment located in eponymous proximity to the church of Notre Dame de Lorette.

46　For a counter-argument on the importance of statistics and naturalism in such works, see Sheon, "Parisian Social Statistics"; on the paradigms of medicine, biology, and zoology in the *physiologies*, see Lauster, *Sketches of the Nineteenth Century*, esp. chapter 3.

47　On the *cris de Paris* depicting a "social class distinctive in its homogeneity," see Scott, "Edmé Bouchardon's 'Cris de Paris,'" 77.

48　On pictorial traditions of the *cris de Paris*, physical deformities caused by labour, and social attitudes toward manual, intellectual, and artistic work, see McTighe, "Perfect Deformity, Ideal Beauty, and the 'Imaginaire' of Work."

49　Gavarni's contributions decrease with each successive volume in tandem with an increase in the number of artists who contribute types. In general, celebrated "caricaturists" such as Gavarni, Monnier, Charlet, Daumier, Grandville, and Traviès stack the full-page types in the early volumes while lesser-known artists feature scarcely or in supporting roles in the first volumes and then increase their contribution of full-page types in the later and provincial volumes. Authorship of types throughout the eight volumes is distributed as follows (in descending order): Pauquet, 115; Gavarni, 105; Monnier, 45; Loubon, 28; Lami, 23; Charlet, 12; Penguilly, 10; Geniole, 8; Grandville, 7; Dauzats and St. Germain, 6; Pelez, 5; Meissonier, Jeanron, and Radiguet, 4; Johannot, Daumier, Ferogio, and Gaildreau, 3; Traviès, Emy, Jacque, 2; Daubigny, Gagniet, Bellange, Laurentz, Grenier, Vogel, 1.

50　See Kleinert, "Les débuts de Gavarni," and Lemoisne, *Gavarni, peintre et lithographe*.

51　Stamm, *Gavarni and the Critics*, 8–10.

52　Higonnet, "Real Fashion," 144–5.

53　For further analysis of this social type, and the role of fashion in the construction of female identity, see Hiner, *Accessories to Modernity*, esp. 22–30.

54　"Elle sait qu'on l'étudie; elle sait que presque tous, même les femmes, se retournent pour la revoir." H. de Balzac, "La femme comme il faut," in *Les Français*, vol. 1, 26.

55　Here I am expanding on Sara Maza's argument, in *The Myth of the French Bourgeoisie*, that the bourgeois was an "imaginary other" rather than a positive term of

self-identification. Aimée Boutin intuits a similar dynamic in the *physiologies*, whereby the authors' self-reflexive ironic tone undermines the type's legibility (and the pretense of a scientific study) and addresses the reader as a sympathetic "insider who is 'in' on the joke." "The Title of Lawyer," 69–70.

56 The *figurante* was a minor dancer who was required to pose, to figure in the theatrical scene, but did not figure centrally in the choreography, perform solo dances, or speak any lines.

57 Gavarni's costume designs for theatre and carnival were widely emulated. Lemoisne, *Gavarni, peintre et lithographe*, vol. 1, 109–13. See chapter 5 for further discussion of the *débardeur* or longshoreman's costume Gavarni designed and popularized.

58 See Perrot, *Fashioning the Bourgeoisie*, especially chapters 4 and 5.

59 Baudelaire, "Some French Caricaturists," 183.

60 "Les folles nuits de l'Opéra, les galanteries du quartier Notre Dame de Lorette étaient le partage exclusif de Gavarni, qui créait une langue à lui, des attitudes à lui, des mots à lui. Daumier sondait les couches plus basses: les gens sans le sou, les pauvres, les chevaliers d'industrie, les industriels qui n'étaient pas chevaliers. Femmes du monde et dandies imitaient les poses des héros de Gavarni. Son esprit faisait école et plus d'une actrice a étudié la langue française dans ses legendes. Le crayon brutal de Daumier, écrasé sur la pierre par une main virile, rendait sans cesse des traits grotesques et grimaçants … [il] ne fit aucune concession pour adoucir sa mâle personnalité." Champfleury, *Histoire de la caricature moderne*, 302–3.

61 Benjamin, "Paris, Capital of the Nineteenth Century [Expose of 1939]," in *The Arcades Project*, 22–3.

62 "Production not only supplies a material for the need, but it also supplies a need for the material. As soon as consumption emerges from its initial state of natural crudity and immediacy … it becomes itself mediated as a drive by the object. The need which consumption feels for the object is created by the perception of it. The object of art – like every other product – creates a public which is sensitive to art and enjoys beauty. Production thus not only creates an object for the subject, but also a subject for the object. Thus production produces … the object of consumption, the manner of consumption and the motive of consumption. Consumption likewise produces the producer's inclination by beckoning to him as an aim-determining need." Marx, *Grundrisse*, 92.

63 Adorno and Horkheimer, *Dialectic of Enlightenment*, 127.

64 Applbaum, *The Marketing Era*, 1–18.

65 To take a contemporary example, Malcolm Gladwell's popular business journalism comments and capitalizes upon the market potential of this interdisciplinary mixture in works like "The Coolhunt" (*The New Yorker*, 17 March 1997) and *The Tipping Point* (New York: Little, Brown and Company 2002).

66 See Terence Nevett and Ronald A. Fullerton, "The Evolution of Marketing Thought," and Jagdish N. Sheth and Barbara L. Gross, "Parallel Development of Marketing and

Consumer Behavior: A Historical Perspective," in *Historical Perspectives in Marketing*, 1–4, 9–33.

67 Hahn, *Scenes of Parisian Modernity*, 144.

CHAPTER FOUR

1 Béraldi, *Les Graveurs*, vol. 5, 221.

2 For example, the plate for "7 heures du matin" (Fig. 4.6) was reproduced in *Le Follet, Courrier des Salons*, 6 May 1830.

3 This was a timely meditation; in the same year Hugo declared that the modern printing press would supplant the cathedral as producer of "the great script of the human race." Hugo, *Notre Dame de Paris*, 194.

4 "In the 1840s, the individual English railway companies proceeded to standardize time, but did no coordinate their efforts … When, after the establishment of the Railway Clearing House, the companies decided to cooperate and form a national railroad network, Greenwich Time was introduced as the standard time, valid on all the lines. Yet railroad time was not accepted as anything but schedule time until late in the century … in 1880, railroad time became general standard time in England. In Germany, official recognition came in 1893; as early as 1884, an international conference on time standards, held in Washington, DC, divided the world into time zones." Schivelbusch, *The Railroad Journey*, 43–4.

5 On nightlife, see Schivelbusch, *The Industrialization of Light*, 137–54.

6 It was not unusual for earlier genre or fashion prints to be organized as a temporal series; however, the increments typically followed the longer horizons of seasons or stages of life as opposed to hourly clock time. Devéria had pictured the course of a woman's life with scenes progressing from child's play and youth through artistic accomplishments to marriage, or from mother to widow and grandmother.

7 Mainardi, *Another World*, 47. Balzac later chronicled the hourly activity to be seen on the boulevards of Paris in an essay published in *Le Diable à Paris*: "Histoire et physiologie des boulevards de Paris." See Hahn, "Boulevard Culture and Advertising as Spectacle," 158.

8 For a brilliant discussion of the developments that led from this early phase of recalibrated life-rhythms to our present expectations of continuous functioning and non-stop production and consumption, see Crary, *24/7: Late Capitalism and the Ends of Sleep*.

9 The series, published by Pierre de La Mésangère, comprised thirty-three hand-coloured plates engraved by Georges Jacques Gâtine, thirty-one of them based on watercolours by Horace Vernet. A few plates were issued each year from 1810 to 1818. See *Incroyables et merveilleuses*, ii, and Siegfried, "Vernet's Ladies," 113.

10 The *incroyables* were a subject first taken up by Horace's father, Carle, in two satirical

prints of 1796 that lampooned extreme fashions and reactionary attitudes. Gaudriault, *La Gravure de mode féminine*, 59. While the Directory *incroyables* celebrated the overthrow of Robespierre with decadent styles recalling the *ancien régime* (silk knee breeches, powdered hair, foppish cravats), the Empire *incroyables* abandoned courtly breeches for leather trousers and tall boots, manly elements associated with horsemanship and the military. The Empire *merveilleuses* transformed the louche neoclassical undress style of their predecessors by adding modest layers (high collars, long sleeves, bonnets, short jackets) and colourful accents to their simple colourless gowns.

11 On Vernet's studio, see Athanassoglou-Kallmyer, "Imago Belli: Horace Vernet's *L'Atelier*."

12 Carle was one of the first artists to enter the fashionable world of hunts, horse races, and promenades as a participant rather than an artisan or court servant. Duncan, *The Pursuit of Pleasure*, 15–16. His wife, "Fanny," etched and coloured at least one of Carle's fashion plates; she also had a significant artistic pedigree, as the daughter of Moreau le Jeune. Siegfried, "Vernet's Ladies," 122.

13 Carle and Horace made hundreds of fashion drawings for *Le Journal des dames*. Gaudriault, *La Gravure de mode féminine*, 47.

14 Between 1811 and 1817, Horace earned 12,584 francs for fashion drawings in *Journal des dames*, *Bon genre*, the *Incroyables et merveilleuses*, and *Annuaire des modes*. Kleinert, "Les débuts de Gavarni," 222. Madame Vernet records 4,870 francs in income from Horace's lithographs in 1818. *Horace Vernet (1789–1863)*, 50–2. See also Siegfried, "Vernet's Ladies," 113.

15 As Susan Siegfried shows, this more contextual approach was one that Horace Vernet later pursued in his half-length oil portraits of fashionable women (exhibited at the Salon in 1831 and 1833), though not in his earlier drawings for fashion plates. Siegfried, "Vernet's Ladies," esp. 114–17.

16 Occasionally, plates for the *Journal des dames* featured a piece of furniture or a miniature background scene (such as a view of Tivoli) that typically does not rise above the figure's knee-level. See Gaudriault, *La Gravure de mode féminine*, 48, 59.

17 *Le Journal des dames* was directed by la Mésangère from 1799 to 1831. Each number had eight pages of text with one or two hand-coloured hors-texte engravings. Ibid., 44–5.

18 Each number of *Petit courrier des dames ou Nouveau journal des modes* (1821–68) had eight pages of text and seven hand-coloured engravings. A yearly subscription cost 36 francs. Ibid., 49–51. On the *Petit courier*, see also Holland, *Hand Coloured Fashion Plates*, 64–7.

19 Gavarni became the principal artist at *La Mode* in April 1830. Kleinert, "Les débuts de Gavarni," 218. *Petit courrier*, *Le Follet*, and *La Mode* were the leading fashion periodicals throughout the July Monarchy, despite the emergence of more than 100 new fashion journals during that period. Most had hors-texte plates in engraving or lithography. Gaudriault, *La Gravure de mode féminine*, 64.

20　Kleinert, "Les débuts de Gavarni," 218, and *Le dessin sous toutes ses coutures*, 120. Exhibitions of "dessins de mode" did not really develop until the 1880s. The world's fairs of 1893 and 1900 featured exhibitions of costume history and fashion illustration. *Le dessin sous toutes ses coutures*, 120–1.

21　See Holland, *Hand Coloured Fashion Plates*, 69, and Gaudriault, *La Gravure de mode féminine*, 65.

22　Higonnet, *Berthe Morisot's Images of Women*, 90.

23　*Achille Devéria, témoin*, 43.

24　Gavarni produced more than 100 designs for *La Mode* in 1830–1. Béraldi, *Les Graveurs*, vol. 7, 41. Balzac's "Traité de la vie élégante" appeared in the feuilleton of *La Mode* in October and November 1830.

25　Devéria's fashion plates also appeared in *Le Journal des jeunes personnes* (founded in 1833), the *Musée des familles* (1833), and the *Journal des femmes, gymnase littéraire* (1832). Gaudriault, *La Gravure de mode féminine*, 67.

26　Hahn, *Scenes of Parisian Modernity*, 63–9.

27　Ibid.

28　Vyvyan Holland differentiates between the *costume plate*, depicting national or theatrical costumes or putting fashions on record, and the modern *fashion plate* (emerging around 1800), indicating what clothes one should wear. He also identifies a third category of *trade plates*: issued by fashion houses and manufacturers of materials to suggest how silks and cloths could be made to best advantage. *Hand Coloured Fashion Plates*, 21–2.

29　There were ready-made military uniforms from the 1830s and ready-made civilian clothes for the popular classes in the 1840s. Mass production and large-scale retailing of finished articles in department stores arrived in the last third of the nineteenth century. P. Perrot, *Fashioning the Bourgeoisie*, 53, 59. Ready-made occupational outfits appeared in 1850. By the late 1860s, ready-made clothes would dominate the menswear market. Chenoune, *A History of Men's Fashion*, 67.

30　This type of transaction is portrayed in Gavarni's *Voila comme je serai le dimanche* (Fig. 3.15).

31　"En règle très générale, aucun nom de fournisseur n'est cité sous les planches ou dans le texte, avant 1824." Gaudriault, *La Gravure de mode féminine*, 51. "Dès 1823, *Le Petit courrier des dames* décrit des manteaux, reproduits en gravure, créés par des couturières, mais aussi par [magasins de nouveauté] le *Diable d'argent* ou la *Fille d'honneur*." *Au paradis des dames*, 20. Prior to the 1820s, advertising was present in the editorial texts of fashion magazines: for example, in *Journal des dames*, La Mésangère's column "Modes" describes costumes by specific tailors, couturières, and coiffeurs. Sullerot, *Histoire de la presse féminine en France*, 94–5.

32　Armelhaut and Bocher, *L'Oeuvre de Gavarni*, 302, 328–9.

33　Ibid., 514–23.

34　P. Perrot, *Fashioning the Bourgeoisie*, 40. Balzac mentioned his tailor Buisson in

"Physiologie du marriage" (1829), *Eugénie Grandet* (1833), and *Le Cabinet des Antiques* (1838). For an insightful study of the redrawn and porous relations between literature and advertising in Balzac and Dickens, see Sara Thornton, *Advertising, Subjectivity, and the Nineteenth-Century Novel.*

35 Applbaum, *The Marketing Era*, 20.

36 Steele, *Paris Fashion*, 112.

37 "Achetés par les maisons, ils sont reproduits dans les journaux comme leur appartenant; ainsi, Compte-Calix recopie dans *Les Modes parisiennes* les toilettes dessinées par Pilatte pour Madame Ghys. Les couleurs et les poses sont souvent lés mêmes." *Au paradis des dames*, 39.

38 Evidence of the mediating role of industrial illustrators is sparse, partly because it seems the intellectual property transferred from the draftsman to dressmakers. Researching the collections of Worth and Ghys, Françoise Tétart-Vittu discovered dress designs (sketches, cut-out figures, and watercolours) by "dessinateurs industriels en modes comme Charles Pilatte, Ernest Leduc, Robin, Leray and Paulin … L'histoire légendaire de la haute couture a masqué l'existence du créateur de modèles au profit de la seule reproduction artistique du journal de mode. Cette valorisation est volue par le marchand qui, dans son souci de genre, recherche le crayon d'artistes de qualité susceptibles de magnifier ses articles. Or, Lanté ou Jules David n'ont jamais créé de modèles pour les maisons dont ils reproduisent les vêtements." Ibid., 37. See also the essays by Tétart-Vittu in *Le dessin sous toutes ses coutures.*

39 Gaudriault, *La Gravure de mode féminine*, 49.

40 Ibid., 48–9, 64.

41 *Le Goût nouveau, Motifs variés pris d'apres nature* (1831). The BN edition (Dc 178 d res., t. VI) has 24 plates, including portraits of Mme Achille Devéria (3), Laure Devéria (5), Mme Vatrin (3), Annette Boulanger, Louise de Radepont, Mme de Ratelot, Mlle de Nisdal (or d'Hinnisdal), Mme du Coté, Annete Dubois, Mme de Burck, Zoe Champollion, Mlle A. Barre, Mlle de Luc Grange, Mlle Gauguin, and Mlle François (who later married Léon Noel).

42 Two sister publications were produced between 1831 and 1839: *Costumes historiques pour travestissements dessinés d'après nature par A. Devéria* (Osterwald and Fonrouge) and *Costumes historiques de ville et de théâtre et travestissements par M. Devéria* (Rittner and Goupil). See *Achille Devéria: témoin*, 35–41, and Béraldi, *Les Graveurs*, vol. 5, 59–63.

43 Bertin, "A propos des deux bals costumés," 15–16.

44 Steele, *Paris Fashion*, 37–40.

45 David designed stage costumes for the actor Talma in 1789 and new republican clothing for officials, civilians, and military in 1794. Chazin-Bennahum, *The Lure of Perfection*, 39, 67, 78. For an excellent study of revolutionary dress see Wrigley, *The Politics of Appearances.*

46 Chenoune, *A History of Men's Fashion*, 53–4. Gluck, *Popular Bohemia*, 25–32.

47 Adèle Hugo, *Victor Hugo raconté*, 309–10.

48 "They were clad in every variety of fancy dress, Théophile Gautier being especially conspicuous in what is usually described as a gilet rouge (a red waistcoat) but was in reality a pourpoint (a doublet) of scarlet satin." Laver, *The Age of Illusion*, 174.

49 Blanc, *Les artistes de mon temps*, 93. Maigron, *Romantisme et la mode*, 73.

50 On the spread of medieval and pseudo-Elizabethan styles, see Maigron, *Le Romantisme et la mode*, and Byrde, *Nineteenth-Century Fashion*, 39. On sleeve styles in the Restoration, see Uzanne, *Fashions in Paris*, 68–9.

51 On romantic artists and the theatre as inspiration for fashion, see the previous note and Chenoune, *A History of Men's Fashion*, 50–5.

52 *Journal des tailleurs* (16 January 1833), qtd. in Chenoune, *A History of Men's Fashion*, 49.

53 The intervention of a dressmaker is unlikely given the lack of publicity; the work of an industrial draughtsman is unlikely owing to the time period and the nature of the publication, which combines fashion, portraiture, and genre scenes.

54 C. Hall, "The Sweet Delights of Home," 66–74.

55 Auslander, "The Gendering of Consumer Practices," 83.

56 The stress on aesthetic individuality in home decor would not be common until the 1880s. Ibid., 79–112.

57 C. Hall, "The Sweet Delights of Home," 89.

58 M. Perrot, "The Family Triumphant," 191.

59 Martin-Fugier, "Bourgeois Rituals," 268–9.

60 M. Perrot, "The Family Triumphant," 134.

61 Chenoune, *A History of Men's Fashion*, 36.

62 Uzanne, *Fashions in Paris*, 79–80.

63 Martin-Fugier, "Bourgeois Rituals," 274, 281–5.

64 Ibid., 278.

65 Pollock, "Modernity and the Spaces of Femininity."

66 "L'absence de tout mouvement féministe pendant ces quinze années est à souligner. Le divorce a été supprimé en 1816. Les femmes ne jouissent d'aucun droit public." Sullerot, *Histoire de la presse féminine*, 130.

67 The address 45 rue Neuve-Notre-Dame des Champs is given on the marriage contract of Achille and Céleste dated 6 July 1829. The birth certificates of Achille's children (1833 and 1844), as well as the 1841 marriage contract of Eugène Devéria, list the address as number 38, rue de l'Ouest. See Charles Nauroy, *Le Curieux*, vol. 2 (1885), 74–8. Martin-Fugier suggests that the house had two entrances, one on rue Neuve-Notre-Dame des Champs and a second on rue de l'Ouest. *Les Romantiques*, 105.

68 Ibid., 104–5.

69 See the drawing by Champin of 11 rue Notre-Dame-des-Champs, in the Musée Victor Hugo.

70 Here Hugo wrote the preface to *Cromwell*, read *Marion Delorme* for his cabal, and

composed and prepared for the battle of *Hernani*. There was such a surge of social activity following the *Hernani* première (25 February 1830) that the landlords who lived on the ground floor asked the couple to move. Boyé, *La Mêlée romantique*, 211.

71 "La maison qu'habitaient les Devéria, située rue de l'Ouest, était le centre du romantisme, le quartier général des poëtes nouveaux, des jeunes artistes et des jeunes-France. On y voyait venir Emile Deschamps, Louis Boulanger, Eugène Delacroix, Alfred de Musset, Paul de Musset, Chenavard, Amaury Duval, Alexandre Dumas, Edgar Quinet, Charton, Larrey, Sainte-Beuve, Henriquel Dupont, Marie Dorval, Mélanie Waldor, Charles Nodier et sa fille, presque tous ceux enfin ou toutes celles qui ont eu depuis un nom, un grand nom. Victor Hugo y trônait; Liszt, enfant, y faisait de la musique … Achille Devéria, l'aîné de la famille, toujours le crayon à la main, exerçait une grande influence sur les artistes." Blanc, *Les artistes de mon temps*, 94.

72 Ricourt, the director of *L'Artiste*, brought Dumas to Devéria's studio to have his portrait made the day after the triumphal opening of *Henri III* on 10 February 1829. See Dumas, *Les Morts vont vites*, vol. 2, 222–6; *Achille Devéria, témoin*, 17–18; M. Gauthier, *Achille et Eugène Devéria*, 92–5; and Béraldi, *Les Graveurs*, vol. 5, 221–3.

73 *Eugène Devéria d'après des documents originaux*, 11.

74 In July 1829 Hugo first read *Marion Delorme* (the original title was *Un Duel sous Richelieu*) to a large crowd at the Devéria home. Boyé, *La Mêlée romantique*, 211.

75 Laure "fut la grâce et le charme des réceptions de la rue Notre-Dame-des-Champs, comme Marie Nodier l'était des réunions de l'Arsenal." Ibid., 209–10.

76 On salons and soirées chez Nodier at the Arsenal, see Martin-Fugier, *Les Romantiques*, 96–9.

77 Canh-Gruyer, "Cénacles Romantiques" [n.p.].

78 Martin-Fugier, *Les Romantiques*, 105. A. Hugo, *Victor Hugo raconté*, vol. 2, 87.

79 S. Vincent, "Elite Culture," 328–32.

80 Ibid., 329.

81 Hahn, *Scenes of Parisian Modernity*, 66–73.

82 Bermingham, *Learning to Draw*, 196.

83 Incidentally, Achille allots more time for this activity than any other: there is a three-hour gap between the 4 p.m. painting scene and the next scene at 7 p.m. The only other exceptions to the rule of hourly increments are between midnight and 4 a.m., when our lady is at the ball, and between 5 and 7 a.m., when she is presumably sleeping.

84 Bermingham, *Learning to Draw*, 183–227.

85 Farwell, *Charged Image*, 72.

86 On exhibitions and collections of Laure's works, see Gauthier, *Achille et Eugène Devéria*, 114–16. The Louvre catalogue lists three flower paintings by Laure in lead pencil, watercolour, and black ink: INV 26220, *Camarilis, fleurs*; 26221, *Dathura, fleurs*; 26222, *Tulipe, fleurs*.

87 Bermingham, *Learning to Draw*, 184.

88 Martin-Fugier, *La vie élégante*, 105–7. On the structure, decor, and activity at this stu-
dio, see Boyé: "Le *Mazeppa* avait été peint dans l'atelier qu'Eugène Devéria avait fait
élever sur un terrain vague de la rue Notre-Dame-des-Champs. On y avait trans-
porté un des trois baraquements voisins de la Chambre des Députés, dans lesquels
durent exécutées les statues colossales destinées au pont de la Concorde, aujourd'hui
à Versailles. De belles tapisseries, de somptueuses portières ornaient ce vaste atelier
où Boulanger exécuta son *Mazeppa* pendant que Devéria achevait sa *Naissance de
Henri IV* … Des fêtes marquèrent ces succès. Un bal masqué est demeuré fameux,
au course duquel le tout jeune Alfred de Musset apparut en page de la Renaissance."
La Mêlée romantique, 184.

89 "Eugène Devéria a été un des grands noms du romantisme. Un instant, mais rien
qu'un instant, il a été le rival d'Eugène Delacroix … il se mit tout entier dans un ta-
bleau. Son coup d'éclat, son coup de maître, la *Naissance d'Henri IV*, il le fit a vingt-
deux ans." Blanc, *Les artistes de mon temps*, 90.

90 "Le brave garçon était le soutien de la famille, sa grande facilité lui servait a multi-
plier ses productions; il faisait rapidement des lithographies adroites et spirituelles
qui lui étaient payées 100 fr. Il sentait bien qu'il gaspillait un peu son talent, supé-
rieur à ce commerce, mais il se consolait en pensant que ce qu'il perdait en réputa-
tion sa mère et ses soeurs le gagnaient en bien-être." A. Hugo, *Victor Hugo raconté*,
vol. 2, 86–7.

91 "Devéria pouvait être un grand peintre; mais il avait une mère et une sœur. Il com-
prit que la grande peinture ne nourrirait pas sa famille; il se jeta dans la vignette."
"Pauvre grand artiste, en cage derrière son bureau." Dumas, *Les Morts vont vites*,
vol. 2, 226, 229.

92 "Dans cette noble intention, et par un sacrifice admirable, Achille Devéria résolut de
s'effacer pour laisser paraître au premier plan son frère Eugène, et, abandonnant la
peinture pour la lithographie, il se mit à produire, avec une fécondité qui tient du
prodige, ces compositions innombrables qui ont retranché de sa gloire tout ce
qu'elles ont ajouté au bien-être des siens." Blanc, *Les artistes de mon temps*, 94–5.

93 "Ce n'était alors, parmi la jeunesse, que nobles aspirations, espérances de gloire, en-
thousiasme pour la beauté d'expression et de sentiment, ardent amour de la liberté
en toute chose … On était tout flamme pour ces choses inutiles, qui sont pourtant
si nécessaires à la vie d'un peuple: la poésie, la grâce, l'idéal!" Ibid., 89.

94 Adèle also applied similar terms to her description of the Devéria sisters. Laure was
the cultivated flower of the household: adored, admired, celebrated, and served like
an idol, while her sister Desirée devotedly managed the household and economized
the money Achille earned. A. Hugo, *Victor Hugo raconté*, vol. 2, 86.

95 Blanc, *Les artistes de mon temps*, 96.

96 "Par un dévouement admirable, immolant son talent de peintre à la nécessité de

gagner le pain quotidien, il concentrait tous ses r ves de gloire sur le jeune frère dont il avait entrepris l'éducation artistique et auquel il donnait de lui-même tout ce qu'il pouvait donner." *Eugene Devéria d'après des documents originaux*, 10–12.

97 Kloss and Timbrell, "Two Portraits of Henri Herz by the Devéria Brothers," 52. [Quoting from Gauthier, *Achille et Eugène Devéria*, 39: "c'était notre tableau, quoiqu'il portât mon nom seul."]

98 *Eugene Devéria d'après des documents originaux*, 13–16.

99 "Riez pourtant," a lithograph signed by Eugène and Achille, accompanied by four lines of verse by Hugo; see *Devéria, témoin*, 61, cat. 75.

100 In addition, the brothers made at least two more portraits of Herz: a drawing by Achille and a lithograph by Eugène. "Achille Devéria a fait un autre portrait de Herz, en le dessinant assis au milieu d'un cercle de dames en train d'improviser au piano (Adhémar, n.309). Une aquarelle (A. Arbor, 1970–1971, reprod. n.5) et une lithographie (Adhémar, n.24) d'Eugène Déveria représentent également Herz assis devant son piano." *Devéria, témoin*, 24.

101 "This modest watercolor is a somewhat immodest advertisement for a virtuoso, his compositions, and his piano firm." Kloss and Timbrell, "Two Portraits of Henri Herz," 53–4.

102 On the Salon portrait of Laure, see M. Gauthier, *Achille et Eugène Devéria*, 165. David d'Angers also made two bronze portrait medallions of Laure Devéria, both dated 1828 and housed at the Musée Carnavalet, Paris.

103 The folios at the BN are *Album de fleurs peintes et lithographiées par Laure Devéria* [JD-93-ET FOL]; Recueil. Collection Achille Devéria. Oeuvre de Laure Devéria [ZA-569 (65)-BOITE ET FOL]; and Recueil. Oeuvre de Laure Devéria [SNR-3 (Devéria, Laure)].

104 Achille must have assembled this collection of Laure's work [JD-93-ET FOL] as a tribute to her memory and oeuvre after her death. Among the diverse images gathered here are Laure's drawings and paintings, Achille's portraits of Laure, and, curiously, a "Motif Ornamental par Annette Boulanger" paired with a portrait of Annette by Achille. Annette was Louis Boulanger's sister and a pupil of Achille's. Presumably, he filed these works by and of his other female pupil with Laure's oeuvre because there was no other logical place for them to reside at the BN. Also included in this collection [*Album de fleurs* JD-93-ET FOL] is a suite of lithographs drawn by Achille, coloured by Laure, and printed by Lemercier. It features bust-length medallion portraits of young women, surrounded by garlands of flowers, hand-painted in watercolour. Each plate, captioned in French and English, represents a national type paired with a flower species: the Rose of England, the Pomegranate of Spain, the Tulip of Hollande, and so on. Outside of this particular folio attributed to Laure at the BN, however, one encounters this same suite as an independent work credited only to Achille and titled *Flore des Salons, ou Les Fleurs et les femmes de tous les pays, par Devéria* (Paris: Janet 1831).

105 He was conservateur-adjoint from 1848, then conservateur titulaire in April 1857.
See Jubert, "Achille Devéria, Conservateur. "

106 Blanc, *Les artistes de mon temps*, 90.

107 As exemplified in the exhibition *Achille Devéria: témoin du romantisme parisien,
1800–1857.*

108 Higonnet, "Secluded Vision," 16–36.

109 On Adèle as amateur artist, see ibid., 172–3.

110 Ibid., 179.

111 "Son œuvre de lithographe est de premier ordre; mais pour le trouver tel, il faut se
livrer préalablement à une opération radicale: en jeter les quatre cinquièmes par
dessus le bord. En d'autres termes, séparer la production commerciale de la produc-
tion artistique, les sujets de genre des portraits. Devéria a été d'une fécondité
qu'explique la facilité du procédé lithographique: ce que les éditeurs lui deman-
daient, il le faisait." Béraldi, *Les Graveurs*, vol. 5, 221.

CHAPTER FIVE

1 M. Clark, "Understanding French Opera," 121.

2 Véron's efforts to promote the Opera included using his artists, his horse and car-
riage, and his dinner in cafés for publicity. Chazin-Bennahum, *The Lure of Perfec-
tion*, 204. On the business and artistic program of the Opera, see also Barbier,
Opera in Paris; Roqueplan, *Les Coulisses de l'Opéra*; and Sécond, *Pétites Mystères
de l'Opéra.*

3 Of 1,792 places in the Salle Le Peletier, 960 were in the loges (first level, 202; second,
238; third, 246; fourth, 144; and fifth, 44). There were 832 places on the ground level
(orchestra, 204; seated parterre, 311; amphitheatre, 137). Gourret, *Historie des salles
de l'Opéra*, 144.

4 One of the crucial new features of the Palais Garnier (which has housed the Opera
from 1873 to the present) was to incorporate these backstage spaces architecturally.
In the past, the dispersal of these spaces had given rise to creative connections, such
as the footbridge linking the Richelieu site to its decor warehouse and painting
studio across the street or the *passages de l'Opéra* connecting the Le Peletier theatre
to its subsidiary complex of boutiques and apartments. Ibid., 111, 145–6.

5 Véron lowered the wages of minor dancers and raised those of the soloists. The ad-
ministration encouraged business relations between the minor dancers and wealthy
patrons, who often paid for dance lessons and clothes and helped to support
dancer's families. M. Clark, "Understanding French Opera," 41–2, 122.

6 These forms of journalistic advertising ranged from overt to tangential, including
ads for specific productions and editorial praise in current-events reportage, art crit-
icism, and gossip columns. In the hopes of attracting unpaid publicity, the Opera

management provided journalists with free tickets and access to dressing rooms and rehearsals and encouraged both friendly and sexual liaisons with female performers.

7 This was a typical way to romanticize the situation: the reality of artistic prostitution (in literature or on stage) was mitigated by the more flattering prospect that authentic non-venal relationships were still possible among members of the artistic community. In a similar vein, Thompson argues that in the 1840s the *grisette* was a favoured topic, an ally and proxy for journalists seeking a professional image that would emphasize disinterestedness and creativity rather than the degradations of the literary marketplace. Thompson, *The Virtuous Marketplace*, 36–51.

8 M. Clark, "Understanding French Opera," 41–2.

9 Among Daguerre and Cicéri's legendary collaborations are the sets for *Aladin* (1822), the first to employ gas lighting and costing some 170,000 francs to realize. Chazin-Bennahum, *The Lure of Perfection*, 160.

10 Tresch, "The Prophet and the Pendulum," 25–6.

11 M. Clark, "Understanding French Opera," 31–50.

12 Ibid., 48–50.

13 Tresch, "The Prophet and the Pendulum," 24.

14 See Chazin-Bennahum, *The Lure of Perfection*, 210, and M. Clark, "Understanding French Opera," 48–50.

15 See M. Clark, "Understanding French Opera," 20–7, and *Gautier on Dance*.

16 Taglioni's role in *La Sylphide* (1832) was a key incarnation of the romantic ballet: her weightless toe dancing was complemented by a transparent ethereal costume designed by E. Lami. She was represented in a number of lithographs, including one by A. Devéria: "a celebrated colored lithograph of the Sylphide bounding toward the footlights with very high jetés." Chazin-Bennahum, *The Lure of Perfection*, 219.

17 Join-Diéterle, *Les décors de scène de l'Opéra*, 76.

18 M. Clark, "Understanding French Opera," 119–56.

19 She cites the fashion reportage of the Vicomtesse de Renneville, who asserted: "The success of plays is certainly not purely literary. In most cases the theatre can be certain of big crowds when sumptuous dresses can be seen on stage … Hardly has the rumour gone round that in a certain play new toilettes will be shown, than a considerable part of the population is in a frenzy of excitement – dressmakers, modistes, makers of lingerie and designers." Steele, *Paris Fashion*, 153–4.

20 Chazin-Bennahum, *The Lure of Perfection*, 49.

21 Ibid., 217.

22 *L'Illustration* (3 September 1853), no. 549, 155–8, qtd. in Berlanstein, "Historicizing and Gendering Celebrity Culture," 71. Rachel was born Elisa Félix (1821–58).

23 Ibid., 72.

24 Jones, *Sexing la Mode*, 169.

25 Ibid., 96 and 169.

26 "Sarah Bernhardt quarreled with Worth when she refused to use only his dresses on stage." Steele, *Paris Fashion*, 140 and 154.

27 "Ah! La reine de l'Opéra est mieux reçue que la reine des Français." Qtd. in Join-Diéterle, *Les décors de scène de L'Opéra*, 23.

28 Berlanstein, "Historicizing and Gendering Celebrity Culture," 67–9.

29 See Hahn, "Fashion Discourses in Fashion Journals" and *Scenes of Parisian Modernity*, 63–4.

30 Hahn, *Scenes of Parisian Modernity*, 31–5.

31 Melcher, *Life and Times of Henry Monnier*, 40, 101–18.

32 Lemoisne, *Gavarni, peintre et lithographe*, 82–129.

33 The *physiologies* illustrated by Gavarni include *Physiologie des femmes*, *Physiologie de la femme politique*, *Physiologie du collectionneur*, *Physiologie de l'écolier*, *Physiologie du provincial à Paris*, *Physiologie de la lorette*, *Physiologie du débardeur*, *Physiologie de l'amoureux*, *Physiologie de l'industriel*, *Physiologie de l'étudiant*, and *Physiologie du tailleur*. Béraldi, *Les Graveurs*, vol. 7, 65. In *Les Français* female types portrayed by Gavarni in the first volume alone include La Grisette, La Femme comme il faut, Les Femmes politiques, Une Femme à la mode, L'Actrice, Les Duchesses, La Figurante, La Grande dame de 1830, La Sage-femme, La Chanoinesse, La Maitresse de table d'hôte, La Femme de chambre, La Femme sans nom, L'Élève du conservatoire, La Nourrice sur place, L'Âme méconnue, and La Revendeuse à la toilette.

34 "Gavarni fréquente beaucoup alors le monde des Théâtres: lié depuis longtemps avec Déjazet, pour laquelle il avait dessiné des costumes, il voit aussi: Levassor et Arnal, dont il nous laissera deux si jolis portraits; Anicet, les Taigny, Anaïs Fargueil, Laférière, Mlle George, etc … Il passe la plupart de ses soirées dans les coulisses et … il se met à crayonner, à aquareller surtout, des costumes, accessoires, etc … Si bien qu'on ne pourra bientôt plus monter une pièce au Palais-Royal, au Vaudeville, à la Porte-Saint-Martin, puis à la Renaissance, sans l'artiste qui, en quelques coups de pinceau, saura prêter à tous son originalité." Lemoisne, *Gavarni, peintre et lithographe*, 76.

35 Marguerite-Joséphine Weimer (1787–1867).

36 Lemoisne, *Gavarni, peintre et lithographe*, 76.

37 Melcher, *The Life and Times of Henri Monnier*, 113, and Lemoisne, *Gavarni, peintre et lithographe*, 98.

38 Lami designed many costumes for the Opera in the early 1830s, contributing to the fairy world of *La Sylphide* (1832) and specializing in military uniforms for the stage. Louis Boulanger designed costumes for *La Esméralda* (1836) and Victor Hugo's *Hernani* and *Lucrèce Borgia*. Eugène Delacroix designed a costume for *La Belle au bois dormant*. Chazin-Bennahum, *The Lure of Perfection*, 201–2.

39 Ibid., 77–8.

40 The first real contender, *Petit courrier des dames ou Nouveau journal des modes*,

appeared in 1821. More than one hundred new periodicals devoted to fashion appeared between 1830 and 1848. Gaudriault, *La Gravure de mode feminine*, 64.

41 Kleinert, "Les Debuts de Gavarni," 215–17.

42 La Mésangère believed that the public was not much interested in carnival disguises, beyond the traditional Pierrot, Polichinelle, and Arlequin; he added that some society ladies had no taste for such things at all. Still, he published Gavarni's *Travestissemens* [sic] (1827 to 1830) in a print run of 1,300, crediting the engraver Gâtine but omitting Gavarni's name. Despite La Mésangère's doubts, the series was a great success: new editions appeared in 1838 and 1840 and led to the regular inclusion in such publications of drawings of masquerade costumes, especially during carnival season. Ibid., 215–18.

43 Olson, *Gavarni: The Carnival Lithographs*, 21.

44 *Nouveaux travestissements* (Rittner et Goupil; Hautecœur-Martinet, 1830-41) was the most extensive publication of this nature aside from the *Musée de costumes*, 106 plates (Aubert, 1837). Others include *Travestissements de femmes*, 12 lithographs (Rittner and Goupil; Tilt, 1832); *Travestissements grotesques*, 6 lithographs (Aubert, 1833 and in *Le Charivari*); and *Travestissements parisiens: Costumes composés pour les bals de cette année par Gavarni*, 8 lithographs (Aubert, 1837). Béraldi, *Les Graveurs*, vol. 7, 44–5. Some of these costume plates appeared first in *La Mode* from 1830 to 1837 and were reissued in other magazines or published in albums such as *Nouveaux travestissements*. See Farwell, *French Popular Lithographic Imagery*, vol. 4, 76–9.

45 "After Gavarni's talent for designing costumes brought special success to the masked balls, he began to receive his friends on Saturday evenings in his studio, in the rue Blanche between 1835 and 1838, and then for seven years in his famous apartment, rue Fontaine-Saint-Georges." Melcher, *The Life and Times of Henri Monnier*, 128–9.

46 Lemoisne, *Gavarni, peintre et lithographe*, 97–8.

47 "Un logis enfin qui était vraiment comme l'atelier, le magasin, la buvette et l'antichambre du carnaval." Goncourt, *Gavarni, l'homme et l'oeuvre*, 151.

48 "C'est dans ce petit appartement de la rue Blanche qu'on se réunit pendant tout le carnaval, de là que partent les convocations, ordres et contre-ordres; là que les amis viennent chercher des idées ou des costumes, là que la bande, enfin, se rassemble avant de faire son entrée au bal Berthelemot ou aux Vendange de Bourgogne. Gavarni, en effet, se plaisait à la fréquentation des bals masqués dont il soutint et anima la vogue." Lemoisne, *Gavarni, peintre et lithographe*, 71.

49 The comic monologues were performed by Méry, Ourliac, and Monnier. Melcher, *The Life and Times of Henri Monnier*, 129.

50 Description of Doré's fancy dress in *Nadar/Warhol*, 112.

51 On Monnier's costume, which he wore to the opera ball organized by Dumas in 1835, see Melcher, *The Life and Times of Henri Monnier*, 112.

52 "By the late 1830s, Macaire had become a recognized *type parisien* and a popular

disguise worn at the masked balls." Olson, *Gavarni: The Carnival Lithographs*, 14. Daumier had reinvented Macaire for a substantial series in *Le Charivari*, but the character had roots in melodrama, vaudeville, and comic performances by actor Frédéric Lemaître.

53 Steele, *Paris Fashion*, 141–2.

54 On Calicot, see Nina Athanassoglou-Kallmyer, "Truth and Lies: Vernet, Vaudeville, and Photography," in *Horace Vernet and the Thresholds of Nineteenth-Visual Culture*, 212. On Mayeux, see Elizabeth K. Menon, "The Image that Speaks: The Significance of M. Mayeux in the Art and Literature of the July Monarchy," in *The Popularization of Images*, 37–57.

55 Terni, "Paris Imaginaire."

56 The *patron de bateau*: "costume que Gavarni dessina pour lui et pour l'ami Tron-quoy en 1836, destiné à paraitre à côté du débardeur dans les entrées de la troupe joyeuse." Lemoisne, *Gavarni, peintre et lithographe*, 111.

57 Olson, *Gavarni: The Carnival Lithographs*, 18.

58 Ibid., 24.

59 Lemoisne, *Gavarni, peintre et lithographe*, 112–13.

60 Duncan, *The Pursuit of Pleasure*, 57.

61 Ibid., 35.

62 Since the sixteenth century, courtly costumes were created by the *ordonnateur des fêtes* in close collaboration with his sovereign. The *maquette de costume* was born in connection with the birth of the ballet in the Italian courts and its flowering under the Valois, Tudors, Stuarts, and Louis XIV. The first state was a pen-and-ink drawing with details of ornaments and annotations of colours. The second state was a water-colour maquette (with more details of the head, hands, and pose, often furnished by assistants) which would be presented to the prince for approval and adjustments before being confided to a tailor. Once the costume had been executed and worn to the fête or performance, the figure was more carefully redrawn and embellished with decor, a description, and a frame in preparation for engraving. *Le dessin sous toutes ses coutures*, 25–6.

63 Costumes designed by Garnerey were materialized by the famous couturier LeRoy and in some cases illustrated afterwards by Horace Vernet. Chazin-Bennahum, *The Lure of Perfection*, 156–63. Gaudriault, *La Gravure de mode féminine*, 49.

64 *Le dessin sous toutes ses coutures*, 31–2.

65 *Suite de déguisements pour un bal masqué, chez A. Dumas* (Paris: Ostervald 1830). Although the title indicates a party held by Dumas, letters discovered by Eric Bertin indicate that Achille Devéria was the host. Bertin suggests this event is often con-fused with a costume ball held by Dumas three years later, on 30 March 1833. Bertin, "A propos des deux bals costumés," 15–16.

66 Chenoune, *A History of Men's Fashion*, 54.

67 The most extensive are *Costumes historiques pour travestissements dessinés d'après nature par A. Devéria*, and *Costumes historiques de ville et de théâtre, et travestissements par M. Devéria*. See *Deveria, témoin*, 35.

68 "Et c'est ainsi que le costume du théâtre, peu à peu, impose au costume de ville le ton, la forme, la couleur … que le genre moyen-âge détermine le goût nouveau … Par la voie du théâtre, puis du bal, la révolution romantique, exclusivement littéraire à l'origine s'étendit à la toilette féminine, à la toilette masculine, à l'architecture, au mobilier, à tous les arts décoratifs." M. Gauthier, *Achille et Eugène Devéria*, 83–4. See also Maigron, *Le Romantisme*: on medieval styles in clothing, 5–14, 19–25; on decor and material culture, 41–7, 97–118.

69 The ball was held in the Salle Le Peletier on 14 January 1835. See Melcher, *The Life and Times of Henri Monnier*, 112–13.

70 Gourret, *Historie des salles de l'Opéra de Paris*, 147.

71 Uzanne, *Fashions in Paris*, 96.

72 Join-Diéterle, *Les décors de scène de l'Opéra*, 26.

73 Olson, *Gavarni: The Carnival Lithographs*, 6.

74 M. Clark, "The Quadrille as Embodied Musical Experience," 508.

75 Uzanne, *Fashions in Paris*, 96–8.

76 Musard conducted at the Variétés, then in his own Salle de Concerts, then at the Opera from 1837. Olson, *Gavarni: The Carnival Lithographs*, 6. The apogée of Musard's Opera balls came in 1846, with close to five thousand revellers. Gourret, *Historie des salles de l'Opéra*, 147.

77 "L'Opéra s'était jadis réservé le privilege d'être la plus triste réunion carnavalesque de la capitale, il s'y faisait moins de bruit que dans les salles d'étude des sourds-muets. Le chef d'orchestre aurait pu réclamer le titre de maitre de chapelle … A cette époque Musard n'etait pas encore inventé. C'était un cloitre ou l'on n'entrait que sous le froc du domino … Tout cela est changé, l'Opéra est aujourd'hui à la bac-cante." *Physiologie de débardeur*, 35.

78 "The music he played was generally familiar. He would play extracts from *Robert le Diable* or other famous operas. But, torn from their context, in Musard's hands they seemed to acquire a new and independent existence, transformed into infernal quadrilles and galops. When Musard conducted, it was as though the elements were unleashed. While the tempest was at its height, he would suddenly feel the need to show his power over it. He would spring to his feet … smash the stool on which he had been sitting or walk to the edge of the platform and fire a pistol into the air. His satellites would seem to have been awaiting this signal for their ecstasy to reach its climax, and pandemonium would break loose. And Musard, Napoléon Musard, the great Musard, would be carried shoulder-high over the crowd of the possessed." Kracauer, *Orpheus in Paris*, 58–9.

79 The cancan was performed by both men and women but its early history is associated with working-class men, *cancanneurs* who amazed audiences at public balls

with kicks above their head. Clark, "The Quadrille as Embodied Musical Experience," 511.

80 "The magician at the wave of whose wand these orgies were kindled was Musard …
he cast a spell that could only derive its force from the powers of the underworld."
Kracauer, *Orpheus in Paris*, 58. Wagner went so far as to claim that in this style of
dance "the immediate act of procreation is symbolically consummated." M. Clark,
"The Quadrille as Embodied Musical Experience," 511. See also Taxile Delord, "Le
Chicard" [illustrated by Gavarni], in *Les Français peints par eux-mêmes*, vol. 2,
361–76.

81 "Si c'est du Plaisir, c'est un plaisir de sauvages; ce sont des hommes tatoués, des
femmes à moitié nues. Ce sont des cris de panthers, une joie qu'on prendrait pour
de la fureur. Vous ne sauriez vous imaginer, madame, ce que c'est que leur galop:
une ronde de sabbat, un tourbillon à quoi rien ne résiste, qui vous prend et vous em-
porte. On y est broyé, on y roule pêle-mêle sur les choses et sur les gens. En route, les
femmes échevelées et meurtries ont changé d'hommes, les hommes de chapeaux."
Gavarni qtd. in Lemoisne, *Gavarni, peintre et lithographe*, 108.

82 Remarking on the *chahut* and public dancing at the Bal Chicard: "Ce n'est point une
danse, c'est encore une parodie; parodie de l'amour, de la grâce, de l'ancienne *poli-
tesse* française … pour aider à la vérité de sa pantomime, le danseur, ou plutôt l'ac-
teur, appelle ses muscles à son secours; il s'agite, il se disloque, il trépigne, tous ses
mouvements ont un sens, toutes ses contorsions sont des emblems." Delord, "Le
Chicard" in *Les Français*, vol. 2, 372.

83 Fanny Essler: "elle danse même quelque chose de plus cancan que le cancan lui-
meme." *Physiologie de l'Opéra, du Carnaval*, 78.

84 M. Clark, "The Quadrille as Embodied Musical Experience," 513–14.

85 In pursuit of novelty, they tried everything: "Arnal, travesti en maestro, a conduit un
orchestre de mirlitons à l'Opéra. L'Opéra-Comique a eu ses Fêtes vénitiennes, dans
lequelles on a montré des bonhommes de cire comme chez Curtius, et au milieu
desquelles Musard et 99 musiciens étaint suspendus sur un pont … On a distribué
des bouquets de papier peint aux dames; on a joué des parades, des proverbes; on a
essayé des quadrilles de nymphes, de naiades très-peu vêtues: rien de tout cela n'a
séduit les habitués … C'est le galop qu'il leur faut … Cependant avouons que la
troupe des amis du cancan est un peu moutonnière; elle a répudie la plus belle salle
de bal de Paris, la salle des débuts de Musard." *Physiologie du débardeur*, 24, 26–7.

86 On price points, see *Physiologie de l'Opera*, 12. On the different publics at each venue,
see ibid., 85–7. On the decline of dominos and old intrigue, replaced by débardeurs,
Musard, and the cancan, see ibid., 88–91.

87 "Ce qui distingue les bals publics, se sont des nuances presque insaisissables. Partout
le débardeur règne, il se fait le même partout … Seulement, à l'Opera, ses rubans
sont plus frais, sa perruque plus touffue, son velours est plus beau." *Physiologie du
débardeur*, 35–6.

88 "Puis il tombera dans le domaine banal de la location: de la Lorette, il passera à la grisette, et puis après les femmes qui le porteront n'ont plus de nom; ses beaux jours ont commencé à l'Opéra, ils finiront à la Porte d'Idalie ou au bal du Boeuf-Rouge." Ibid., 112–17.

89 See Hiner, *Accessories to Modernity*, 77–106, quote on 79.

90 Olson, *Gavarni: The Carnival Lithographs*, 18.

91 Lemoisne says the trousers were red velvet: "dont le fameux débardeur de Déjazet à pantalon de velours rouge." *Gavarni, peintre et lithographe*, 76.

92 Stokes, "Déjazet/déja vu," 94. A late portrait of Déjazet by the Nadar studio shows her in this typical travestied old-regime costume, with powdered wig, tight silk breeches, and buckled shoes. See NA 237 02149 G in the collection of Ministère de la Culture (France) – Médiathèque de l'architecture et du patrimoine.

93 Stokes, "Déjazet/déja vu," 82–98.

94 Gavarni's choice of masquerade costume for Déjazet was well suited to a character (Indiana) who was meant to embody female vitality as a foil to the deflated virility of the male lead, Charlemagne, a humble shirt-maker disguised in the uniform of a Hussar. Indiana's bold cross-dressing makes us think about the extent to which the military uniform might disguise effeminacy, weakness, or pretention in the male lead. Evidence of another crossover from the balls to the stage: when Indiana and Charlemagne reunite, they perform an elated *galop* before agreeing to marry. Ibid., 95–6.

95 On the lorette, see *Physiologie de la lorette*; *Physiologie de l'Opéra*; Hiner, *Accessories to Modernity*, 31–42; and Yousif, "Word, Image, Woman."

96 On female types who appropriate male norms, "stand out," and otherwise deviate from female propriety (*lorette, lionne, femme à la mode*, and female eccentric), see Gill, *Eccentricity and the Cultural Imagination*, esp. 89–101.

97 Some have speculated that Gavarni's emphasis on these unconventional female characters demonstrates his interest in changing sexual mores and perhaps also current debates about divorce, prostitution, and women's rights. See *Femmes de Gavarni*. However, Gavarni was also a notorious rake and womanizer: "'Conquerer' he certainly was, in the sense in which the brothers de Goncourt mean it. He [Gavarni] loved women for the sake of conquering them, and few indeed they were who could resist his 'go,' his ardour … His whole life was one long chassé-croisé of mistresses, with joyous eyes, and flowers and laughter, and never aught of tragical jealousy, never a sorrow-bearing encounter." Uzanne, "The Life and Work of Gavarni," in Holme, *Daumier and Gavarni*, G iv.

98 Description of the *lorette* in Henry Murger's *Scènes de la vie de bohème*, as quoted and translated in Hiner, *Accessories to Modernity*, 33.

99 Yousif's "Word, Image, Woman" traces a transformation from Gavarni's playful, lighthearted depictions of the *lorette* (in "Les Lorettes" in *Le Charivari*, 1840–3) to the Goncourts' brutal portrait of a corrupt, insatiable type in *La lorette* (1853).

100 Alhoy, *Physiologie du débardeur*, 9–10.

101 Stokes, "Déjazet/déja vu," 91.

102 Castle, "The Culture of Travesty," 82–100. Quote from page 93.

103 See the *Physiologie de l'Opera*, 54–8 and 88–91.

104 *Physiologie du débardeur*, 10, 117. *Physiologie de l'Opéra*, 87.

105 Terni, "A Genre for Early Mass Culture," 229–32.

106 *Les Femmes de Gavarni, Scènes de la vie parisienne*, a play with three acts and one "mascarade" by Théodore Barrière, Adrien Decourcelle, and Léon Beauvallet, had its debut at the Théâtre des Variétés on 3 June 1852. Noted in *Femmes de Gavarni* [n.p.]. A libretto detailing the characters, plot, and dialogue is held at the BN: Z ROTHSCHILD-7199, accessible at http://catalogue.bnf.fr/ark:/12148/cb303089082.

107 Stokes, "Déjazet/déja vu," 88–9.

108 See Verhagen, "The Poster in *Fin-de-Siècle* Paris"; Iskin, *The Poster*; Tiersten, *Marianne in the Market*; Segal, "Commercial Immanence"; and Richards, "Those Lovely Seaside Girls," in *The Commodity Culture of Victorian England*, 205–48.

109 Gluck, *Popular Bohemia*, 20, 27.

110 Gluck sees the bohemians of 1830s not only as a new type of "carnivalesque urban performer" (ibid., 44) but as the source of aesthetic and political radicalism, the "prototypes of modern youth movements and 'spectacular subcultures'" (33) of modernism and the avant-garde (2).

111 "This inventor of costumes, this genial fashion-maker was himself irreproachably dressed, and extremely fastidious as to what he wore. He was a dandy of the Brummel or the Alfred de Musset type – from natural taste and physical necessity." Uzanne, "The Life and Work of Gavarni," in Holme, *Daumier and Gavarni*, G iv.

112 Rhonda Garelick, *Rising Star*.

113 This resonant phrase, *faire figure*, was brought to my attention by the introductory remarks in Alison Matthews David, "Cutting a Figure."

CONCLUSION

1 See Schwartz, *Spectacular Realities*; Samuels, *Spectacular Past*; and Crary, "Spectacle, Attention, Counter-Memory."

2 Mainardi, *Another World*, 2.

3 See Mainardi, "The Invention of Comics," and Willems, "Between Panoramic and Sequential."

4 On David, Toudouze, and the Colin sisters (all trained as painters, and among the most important and prolific illustrators working for both French and British fashion journals through the late nineteenth century), see Steele, *Paris Fashion*, 102–11; Marcus, "Reflections on Victorian Fashion Plates"; and Higonnet, "Secluded Women" and *Berthe Morisot*, 91–6. After 1860 the professional rubric of *modélistes* or *dessina-*

teurs en costumes et robes was used to describe the makers of graphic dress designs, which served as models to be consulted by the illustrators of fashion plates and clothes makers; these artists included Emile Mille, Léon Sault, Charles Leray, Charles Pilatte, Amédée Ploux, and Paul Robin. Couturiers continued to commission models and figurines from freelance *modélistes* until the 1880s, when designers were typically employed in-house. See *Le dessin sous toutes ses coutures*, 31–5.

5 Periodicals featuring hand-drawn editorial images in the late nineteenth century include the satirical publications *L'Eclipse*, *Don Quichote*, and *Gil Blas*. See Mainardi, *Another World*, 114.

6 Manet and Mallarmé published *Le Corbeau* in 1875 and *L'Après-midi d'un faune* in 1876. On their collaboration and the development of the *livre de peintre*, see Arnar, *The Book as Instrument*.

7 See Leard, "The Société des Peintres-Graveurs Français in 1889–97."

8 At the 1855 Universal Exhibition reproductive engravers figured prominently in the jury, the works selected for exhibition, and the medals awarded. Academic engravers monopolized the adjudication and narration of nineteenth-century print until the 1880s when amateurs took the curatorial and historiographic lead. Béraldi, "L'Estampe en 1889," in *Les Graveurs*, vol. 9, 255–71.

9 On late-nineteenth-century iconophiles and print collectors, see Iskin, *The Poster*, esp. chapter 8.

10 See Iskin, *The Poster*, 294–8, and Béraldi, "L'Estampe en 1889."

11 Degas owned 750 prints by Daumier and 2,000 lithographs by Gavarni, in both distinguished and ordinary impressions, some cut directly from *Le Charivari*. Degas also collected original prints by his contemporaries (Manet, Whistler, Bracquemond, Pisarro, Cassat, Gauguin) and the work of Ingres and Delacroix. See A. Dumas, "Degas and His Collection."

Bibliography

ABBREVIATIONS

AN Centre historique des Archives nationales, Paris
BN Bibliothèque nationale de France, Paris
BN EST Bibliothèque nationale de France, Cabinet des Estampes, Paris
MPUB Musée de la Publicité, Musée des Arts décoratifs, Paris

ARCHIVAL SOURCES

Catalogues de la librairie. BN Serie Q-10, T4-N8 MAG.082. Consulted: (CURMER) 1841, 1842,
 1844, 1845, 1847, 1848, 1855, 1856, 1858, 1867; (HETZEL) 1843, 1862; and (LADVOCAT) 1829.
Correspondence des Français. Covers and front-matter of instalments N. 1–398 are
 archived as a "tome X" of *Les Français peints par eux-mêmes* in BN, mfm. 11372.
Declarations des imprimeurs, relève des tirages indiqués à la Direction de la Librairie. AN
 Serie F18* (II) 1 A 182, 1815–1881, "Imprimerie, Librairie, Presse, Censure: Enregistrement
 des declarations des Imprimeurs Parisiens." Consulted: F 18* II 26 (2 Jan.–31 Dec. 1839)
 to F 18* II 33 (2 Jan.–31 Dec. 1846).
Papiers Hetzel. BN Manuscrits, NAf. 16932–17152.

PUBLISHED SOURCES

Achille Devéria: témoin du romantisme parisien, 1800–1857. Paris: Musée de la ville de
Paris 1985.

Adamowicz-Hariasz, Maria. "From Opinion to Information: The *Roman-Feuilleton* and
the Transformation of the Nineteenth-Century French Press." In Dean de la Motte
and Jeannene M. Przyblyski, eds., *Making the News: Modernity and the Mass Press in
Nineteenth-Century France*, 160–84. Amherst: University of Massachusetts Press 1999.

Adhémar, Jean, and Jean-Pierre Seguin. *Le livre romantique.* Paris: Éditions du Chêne 1968.

Adorno, Theodor, and Max Horkheimer. *Dialectic of Enlightenment.* Translated by John
Cumming. New York: Continuum 1998.

Album lithographique par Raffet. Paris: Gihaut Frères 1835.

Album lithographique par Raffet. Paris: Gihaut Frères 1837.

Allen, James Smith. "Le commerce du livre romantique à Paris, 1820–1843." *Revue française
d'histoire du livre* 26 (January–March 1980): 69–93.

– *In the Public Eye: A History of Reading in Modern France, 1800–1940.* Princeton, NJ:
Princeton University Press 1991.

Amann, Elizabeth. "The Devil in the Omnibus: From *Le Charivari* to *Blackwood's Maga-
zine*." *Nineteenth-Century Contexts* 39, no. 1 (2017): 1–13.

Amossy, Ruth. "Types ou stéréotypes? Les 'Physiologies' et la littérature industrielle."
Romantisme 64, no. 2 (1989): 113–23.

Anderson, Benedict. *Imagined Communities: Reflections on the Origin and Spread of
Nationalism.* London: Verso 1991.

*Les Anglais peints par eux-mêmes. Par les sommités littéraires anglaises, dessins de M. Kenny
Meadows.* Translated by Émile de la Bédollière. 2 vols. Paris: Curmer 1840–41.

Appadurai, Arjun. *Modernity at Large: Cultural Dimensions of Globalization.* Minneapolis:
University of Minnesota Press 1996.

Applbaum, Kalman. *The Marketing Era: From Professional Practice to Global Provisioning.*
New York: Routledge 2004.

Armelhault, J. (Marie Joseph François Mahérault), and Emmanuel Bocher. *L'Œuvre de
Gavarni, lithographies originales et essais d'eau-forte et de procédés nouveaux, catalogue
raisonné.* Paris: Librairie des bibliophiles 1873.

Arnar, Anna S. *The Book as Instrument: Stéphane Mallarmé, the Artist's Book, and the
Transformation of Print Culture.* Chicago and London: University of Chicago Press 2011.

Arrieta, Hernán Díaz, ed. *Eugène Devéria d'après des documents originaux, 1805–1865.*
Paris: Librairie Fischbacher 1887.

L'Artiste, journal de la littérature et des beaux-arts. Paris, 1831–1904.

Athanassoglou-Kallmyer, Nina. "Imago Belli: Horace Vernet's *L'Atelier* as an Image of
Radical Militarism under the Restoration." *Art Bulletin* 68, no. 2 (June 1986): 268–80.

Auslander, Leora. "The Gendering of Consumer Practices in Nineteenth-Century France."

In Victoria de Grazia with Ellen Furlough, eds., *The Sex of Things: Gender and Consumption in Historical Perspective*, 79–112. Berkeley: University of California Press 1996.

Un Autre monde, transformations, visions, incarnations … par Grandville. Paris: H. Fournier 1844.

Baldwin, Gordon, and Judith Keller. *Nadar/Warhol/Paris/New York: Photography and Fame*. Los Angeles: J. Paul Getty Museum 1999.

Balzac, Honoré de. *Lost Illusions*. Translated by Kathleen Raine. New York: Random House 2001. Originally published in serial form, 1837–43.

Bann, Stephen. "Achille Devéria and French Illustration in the Romantic Period." *Print Quarterly* 29, no. 3 (September 2012): 288–99.

– *Distinguished Images: Prints in the Visual Economy of Nineteenth-Century France*. New Haven, CT: Yale University Press 2013.

– "Horace Vernet and Paul Delaroche: Media Old and New." In Daniel Harkett and Katie Hornstein, eds., *Horace Vernet and the Thresholds of Nineteenth-Century Visual Culture*, 228–44. Hanover, NH: Dartmouth College Press 2017.

– *Parallel Lines: Printmakers, Painters and Photographers in Nineteenth-Century France*. New Haven, CT: Yale University Press 2001.

Barbier, Patrick. *Opera in Paris, 1800–1850: A Lively History*. Translated by Robert Luoma. Portland, OR: Amadeus Press 1995.

Bargiel, Réjane, and Ségolène Le Men. *L'affiche de librairie au XIXe siècle*. Paris: Éditions de la Réunion des musées nationaux 1987.

Barthes, Roland. "The Death of the Author" (1968) and "The Reality Effect" (1968). In *The Rustle of Language*, translated by Richard Howard, 49–55, 141–8. Berkeley: University of California Press 1986.

Batchen, Geoffrey. *Burning with Desire: The Conception of Photography*. Cambridge, MA: MIT Press 1997.

Baudelaire, Charles. "Some French Caricaturists" (1857) and "The Painter of Modern Life" (1863). In *The Painter of Modern Life & Other Essays*, translated and edited by Jonathan Mayne, 1–40, 166–86. New York: Da Capo Press 1986.

Baudrillard, Jean. *La société de consommation*. Paris: Gallimard 1970.

Bellanger, Claude. *Histoire générale de la presse française*. 4 vols. Paris: Presses universitaires de France 1969.

Bellos, David. "Le marché du livre à l'époque romantique." *Revue française d'histoire du livre* 20 (summer 1978): 647–60.

Benjamin, Walter. *The Arcades Project*. Translated by Howard Eiland and Kevin McLaughlin on the basis of the German edition by Rolf Tiedemann. Cambridge, MA: Belknap/Harvard University Press 1999.

– *Charles Baudelaire: A Lyric Poet in the Era of High Capitalism*. London: Verso 1983.

Béraldi, Henri. *Les Graveurs du XIXe siècle, Guide de l'amateur d'estampes modernes*. 12 vols. Paris: L. Conquet 1885–92.

Bibliography

Berg, Keri Ann. "Fighting for the Page: Balzac, Grandville and the Power of Images, 1830–1848." PhD diss., University of Texas at Austin, 2003.

– "Taming the Bourgeoisie: Grandville's *Scènes de la vie privée et publique des animaux* (1840–1842)." *EnterText* 7, no. 3 (December 2007): 43–69.

Berlanstein, Lenard R. "Historicizing and Gendering Celebrity Culture: Famous Women in Nineteenth Century France." *Journal of Women's History* 16, no. 4 (2004): 65–91.

Berman, Marshall. *All That Is Solid Melts into Air: The Experience of Modernity.* New York: Simon and Schuster 1982.

Bermingham, Ann. *Learning to Draw: Studies in the Cultural History of a Polite and Useful Art.* New Haven, CT: Yale University Press 2000.

– "Reading Constable." *Art History* 10, no. 1 (March 1987): 38–58.

Bertin, Eric. "A propos des deux bals costumés donnés par Achille Devéria (1830) et Alexandre Dumas (1833)." *Bulletin de la Société des amis du Musée national Eugène Delacroix* 4 (2006): 15–16.

Bibliographie de la France, Journal de l'imprimerie et de la librairie. Paris: Cèrcle de la Librairie. Consulted 1840–45.

Blachon, Remi. *La gravure sur bois au XIXe siècle. L'âge du bois de bout.* Paris: Les Éditions de l'Amateur 2001.

Blanc, Charles. *Les artistes de mon temps.* Paris: Firmin-Didot 1876.

Blanchard, Gérard. "Curmer ou la leçon d'un grand éditeur romantique." *Le Courrier graphique* 117 (January–March 1962): 42–51.

Boime, Albert. *Art in an Age of Counterrevolution, 1815–1848.* Chicago: University of Chicago Press 2004.

– "Declassicizing the Academic: A Realist View of Ingres." *Art History* 8, no. 1 (March 1985): 50–65.

Bourdieu, Pierre. *Distinction: A Social Critique of the Judgement of Taste.* Translated by Richard Nice. Cambridge, MA: Harvard University Press 1984.

– "The Field of Cultural Production." In David Finkelstein and Alistair McCleery, eds., *The Book History Reader*, 77–99. London and New York: Routledge 2001.

– *The Logic of Practice.* Translated by Richard Nice. Stanford, CA: Stanford University Press 1990.

– *The Rules of Art: Genesis and Structure of the Literary Field.* Translated by Susan Emanuel. Stanford, CA: Stanford University Press 1996.

Bourdieu, Pierre, and Erec R. Koch. "The Invention of the Artist's Life." *Yale French Studies* 73, *Everyday Life* (1987): 75–103.

Boutin, Aimée. "'The Title of Lawyer Leads Nowhere!': The 'Physiology' of the Law Student in Paul Gavarni, Émile de la Bédollierre and George Sand." *Nineteenth-Century French Studies* 40, nos. 1 and 2 (fall–winter 2011–12): 57–80.

Boyé, Maurice Pierre. *La Mêlée romantique.* Paris: René Julliard 1946.

Briggs, Jo. "Gavarni at the Casino: Reflections of Class and Gender in the Visual Culture of 1848." *Victorian Studies* 53, no. 4 (summer 2011): 639–64.

Brivois, Jules. *Guide de l'amateur. Bibliographie des œuvrages illustrés du XIX siècle, princi-palement des livres à gravures sur bois.* Paris: L. Conquet 1883.

Brooks, Beaulieu, and Annette Leduc. "Gavarni at Yale." *Yale University Art Gallery Bulletin* 40, no. 2 (spring 1988): 12–21.

Buck-Morss, Susan. *The Dialectics of Seeing: Walter Benjamin and the Arcades Project.* Cambridge: MIT Press 1989.

– "The Flaneur, the Sandwichman, and the Whore: The Politics of Loitering." *New German Critique* 39 (fall 1986): 99–140.

Buisine, Alain. "Sociomimesis: physiologie du petit-bourgeois." *Romantisme* 17–18 (1977): 44–55.

Byrde, Penelope. *Nineteenth-Century Fashion.* London: B.T. Batsford 1992.

Canh-Gruyer, France. "Cénacles Romantiques." In *Dictionnaire de la littérature française du XIXe siècle.* Encyclopedia Universalis 2014.

Carter, Karen Lynn. "L'Age de l'affiche: The Reception, Display and Collection of Posters in Fin-de-Siècle Paris." PhD diss., University of Chicago, 2001.

– "The Spectatorship of the *affiche illustrée* and the Modern City of Paris, 1880–1900." *Journal of Design History* 25, no. 1 (March 2012): 11–31.

Carteret, Leopold. *Le trésor du bibliophile romantique et moderne, 1801–1875.* 6 vols. Paris: Carteret 1924–28.

Castle, Terry. "The Culture of Travesty: Sexuality and Masquerade in Eighteenth-Century England." In *The Female Thermometer: Eighteenth-Century Culture and the Invention of the Uncanny*, 82–100. New York and Oxford: Oxford University Press 1995.

Champfleury, Jules. *Histoire de la caricature moderne.* Paris: E. Dentu 1865.

Le Charivari. Paris, 1832–1937.

Chazin-Bennahum, Judith. *The Lure of Perfection: Fashion and Ballet, 1780–1830.* New York and London: Routledge 2005.

Chenoune, Farid. *A History of Men's Fashion.* Translated by Deke Dusinberre. Paris: Flammarion 1993.

Childs, Elizabeth. "Big Trouble: Daumier, Gargantua, and the Censorship of Political Caricature." *Art Journal* 51 (spring 1992): 26–37.

– "The Body Impolitic: Press Censorship and the Caricature of Honoré Daumier." In Dean de la Motte and Jeannene M. Przyblyski, eds., *Making the News: Modernity and the Mass Press in Nineteenth-Century France*, 43–81. Amherst: University of Massachusetts Press 1999.

Chotard, Loïc. "La Biographie contemporaine en France au dix-neuvième siècle: autour du Panthéon-Nadar." PhD diss., Université de Paris IV, 1987.

– "Histoire de la grandeur et de la décadence du Panthéon-Nadar." In *Nadar Caricatures et photographies*, 66–85. Paris: Paris Musées 1990.

Clark, Maribeth. "The Quadrille as Embodied Musical Experience in 19th-Century Paris." *Journal of Musicology* 19, no. 3 (summer 2002): 503–26.

Bibliography

– "The Role of *Gustave ou le bal masqué* in Restraining the Bourgeois Body of the July Monarchy." *Musical Quarterly* 88, no. 2 (summer 2005): 204–31.
– "Understanding French Opera through Dance." PhD dissertation, University of Pennsylvania, 1998.
Clark, T.J. *The Absolute Bourgeois: Artists and Politics in France, 1848–1851.* Princeton, NJ: Princeton University Press 1973.
– *Image of the People: Gustave Courbet and the 1848 Revolution.* Princeton, NJ: Princeton University Press 1973.
Clifford, James. "On Ethnographic Authority." In *The Predicament of Culture: Twentieth-Century Ethnography, Literature, and Art,* 21–54. Cambridge, MA: Harvard University Press 1988.
Cloche, M. "Un grand éditeur du XIXe siècle, Léon Curmer." *Arts et Métiers graphiques* 31 (1931–32): 27–32.
Cohen, Margaret. "Panoramic Literature and Everyday Genres." In Leo Charney and Vanessa Schwartz, eds., *Cinema and the Invention of Modern Life,* 227–52. Berkeley: University of California Press 1995.
– *Profane Illumination: Walter Benjamin and the Paris of Surrealist Revolution.* Berkeley: University of California Press 1993.
– *Sentimental Education of the Novel.* Princeton, NJ: Princeton University Press 1999.
Cohen, Margaret, and Anne Higonnet. "Complex Culture." In Vanessa R. Schwartz and Jeannene M. Przyblyski, eds., *The Nineteenth-Century Visual Culture Reader,* 15–26. New York: Routledge 2004.
Cordroc'h, Marie, ed. *De Balzac à Jules Verne, un grand éditeur du XIXe siècle, Pierre-Jules Hetzel.* Paris: Bibliothèque nationale 1966.
Crary, Jonathan. "Gericault, the Panorama, and Sites of Reality in the Early Nineteenth Century." *Grey Room* 9 (fall 2002): 7–25.
– "Spectacle, Attention, Counter-Memory." *October* 50 (autumn 1989): 96–107.
– *Techniques of the Observer: On Vision and Modernity in the Nineteenth Century.* Cambridge, MA: MIT Press 1990.
– *24/7: Late Capitalism and the Ends of Sleep.* London: Verso 2013.
Cuno, James. "Charles Philipon, La Maison Aubert, and the Business of Caricature in Paris, 1829–41." *Art Journal* 43 (winter 1983): 347–54.
– "Charles Philipon and La Maison Aubert: The Business, Politics and Public of Caricature in Paris, 1820–1840." PhD diss., Harvard University, 1985.
– "Violence, Satire, and Social Types in the Graphic Art of the July Monarchy." In Petra Ten-Doesschate Chu and Gabriel Weisberg, eds., *The Popularization of Images: Visual Culture under the July Monarchy,* 10–36. Princeton, NJ: Princeton University Press 1994.
Curmer, Léon. *Aux citoyens, ouvriers, fondeurs, compositeurs, imprimeurs et relieurs de la capitale.* Paris: Le Normant 1848.
– *Note presenté à MM. les membres du jury central de l'exposition des produits de l'industrie*

française sur la profession d'éditeur et le développement de cette industrie dans le commerce de la librairie française. Paris: A. Everat 1839.

– *La Propriété intellectuelle est un droit* (15 Sept. 1858). Paris: E. Dentu 1860.

Darnton, Robert. "A Bourgeois Puts His World in Order: The City as Text." In *The Great Cat Massacre and Other Episodes in French Cultural History*, 107–43. New York: Vintage Books 1985.

– *The Business of Enlightenment. A Publishing History of the Encyclopédie, 1775–1800.* Cambridge, MA: Harvard University Press 1979.

Daumard, Adeline. *Les Bourgeois de Paris au XIX siècle.* Paris: Flammarion 1970.

– "Le peuple dans la société française à l'époque romantique." *Romantisme* 13 (1975): 21–8.

Daumier 1808–1879. Ottawa: National Gallery of Canada 1999.

David, Alison Matthews. "Cutting a Figure: Tailoring, Technology and Social Identity in Nineteenth-Century Paris." PhD dissertation, Stanford University, 2002.

De la Motte, Dean. "Utopia Commodified: Utilitarianism, Aestheticism, and the *presse à bon marché.*" In Dean de la Motte and Jeannene M. Przyblyski, eds., *Making the News: Modernity and the Mass Press in Nineteenth-Century France*, 141–59. Amherst: University of Massachusetts Press 1999.

Le Dessin sous toutes ses coutures: Croquis, illustrations, modèles, 1760–1994. Paris: Musée de la mode et du costume 1995.

De Young, Justine. "Not Just a Pretty Picture: Fashion as News." In Jason Hill and Vanessa Schwartz, eds., *Getting the Picture: The Visual Culture of the News*, 109–15. London: Bloomsbury 2015.

Le Diable à Paris. Paris et les Parisiens. Mœurs et coutumes, caractères et portraits des habitants de Paris, tableau complet sur leur vie privée, politique, artistique, littéraire, industrielle etc. etc. 2 vols. Paris: P.-J. Hetzel 1845–46. The first instalment was published in April 1844.

Doherty, Brigid. "'The Colportage Phenomenon of Space' and the Place of Montage in *The Arcades Project.*" In Beatrice Hanssen, ed., *Walter Benjamin and the Arcades Project*, 157–83. London: Continuum International Publishing 2006.

Driskel, Michael Paul. "Singing 'The Marseillaise' in 1840: The Case of Charlet's Censored Prints." *Art Bulletin* 69, no. 4 (December 1987): 604–25.

Dumas, Alexandre. *Les Morts vont vites.* 2 vols. Paris: Michel Lévy frères 1861.

Dumas, Ann. "Degas and His Collection" and "Degas and the Collecting Milieu." In Ann Dumas et al., eds., *The Private Collection of Edgar Degas*, 3–73, 109–34. New York: Metropolitan Museum of Art 1997.

Duncan, Carol. *The Pursuit of Pleasure: The Rococo Revival in French Romantic Art.* New York: Garland Publishing 1976.

Duplessis, Georges. *Gavarni, étude, ornée de quatorze dessins inédits.* Paris: Rapilly 1876.

Eitner, Lorenz. *Géricault: His Life and Work.* Ithaca, NY: Cornell University Press 1983.

Études pris dans le bas peuple, ou les Cris de Paris. Paris: Joullain and Fessard 1737–46.

Bibliography

Farwell, Beatrice. *The Charged Image: French Lithographic Caricaturists, 1825–1848*. Santa Barbara, CA: Santa Barbara Museum of Art 1989.

– *French Popular Lithographic Imagery, 1815–1870*. 12 vols. Chicago: University of Chicago Press 1981.

Felkay, Nicole. *Balzac et ses éditeurs, 1822–1837: essai sur la librairie romantique*. Paris: Promodis; Éditions du Cercle de la librairie 1987.

– "La librairie et la presse de 1825 à 1845. Documents inédits. Première partie: années 1825–1829 incluse." *Revue française d'histoire du livre* 29 (October/November 1980): 685–99.

– "Les Libraires de l'époque romantique d'après des documents inédits." *Revue française d'histoire du livre* 9 (1975): 31–86.

Femmes de Gavarni: Gavarni's Images of Women. Birmingham: University of Alabama at Birmingham Visual Arts Gallery 1985.

Ferguson, Priscilla Parkhurst. *Paris as Revolution: Writing the Nineteenth-Century City*. Berkeley: University of California Press 1994.

Foster, Hal. "Brow Beaten" and "Design and Crime." In *Design and Crime (and Other Diatribes)*, 3–12, 13–26. London: Verso 2002.

Foucault, Michel. *Discipline and Punish: The Birth of the Prison*. Translated by Alan Sheridon. New York: Vintage Books 1979.

– "Fantasia of the Library" (1967). In *Language, Counter-Memory, Practice*, 87–109. Edited and translated by Donald F. Bouchard. Ithaca, NY: Cornell University Press 1977.

– *The Order of Things: An Archaeology of the Human Sciences* (1966). New York: Vintage Books 1994.

Les Français. Costumes des principales provinces de la France, dessinés d'après nature par MM. Gavarni, H. Monnier, E. Lami, Loubon, Geniole, H. Émy; lithographiés par MM. Pauquet et V. Coindre. Paris: L. Curmer 1840.

Les Français peints par eux-mêmes: Encyclopédie morale du dix-neuvième siècle. 8 vols. Paris: L. Curmer 1840–42. The first instalment was published in May 1839.

Fried, Michael. *Manet's Modernism: or, the Face of Painting in the 1860s*. Chicago: University of Chicago Press 1996.

Galerie de la Presse, de la littérature et des beaux-arts. Directeur des dessins M. Charles Philippon, rédacteur en chef Louis Huart. 2 vols. Paris: Aubert 1838–41.

Garelick, Rhonda. *Rising Star: Dandyism, Gender, and Performance in the Fin de Siècle*. Princeton, NJ: Princeton University Press 1998.

Garrioch, David. *The Formation of the Parisian Bourgeoisie 1690–1830*. Cambridge, MA: Harvard University Press 1996.

Gaudriault, Raymond. *La Gravure de mode féminine en France*. Paris: Éditions de l'amateur 1983.

Gautier, Maximilien. *Achille et Eugène Devéria*. Paris: Floury 1925.

Gauthier on Dance. Translated and edited by Ivor Guest. London: Dance Books 1986.

Gill, Miranda. *Eccentricity and the Cultural Imagination in Nineteenth-Century Paris*. Oxford: Oxford University Press 2009.

Ginzburg, Carlo. "Morelli, Freud and Sherlock Holmes: Clues and the Scientific Method." *History Workshop* 9 (spring 1980): 5–36.

Gladwell, Malcolm. "The Coolhunt." *New Yorker* (17 March 1997).

Gluck, Mary. *Popular Bohemia: Modernism and Urban Culture in Nineteenth-Century Paris.* Cambridge, MA: Harvard University Press 2005.

Goncourt, Edmond and Jules. *Gavarni, l'homme et l'œuvre.* Paris: G. Charpentier and E. Fasquelle 1896.

Gondolo Della Riva, Piero. "Les affiches Hetzel." *Art et métiers du livre* 139 (May 1986): 89–92.

Gourret, Jean. *Historie des salles de l'Opéra de Paris.* Paris: Guy Trédaniel 1985.

Le Goût nouveau, motifs variés pris d'après nature. Paris: Tessari, Aumont. London: C. Tilt 1831.

La Grande Ville, nouveau tableau de Paris, comique, critique et philosophique. Vol. 1 by Paul de Kock [no illustrations]. Paris: Bureau central des publications nouvelles 1842–43. Vol. 2 by Balzac, Soulié, Gozlan, Briffault, Ourliac, Guinot, Monnier, Marco de Saint-Hilaire, et al. under the direction of Marc Fournier. Illustrations by Gavarni, Victor Adam, Daumier, et al. Paris: Marescq 1844. Alternate title to second volume is *Nouveau Tableau de Paris, comique, critique et philosophique.*

Green, Nicholas. "Circuits of Production, Circuits of Consumption: The Case of Mid-Nineteenth-Century French Art Dealing." *Art Journal* 48 (spring 1989): 29–34.

– *The Spectacle of Nature: Landscape and Bourgeois Culture in Nineteenth Century France.* Manchester, UK: Manchester University Press 1990.

Gretton, Tom. "The Pragmatics of Page Design in Nineteenth-Century General-Interest Weekly Illustrated Newspapers." *Art History* 33, no. 4 (September 2010): 680–709.

Grew, Raymond. "Picturing the People: Images of the Lower Orders in 19th-C French Art." In Robert Rotberg, ed., *Art and History: Images and Their Meaning*, 203–31. Cambridge: Cambridge University Press 1988.

Guilbaut, Serge, Maureen Ryan, and Scott Watson, eds. *Théodore Géricault: The Alien Body Tradition in Chaos.* Vancouver: Morris and Helen Belkin Art Gallery 1997.

Guillaume, Valérie, and Ségolène Le Men. *Benjamin Roubaud et la Panthéon Charivarique.* Paris: Maison Balzac 1988.

Habermas, Jurgen. *Structural Transformation of the Public Sphere: An Inquiry into a Category of Bourgeois Society.* Translated by Thomas Burger. Cambridge, MA: MIT Press 1989.

Hahn, Hazel Haejeong. "Boulevard Culture and Advertising as Spectacle in Nineteenth-Century Paris." In Alexander Cowan and Jill Steward, eds., *The City and the Senses: Urban Culture since 1500*, 156–75. London and New York: Routledge 2007.

– "Fashion Discourses in Fashion Journals and Madame de Girardin's *Lettres parisiennes* in July Monarchy France." *Fashion Theory: The Journal of Dress, Body and Culture* 9, no. 2 (June 2005): 205–27.

– *Scenes of Parisian Modernity: Culture and Consumption in the Nineteenth Century.* New York: Palgrave Macmillan 2009.

Bibliography

– "Street Picturesque: Advertising in Paris, 1830–1914." PhD diss., University of California, Berkeley, 1997.

Hall, Catherine. "The Sweet Delights of Home." In Michelle Perrot, ed., *A History of Private Life, Volume 4: From the Fires of Revolution to the Great War*, 66–74. Cambridge, MA: Belknap Press 1990.

Hall, Stuart. "Notes on Deconstructing 'the Popular.'" In John Storey, ed., *Cultural Theory and Popular Culture: A Reader*, 442–53. New York: Prentice Hall 1980.

Hannoosh, Michele. *Baudelaire and Caricature: From the Comic to an Art of Modernity*. University Park: Pennsylvania State University Press 1992.

Hanson, Anne Coffin. *Manet and the Modern Tradition*. New Haven, CT, and London: Yale University Press 1977.

Harkett, Daniel, and Katie Hornstein, eds. *Horace Vernet and the Thresholds of Nineteenth-Century Visual Culture*. Hanover, NH: Dartmouth College Press 2017.

Harvey, David. *Paris, Capital of Modernity*. New York: Routledge 2003.

Haynes, Christine. *Lost Illusions: The Politics of Publishing in Nineteenth Century France*. Cambridge, MA: Harvard University Press 2010.

Heads of the People, or, Portraits of the English: Drawn by Kenny Meadows, with Original Essays by Distinguished Writers, 2 vols. London: Robert Tyas 1840–41.

Heidegger, Martin. "The Age of the World Picture." In *The Question Concerning Technology and Other Essays*, 115–54. Translated by William Lovitt. New York: Harper and Row 1977.

Hetzel, Pierre-Jules. *La Propriété littéraire et la domaine public payant* (1858). Bruxelles: Veuve J. Van Buggenhoudt 1860.

Les Heures du jour. Paris: Fonrouge et Ostervald 1829. Reprinted in *Heures de la parisienne*, with a preface by Roger-Armand Weigert. Paris: Éditions Rombaldi 1957.

Higonnet, Anne. *Berthe Morisot's Images of Women*. Cambridge, MA: Harvard University Press 1992.

– "Real Fashion: Clothes Unmake the Working Woman." In Margaret Cohen and Christopher Prendergast, eds., *Spectacles of Realism: Body, Gender, Genre*, 137–62. Minneapolis: University of Minnesota Press 1995.

– "Secluded Vision: Images of Feminine Experience in Nineteenth-Century Europe." *Radical History Review* 38 (1987): 16–36.

Hiner, Susan. *Accessories to Modernity: Fashion and the Feminine in Nineteenth-Century France*. Philadelphia: University of Pennsylvania Press 2010.

– "From Pudeur to Plaisir: Grandville's Flowers in the Kingdom of Fashion." *dix-neuf* 18, no. 1 (April 2014): 45–68.

Histoire de l'édition française. Edited by Henri-Jean Martin and Roger Chartier, in collaboration with Jean-Pierre Vivet. Vol. 3: *Le temps des éditeurs: du Romantisme à la Belle Epoque*. Paris: Promodis 1985.

Historical Perspectives in Marketing: Essays in Honor of Stanley C. Hollander. Edited by Terence Nevett and Ronald A. Fullerton. Lexington, MA: Lexington Books 1988.

Hobsbawm, Eric. *The Age of Revolution, 1789–1848*. New York: New American Library 1962.

Holland, Vyvyan. *Hand Coloured Fashion Plates, 1770 to 1899*. London: B.T. Batsford 1955.

Holme, Charles, ed. *Daumier and Gavarni, with Critical and Biographic Notes by Henri Frantz and Octave Uzanne*. London: Offices of "The Studio" 1904.

Horace Vernet (1789–1863): Académie de France à Rome. Paris: École nationale supérieure des beaux-arts 1980.

Hugo, Adèle Foucher. *Victor Hugo raconté par un témoin de sa vie*. 2 vols. Brussels and Leipzig: Librairie Internationale, A. Lacroix, Verboeckhoven and Company 1863.

Hugo, Victor. *Notre Dame de Paris*. Translated by Alban Krailsheimer. Oxford: Oxford University Press 1993. First published in Paris by Gosselin, 1831.

Incroyables et merveilleuses. Paris: Pierre La Mésangère 1810–18. Reprinted in *Incroyables et merveilleuses: Costumes et modes d'autrefois, Paris 1810–1818*, with a preface by Roger-Armand Weigert. Paris: Rombaldi 1955.

Iskin, Ruth E. "Material Women: The Department-Store Fashion Poster in Paris, 1880–1900." In Maureen Daly Goggin and Beth Fowkes Tobin, eds., *Material Women, 1750–1950, 33–53: Consuming Desires and Collecting Practices*. Farnham, UK: Ashgate 2009.

– *The Poster: Art, Advertising, Design, and Collecting, 1860s–1900s*. Hanover, NH: Dartmouth College Press 2014.

Jobling, Paul, and David Crowley. "A Medium for the Masses I: The Popular Illustrated Weekly and the New Reading Public in France and England during the Nineteenth Century." In *Graphic Design: Reproduction and Representations since 1800*, 9–40. Manchester, UK: Manchester University Press 1996.

Join-Diéterle, Catherine. *Les décors de scène de l'Opéra de Paris à l'époque romantique*. Paris: Picard 1988.

Jones, Jennifer. *Sexing la Mode: Gender, Fashion and Commercial Culture in Old Regime France*. London: Bloomsbury Academic 2004.

Journal des dames et des modes. Paris, 1801–39.

Jubert, Gerard. "Achille Devéria, Conservateur du Département des Estampes de la Bibliothèque Impériale." *Nouvelles de l'estampe* 175 (2001): 6–28.

Kaenel, Philippe. *Le métier d'illustrateur 1830–80: Rodolphe Topffer, J.-J. Grandville, Gustave Doré*. Paris: Messene 1996.

Kerr, David S. *Caricature and French Political Culture, 1830–1848: Charles Philipon and the Illustrated Press*. New York: Oxford University Press 2000.

Kinsman, Jane. "Developing Character: Gavarni's Lithographs for *Paris* 1852–1853." *Gazette des beaux-arts* 115 (1990): 25–33.

Kleinert, Annemarie. "Les débuts de Gavarni, peintre des mœurs et des modes parisiennes." *Gazette des beaux-arts* 134, no. 1570 (November 1999): 213–24.

Kloss, William, and Charles Timbrell. "Two Portraits of Henri Herz by the Devéria Brothers." *Bulletin of the University of Michigan Museums of Art and Archaeology* 9 (1989): 48–57.

Bibliography

Kracauer, Siegfried. *Orpheus in Paris: Offenbach and the Paris of His Time*. Translated by Gwenda David and Eric Mosbacher. New York: Zone Books 2002.

Krämer, Gelix. "'Mon tableau de genre': Degas's 'Le Viol' and Gavarni's 'Lorette'." *Burlington Magazine* 149, no. 1250 (May 2007): 323–5.

La Combe, Joseph-Félix Le Blanc de. *Charlet, sa vie, ses lettres, suivi d'une description raisonnée de son œuvre lithographique*. Paris: Paulin et Le Chevalier 1856.

Lacombe, Paul. *Bibliographie Parisienne. Tableaux de mœurs, 1600–1880*. Paris: P. Rouquette 1887.

Lajer-Burcharth, Ewa. "Modernity and the Condition of Disguise: Manet's 'Absinthe Drinker.'" *Art Journal* 45, no. 1 (spring 1985): 18–26.

Lauster, Martina. *Sketches of the Nineteenth Century: European Journalism and Its Physiologies, 1830–50*. Houndmills, UK, and New York: Palgrave Macmillan 2007.

Laver, James. *The Age of Illusion: Manners and Morals, 1750–1848*. London: Weidenfeld and Nicolson 1972.

Leard, Lindsay. "The Société des Peintres-Graveurs Français in 1889–97." *Print Quarterly* 14, no. 4 (December 1997): 355–63.

Lefebvre, Henri, and Christine Levich. "The Everyday and Everydayness." *Yale French Studies* 73, *Everyday Life* (1987): 7–11.

Le Men, Ségolène. "Balzac, Gavarni, Bertall et les *Petites Misères de la vie conjugale*." *Romantisme* 14, no. 43 (1984): 29–44.

– "Book illustration." In Peter Collier and Robert Lethbridge, eds., *Artistic Relations: Literature and the Visual Arts in Nineteenth-Century France*, 94–110. New Haven, CT: Yale University Press 1994.

– "Hetzel ou la science récréative." *Romantisme* 19, no. 65 (1989): 69–80.

– "De l'image au livre: l'éditeur Aubert et l'abécédaire en estampe." *Nouvelles de l'estampe* 90 (December 1986): 17–30.

– "La vignette et la lettre." In Henri-Jean Martin and Roger Chartier, eds., *Histoire de l'édition française*, 312–27. Vol. 3. Paris: Promodis 1985.

Le Men, Ségolène, ed. *Lanternes magiques: tableaux transparents*. Paris: Éditions de la Réunion des musées nationaux 1995.

Le Men, Ségolène, and Luce Abélès, eds. *"Les français peints par eux-mêmes": panorama social du XIXe siècle*. Paris: Éditions de la Réunion des musées nationaux 1993.

Lemoisne, Paul-André. *Gavarni, peintre et lithographe*. 2 vols. Paris: H. Floury 1924–28.

Lerner, Jillian. "Nadar's Signatures: Caricature, Self-Portrait, Publicity." *History of Photography* 41, no. 2 (May 2017): 108–25.

– "Panoramic Literature: Marketing Illustrated Journalism in July Monarchy Paris." PhD diss., Columbia University, 2006.

Lesage, Alain-René. *Le Diable boîteux*. Paris: Bourdin and Company 1840. First published in 1707.

Lhéritier, Andrée. "Les Physiologies." *Etudes de Presse* 9, no. 17 (1957): 13–58.

Louis, Paul. *Histoire de la classe ouvrière en France, de la Révolution à nos jours. La condition*

matérielle des travailleurs, les salaires et le cout de la vie. Paris: Librairie des sciences politiques et sociales Marcel Rivière 1927.

Loyrette, Henri. "Situating Daumier." In *Daumier 1808–1879*, 12–21. Ottawa: National Gallery of Canada 1999.

Lukács, Georg. "Balzac: Lost Illusions." In *Studies in European Realism*. New York: Grosset and Dunlap 1964.

Lyons, Martyn. *Le triomphe du livre: Une histoire sociologique de la lecture en France au XIXe siècle.* Paris: Promodis 1987.

Maidment, Brian. *Comedy, Caricature and the Social Order, 1820–1850.* Manchester, UK: Manchester University Press 2013.

Maigron, Louis. *Le Romantisme et la mode d'après des documents inédits.* Paris: Champion 1911.

Mainardi, Patricia. *Another World: Nineteenth-Century Illustrated Print Culture.* New Haven, CT: Yale University Press 2017.

– "The Invention of Comics." *Nineteenth-Century Art Worldwide* 6, no. 1 (spring 2007). http://www.19thc-artworldwide.org/index.php/spring07/145-the-invention-of-comics.

Marcus, Sharon. *Apartment Stories: City and Home in Nineteenth-Century Paris and London.* Berkeley: University of California Press 1999.

– "Reflections on Victorian Fashion Plates." *differences: A Journal of Feminist Cultural Studies* 14, no. 3 (2003): 4–33.

Marrinan, Michael. *Painting Politics for Louis Philippe: Art and Ideology in Orleanist France, 1830–1848.* New Haven, CT: Yale University Press 1988.

Martin-Fugier, Anne. "Bourgeois Rituals." In Michelle Perrot, ed., *A History of Private Life, Volume 4: From the Fires of Revolution to the Great War*, 261–337. Cambridge, MA: Belknap Press 1990.

– *La vie élégante ou la formation de Tout-Paris, 1815–1848.* Paris: Seuil 1993.

Marx, Karl. *Capital.* Vol. 1. Translated by Ben Fowkes. London: Penguin Books 1990.

– "Introduction to a Contribution to the Critique of Political Economy" (1857). In *Grundrisse,* translated by Martin Nicolaus c. 1973. London: Penguin 1993.

Marx, Karl, and Friedrich Engels. "La Sainte Famille, ou critique de la Critique critique contre Bruno Bauer et consorts" (1845). In Karl Marx, *Œuvres*, vol. 3, edited by Maximilien Rubel. Paris: Gallimard 1982.

Massin, Robert. *Les Cris de la ville, commerces ambulants et petits métiers de la rue.* Paris: Gallimard 1978.

Maza, Sarah. *The Myth of the French Bourgeoisie: An Essay on the Social Imaginary, 1750–1850.* Cambridge, MA: Harvard University Press 2003.

McCauley, Elizabeth Anne. "Caricature and Photography in Second Empire Paris." *Art Journal* 43, no. 4, *The Issue of Caricature* (winter 1983): 355–60.

– *Industrial Madness: Commercial Photography in Paris 1848–1871.* New Haven, CT: Yale University Press 1994.

McTighe, Sheila. "Perfect Deformity, Ideal Beauty, and the 'Imaginaire' of Work: The

Bibliography

Reception of Annibale Carracci's 'Arti di Bologna' in 1646." *Oxford Art Journal* 16, no. 1 (1993): 75–91.

Meisel, Martin. *Realizations: Narrative, Pictorial, and Theatrical Arts in Nineteenth-Century England.* Princeton, NJ: Princeton University Press 1983.

Melcher, Edith. *The Life and Times of Henri Monnier, 1799–1877.* Cambridge, MA: Harvard University Press 1950.

Melot, Michel. *The Art of Illustration.* New York: Rizzoli 1984.

– *Prints: History of an Art.* New York: Rizzoli 1981.

Merriman, John, ed. *1830 in France.* New York: New Viewpoints 1975.

La Mode. Paris, 1829–54.

Mollier, Jean-Yves. *Le commerce de la librairie en France au XIXe siècle, 1798–1914.* Paris: Maison des sciences de l'homme 1997.

Musée Dantan, Galerie des charges et croquis des célébrités de l'époque, avec texte explicatif et biographique. Paris: Delloye 1839.

Musée Parisien: histoire physiologique, pittoresque, philosophique et grotesque de toutes les bêtes curieuses de Paris et de la Banlieue. Pour faire suite à toutes les éditions des Oeuvres de M. de Buffon. Texts by M. Louis Huart. Illustrated by Grandville, Gavarni, Daumier, Traviès, Lécurieur, and H. Monnier. Paris: Beauger and Company 1841.

Nauroy, Charles. "Les Deveria." *Le Curieux* 2, no. 29 (May 1886): 74–8.

Noriez, Pierre. "Les Affiches de librairie." *Arts et métiers graphiques* 65 (November 1938): 47–54.

Nouveau tableau de Paris au XIXe siècle. Texts by Gozlan, Karr, Soulié, et al. 7 vols. Paris: Mme Charles Béchet 1834–35.

Nouveaux travestissements. Paris: Rittner and Goupil; Hautecœur-Martinet 1830–41.

Oettermann, Stephan. *The Panorama: History of a Mass Medium.* Translated by Deborah Lucas Schneider. New York: Zone Books 1997.

Œuvres choisies de Gavarni: étude de mœurs contemporaines nouvellement classées par l'auteur. 4 vols. Paris: P.-J. Hetzel 1846–48.

Olson, Nancy. *Gavarni: The Carnival Lithographs.* New Haven, CT: Yale University Art Gallery 1979.

Au paradis des dames: nouveautés, modes et confections, 1810–1870. Paris: Éditions Paris-Musées 1992.

Paris au dix-neuvième siècle, recueil de scènes de la vie parisienne, dessinées d'après nature par Victor Adam, Gavarni, Daumier… [et al.] avec un texte descriptif par Albéric Second, Burat de Gurgy, Jaime … [et al.]. Paris: Beauger and Company 1841.

Paris comique. Revue amusante des caractères, mœurs, modes, folies, ridicules, excentricités, niaiseries, bêtises, sottises, voleries et infamies parisiennes. Texte non politique par MM. L. Huart, Michelant, Ch. Philippon et autres rédacteurs du Charivari et de la Caricature … Dessins comiques par MM. de Beaumont, Bouchot, Cham, Daumier, Emy, Gavarni, Grandville et autres artistes du Musée Philippon. Paris: Aubert 1844.

Paris, ou Le Livre des cent-et-un. 15 vols. Paris: Ladvocat 1831–34.

Paris et les parisiens au XIXe siècle: mœurs, arts et monuments; texte par MM. Alexandre Dumas, Théophile Gautier, Arsène Houssaye … illustré par MM. Eugène Lami, Gavarni et Rouargue. Paris: Morizot 1856.

Parménie, Antoine, and C. Bonnier de La Chappelle. *Histoire d'un éditeur et de ses auteurs: P.-J. Hetzel (Stahl).* Paris: A. Michel 1953.

Perrot, Michelle. "The Family Triumphant." In Michelle Perrot, ed., *A History of Private Life, Volume 4: From the Fires of Revolution to the Great War,* 99–166. Cambridge, MA: Belknap/Harvard University Press 1987–91.

Perrot, Philippe. *Fashioning the Bourgeoisie: A History of Clothing in the Nineteenth Century.* Princeton, NJ: Princeton University Press 1994.

Petrey, Sandy. "Pears in History." *Representations* 35 (summer 1991): 52–71.

Physiologie du débardeur, par Maurice Alhoy, vignettes de Gavarni. Paris: Aubert 1842.

Physiologie de la lorette, par Maurice Alhoy, vignettes de Gavarni. Paris: Aubert 1841.

Physiologie de l'Opéra, du Carnaval, du Cancan et de la Cachucha, par un vilain masqué, dessins de Henri Emy. Paris: Raymond-Bocquet 1842.

Physiologie de la Presse, Biographie des journalistes et des journaux de Paris et de la Province. Paris: J. Laisné 1841.

Pinkney, David H. *Decisive Years in France, 1840–1847.* Princeton, NJ: Princeton University Press 1986.

Pinson, Stephen. *Speculating Daguerre: Art and Enterprise in the Work of L.J.M. Daguerre.* Chicago: University of Chicago Press 2012.

Pollock, Griselda. "Modernity and the Spaces of Femininity." In *Vision and Difference: Femininity, Feminism and the Histories of Art,* 50–90. London: Routledge 1988.

Preiss, Nathalie. "Les Physiologies en France au XIXe siècle, étude littéraire et stylistique." PhD diss., Université de Paris IV, 1999.

Prendergast, Christopher. "Balzac and the Reading Public." In *Balzac: Fiction and Melodrama,* 17–38. London: E. Arnold 1978.

– *Paris and the Nineteenth Century.* Oxford: Blackwell Publishers 1995.

Le Prisme, Encyclopédie morale du dix-neuvième siècle. Illustré par MM. Daumier, Gagniet, Gavarni, Grandville, Malapeau, Meissonier, Pauquet, Penguilly, Raymond Pelez, Trimolet. Paris: L. Curmer 1841. The first instalment was published in February 1840.

Provost, Louis. *Honoré Daumier, A Thematic Guide to the Oeuvre.* Edited, with an introduction, by Elizabeth C. Childs. New York: Garland Publishing 1989.

Rappaport, Erika. "A New Era of Shopping." In Vanessa Schwartz and Jeannene Przyblyski, eds., *The Nineteenth-Century Visual Culture Reader,* 151–64. London: Routledge 2004.

Renié, Pierre-Lin. "The Image on the Wall: Prints as Decoration in Nineteenth Century Interiors." *Nineteenth-Century Art Worldwide* 5, no. 2 (autumn 2006). http://www.19thc-artworldwide.org/autumn06/49-autumn06/autumn06article/156-the-image-on-the-wall-prints-as-decoration-in-nineteenth-century-interiors.

Bibliography

Renonçiat, Annie. "P.J. Hetzel et J.J. Grandville." *Art et métiers du livre* 139 (May 1986): 25–8.

Richards, Thomas. *The Commodity Culture of Victorian England: Advertising and Spectacle, 1851–1914.* Stanford, CA: Stanford University Press 1990.

Rieger, Dietmar. *Diogenes als Lumpensammler: Materialien zu einer Gestalt des französischen Literatur des 19. Jahrhunderts.* Munich: W. Fink 1982.

Rifkin, Adrian. "Ingres and the Academic Dictionary: An Essay on Ideology and Stupefaction in the Social Formation of the Artist." *Art History* 6, no. 2 (June 1983): 153–70.

Robin, Christian, ed. *Un Editeur et son siècle: Pierre-Jules Hetzel, 1814–1886.* Saint-Sébastien: Société Crocus 1988.

Roqueplan, Nester. *Les Coulisses de l'Opéra.* Paris: Librairie Nouvelle 1855.

Rosen, Charles, and Henri Zerner. *Romanticism and Realism: The Mythology of Nineteenth Century Art.* New York: Viking Press 1984.

Rosen, Jeff. "The Political Economy of Graphic Art Production during the July Monarchy." *Art Journal* 48, no. 1 (spring 1989): 40–5.

Roth, Nancy Ann. "'L'Artiste' and 'L'art pour l'art': The New Cultural Journalism in the July Monarchy." *Art Journal* 48, no. 1 (spring 1989): 35–9.

Sainte Beuve, Charles-Augustin. "De la littérature industrielle." In *Portraits contemporains,* vol. 1, 484–504. Paris: Didier 1855. First published 1 Sept. 1839 in *La Revue des deux mondes.*

Samuels, Maurice. *Spectacular Past: Popular History and the Novel in Nineteenth-Century France.* Ithaca, NY: Cornell University Press 2004.

Scènes de la vie privée et publique des animaux, vignettes par Grandville, études de mœurs contemporaines publiées sous la direction de M. P.-J. Stahl [Hetzel]. *Avec la collaboration de Messieurs de Balzac, L. Baude, E. de la Bédollierre, P. Bernard, J. Janin, Ed. Lemoine, Charles Nodier, et George Sand.* 2 vols. Paris: P.-J. Hetzel and Paulin 1842.

Schwartz, Vanessa R. *Spectacular Realities: Early Mass Culture in Fin-de-siècle Paris.* Berkeley: University of California Press 1998.

Scott, Katie. "Edmé Bouchardon's 'Cris de Paris': Crying Food in Early Modern Paris." *Word & Image* 26, no. 1 (2013): 59–91.

Second, Alberic. *Petites Mystères de l'Opéra … illustrations par Gavarni.* Paris: G. Kugelmann 1844.

Segal, Aaron. "Commercial Immanence: The Poster and Urban Territory in Nineteenth-Century France." In Clemens Wischermann and Elliott Schore, eds., *Advertising and the European City: Historical Perspectives,* 113–38. Aldershot, UK: Ashgate 2000.

Sheon, Aaron. "Parisian Social Statistics: Gavarni, 'Le Diable à Paris,' and Early Realism." *Art Journal* 44, no. 2 (1984): 139–48.

Sieburth, Richard. "Same Difference: The French Physiologies 1840–42." In *Notebooks on Cultural Analysis,* 163–200. Durham, NC: Duke University Press 1984.

Siegfried, Susan L. "The Artist as Nomadic Capitalist: The Case of Louis Léopold Boilly." *Art History* 13, no. 4 (1990): 516–41.

– "Boilly's 'Moving House': 'An Exact Picture of Paris'?" *Art Institute of Chicago Museum Studies* 15, no. 2 (1989): 126–37, 175–7.
– "Femininity and the Hybridity of Genre Painting." *Studies in the History of Art* 72 (2008): 15–37.
– "Vernet's Ladies: The Romantic Portrait Image." In Daniel Harkett and Katie Hornstein, eds., *Horace Vernet and the Thresholds of Nineteenth-Century Visual Culture*, 111–34. Hanover, NH: Dartmouth College Press 2017.
– "The Visual Culture of Fashion and the Classical Ideal in Post-Revolutionary France." *Art Bulletin* 97, no. 1 (January 2015): 77–99.
Simmel, Georg. "The Metropolis and Mental Life" and "The Philosophy of Fashion." In David Frisby and Mike Featherstone, eds., *Simmel on Culture*, 174–85, 187–206. London: Sage 1997.
Simon, Robert. "The Axe of the Medusa." In Aruna D'Souza, ed., *Self and History: A Tribute to Linda Nochlin*, 55–68. London: Thames and Hudson 2001.
Stamm, Therese Dolan. *Gavarni and the Critics*. Ann Arbor, MI: UMI Research Press, 1981.
– "Upsetting the Hierarchy: Gavarni's *Les Enfants Terribles* and Family Life during the 'Monarchie de Juillet.'" *Gazette des beaux arts* 109 (1987): 152–8.
Steele, Valerie. *Paris Fashion: A Cultural History*. Oxford: Berg 1998.
Stierle, Karlheinz. "Baudelaire and the Tradition of the Tableau de Paris." *New Literary History* 11 (1980): 345–61.
Stokes, John. "Déjazet/déja vu." In *The French Actress and Her English Audience*, 82–98. Cambridge: Cambridge University Press 2005.
Suite de déguisements pour un bal masqué. Paris: Fonrouge and Osterwald 1830.
Sullerot, Evelyne. *Histoire de la presse féminine en France, des origines à 1848*. Paris: Librairie Armand Colin 1966.
Tableau de Paris, par Edmond Texier, illustré de quinze cents gravures d'après les dessins de Blanchard, Cham, Champin et al. 2 vols. Paris: Paulin and Le Chevalier 1852–53.
Tableau de Paris, par L.S. [Louis-Sebastien] *Mercier, nouvelle édition corrigée et augmentée.* 12 vols. Amsterdam, 1782–89. The first volume was published in Hamburg in 1781.
Ten-Doesschate Chu, Petra, and Gabriel Weisberg, eds. *The Popularization of Images: Visual Culture under the July Monarchy*. Princeton, NJ: Princeton University Press 1994.
Terdiman, Richard, ed. *Discourse/ Counter-discourse: The Theory and Practice of Symbolic Resistance in Nineteenth-Century France*. Ithaca, NY: Cornell University Press 1985.
Terni, Jennifer. "A Genre for Early Mass Culture: French Vaudeville and the City, 1830–1848." *Theatre Journal* 58, no. 2 (May 2006): 221–48.
– "Paris Imaginaire: Le vaudeville et le spectacle de la ville moderne dans les années 1820 à 1840." In Karen Bowie, ed., *La Modernité avant Haussmann: formes de l'espace urbain à Paris: 1801–1853*, 177–90. Paris: Éditions Recherches 2001.
Tester, Keith, ed. *The Flâneur*. London: Routledge 1994.
Thomas, Ronald R. *Detective Fiction and the Rise of Forensic Science*. Cambridge: Cambridge University Press 1999.

Bibliography

Thompson, Victoria. *The Virtuous Marketplace: Women and Men, Money and Politics in Paris, 1830–1870.* Baltimore, MD: Johns Hopkins University Press 2000.

Thornton, Sara. *Advertising, Subjectivity, and the Nineteenth-Century Novel: Dickens, Balzac and the Language of the Walls.* New York: Palgrave Macmillan 2009.

Tiersten, Lisa. *Marianne in the Market: Envisioning Consumer Society in Fin-de-Siècle France.* Berkeley: University of California Press 2001.

Travestissements parisiens. Costumes composés pour les bals de cette année par Gavarni. Paris: Aubert 1837.

Tresch, John. "The Prophet and the Pendulum: Sensational Science and Audiovisual Phantasmagoria around 1848." *Grey Room* 43 (spring 2011): 15–41.

Uzanne, Octave. *Fashions in Paris: The Various Phases of Feminine Taste and Aesthetics from the Revolution to the End of the Nineteenth Century.* London: W. Heinemann 1898.

Various Subjects Drawn from Life and on Stone by J. Gericault. London: Rodwell and Martin 1821.

Verhagen, Marcus. "The Poster in *Fin-de-Siècle* Paris: 'That Mobile and Degenerate Art.'" In Leo Charney and Vanessa R. Schwartz, eds., *Cinema and the Invention of Modern Life,* 103–29. Berkeley: University of California Press 1995.

Vicaire, Georges. *Manuel de l'amateur de livres de XIXe siècle, 1801–1893.* 8 vols. Paris: P. Rouquette 1894–1920.

La vie populaire à Paris par le livre et l'illustration, 15.e à 20.e siècle. Paris: Bibliothèque Historique de la Ville de Paris 1907.

Vincent, Steven. "Elite Culture in Early Nineteenth-Century France: Salons, Sociability, and the Self." *Modern Intellectual History* 4, no. 2 (August 2007): 327–51.

Voyage où il vous plaira, par Tony Johannot, Alfred de Musset et P.-J. Stahl [Hetzel]. Paris: Hetzel 1843.

Walker, Sue. "Order and the Abject in Charlet's Suite of Thirty Plates Representing the Imperial Guard." *Object* 10 (2008).

Wechsler, Judith. *A Human Comedy: Physiognomy and Caricature in 19th Century Paris.* Chicago: University of Chicago Press 1982.

Weisberg, Gabriel. "The Coded Image: Agitation in Aspects of Political and Social Caricature." In *The Art of the July Monarchy: France 1830 to 1848,* 148–91. Columbia: University of Missouri Press 1989.

White, Harrison C., and Cynthia A. *Canvases and Careers: Institutional Change in the French Painting World.* Chicago and London: University of Chicago Press 1993.

Willems, Philippe. "Between Panoramic and Sequential: Nadar and the Serial Image." *Nineteenth-Century Art Worldwide* 11, no. 3 (autumn 2012). http://www.19thc-artworld wide.org/autumn12/willems-nadar-and-the-serial-image.

Williams, Rosalind H. *Dream Worlds: Mass Consumption in Late Nineteenth-Century France.* Berkeley: University of California Press 1982.

Witkowski, Claude. *Monographie des éditions populaires. Les Publications illustrées à 20 centimes, les romans à quatre sous, 1848–1870.* Paris: J.-J. Pauvert 1982.

Wolfarth, Irving. "Et Cetera? The Historian as Chiffonnier." *New German Critique* 39 (autumn 1986): 142–68.

Wright, Beth S. "'A Better Way to Read Great Works': Lithographs by Delacroix, Roqueplan, Boulanger, and the Devéria Brothers in Gaugain's Suite of Scott Subjects (1829–1830)." *Word & Image* 26, no. 4 (October–December 2010): 337–63.

– "'That Other Historian, the Illustrator': Voices and Vignettes in Mid-Nineteenth Century France." *Oxford Art Journal* 23, no. 1 (spring 2000): 113–36.

Wrigley, Richard. "Between the Street and the Salon: Parisian Shop Signs and the Spaces of Professionalism in the Eighteenth and Early Nineteenth Centuries." *Oxford Art Journal* 21, no. 1 (1998): 45–67.

– *The Politics of Appearances: Representations of Dress in Revolutionary France.* London: Bloomsbury Academic 2002.

– "Unreliable Witness: The Flâneur as Artist and Spectator of Art in Nineteenth-Century Paris." *Oxford Art Journal* 39, no. 2 (2016): 267–84.

XIXth Century French Posters. Introduction by James Laver and preface by Henry Davray. London: Nicholson and Watson 1944.

Yousif, Keri. *Balzac, Grandville, and the Rise of Book Illustration.* New York: Routledge 2012.

– "Word, Image, Woman: Gavarni's and the Goncourts' Portrayal of the *Lorette*." *Image & Narrative* 15, no. 2 (2014): 22–37.

Index

Index